The TWENTIETH CENTURY ★ in ★ 100 MOMENTS

A Visual History

Heather Rounds and
Akim Reinhardt

THE TWENTIETH CENTURY IN 100 MOMENTS

en the Great War (later known as World r I) erupted in 1914, the vast majority Americans looked at it with a sense of achment and no interest in joining what y saw as a strictly European conflict. In 1916, sident Woodrow Wilson even successfully paigned for re-election with the slogan Kept Us Out of War!" But by the following r, the United States had been drawn into the est and deadliest war the world had yet seen, ng with the British and French against the rmans. Once involved, Americans reached for heights of nationalism. All Americans were ected to support the war effort. The federal ernment opened its first-ever propaganda eau. Most forms of dissent were banned. It even against the law to advocate pacifism. For man Americans, this created a particularly icult circumstance. Germans are the single-est group of ethnic immigrants in American ory, more than seven million having arrived e the founding of the United States. The

first large wave came during the 1840s and 1850s. Some two million had immigrated as recently as the last two decades of the nineteenth century, settling in cities and on farms. German culture, arts, and institutions were thriving in early twentieth-century America, including German-language newspapers, churches, theaters, and schools. However, as war raged, anti-German hysteria swept the nation, and anything German was suspicious. Both the mainstream American society and federal and state governments worked to repress German American culture. Many towns changed their German names, such as Berlin, Michigan, which became Marne. Countless German street names in cities and towns across the country were also changed. Many major orchestras refused to play music by German composers such as Richard Wagner or even Beethoven. School districts throughout America banned teaching the German language. German words were scrubbed from popular culture; frankfurters became hot

GI's in Palm Springs took V-J day in stride. News that it was all over and that World War II was at an end seemed first to have little effect on the men and women in uniform when it was flashed Tuesday afternoon. First impact of the news of the Japanese surrender seemed to stun patients and personnel at Torney General Hospital and men and women at the sth OTU air base here. A startling reaction to air base

personnel and Villagers was the strange quietness that prevailed Wednesday and yesterday. It finally dawned on them that there were no airplanes in the skies. The two-day holiday was in effect. It was the first time in years that the drone of planes above the Village was not heard. At Torney General Hospital the news came just as supper trays were being prepared for evening service on the wards and

World War I, German Americans ced substantial repression as teria rippled through society. World War II, however, German as fared much better than before. the United States again fought . This time, it was Japanese as who bore the brunt of wartime after Japan's attack on Pearl And the levels of oppression ed reached new and frightening Severe anti-Asian racism was monplace in America. Japanese s, even those born here, were en as "foreign." After Pearl anti-Japanese racism fueled fears nese Americans would spy for

In 1969, horse owner Penny Chenery brought two of her thoroughbred mares, Hasty Matelda and Somethingroyal, to Claiborne Farms in Kentucky. Each would be mated with Bold Ruler, one of the nation's premier studs. But instead of taking cash payment for his services, Bold Ruler's owners would take one of the offspring. Who chose first was to be determined by a coin flip. Bold Ruler's owners won the toss, and they chose the filly that would come from Hasty Matelda. That meant Chenery got the colt born from Somethingroyal the following March. A bright-red chestnut horse with three white socks, the colt still had no name after its first birthday, as the Jockey Club had turned

down Chenery's first five applications. Her secretary, Elizabeth Ham, finally submitted a sixth name, which she had come up with herself, and it gained approval: Secretariat. After losing his two-year-old debut on July 4, 1972, Secretariat reeled off eight consecutive victories (though he was disqualified in one), including several important preps for the Kentucky Derby. He was named the two-year-old horse of the year. Secretariat began his three-year-old season with two impressive wins before losing a third; it turned out he had an abscess in his mouth. After healing, he was ready for the premier events in American horseracing, the Triple Crown races: the Kentucky Derby, the Preakness

At the nation's first women's convention, held in 1848 in S Falls, New York, delegates appro Declaration of Sentiments that, a other things, advocated suffrag women. The movement gained until it was overwhelmed by gr sectional tensions. The women's move was centered in the North, and advocates were also active in the antis movement. As war neared, many in the antislavery movement pres women to put the suffrage questio

The
TWENTIETH CENTURY
★ *in* ★

100
MOMENTS

A Visual History of America

Heather Rounds
& Akim Reinhardt

ZENITH PRESS

Quarto is the authority on a wide range of topics.

Quarto educates, entertains and enriches the lives of our readers—enthusiasts and lovers of hands-on living.

www.quartoknows.com

First published in 2015 by Zenith Press, an imprint of Quarto Publishing Group USA Inc., 400 First Avenue North, Suite 400, Minneapolis, MN 55401 USA. Telephone: (612) 344-8100 Fax: (612) 344-8692

quartoknows.com
Visit our blogs at quartoknows.com

Zenith Press titles are also available at discounts in bulk quantity for industrial or sales-promotional use. For details contact the Special Sales Manager at Quarto Publishing Group USA Inc., 400 First Avenue North, Suite 400, Minneapolis, MN 55401 USA.

10 9 8 7 6 5 4 3 2 1

ISBN: 978-0-7603-4743-0

Library of Congress Cataloging-in-Publication Data

Rounds, Heather.
 The twentieth century in one hundred moments : a visual history / Heather Rounds and Akim Reinhardt.
 pages cm
 Includes index.
 ISBN 978-0-7603-4743-0 (plc w/jacket)
 1. United States--History--20th century--Pictorial works. 2. United States--Social life and customs--20th century--Pictorial works. 3. United States--Civilization--20th century. I. Reinhardt, Akim D. II. Title.
 E741.R68 2015
 973.91--dc23
 2015009518

Acquiring Editor: Elizabeth Demers
Project Manager: Madeleine Vasaly
Art Director: James Kegley
Cover Designer: Brad Norr
Layout Designer: Kim Winscher

Endpapers: Library of Congress

Printed in China

CONTENTS

INTRODUCTION

The twentieth century has often been called the American Century, and understandably so. Perhaps no nation has so thoroughly dominated world economy, culture, and politics the way the United States did during the 1900s. In only a hundred years' time, the country transformed itself from an upstart industrial power, tentatively competing with vast European empires, to the world's only true superpower, an international force so dominant that no other nation could imagine competing with it. In many ways, the twentieth century is a story about the rise of the United States, of its victories and innovations, of its success and influence.

However, in the year 1900, America's spectacular rise was hardly a foregone conclusion. The British and French empires were reaching their peaks of glory, wealth, and power. And while other empires, such as the Spanish, Ottoman, and Austro-Hungarian, were in decline, they had been important players on the world stage for many centuries and retained much of their prestige.

Meanwhile, the United States bubbled and percolated on the other side of the Atlantic Ocean, out of sight and, to some degree, out of the minds of European imperial powers. Though growing larger all the time, the United States as a nation was barely a century removed from having been nothing more than thirteen rural, cash-poor colonies among the British Empire's numerous overseas possessions. Indeed, many Americans themselves did not believe the United States was yet capable of playing a dominant part in world affairs, or even that it should. And the tale of its meteoric rise during the twentieth century is also one of frequent struggle and more than occasional setback.

As Americans approached the twentieth century, they looked around and saw a country in flux. What had once been a nation of farmers and small-town craftspeople was changing, as more and more people lived in bustling cities and worked in industrial factories. The rate of urbanization was unrelenting, and the 1920 census would reveal that, for the first time, a majority of Americans lived in cities.

Technological innovations and discoveries also began to fundamentally change the way Americans lived their lives. Light bulbs replaced oil-burning lamps, cars and trucks replaced horses, and improvements in public health and education enhanced daily life for many.

As a nation, the United States was also expanding at a dizzying rate, both in size and in population. Four states were admitted to the union in 1889 alone, and another three would be added before century's end, putting forty-five stars on the ever-changing flag. Meanwhile, huge new waves of immigrants, mostly from Europe, had begun arriving in 1880. This flood of humanity would not slow substantially until the early 1920s, by which time more than twenty-three million new Americans had arrived.

By 1898, US ambitions had moved beyond North America. That year, the United States initiated a major overseas war for the first time. After picking a fight with Spain, it easily defeated the once-mighty European power, whose formerly massive empire had been crumbling for centuries. After coasting to victory, the United States poached some of Spain's remaining colonies in the Caribbean and the Pacific: Cuba, Puerto Rico, Guam, and the Philippines.

With this aggressive overseas expansion, the United States put the European empires on notice: no longer just a collection of former British colonies, America was now a world power to be reckoned with. The United States was poised to capitalize on its recent growth, and the battering of Spain would prove a harbinger of American expansion and success in the century to come.

With hindsight, it is apparent that the classical empires such as the Ottoman Empire and Czarist Russia, with their roots in the feudal systems of the medieval era, were struggling to modernize and failing to do so in important ways. None of the Eurasian empires would survive the Great War, as World War I was then known.

Other, more industrial imperial powers—such as the French and British empires, which emerged during the seventeenth and eighteenth centuries, and the upstart German and Japanese empires, which began flexing their muscles in the late nineteenth century—were successfully

transitioning into modern nation-states. However, they too were on borrowed time. Wedded to visions of empire that were rooted in the age of sail, their commitments to aggressive expansion would soon draw the world into conflict yet again. All would either be utterly destroyed or severely crippled by 1945.

At the conclusion of World War II, the United States bestrode the globe like a colossus. While every other developed nation had suffered the ravages of invasion, the United States emerged stronger than ever. The only real competition it faced was from the successor state to the old Russian Empire. The communist regime of the Union of Soviet Socialist Republics (more often referred to as the USSR or Soviet Union) had been America's uneasy ally against Nazi Germany, but relations between the two nations deteriorated quickly after the war.

The ensuing Cold War between the two sides was occasionally fierce. And before long, the Soviet acquisition of nuclear arms guaranteed that any actual warfare between them would likely result in a suicidal draw. Fortunately, direct armed conflict never materialized. Instead, the two superpowers competed by building up their militaries, gathering important allies, and extending their influence over the smaller nations of the world.

Despite the fear and bravado on both sides, the Soviet Union was never actually in a position to compete seriously with the United States economically. Inheriting a broken economy from the Russian czars, absorbing tremendous damage during World War II, and mired in its own inefficiencies and corruption, the USSR perpetually lagged far behind America's vast engine of wealth generation.

Likewise, Soviet culture never captivated the world to anywhere near the degree that American culture did during the second half of the century. Tightly monitored by an authoritarian government, Soviet culture was often stern, rigid, predictable, and sparse. Meanwhile, all across the globe, people watched Hollywood movies, listened to American jazz and rock-and-roll, and craved Coca-Cola and Levi's jeans.

Along the way, American scientific innovations and discoveries helped modernize the world.

With the Cold War winding down during the late 1980s—first after the USSR's loss of control over its communist satellite states in Eastern Europe and then with its own collapse in 1991—the American Century would conclude with the United States standing solo as the world's only true superpower. It seemed that there was simply no one left to compete with it in a meaningful way.

But the twentieth century was not an unbroken train of American successes. Many people faced tremendous obstacles. Natural disasters, economic calamities, and warfare claimed countless victims. Sometimes Americans turned on each other. Racism, sexism, and economic exploitation drove wedges in society, granting privilege to some and gravely harming others, sometimes irreparably.

Americans often worked hard to triumph over the obstacles, whether circumstantial or self-inflicted, that confronted them. Not everyone witnessed tangible gains, and most improvements were incremental, slowly accruing over time. Nonetheless, by the end of the century, the nation had made tremendous strides toward overcoming its historical hurdles, at least to some degree, and in recognizing other problems worthy of its peoples' attention and effort.

However, no sooner had Americans started looking back with pride on what many proclaimed to be "their" century than they were forced to struggle against dark forces on September 11, 2001. A harsh reminder of life's frailties, the tragedies of that day brought Americans together while simultaneously exposing the nation's differences and vulnerabilities.

The American tale is still being written. And as their ongoing story unfolds in the twenty-first century, Americans are revealing something they have in common with the Americans of a hundred years prior. They are showing themselves to be determined to discover and innovate, to share and be heard, to struggle and triumph, and to create better lives.

—*Heather Rounds and Akim Reinhardt*

CELEBRITY

In 1601, William Shakespeare wrote: "Some are born great, some achieve greatness, and some have greatness thrust upon them."

In Shakespeare's time, greatness was equated with fame. People might have become famous in different ways, as the Bard pointed out, but fame itself was predicated on the idea of "greatness." That is, people were famous because they were important. They mattered.

For most of human history, usually only a few people in each generation achieved fame. And they became famous because they were powerful and influential members of society. Their actions were consequential. Politicians, generals, religious leaders, and a select few who deeply influenced society in other ways were widely known for what they had done, or what they had the power to do.

Indeed, there have always been famous people. But to be famous is not exactly the same as being a celebrity. To be a celebrity is to twist the age-old formula of fame. Instead of being famous for having done something of consequence, most modern celebrities become famous without fulfilling this prerequisite. In fact, many celebrities will never do anything important at all. And while some of them will go on to do important things, it is being famous in the first place that gives celebrities the opportunity to be influential, the exact opposite of someone who becomes famous because of significant action.

Modern celebrity, as such, is a fairly recent phenomenon. Before the twentieth century, very few people were famous without accomplishment. But as the 1900s dawned, a series of developments made modern celebrity possible—and even promoted it.

Of vital importance was the rise of mass media. First came national magazines in the late 1800s, followed in rapid succession by radio and motion pictures. All of these new media, including, eventually, television, helped create one large national audience instead of thousands of local ones. New technologies made it possible for individuals all across the United States to idolize the same musicians, athletes, or movie stars as their fellow Americans a thousand miles away.

The growth of the American economy and the rise of the middle class were also essential. Following the exploits of a celebrity requires having disposable income for new leisure activities and products, such as tickets to professional sporting events and the movies, or for expensive new gadgets, such as radios and TVs.

Another factor was the rise of cities. New urban centers soon became hubs for popular culture. And people at the top of the new pop-culture heap, particularly entertainers such as athletes, musicians, and actors, became nationally famous. Eventually, some celebrities would become famous for no other reason than having the desire and opportunity to have their picture taken.

Newfound fame afforded some celebrities, and more often the astute businesspeople connected to them, the opportunity for newfound wealth. Movie studios promoted their stars. Sports teams profited as daily newspapers covered their players' every move. Radio collected sponsorship money from companies looking to associate with the latest singer or actor. Modern celebrity meant not only wide recognition, but also the potential for tremendous wealth. And so fame became an end in and of itself, not just the by-product of having done something significant.

As the twentieth century opened, the United States was pioneering a new path to fame. Ballplayers and actors could now rub elbows in the newspaper with presidents and popes. As US wealth, power, and prestige grew, particularly after World War II, American celebrities were often famous worldwide, which has remained the case ever since.

Here in the twenty-first century, other countries have developed their own cities and popular cultures that create their own celebrities. International soccer stars routinely make headlines around the world, not just for their play on the field but for whom they date and marry. The world's largest film industry is not in Hollywood, but "Bollywood" in Mumbai, India. K-pop, the Korean popular culture that is wildly popular across most of East Asia, produced global celebrity singer Psy, whose music video for the song "Gangnam Style" was viewed over two billion times on YouTube in less than two years.

The American system of celebrity is now a global phenomenon. And it all began right here, at the start of a new century.

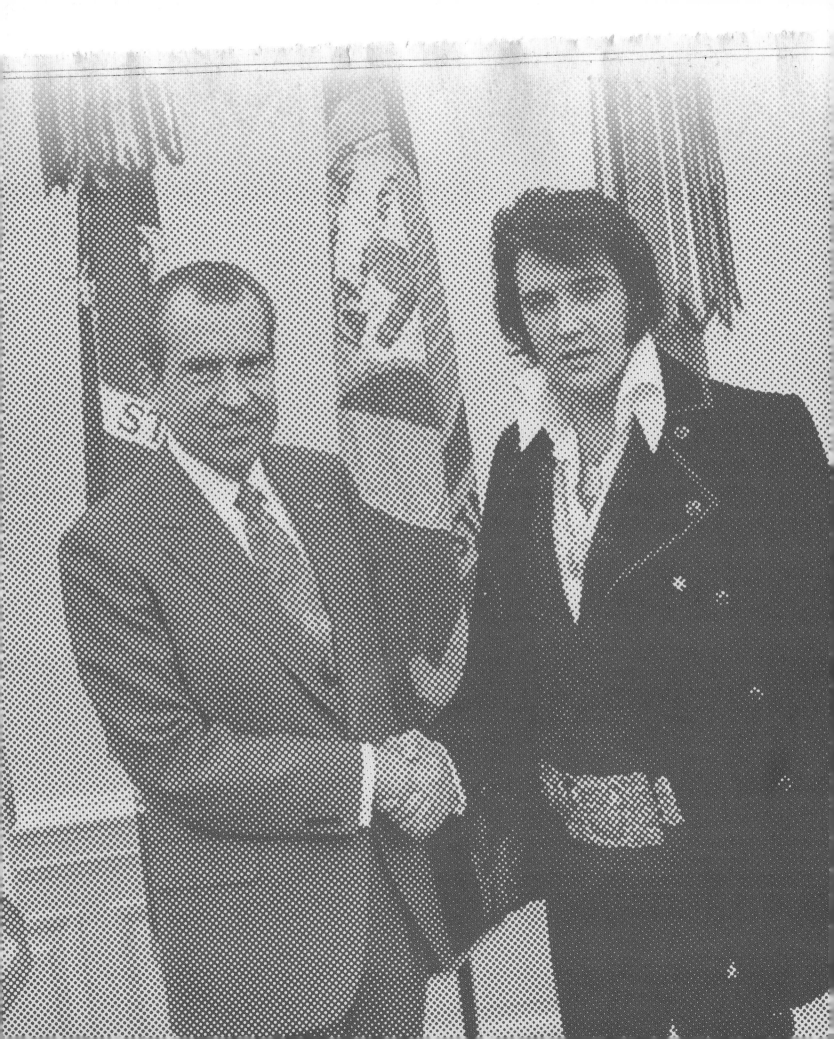

BUFFALO BILL CODY

GLORIFYING THE 19TH CENTURY AS AMERICA MOVES INTO THE 20TH CENTURY

As the twentieth century opened, many Americans began to look back fondly upon the past. People in the bustling industrial cities of the East began to pine for a nostalgic vision of the Old West. Emerging out of the nineteenth century to provide Americans with a ready-made version of that romanticized history was one of the twentieth century's first celebrities: William "Buffalo Bill" Cody (1846–1917).

Cody was intimately familiar with the brutal realities of the nineteenth century. As a young boy in Kansas, his father was attacked for his vocal antislavery views. After the Civil War, Cody worked as an army scout, sometimes helping to track down, fight, and even kill Native people. He also worked as a buffalo hunter on the Great Plains, slaughtering the great beasts to feed the army. But he also had an eye on fame and a flair for self-promotion.

In his late twenties, Cody began working as an actor in traveling Wild West road shows. This new form of entertainment was a live variety show held under a large circus tent, where people watched such displays of skill as sharpshooting, trick riding, and rope tricks. But the main feature was the large-scale dramatizations of daring Western stories, usually battles between Americans and Indians, complete with galloping horses. While promoters claimed that their stories were true, in reality they were often fictionalized, or at the very least exaggerated, giving the audience a romanticized, melodramatic, and falsely heroic version of the brutal US conquest of Native nations (*see* **Cultural Genocide**, *pages 160–162*).

At the age of thirty-three, Cody published his memoir, *The Life and Adventures of Buffalo Bill*. The book was popular, and in 1883 he founded his own road show, *Buffalo Bill's Wild West*. It was highly successful, and Cody spent the better part of three decades touring the United States and Europe with a large company of entertainers. Among them were many Indian people from the West, with whom he had a complicated relationship. Cody's show provided them decent wages, a way to escape the grinding poverty of the new reservations, and a chance to see the world. In return, they performed for mostly white audiences who viewed them as wild, bloodthirsty savages doomed to extinction. Meanwhile, some of the white performers with whom Cody worked, such as Annie Oakley and "Wild" Bill Hickok, became celebrities in their own right, idolized by Americans eager for tales of frontier heroes.

In 1895, he helped found the Wyoming town that bears his name and

opposite page: Portrait of Amos Two Bulls, a Sioux Brave employed by Buffalo Bill.
Library of Congress

right: Chromolithographic poster of Buffalo Bill Cody by the Courier Lithography Company.
National Portrait Gallery, Smithsonian Institution

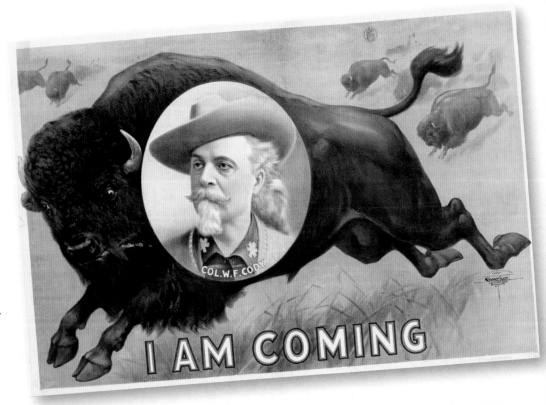

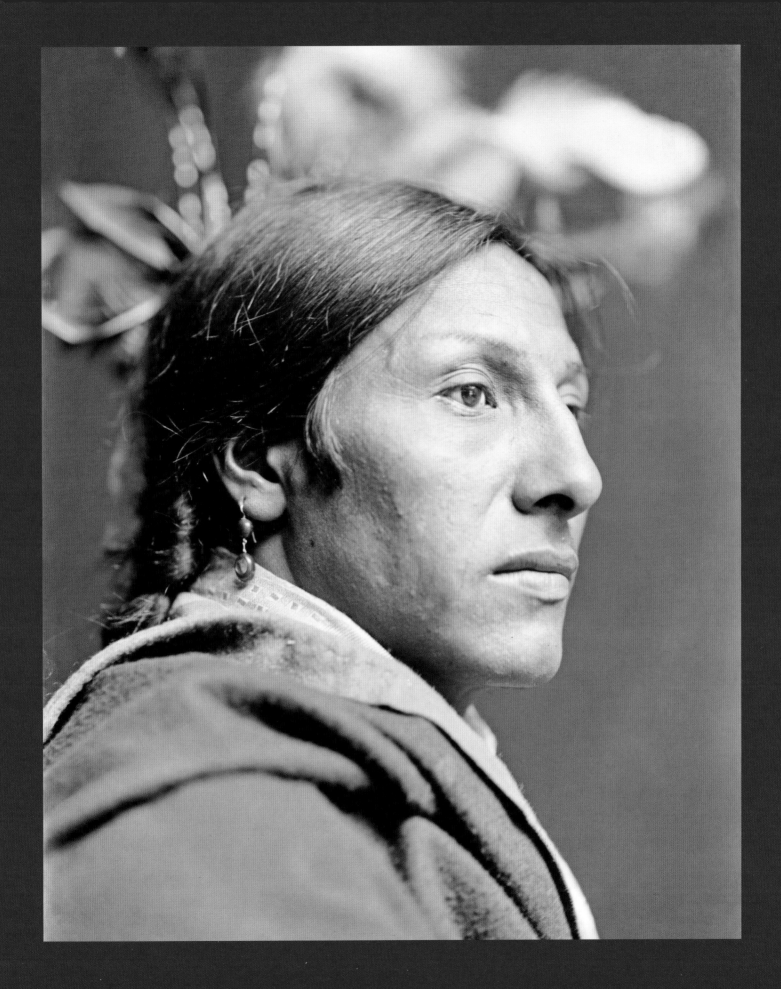

tried to turn it into a tourist destination. Other businesses included a dude ranch, camping trips, and big game–hunting expeditions. At his eight-thousand-acre ranch, he entertained prominent visitors from around the world. From 1886 to 1887, Cody's show played in New York City, including a long engagement at Madison Square Garden.

By 1900, Buffalo Bill Cody was one of the most famous Americans in the world. And he had achieved his celebrity by offering people an idealized version of the complicated and tumultuous nineteenth-century American West.

left: Buffalo Bill. *Library of Congress*

below: Chromolithograph poster advertising Buffalo Bill's Wild West Show. *Library of Congress*

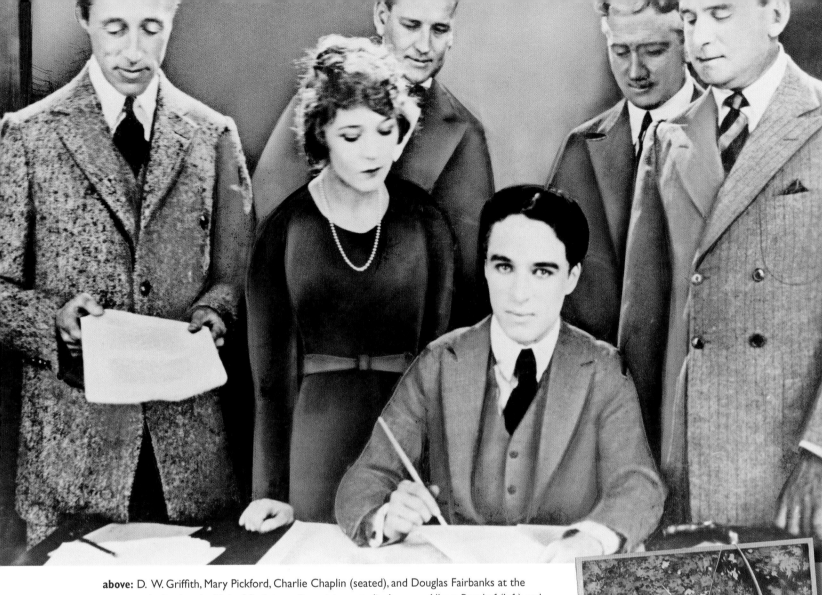

above: D. W. Griffith, Mary Pickford, Charlie Chaplin (seated), and Douglas Fairbanks at the contract signing for the United Artists motion-picture studio. Lawyers Albert Banzhaf (left) and Dennis F. O'Brien (right) stand in the background. *Library of Congress*;

right: Douglas Fairbanks featured on a movie poster for United Artists *Robin Hood* film, considered one of the most expensive films of the 1920s. *Public domain*

CHARLIE CHAPLIN, MARY PICKFORD, AND DOUGLAS FAIRBANKS

THE RISE OF HOLLYWOOD CELEBRITY

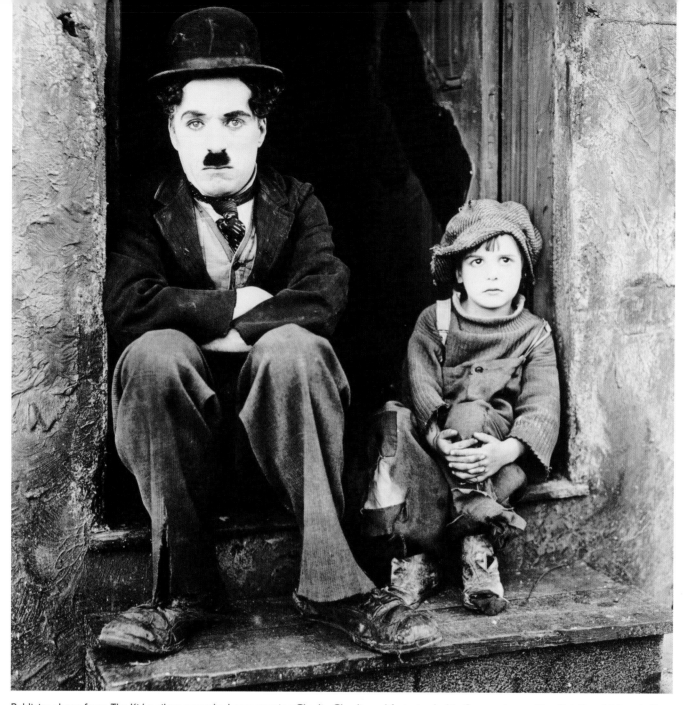

Publicity photo from *The Kid*, a silent comedy-drama starring Charlie Chaplin and featuring Jackie Coogan. It was Chaplin's first full-length film as a director and one of the first American films to combine dramatic and comedic elements. *Public domain*

The first public exhibition of a motion picture in America occurred in New York City in 1896. Early films, which could be viewed in urban entertainment arcades, were simple, single scenes. By the 1910s, however, feature films with multiple scenes, developed characters, and fuller story lines were becoming popular. As the nascent movie industry moved from the East Coast to Hollywood, the first movie studios arose, producing and distributing silent movies around the country.

As silent films became popular, early stars gained national fame. The studios began to promote not only their movies but the private lives of their actors in magazines and newspaper columns. Reaching an audience that stage actors could only dream of, the first modern movie stars began to emerge, aided by increased exposure from the Hollywood publicity machine.

By far the biggest early stars were a trio of actors who captured the national imagination in the 1910s: Charlie Chaplin, Mary Pickford, and Douglas Fairbanks Sr. Chaplin's character of the loveable tramp, still revered by modern film critics, appeared in smart, warm-hearted comedies that made audiences laugh while tugging at their heartstrings. Fairbanks and Pickford were lead actors in a series of successful romantic dramas. The first Hollywood divorce scandal occurred when each left their spouse and ran off with the other, their whirlwind love affair mirroring their onscreen romances.

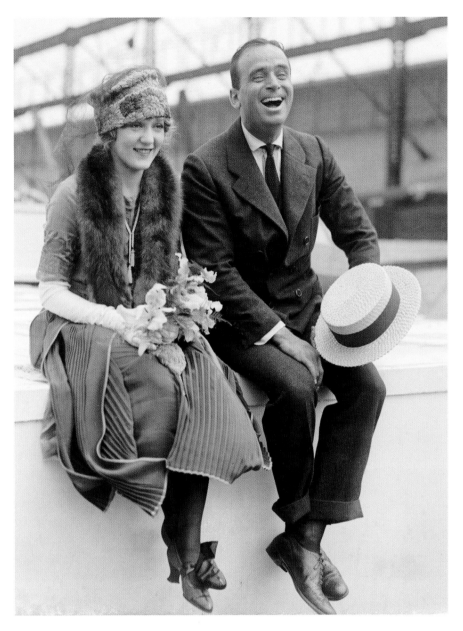

The three stars reached levels of wealth and fame previously unknown to actors, becoming the first modern Hollywood celebrities. They were so well known that in 1919 they were able to join forces with director D. W. Griffith and break away from the established Hollywood studios. Seeking more creative control over their films and a bigger share of the profits, they formed a new studio: United Artists.

Initially, UA struggled, but eventually it established itself as a major player in the business. Fairbanks's and Pickford's acting careers, however, ended with the rise of sound in the late 1920s. Chaplin was popular enough to continue making movies without dialogue throughout the 1930s, but he became a controversial figure during the 1940s because of his communist sympathies, a paternity suit filed against him, and his marriage to a much younger woman. But even as their careers declined, their places in history were cemented. Pickford, Fairbanks, and Chaplin created the template for the Hollywood movie star.

left: Douglas Fairbanks and Mary Pickford. *Library of Congress*

below: The United Artists Theater in downtown Los Angeles. At the time of this photo, it was being used as the Los Angeles University Cathedral; today, it is the Ace Hotel. *Andreas Praefcke*

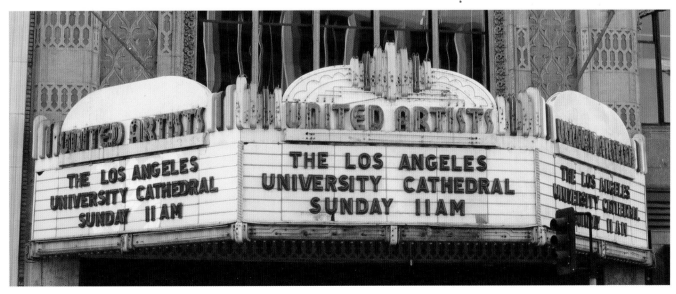

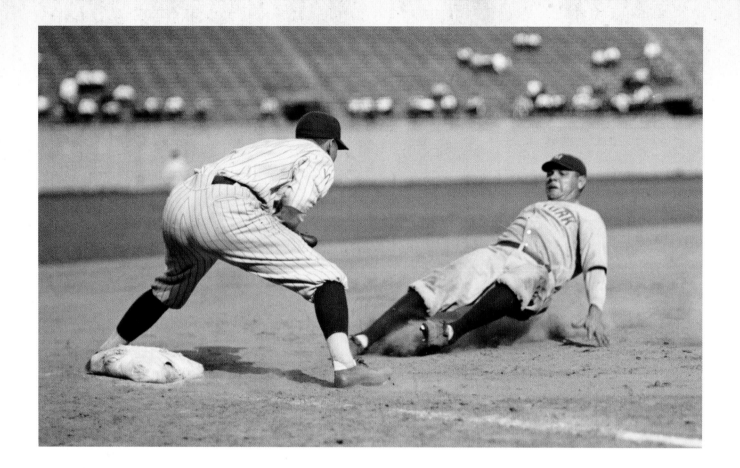

BABE RUTH

CELEBRITY FOR CELEBRITY'S SAKE

By the time George Herman "Babe" Ruth became the nation's most famous athlete during the Roaring Twenties, he had also come to represent a new America. His background, his personality, and his athletic prowess all contradicted the symbols and culture of nineteenth-century America. He was a new kind of celebrity for a new century.

The older America had championed rural values, Protestant Christianity, restraint, decorum, and abstention from alcohol (*see* **A Dry Nation**, *page 170*). Ruth was born and raised in Pigtown, a rough-and-tumble neighborhood of South Baltimore. His family was Catholic. His father owned a saloon. Ruth himself was boisterous, a braggart, and bigger than life. Even the way he played the game defied American norms.

above: Babe Ruth safe at third in the fourth inning on Bob Meusel's fly out. *Library of Congress*

opposite: Secretary of War James W. Good receives autographed balls and bats from Ruth to be awarded as prizes at citizen's military training camps. *Library of Congress*

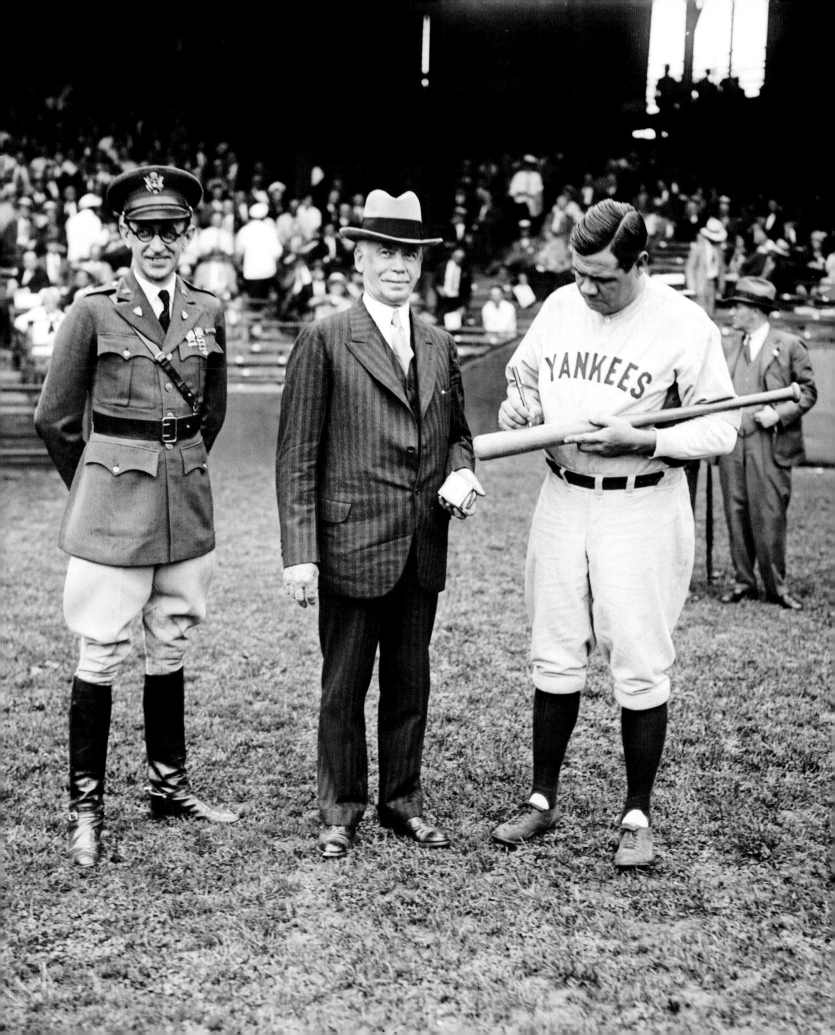

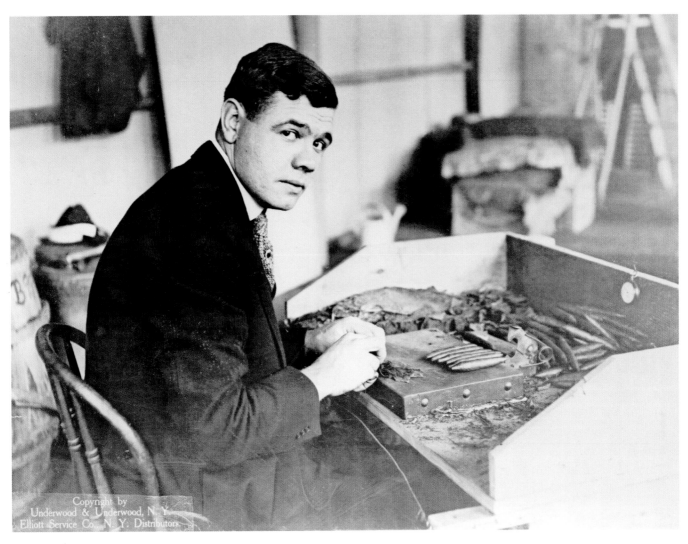

Ruth rolling a cigar. *Library of Congress*

Baseball had long been dominated by what is known as the "inside game." Teams scratched and clawed for runs with walks, bunts, stolen bases, hit-and-runs, fielder's choices, and sacrifice bunts and flies. Low-scoring games were the norm and home runs were a rarity. This style of play was thought by many to represent the American values of hard work and sacrifice (*see* **Living**, *page 110*). Babe Ruth changed all that.

A pitcher during his early years, Ruth was able to create his own batting style. Instead of a modest approach to hitting, the left-hander developed a ferocious swing and began sending balls over the fence at an unheard-of rate. In 1919, he became an outfielder and broke the single season major-league home run record. That winter, the Boston Red Sox sold him to the New York Yankees, where he played for the next fifteen years. His dominance on the field has never been recreated. Both in 1920 and in 1927, he hit more home runs for the season than did any other entire *team* in the league. His impact was revolutionary, taking home runs from a rarity and making them a regular part of the game.

Off the field, Ruth was also larger than life, demanding attention with his prodigious appetites for food, beer, and women. The Roaring Twenties challenged traditional, conservative values (*see* **The Roaring Twenties**, *page 118*), and in many ways Ruth represented the new, audacious attitudes. By 1930, his $80,000 salary (about $1.1 million in 2015 dollars) had made him the first baseball player to earn more than the president of the United States (Herbert Hoover made $75,000). Many Americans were incensed, since a ballplayer was obviously much less important than the president. When asked to defend his outrageous salary, Ruth quipped, "I had a better year than Hoover."

It was hard to argue with his logic. Once again, he'd led the majors in home runs, as well as four other major categories, while Hoover was taking the heat for the Great Depression.

CHARLES LINDBERGH
CELEBRITY FOR CELEBRITY'S SAKE

Why was Charles Lindbergh so famous for so long?

For almost the entire twentieth century, virtually every American knew his name. But eventually many people no longer remembered why he was famous to begin with. Many mistakenly believed he was the first person to fly across the Atlantic Ocean. Lindbergh was neither the first person to fly nonstop across the Atlantic nor the first to fly solo across the Atlantic. And he certainly blazed no new trails in the sky above the much-larger Pacific Ocean.

All of those aeronautical firsts, and many others, were achieved by others. Lindbergh, however, was the first person to fly solo *and* nonstop across the Atlantic.

So why did Lindbergh achieve such enormous and lasting fame, while all of the other aviation pioneers quickly faded from popular culture? The answer has less to do with Lindbergh himself and more to do with the nature of modern celebrity.

In 1919, a New York hotel owner who was captivated by the era's aeronautical breakthroughs offered a $25,000 reward to the first person who could achieve what Lindbergh eventually would. For several years the prize went unclaimed. But as more and more people tried and failed during 1926 and 1927, and the deaths and injuries mounted, the popular press became interested in the story.

With the increased attention, crowds were now regularly gathering to watch planes depart from Long Island. Lindbergh launched his attempt in 1927 amid the

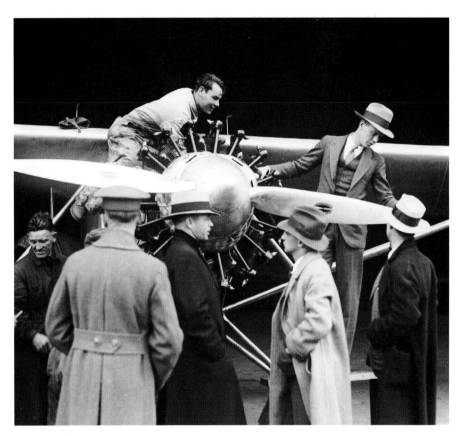

The *Spirit of St. Louis. Library of Congress*

growing fanfare. And when he successfully touched down at Le Bourget airfield in France on May 21, approximately 150,000 people were waiting to see him. After landing, they dragged him from his plane and carried him over their heads for some ninety minutes.

Lindbergh then toured Europe to wide acclaim. Upon returning to America, he was welcomed with a ticker-tape parade in Manhattan. Later that year, Congress awarded him the Medal of Honor. Though

no more important than many other aviation pioneers, and less important than many, Charles Lindbergh's celebrity was born.

Lindbergh furthered his celebrity by quickly producing a best-selling memoir and by touring all forty-eight states and nineteen foreign countries. Tragedy also bolstered his fame when his twenty-month-old son was kidnapped and eventually murdered in 1932. The press dubbed it "the Crime of the Century."

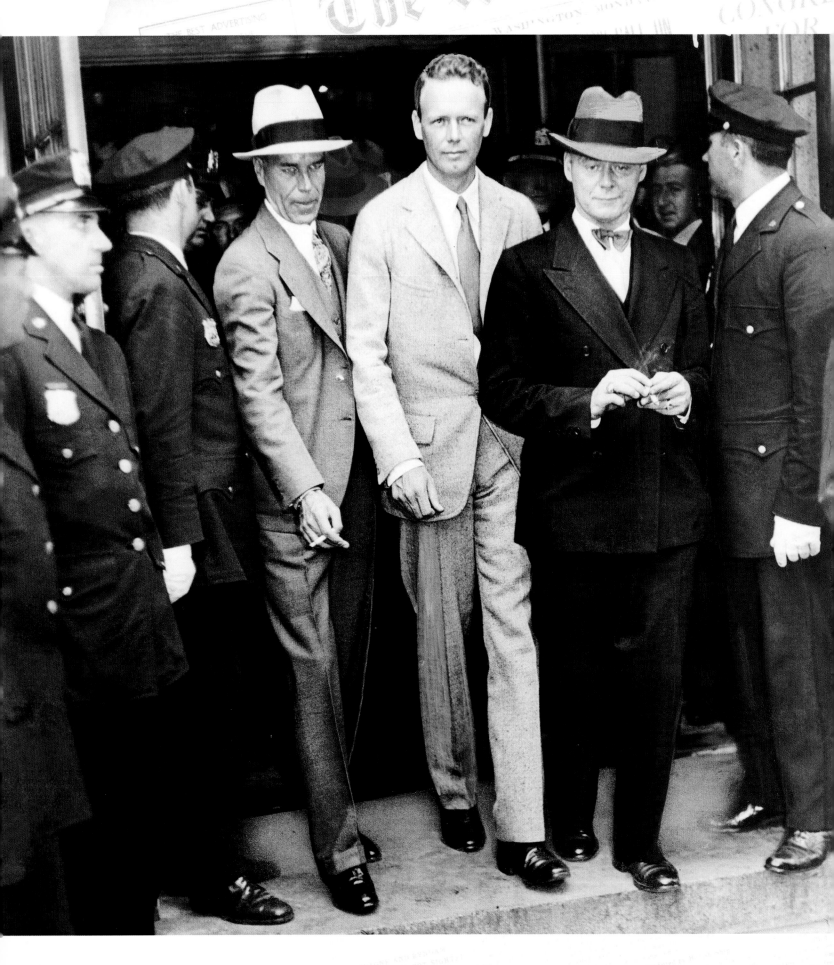

When the kidnapper was found, tried, and convicted two years later, the affair once again became a press extravaganza.

Now disgusted by his fame, Lindbergh moved his family to Europe from 1936 to 1939. Later, his public persona would be marred by controversy when he made numerous comments sympathetic to Nazi Germany's anti-Jewish policies and publically espoused deeply racist views.

In less than fifteen years, Charles Lindbergh had gone from celebrity hero to celebrity victim to celebrity villain. Throughout everything, he was still a celebrity.

opposite page: Lindbergh, accompanied by Col. H. Norman Schwarzkopf of the New Jersey State Police, leaves the courthouse after telling the Bronx grand jury about the $50,000 ransom payment he paid for his son. *Library of Congress*

right: Lindbergh's Distinguished Service Medal of the American Legion, on exhibit at the Missouri History Museum, Saint Louis, Missouri. *Robert Lawton/Creative Commons*

below: Graphite, ink, and watercolor portrait of Calvin Coolidge and Charles Lindbergh. Coolidge, president when the *Spirit of St. Louis* touched back down on American soil, awarded "Lucky Lindy" the first ever Distinguished Flying Cross on June 11, 1927. *Library of Congress*

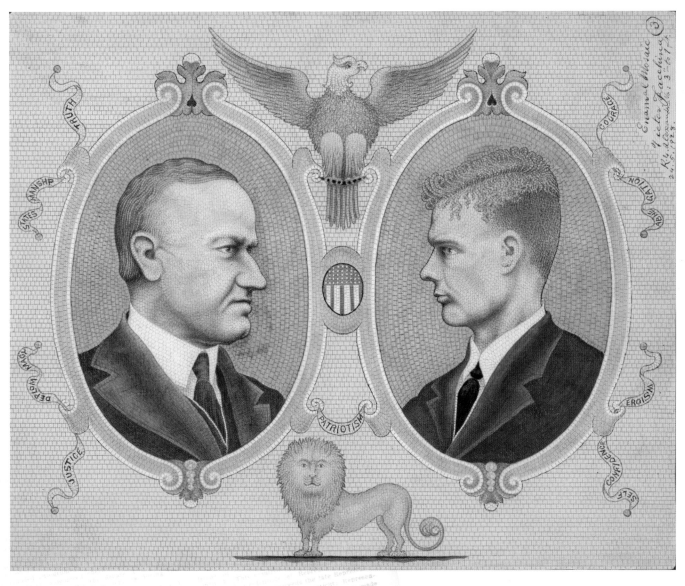

SHIRLEY TEMPLE

CHILD CELEBRITY

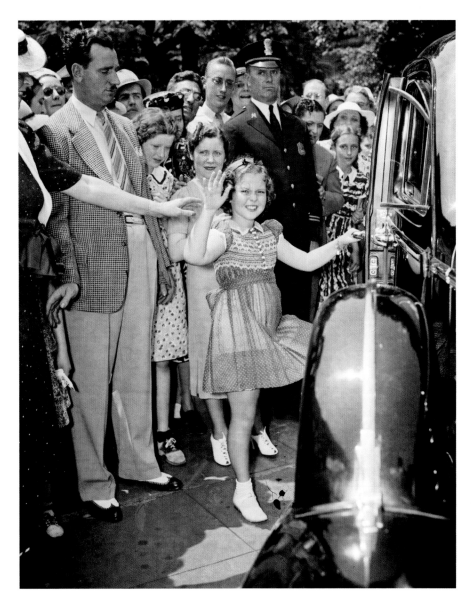

Shirley Temple leaving the White House offices after conferencing with President Roosevelt, 1938. *Library of Congress*

As celebrity became a growing part of American popular culture during the early twentieth century, the first true child star, and still today one of the biggest stars of all time, was Shirley Temple.

Born in 1928, Shirley Temple's mother enrolled her in acting class when she was only three years old. By the age of six, she was an international celebrity after having starred in the movie *Bright Eyes*. It was a huge success, thanks in no small part to Temple's stunning talent; the small child was able to dance, act, and sing, and her overpowering charisma seemed to jump off the screen. The following year, the Academy Awards created a special Oscar for her—the Juvenile Academy Award. A star was born, not long after she'd actually been born.

During the 1930s, as the United States slogged through the Great Depression (see **A Poor Nation**, page 172), Temple's movie studio marketed her carefully. Twentieth Century Fox consistently featured uplifting, sentimental stories about hard-pressed people overcoming life's many obstacles by finding happiness in the irrepressible joy and endless optimism of one special little girl. Often playing an orphan, her smile and warmth led criminals to reform, reconciled estranged spouses, and softened various hard hearts. American audiences responded enthusiastically, and the movies, with their hit formula, kept coming.

Temple starred in a string of 1930s box-office smashes. Films such as *Curly Top*, *Heidi*, and *The Littlest Rebel* were all enormous hits. By 1935, and still at only eight years old, Temple was making $2,500 per week (over $40,000 in 2015 dollars). By 1937, top adult stars were lining up to work with her. She was the

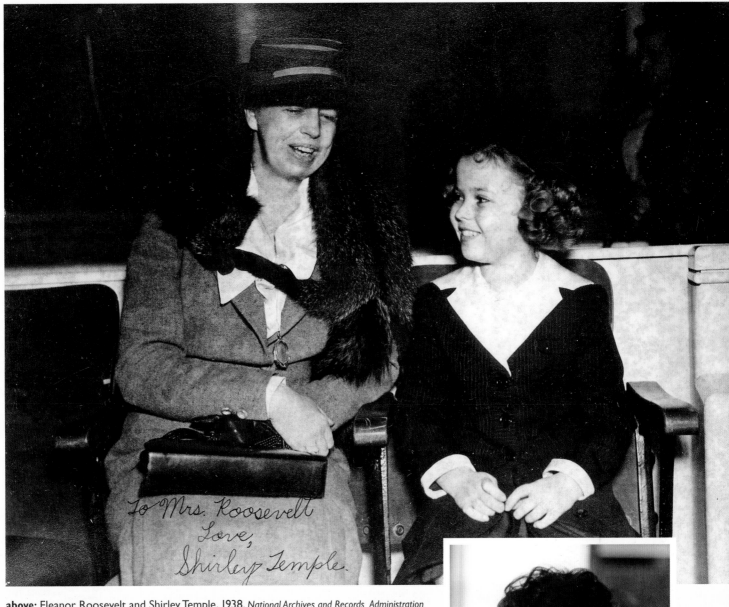

above: Eleanor Roosevelt and Shirley Temple, 1938. *National Archives and Records Administration*

right: Shirley Temple Black in Prague, Czechoslovakia, serving as US ambassador in 1990. *David S. Nolan, US Air Force*

To Mrs. Roosevelt
Love,
Shirley Temple.

top-grossing Hollywood star at the box office every year from 1935 to 1938. In 1939, MGM desperately wanted Temple to star as Dorothy in *The Wizard of Oz*, but Twentieth Century Fox refused to let her do the movie.

By 1940, Shirley Temple's run as a child movie star had come to an end, and her acting career fizzled. But her adult accomplishments were also impressive. She eventually became an established American diplomat, serving at different times as the US ambassador to the former Eastern European nation of Czechoslovakia and to the West African nation of Ghana. However, her diplomatic success received scant attention compared to her fame as a child movie star. No matter her adult achievements, the American public continued to remember Shirley Temple as the little girl on the big screen.

JOHN DILLINGER
and the Depression Era Gangsters

During the first three decades of the twentieth century, the new breed of American celebrities were mostly entertainers. And as top athletes and stars of film and radio garnered fame and fortune, more and more Americans began emulating them. People across the country began aspiring to successful careers as singers and actors, baseball players and boxers.

But what does it mean when people become famous for doing bad things? What does it mean when criminals become celebrities?

Many cultures have old stories about people who do bad things for the right reason. Robin Hood, the legend goes, stole from the rich and gave to the poor. Stealing is wrong, of course, but in the case of Robin and his Merry Men, we can make an exception. Besides, it's just a story.

But during the Great Depression of the 1930s, a series of real life criminals, murderers and thieves, became celebrities. With the economy in ruins and roughly half the work force unable to find a full time job, many Americans wanted to believe that the nation's most famous and notorious criminals were modern-day Robin Hoods. And after millions had lost money in collapsed banks, which were then uninsured, many wanted to believe that the bankers that gangsters stole from were the true villains.

Criminals like Baby Face Nelson, Bonnie and Clyde, Machine Gun Kelly, and Pretty Boy Floyd captured the nations attention. With a string of daring heists, shootouts, and jailbreaks, they became romantic outlaws in the public imagination. Among the many, John Dillinger was the biggest celebrity criminal from the era.

Handsome and fearless, Dillinger terrorized bank tellers and police officers across the Midwest. With a base of operations in Chicago, his gang robbed two dozen banks and four police stations during its brief heyday, while Dillinger burnished his own growing legend by successfully escaping from two different jails. He also murdered an Indiana police officer in a shootout.

John Dillinger met his own demise in 1934, when FBI agents shot him dead outside a Chicago movie theater. He was thirty-one years old.

Other celebrity gangsters were also hunted down. Pretty Boy Floyd was killed by law enforcement at the age of thirty. Bonnie and Clyde were ambushed and shot to death by Texas and Louisiana police when they were twenty-three and twenty-five years old respectively. Baby Face Nelson,

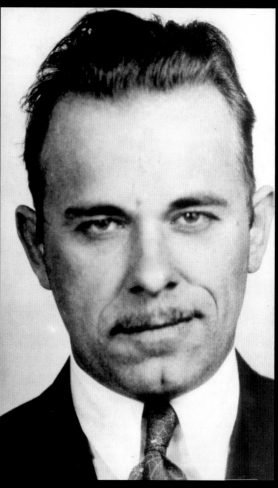

FBI mug shot of John Dillinger. *Public domain*

who killed more FBI ag[...]
anyone before or since, wa[...]
down when he was tw[...]
Machine Gun Kelly was [...]
when he was thirty-three a[...]
the rest of his life in prison[...]

Later, during the 196[...]
1970s, when the America[...]
again turned cynical, th[...]
because of racial opp[...]
Vietnam, and Watergat[...]
legends of 1930s gangste[...]
revived. Long dead crimina[...]
Dillinger and Bonnie and [...]
became Hollywoods read[...]
anti-heroes in string of succ[...]
outlaw movies. Proving once[...]
that every once in a while, [...]
want to root for Robin Hood.

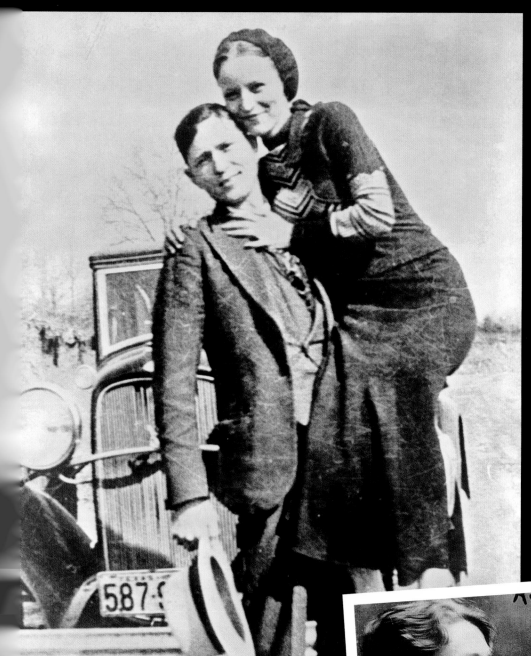

left: Criminal lovebirds Bonnie and Clyde on the run, posing in front of ar[...] early 1930s Ford V-8. *Library of Congress*

below: FBI mug shot of Lester Gillis, A[...] Baby Face Nelson. *Public domain*

CLARK GABLE AND THE CASE OF THE MISSING UNDERSHIRT

Clark Gable was one of the most successful leading men in Hollywood history. Known as the King of Hollywood during the 1930s and 1940s, he was a top-ten-grossing actor sixteen different years. He was a leading man in over sixty movies, he was nominated for an Academy Award three times, and he won once. His Oscar-nominated role as Rhett Butler in the 1939 smash hit *Gone with the Wind* made him one of the most famous people in the world. But perhaps the true mark of his celebrity can be seen in the kerfuffle over his undershirt.

In 1934, Gable starred opposite Claudette Colbert in the romantic comedy *It Happened One Night*. During one notorious scene, the strapping leading man unbuttoned and removed his shirt. To the shock of audiences across America, he was not wearing an undershirt beneath it. His bare-chested scene was racy by the standards of the day.

Gable was already on his way to becoming a star when *It Happened One Night* became a national sensation. The comedy was clever, the dialog fast paced and witty, and the chemistry between Gable and Colbert sizzled. It is still considered one of the best films ever made and the first great romantic comedy. It garnered Gable his only Oscar and catapulted him into the top ranks of celebrity. And as Gable's fame grew, so did the myth of his star-making turn.

Clark Gable and Jack Oakie sight the "wolves" in *The Call of the Wild*. *Public domain*

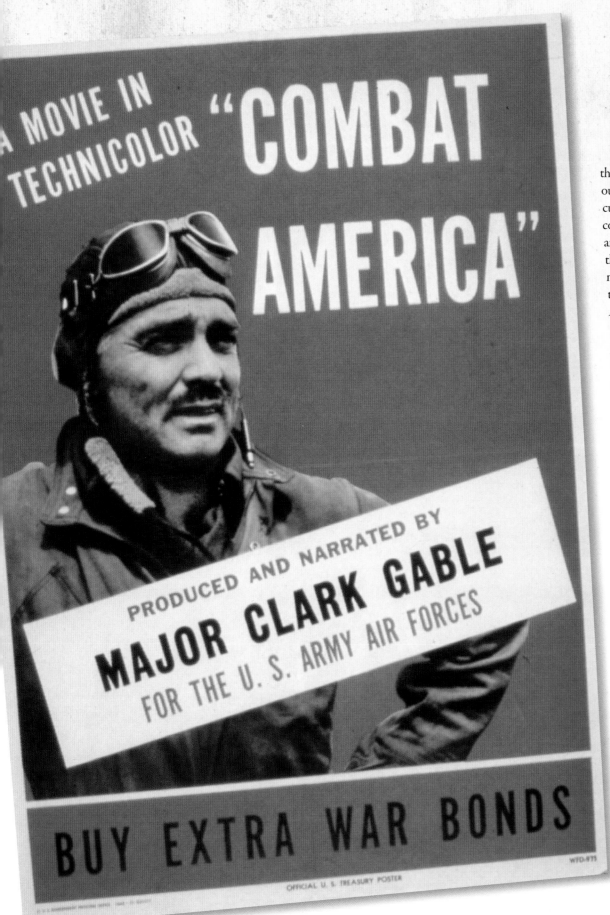

A MOVIE IN TECHNICOLOR "COMBAT AMERICA"

PRODUCED AND NARRATED BY MAJOR CLARK GABLE FOR THE U. S. ARMY AIR FORCES

BUY EXTRA WAR BONDS

OFFICIAL U. S. TREASURY POSTER

Rumors eventually arose that the shirtless scene had had an outsized impact on American culture. Clark Gable was widely considered the sexiest man alive, and if he didn't wear an undershirt, then apparently other American men didn't want to either. Soon there were claims that, following *It Happened One Night*, undershirt sales in America plummeted. Some began to say that sales dropped by as much as 75 percent. By midcentury, it had become received wisdom that undershirt sales had in fact fallen dramatically after his steamy scene with Colbert.

Did undershirt sales really nosedive? There's actually no evidence to support the claim. Most likely, the answer is no. But the legend continued to swirl, largely unchallenged, for decades. And that says more about Clark Gable's enduring celebrity than it does about men's fashions in the 1930s. Americans clung to the story because they needed a way to describe just how famous the King of Hollywood was.

Poster for the 1943 Allied propaganda film *Combat America*. *National Archives and Records Administration*

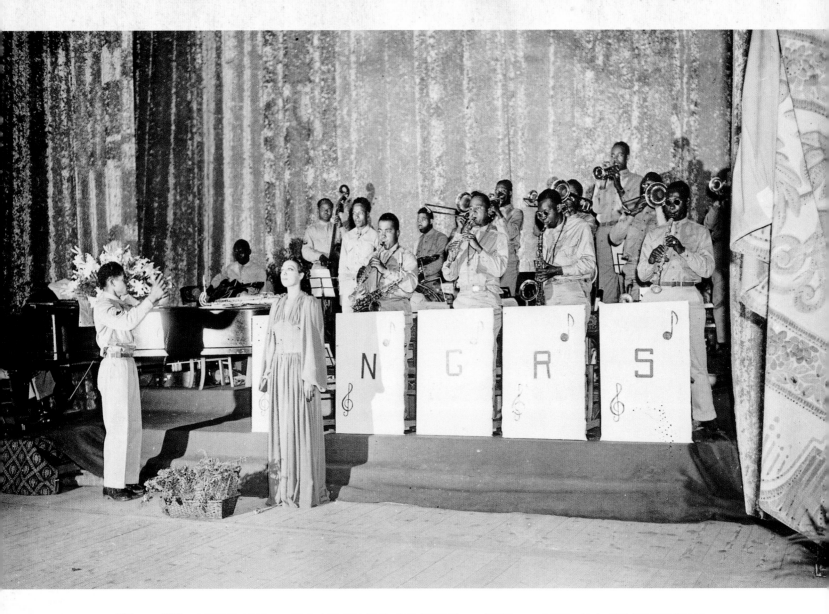

JOSEPHINE BAKER
CELEBRITY IN EXILE

Born in St. Louis, Missouri, in 1906, Josephine Baker was already a successful entertainer at age fifteen. However, by 1937 she had become a citizen of France, where she remained for most of her life, unwilling to endure the slings of US racism.

During the early 1920s, Baker achieved fame as a dancer, actor, and singer in three popular Broadway shows. In 1925, she performed in Paris for the first time and was an instant sensation, wowing Parisian audiences with her singing and erotic dancing. She remained in France, in part because of her tremendous success there and in part because

above: Baker performs the National Anthem as the show finale at the Municipal Theater, Oran, Algeria. *National Archives and Records Administration*

opposite page: Portrait of Baker in Paris, 1949. *Library of Congress*

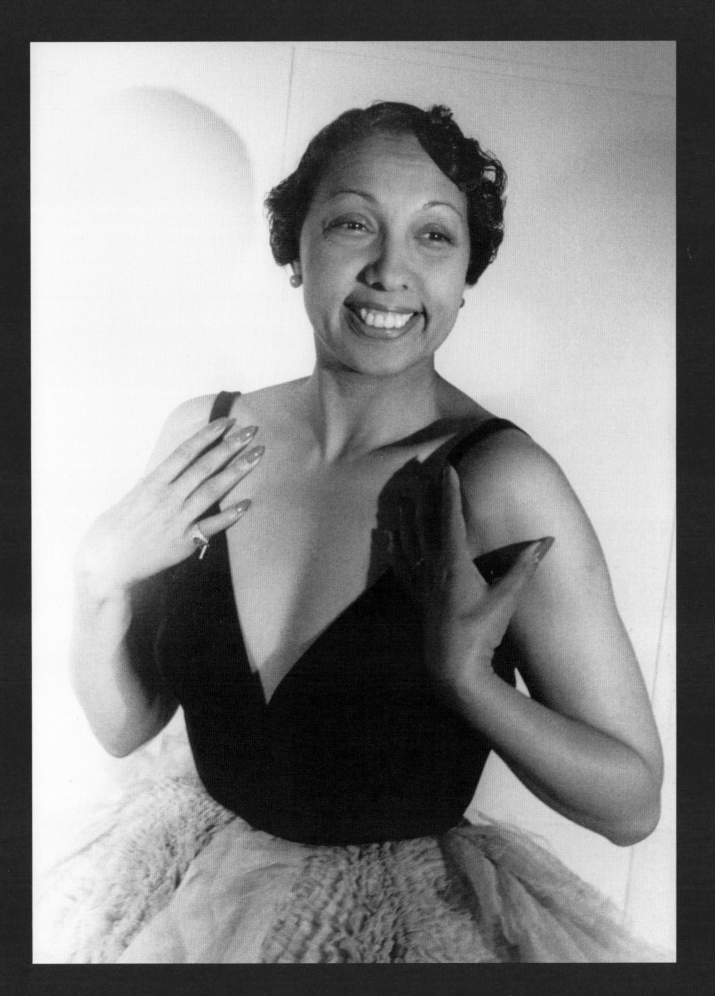

life as a black person was less onerous there than it was in the United States.

In 1934, Baker became the first black woman to star in a major motion picture, the French film *Zouzou*. She was, by then, the most popular American entertainer in Europe, and her success set the precedent for numerous black jazz musicians who lived in France after World War II.

White American audiences were generally uncomfortable with the notion of a black woman in a sophisticated leading role. When Baker returned to the United States to star in the Ziegfeld Follies in New York City in 1935, ticket sales were low. *Time* magazine referred to her as a "Negro wench." Two years later, she was back in France, married to a French Jew, and had been granted French citizenship.

Her devotion to France was as strong as her rejection of US racism. She remained there throughout the devastation of World War II, and early in the war she worked for French military intelligence, reporting back the information she obtained while hobnobbing with influential German, Italian, and Japanese figures. During the Nazi occupation, she was active in the French resistance. She also traveled through parts of Europe and North Africa to gather information clandestinely and later entertained Allied troops across North Africa. After the war, the French government awarded Baker two awards, the Croix de guerre and the Médaille de la Résistance with rosette, and made her a chevalier of the Légion d'honneur.

In 1951, Baker returned to the United States and received rave reviews. In Miami, she turned down a $10,000 offer (more than $90,000 in 2015 dollars) to play to segregated audiences; the club acquiesced and desegregated. In Harlem, one hundred thousand people turned out for a parade in her honor. However, her complaint of racist treatment at a club in New York City became a contentious issue in the national press, and the State Department canceled her work visa, forcing her to return to France. She was not allowed back in the United States for nearly a decade.

Baker remained active in the US civil rights movement from afar, working with the NAACP. In 1963, with Martin Luther King at her side, she spoke at the same March on Washington at which MLK gave his famous "I Have a Dream" speech (*see* **Searching for the American Dream**, *page 189*).

In 1973, the US public warmly welcomed Josephine Baker back as she played New York's Carnegie Hall to standing ovations. But by then, she had long established her home and family in France, where she continued to live until her death in 1975.

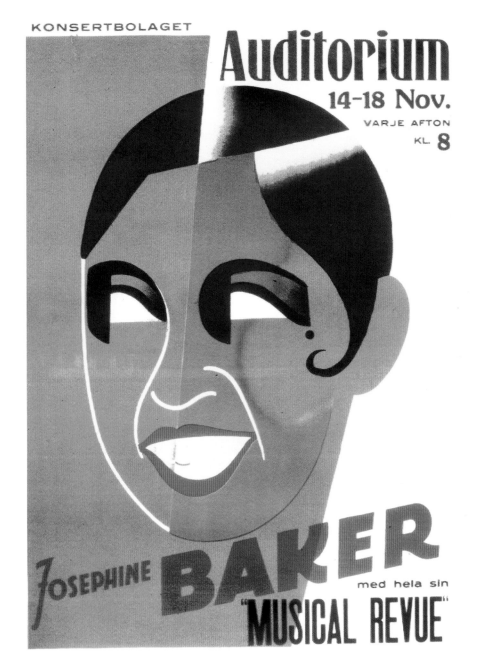

Poster advertising Baker's 1938 performance in Stockholm, Sweden. *Public domain*

GRETA GARBO
RECLUSIVE CELEBRITY

Americans are often envious of celebrities, coveting their fame. However, many celebrities carefully guard their private lives and even remove themselves from the public eye periodically. Rare, however, is the celebrity who rejects fame outright. The star who became most known for adamantly rejecting her own fame was Greta Garbo.

Born in 1905, the Swedish actress first established herself at the age of nineteen, and Hollywood recruited her the next year. She made a splash in several silent movies and by 1936 was an international star.

Unlike many stars of the silent era, Garbo not only made a successful transition to talkies but even saw her star power increase. During the 1930s, she was nominated for three Academy Awards and won two best actress awards from the New York Film Critics Circle; she received an honorary lifetime Oscar in 1934. In 1999, the American Film Institute rated her the fifth-greatest female star of the twentieth century, behind only Katherine Hepburn, Bette Davis, Audrey Hepburn, and Ingrid Bergman. However, in 1941, when she was only thirty-five years old, Greta Garbo retired from film.

Part of Garbo's success had depended on eager European audiences, which were no longer available during World War II. At first, Garbo was willing to wait out the war. However, by the time it ended in 1945, she was less sure. Garbo

Portrait of Greta Garbo. *Library of Congress*

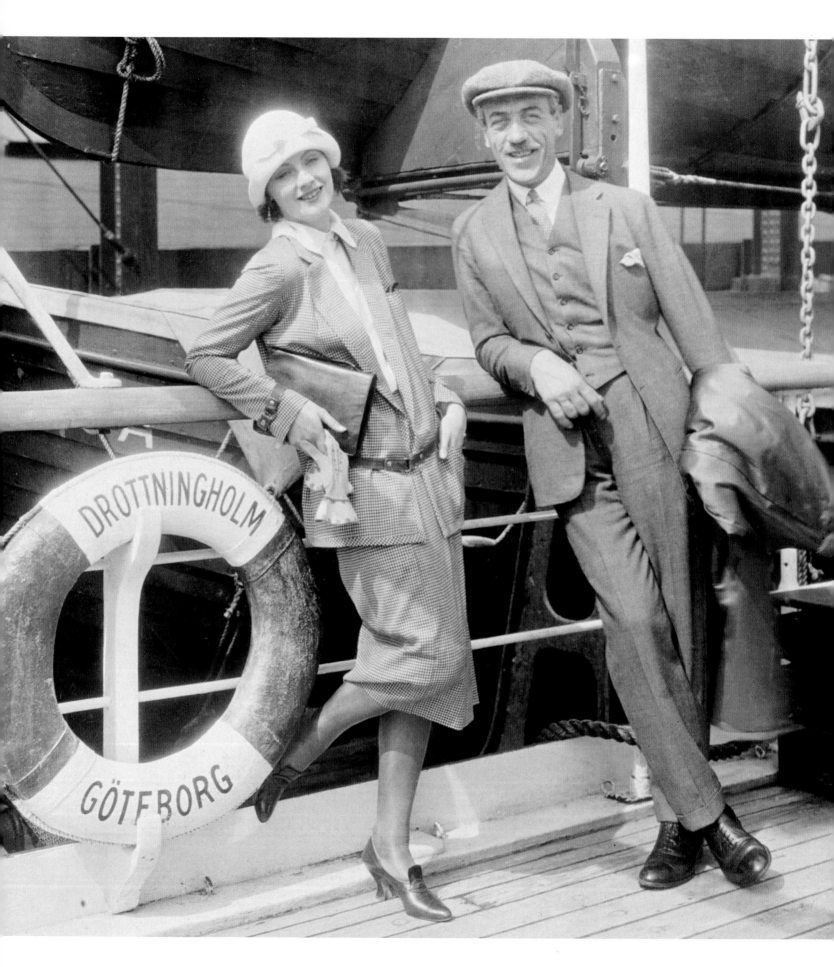

above: A public square named in honor of Garbo, located in Stockholm, Sweden. *Arild Vågen*

left: Garbo with Mauritz Stiller, the Finnish-Swedish film director revered for discovering the actress and bringing her into the American limelight. *Library of Congress*

continued biding her time, until finally signing on to appear in a new film in 1948. But financing fell through, and the project never materialized.

By 1949, Garbo showed little interest in returning to Hollywood, turning down a leading role in the film *Sunset Boulevard*. Afterward, she never again appeared in any films, despite countless offers. On a very few occasions she initially agreed, only to back out after the slightest problem arose.

Garbo had never enjoyed making public appearances, and early on, MGM capitalized on this by promoting her as a mysterious, reclusive star. When she maintained efforts to keep her private life private during retirement and abandoned her public life, the myth grew. American popular culture reveled in portraying Greta Garbo as lonely and impenetrable. In truth, she traveled widely, collected art, and had many friends and acquaintances. But the mythical image of her as a reclusive spinster desperately running from her own fame persisted, because it helped explain what so many people could not comprehend: why someone had willingly abandoned celebrity.

MARILYN MONROE

TROUBLED CELEBRITY

Americans are well acquainted with the idea of celebrities becoming overwhelmed by their fame. The tragic downward spiral of massive stars such as Elvis Presley and Michael Jackson no longer shocks the public, while the untimely demise of countless lesser stars has made the "troubled celebrity" a familiar trope in American culture. Perhaps no one in American culture represents the tragedy of the troubled celebrity more than Marilyn Monroe.

Born Norma Jean Mortenson in 1926, she landed a film contract with Twentieth Century Fox at the age of twenty by leveraging her successful modeling career. The studio changed her name to Marilyn Monroe. Monroe's career took off in 1950, but two years later she became embroiled in scandal when nude photos from the 1940s became public. The scandal threatened to derail her career, but Monroe convinced the studio to let her tackle the issue head on. She told the press that she had posed nude only because she had been poor and out of options. It worked. Many stories portrayed her in a sympathetic light by emphasizing her difficult childhood, which included an abusive mother and time in foster homes. Her career was saved, though these stories also later bolstered her image as a fragile victim.

One of Monroe's nudes appeared in the debut issue of *Playboy*, the magazine

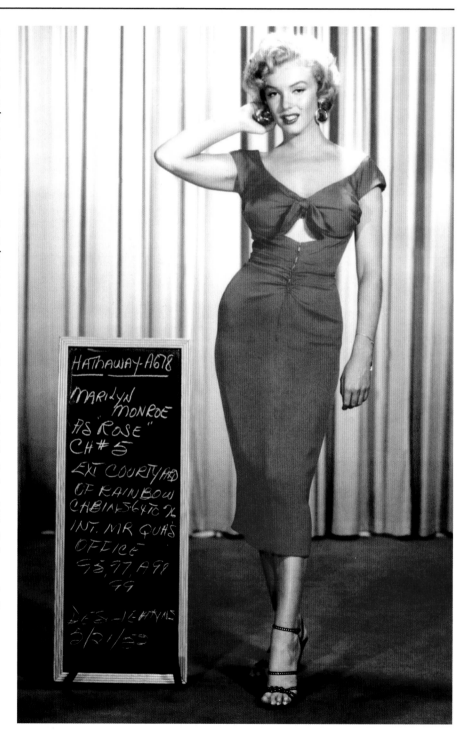

right: Studio publicity portrait of Monroe for the film *Niagara*. *Public domain*

opposite page: Monroe in Korea on her USO tour, 1954. *US Marine Corps*

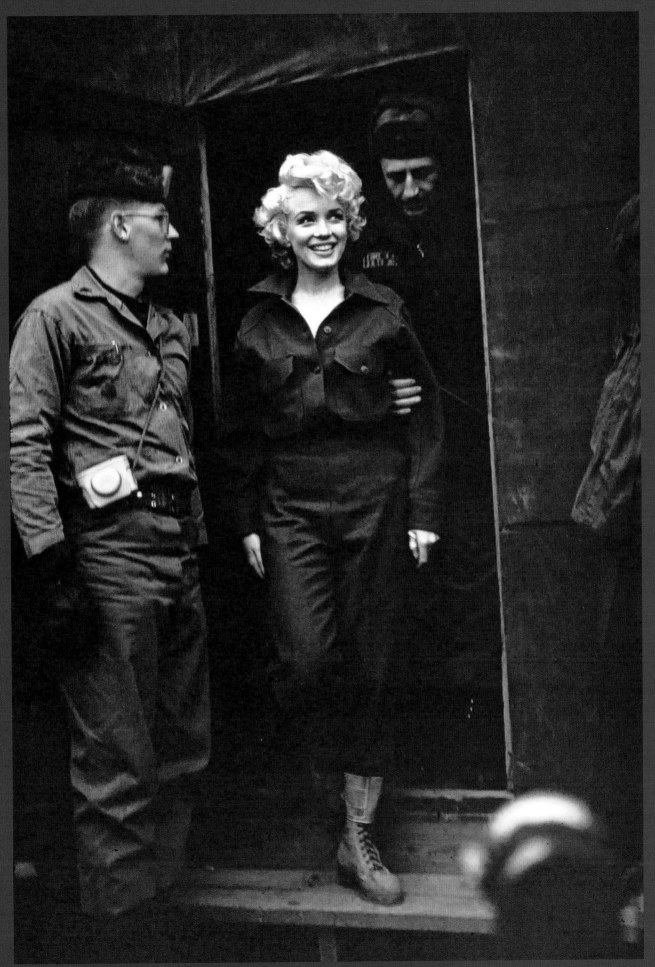

naming her its first-ever Playmate of the Month in December of 1953. By then, her film career was firmly established. Monroe was now a Hollywood star and a sex symbol the likes of which America had never seen. Films such as *How to Marry a Millionaire*, *The Seven Year Itch*, *Monkey Business*, and *Gentlemen Prefer Blondes* framed her as the dumb, sexy blonde. But despite the stereotype, Monroe was smart and talented. One of her last films, the 1961 drama *The Misfits*, showcased her strong acting alongside movie heavyweights Clark Gable (*see page 26*) and Eli Wallach.

Monroe's celebrity was also bolstered by her marriages. In 1952, she began dating America's most famous athlete, recently retired New York Yankee Joe DiMaggio. They were married in January, 1954, but DiMaggio was forever uncomfortable with his wife's public role as America's sex star, and the marriage did not last the year.

Soon Monroe began dating and eventually married America's most famous playwright of the 1950s, Arthur Miller, who later wrote *The Misfit* for her. This too would end in divorce.

Along the way, Monroe endured various traumas. She had two miscarriages, suffered from insomnia and intense stage fright, and developed an addiction to prescription pills. As her situation declined, she was rumored to have had affairs with President John Kennedy and his brother, Attorney General Robert Kennedy, as well as with actor Marlon Brando.

In 1962, at only thirty-six years of age, Marilyn Monroe died of a drug overdose. In death she remained one of America's premier celebrities. She was both revered as the ultimate sex symbol and mourned as a tragic figure, someone supposedly too

fragile to endure the blinding lights of fame. For the remainder of the twentieth century, Americans simultaneously reveled in her sexuality and cast her as a cautionary tale against the ravages of celebrity.

below: Monroe performing for the 3rd US Infantry Division at the USO camp show *Anything Goes. Department of Defense/Department of the Army/Office of the Chief Signal Officer*

inset: Postcard photo of Monroe, taken during her pre-stardom modeling days. *Public domain*

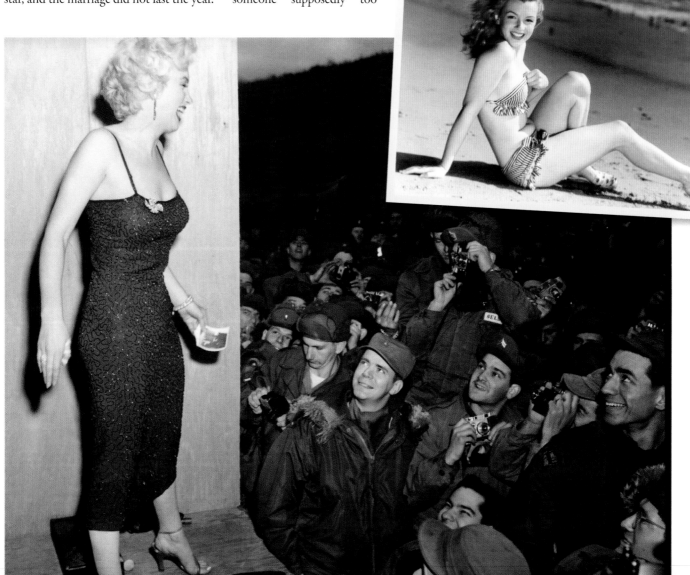

FRANK SINATRA

FROM HEARTTHROB TO CHAIRMAN OF THE BOARD

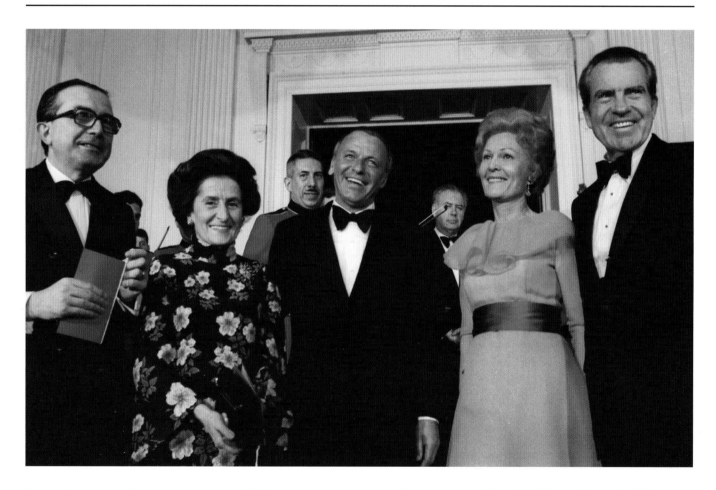

Born in 1915 to Italian immigrants in Hoboken, New Jersey, Francis Albert Sinatra became one of the most famous people of the twentieth century. The key to his enduring celebrity was his ability to continually reinvent himself for the public.

Frank Sinatra's first break as an entertainer came in 1939 as a singer in Harry James's big band. But his star turn came at the end of the year when bandleader Tommy Dorsey hired him. In his first year with Dorsey, Sinatra released forty songs, including "I'll Never Smile Again," which topped the charts for a dozen weeks. By 1941, Sinatra was the biggest singer in the country, adored by the throngs of teenage girls known as Bobby Soxers. Before Elvis (*see page 42*) or the Beatles (*page 47*), Sinatra was the first singer to exploit the female teen market, and their screaming fits and histrionics became a standard part of his concerts.

Classified as 4F (unfit for military service) by the draft board, Sinatra performed for the troops during World War II. But as he neared age thirty and his appeal as

above: Frank Sinatra dines at the White House with President Nixon, First Lady Pat Nixon, and fellow guests Giulio Andreotti, president of the Council of Ministers of the Italian Republic, and his wife, 1973. *National Archives and Records Administration*

next page: Sinatra in the recording studio of Liederkrantz Hall, New York City. *Library of Congress*

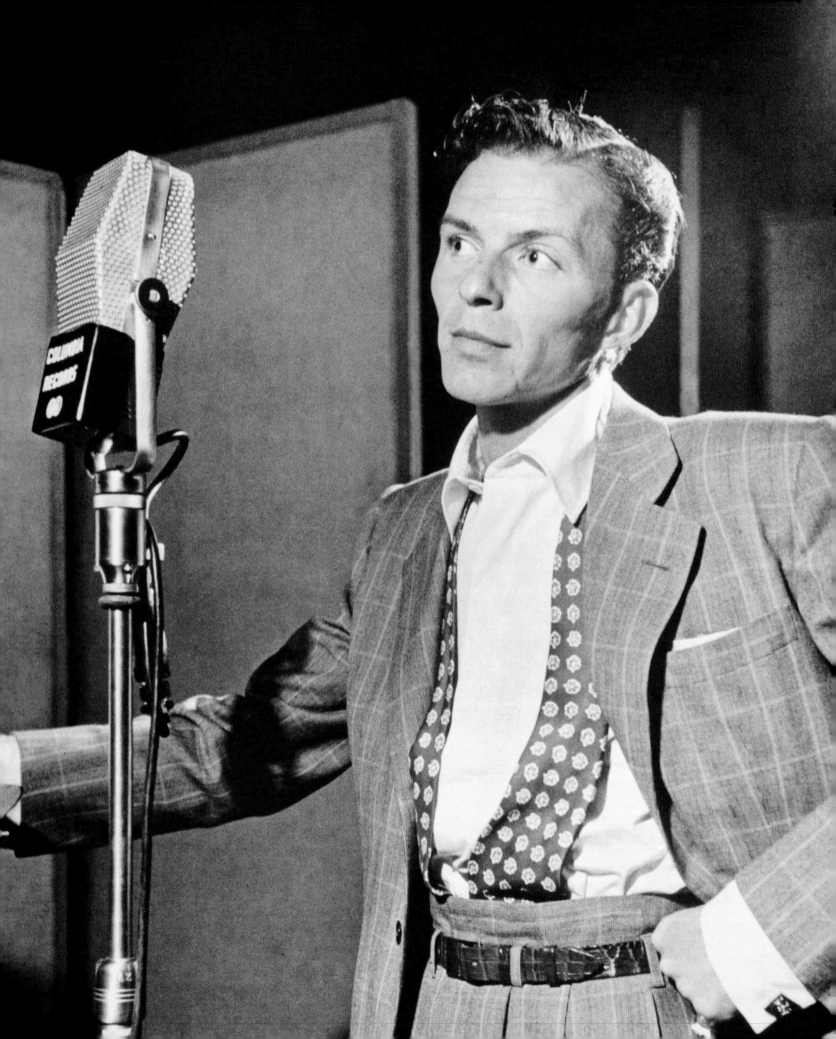

a teen idol diminished, he needed to redefine himself.

By 1945, Sinatra was starring in Hollywood movies, including three musicals with dancer Gene Kelly. But his true emergence as an adult celebrity came with his role in the 1953 drama *From Here to Eternity*. Sinatra won the Oscar for best supporting actor and established himself as an adult box-office draw. Two years later, at the age of forty, he cemented his new image by playing a heroin-addicted musician in *The Man with the Golden Arm*.

During this era, Sinatra also reinvigorated his singing career with a leading role in the 1955 musical *Guys and Dolls*. Backed by the famed Nelson Riddle Orchestra, he also released a string of successful albums that included many of the standards for which he would become best known. Sinatra's fame as an adult also grew when he married movie star Ava Gardner, touted by the press as the world's most beautiful woman.

In 1960, a middle-aged Sinatra redefined himself yet again through his lounge act in Las Vegas and via lighthearted on-screen performances in films such as the comedic caper *Ocean's Eleven*. Leading a troupe of friends and fellow entertainers known as the Rat Pack, which included Dean Martin and Sammy Davis Jr., Sinatra marketed himself as a charming rapscallion nicknamed "Old Blue Eyes." Sympathetic to civil rights, he also worked during this era to desegregate Las Vegas hotels.

Rumors of Sinatra's connections to the Mafia had dogged him since the 1940s. Though these were once a burden, he now playfully nodded to the stereotype, playing comedic mob roles. The idea was soon enmeshed in popular culture. In the 1972 film *The Godfather*, mobbed-up young singer and wannabe movie star Johnny Fontane is a fictionalized reference to a young Sinatra.

In 1970, Sinatra teased the public with a self-imposed retirement. But by the middle of the decade, he was back as a successful singer—a confident, gray-haired star now nicknamed "The Chairman of the Board." It was his final celebrity incarnation, and Sinatra maintained this image until his death in 1998 at the age of eighty-two.

Sinatra, with chief clerk Mae E. Jones, signing his induction papers at local board No. 19-160, Jersey City, New Jersey. *Library of Congress*

LOUIS ARMSTRONG
Twentieth-Century Celebrity

Most celebrities have intense fame for only a short period of time, usually when they are fairly young. As such, they can come to symbolize a particular moment in American history. Rare is the figure whose life and prominence last the better part of a century and reflect the nation's evolution over a long stretch of time. Jazz musician Louis "Satchmo" Armstrong was one of those people.

Armstrong was born in New Orleans on August 4, 1901. He would eventually become so much a part of the story of twentieth-century America that his birthday was often mistakenly reported as July 4, 1900, an error that Armstrong himself was more than happy to go along with.

New Orleans was the birthplace of jazz, and by age eleven, Armstrong was an aspiring musician. Soon he was playing professionally around town and on riverboats up and down the Mississippi. During the 1920s, jazz emerged as America's premier form of popular music (see **The Roaring Twenties,** *page 118*). Armstrong moved to Chicago in 1922 and established himself as one of the nation's top musicians. His innovative trumpet improvisations, raspy voice, and slick, fast-paced scat singing were showcased on records he made between 1925 and 1928 with his bands, the Hot Five and the Hot Seven. The recordings revolutionized jazz.

In 1932, Armstrong began touring Europe. Upon his return, he reencoun-

above: Louis Armstrong in 1953.
Library of Congress

inset: Armstrong and jazz producer Willis Conover at the Newport Jazz Festival, 1958.
Michael Williams/Creative Commons

tered American racism, from which he'd had a brief respite while overseas. Some critics were outwardly racist in their reviews of his music, smearing him as merely a "wild" black man. But Armstrong fought back. He was the first black entertainer to have it in his contract that he would not perform in any hotel that would not let him stay as a guest.

In 1936, Armstrong became the first black musician to have a featured role in a Hollywood film: *Pennies from Heaven*, starring Bing Crosby. The next year, he became the first African American to host his own sponsored radio program. Transitioning seamlessly into the Big

Band era, Armstrong went on to appear in over thirty movies and became the first black musician to appear on the cover of *Time* magazine.

When the Big Band era came to an end, Armstrong slimmed down to a smaller group. In the 1950s and 1960s, he toured the world, some

times with the support of the US State Department. During the Cold War, the US government looked for ways to highlight American culture as more exciting than Russian culture, and thus more appealing globally. It chose some of its most famous artists and musicians to tour the world, and Armstrong was among the select few it directly supported.

During middle age, by which time he was affectionately nicknamed "Pops," Armstrong recorded some of his biggest hits. In his early sixties, he continued playing shows upwards of three hundred nights per year. When he was sixty-three, he became the oldest person to ever have a number-one song, with his rendition of "Hello Dolly." He produced records and toured until his death at age seventy-one, by which time he had made thousands of recordings.

Armstrong's celebrity continued posthumously. A new generation of top jazz musicians began citing him as a major influence, and historians acknowledged him as a pioneer in the pre–World War II civil rights movement. Then, sixteen years after his death, Armstrong's version of the song "What a Wonderful World" became a number-one hit in the United States after being featured in the film *Good Morning, Vietnam*.

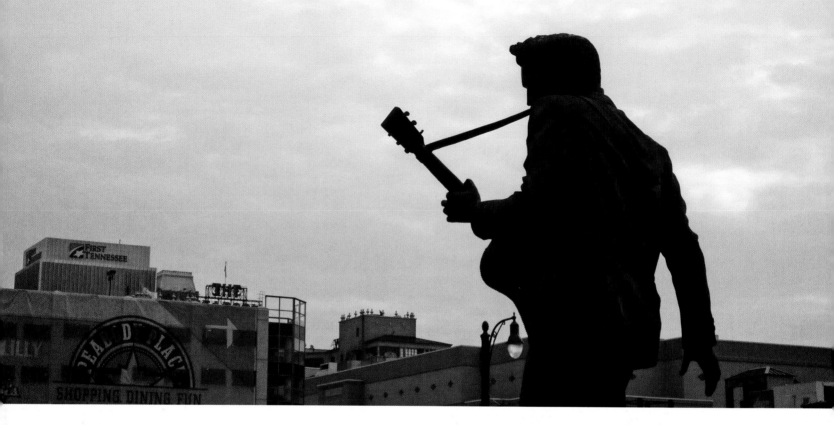

Elvis statue in downtown Memphis.
Ethan Kan/Creative Commons

ELVIS

FLIRTING WITH THE COLOR LINE

During the twentieth century, many—perhaps most—innovations in American popular music came from African American musicians. But because of segregation and racism throughout the United States, most white Americans during the first half of the century had little direct exposure to black music. Black performers with crossover success among white audiences, such as Louis Armstrong, were rare. Instead, most white audiences were usually more familiar with white musicians who were heavily influenced by African American forms of music such as gospel, ragtime, jazz, big band, and rhythm and blues.

While some white artists merely mimicked and covered black music, often without attribution, other more serious musicians used black musical influences to find their own artistic voice. No one did this to greater effect than Elvis Presley.

Elvis Aaron Presley was born in Tupelo, Mississippi, in 1935. Living in a neighborhood with a sizeable African American community, Presley absorbed both the country and gospel traditions of his own family and the blues and gospel traditions of his neighbors. When he was thirteen, Elvis's family moved to Memphis, Tennessee, and he continued reveling in both white and black music via the city's segregated clubs and radio stations.

After a number of failed attempts as a singer, Elvis scored big in 1954 by covering a black blues musician, Arthur "Big Boy" Crudup. His upbeat and expressive version of Crudup's "That's Alright Mama" was immediately a local hit. Effectively channeling black influences, Presley led some radio listeners to wonder whether he was white or black.

A few days later, for the B-side, Elvis recorded a jazzed-up version of Bill Monroe's bluegrass classic "Blue Moon of Kentucky." He was soon a huge regional star, and his mixing of white and black musical styles was illustrated with multiple nicknames the press gave him, including "The King of Western Bop," "The Hillbilly Cat," and "The Memphis Flash."

By 1956, America's postwar blend of up-tempo, electrified white and black music was coalescing into rock-and-roll, and Elvis was soon its undisputed king. Among his early chart-toppers were "Blue Suede Shoes," which was a cover of a Carl Perkins rockabilly song, and "Hound Dog," a cover of an R&B song by Big Mama Thornton.

National TV appearances boosted his fame to extraordinary heights. When Elvis appeared on *The Ed Sullivan Show* in 1956, more than 82 percent of America's television sets were tuned in as over sixty million people watched his performance. However, there were also protests and boycotts by adults who were disturbed by

The front gates to Graceland in Memphis, Tennessee. *Library of Congress*

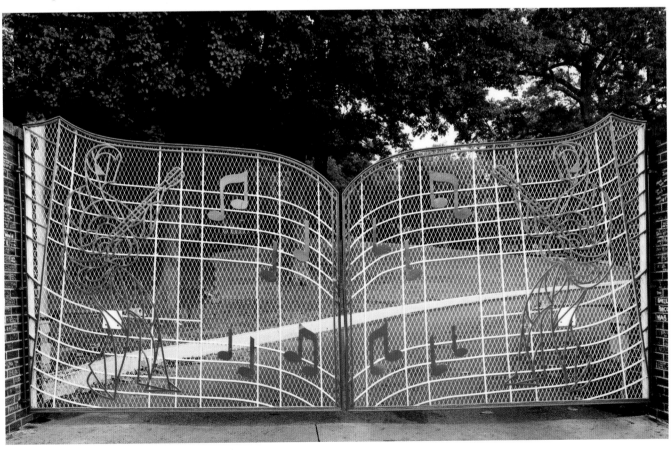

Elvis's amped up sexuality and by white racists who thought his music was "too black." But the protests were for naught. From 1956 to 1960, Elvis had fifteen number-one hits.

By the 1960s, Elvis had become a national icon. His Memphis house, Graceland, was the most famous private home in America. Now that he had transitioned into a movie star, his music was less relevant to modern rock. Nevertheless, his influence was profound. Largely because of Elvis, rock-and-roll was firmly established as a genre where white musicians openly and unapologetically embraced black musical influences. And as the century progressed, more and more black artists were able to directly market their music to white audiences, no longer needing white intermediaries to perform it for them.

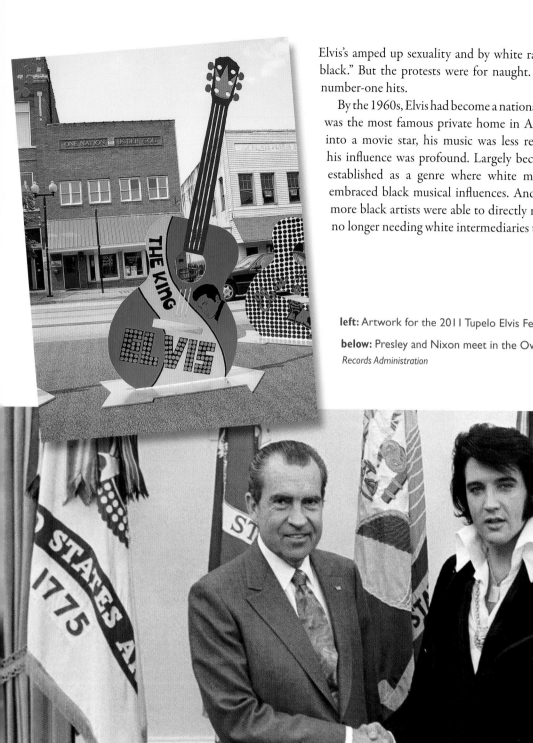

left: Artwork for the 2011 Tupelo Elvis Festival. *Thomas R. Machnitzki*

below: Presley and Nixon meet in the Oval Office. *National Archives and Records Administration*

THE KENNEDYS

CELEBRITY AND GLAMOUR IN POLITICS

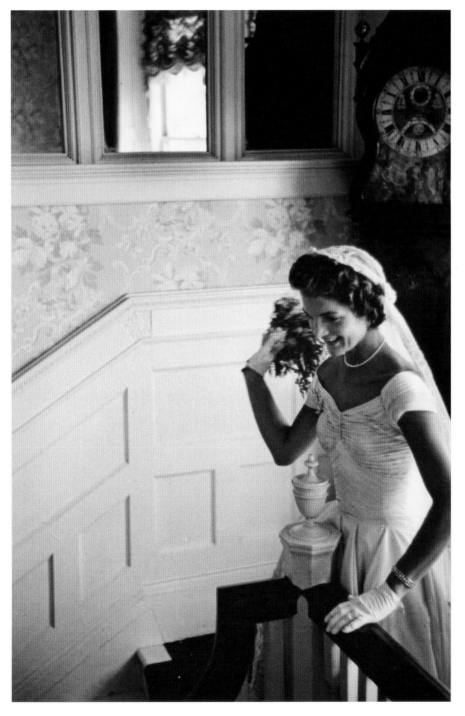

Jackie throws the bouquet at Kennedy wedding. *Library of Congress*

When Americans learn about US presidents, they are often confronted with a string of grim, bearded men from the nineteenth century. Early twentieth-century presidents, such as Calvin Coolidge and Herbert Hoover, might look more familiar to modern generations, as they were clean-shaven and wore business suits, but they were still not very accessible in their own time. Even Franklin Delano Roosevelt, whose Fireside Chat radio broadcasts during the Great Depression made him the first president to regularly address Americans through mass media in an approachable manner, had relatively little air of modern celebrity about him. FDR, Harry S. Truman, and Dwight D. Eisenhower were all more avuncular than glamorous.

But when John F. Kennedy assumed the presidency in 1961, he and his wife, Jacqueline, became the first White House couple to transcend politics and become celebrities, not just as political actors but also as cultural icons.

Several things set the Kennedys apart from their predecessors. For starters, at forty-three years of age, John Kennedy was the youngest person ever elected to the White House, and he became the first president to strike a chord with the emerging youth culture of mid-twentieth-century America.

With youth came beauty. The Kennedys were highly attractive by any standard, but also tremendously

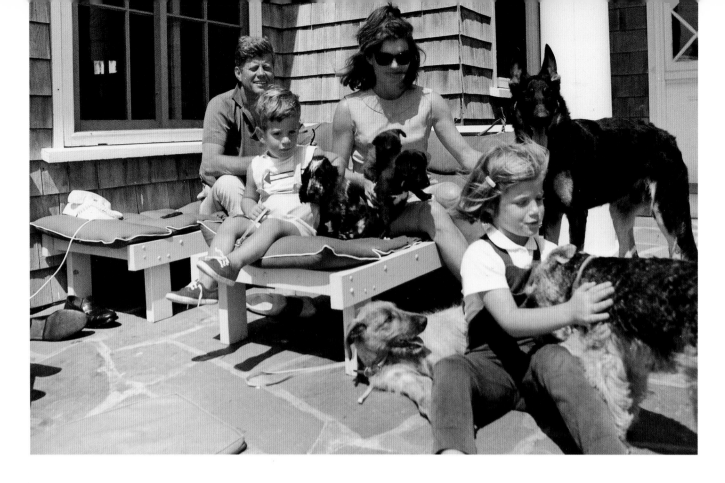

above: The Kennedy family in Hyannis Port, Massachusetts, 1962. *Cecil W. Stoughton/ White House*

below: The president and first lady arriving at Love Field in Dallas, Texas, on the day of Kennedy's assassination. *Cecil W. Stoughton/White House*

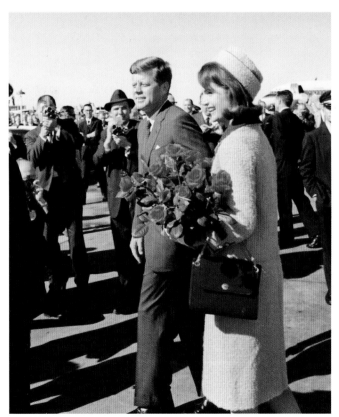

photogenic: she in her stylish dresses, he in his tailored suits, their hair perfectly coiffed, their smiles radiating across magazine pages and TV screens.

As a politician, Kennedy was acutely aware of how he was perceived. Needing to overcome prejudice against his Roman Catholicism as well as concerns about his relative youth, he and his team carefully crafted his public image. For example, he was the first president to fully appreciate the relatively new medium of television, using TV appearances not only to make himself accessible but also to look good. He was not afraid to use makeup to create his best possible appearance.

Perhaps above all, the well-heeled Kennedys had a degree of charm, grace, and charisma that is unusual in politics. Jacquelyn's sense of style was trendsetting. Her hairdos, clothing, and accessories became popular across the country, and even internationally. Her stylish redecorating of the White House was covered by the press, and she invited cameras inside for an intimate tour. These kinds of images transcended politics, and even many Americans who had not voted for Kennedy embraced the first family as a cultural symbol: a glamorous young couple at the vanguard of American prosperity and confidence.

While voters remained divided in their opinion of JFK as a politician during his presidency, public opinion shifted dramatically after his assassination on November 22, 1963. He immediately became one of the most popular presidents of all time, and the large Kennedy clan became fixtures in American popular culture for the remainder of the century.

THE BEATLES

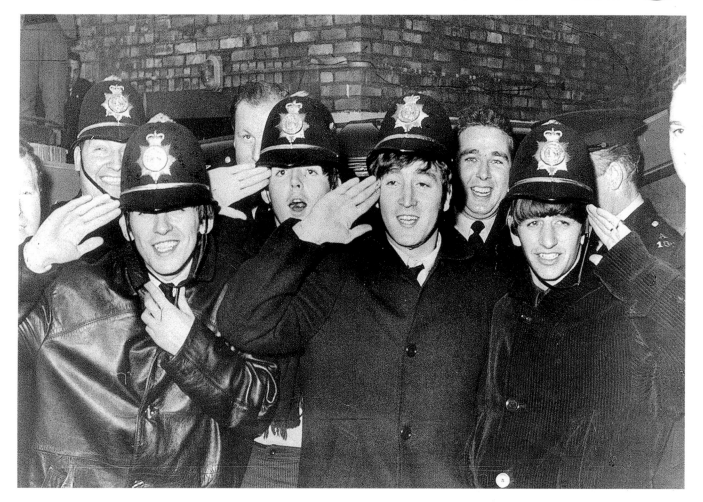

YOUTH CULTURE GROWS UP

Frank Sinatra (*see page 37*) had worked hard to successfully remake his image after his appeal to teenagers began declining after World War II. At the end of the 1950s, Elvis (*page 42*), who did not radically reinvent himself, was soon bypassed in teen pop culture as the rock music he spawned moved on to new interests. But during the 1960s, the Beatles took a new approach to celebrity: after ascending the peak of adolescent pop culture, they invited their generation to grow up with them.

Nicknamed the Fab Four, the band from Liverpool, England, took America by storm in 1964 with sold-out concerts and a relentless string of hits. At first, the Beatles' seemed to attract only teenyboppers, reminiscent of previous heartthrobs

The Beatles are escorted by police into the Birmingham Hippodrome in 1963, a year before they took the United States by storm. *West Midlands Police/Creative Commons*

such as Sinatra and Elvis. But instead of fading from public view or trying to remake their image as more "adult," the Beatles quickly asserted themselves as the voice of a generation instead of a moment, and their teen audience eagerly embraced them.

The band soon moved beyond its early bubblegum pop and began to explore mature themes. By the late 1960s, their music had become more experimental and their lyrics were at turns serious and satirical. By the time the band members split up in 1970, their celebrity image had already transformed radically from the well-groomed, silly young heartthrobs who had first arrived in the United States only six years earlier. They had taken on well-defined adult personas, which much of their audience continued to idolize.

George Harrison became associated with religious spirituality and philanthropy. Paul McCartney's marriage to and musical collaboration with Linda Eastman marked him as the happy and stylish family man. Ringo Starr, often seen as the least talented of the bunch, defied critics and expectations by striking out on his own and reestablishing himself as a successful artist. And John Lennon and his wife, Yoko Ono, championed avant-garde art and became politically outspoken advocates for peace and racial harmony, while harshly criticizing the Vietnam War.

Throughout the 1970s, the individual Beatles went their separate ways, furthered their musical careers, and continued growing as celebrities and people. Along the way, their adolescent fan base joined them in full-fledged adulthood. Postwar youth culture had grown up.

right: The Beatles arrive at Kennedy Airport, 1964. *Library of Congress*

below: John Lennon and Yoko Ono performing at the John Sinclair Freedom Rally, 1971. *Public domain*

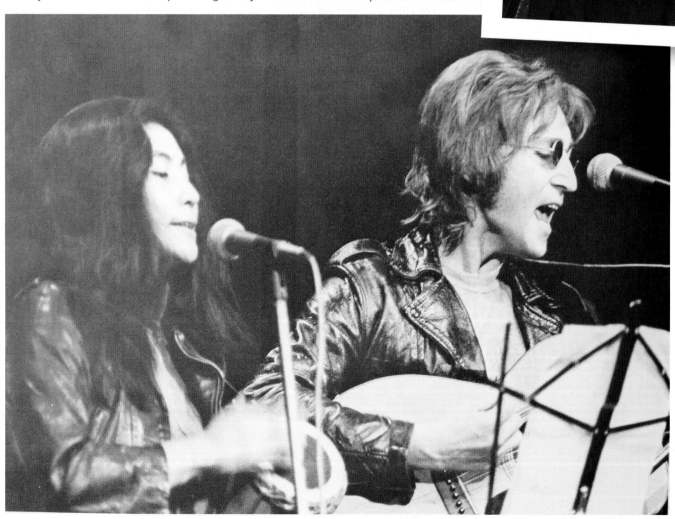

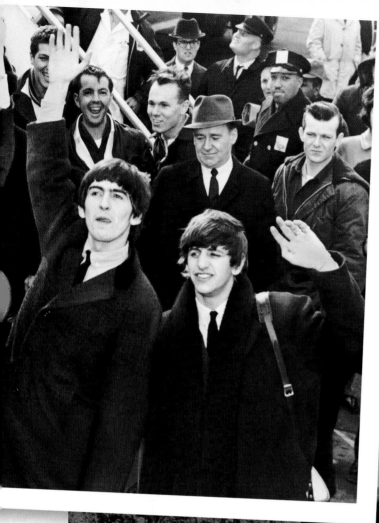

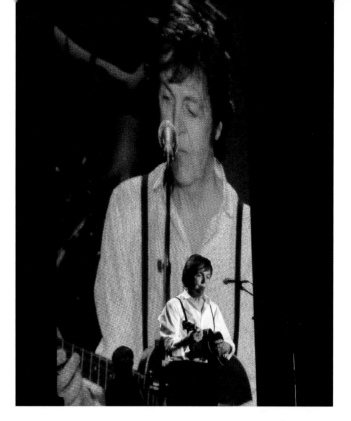

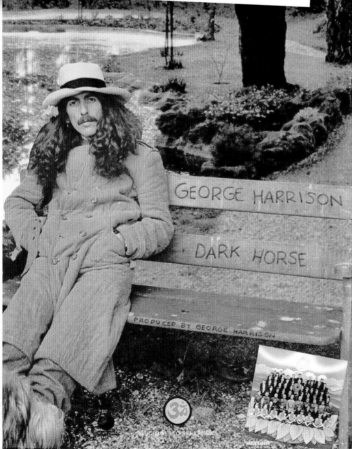

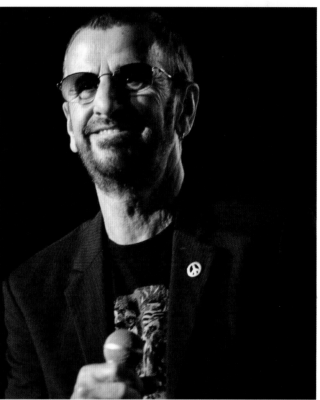

above: Ringo Starr performs with his All-Starr Band in Sydney, Australia. *Eva Rinaldi/Creative Commons*

top: Paul McCartney performs in Bologna, Italy. *Gorupdebesanez/ Creative Commons*

left: Trade ad for George Harrison's *Dark Horse* album. *Apple Records*

JOHN WAYNE

DEFINING THE AMERICAN MAN

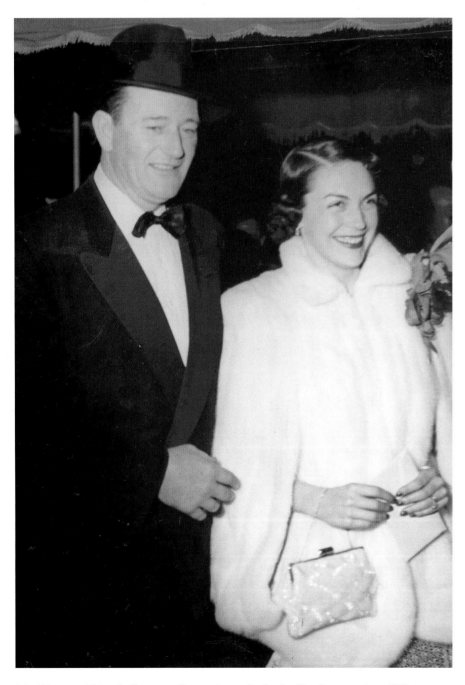

John Wayne and his wife, Esperanza Baur, arrive at the *Sands of Iwo Jima* premiere, 1949.
US Marine Corps Archives and Special Collections

How should the ideal American man conduct himself? In post–World War II America, many people looked to one celebrity in particular as the embodiment of American manhood: John Wayne. But John Wayne, the ultimate incarnation of American masculinity, wasn't born. He was made.

Marion Morrison was born in Iowa in 1907. When he was four years old, his family moved to Southern California. Unhappy with his given name, he quickly picked up the nickname "Duke." After high school, Morrison landed a football scholarship from the University of Southern California, but when he broke his collarbone in a surfing accident, the scholarship was withdrawn and he was forced to quit school. Afterward he concentrated on building a film career.

Morrison had gotten a job in the props department of a movie studio after giving USC football tickets to Tom Mix, the star of many Westerns during the silent-film era. While working there, Morrison was able to land some bit parts in movies. He also struck up a close friendship with the man who would eventually become instrumental to his success, director John Ford.

The crafting of Marion Morrison's onscreen image began almost immediately. Without even consulting him, studio executives changed his stage name in 1930 to the more muscular sounding John Wayne. For most of the decade, Wayne was relegated to small roles in big pictures and bigger roles in small pictures. During this era, he trained with stuntmen to learn the art of horse riding and mock fighting. He also developed his distinctive pattern of speech, with its unusual drawl, and his loping, cowboy-inflected walk. In 1939, Wayne got a lead role in John Ford's film *Stagecoach*. It was a huge hit, and at age thirty-two, he was finally a star.

World War II erupted just as his career was taking off, and he stayed at home—his age (thirty-four) and family status (four children) earned him a deferment. His studio also did not want him to join the military, and Wayne himself was deeply

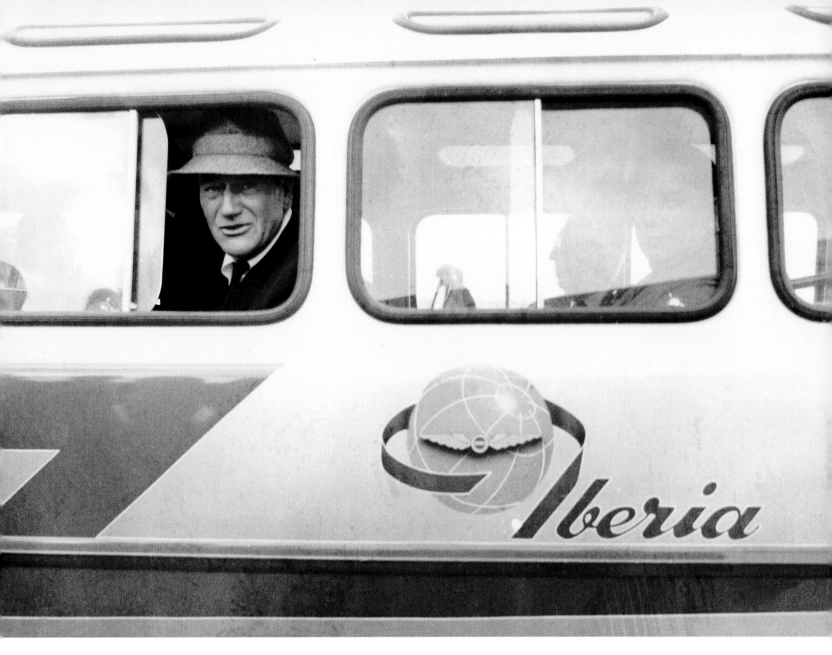

above: Wayne in Barcelona, Spain, 1963. *Iberia Airlines*

right: Film still from the 1963 comedy Western *McLintock!*. *Batjac-Paramount Pictures*

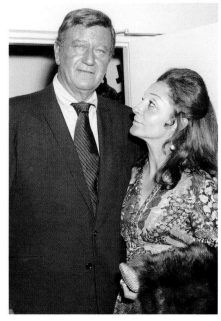

conflicted. He did have opportunities to join Ford's military unit overseas, but kept postponing to finish another film or two. He never did join up, but during this time he cemented his star status in Hollywood.

During his career, Wayne starred in over 140 pictures, mainly Westerns and war films. In nearly all of them, he played a rugged, honest, plain-speaking, square-jawed hero who said what he meant, meant what he said, and was quick to back it up with his fists or a gun if need be. He was the cavalry officer riding to the rescue against Indians, the sergeant leading his men into fierce battle against the Nazis, the rancher fighting off cattle rustlers and desperados. He was the ultimate American hero, Hollywood style. Later in life, his third wife would say it was his guilt about staying home during World War II that led to his intense patriotism.

For the remainder of the twentieth century, even after his death in 1979, millions of people looked to the carefully crafted image of John Wayne the star, as opposed to Marion Morrison the man, as the definitive image of American manhood.

MUHAMMAD ALI

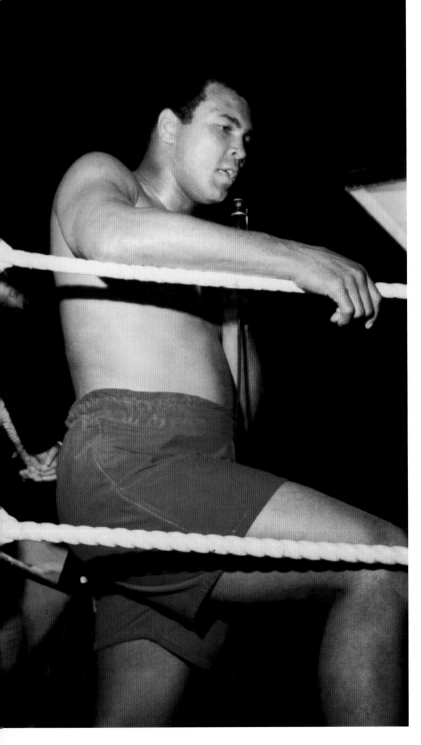

THE WORLD'S MOST FAMOUS CELEBRITY?

While athletes have long been celebrities, the homegrown American sports of baseball and football have held almost no appeal in the rest of the world. But this was not the case for boxing, which dates back to ancient times. Beginning with John L. Sullivan in 1882, whichever man held the title of undisputed Heavyweight Champion of the World was known far and wide. During the twentieth century, most heavyweight champions were American, but the sport was truly international, and notable exceptions included Germany's Max Schmeling, Italy's Primo Carnera, and Sweden's Ingemar Johansson. Like most global celebrities, heavyweight title holders were recognized around the world, but also generally seen as representing their home country.

Muhammad Ali during a match in Washington, United Kingdom. *Tyne and Wear Archives and Museums*

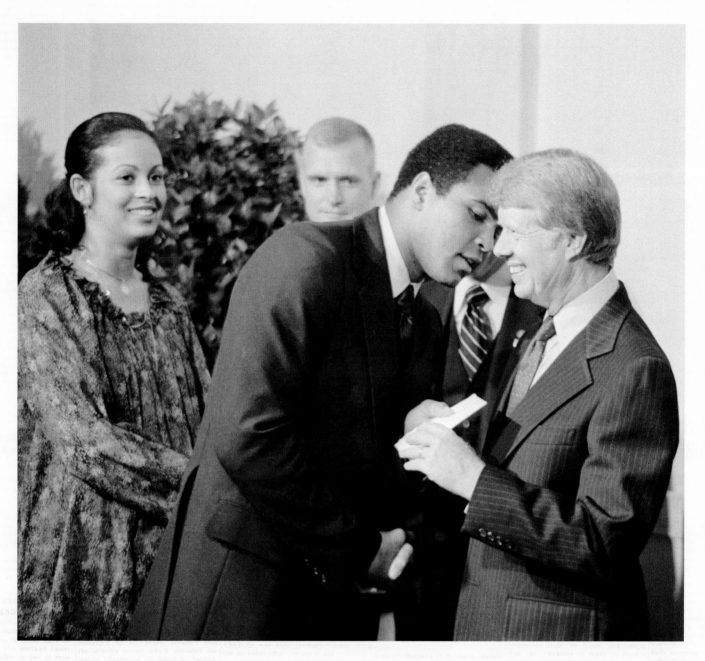

President Jimmy Carter and Muhammad Ali at a White House dinner, celebrating the signing of the Panama Canal Treaty. *Library of Congress*

However, only one heavyweight champion, and in some ways only one American celebrity, ever transcended national borders to become a true global phenomenon, embraced by the world's people as one of their own: Muhammad Ali.

Born Cassius Marcellus Clay in Louisville, Kentucky, in 1942, he emerged as a promising boxer during his teens. Tall, fast, and quick, Clay won six Kentucky Golden Gloves titles and two national amateur titles before earning a gold medal at the 1960 Olympics in Rome. Clay's wide smile, charming personality, and quick wit soon made him a star. But he was not universally beloved. Some criticized his bragging and occasional arrogance. But more important, Clay was proud and supremely confident; he refused to play the socially acceptable role of the modest black man, challenging Americans to accept him on his own terms.

At only twenty-two years of age, Cassius Clay pulled a stunning upset, winning the heavyweight crown by knocking out feared champion Sonny Liston. Soon thereafter, he announced his conversion to Islam and changed his name to Muhammad Ali, dismissing Cassius Clay as his "slave name."

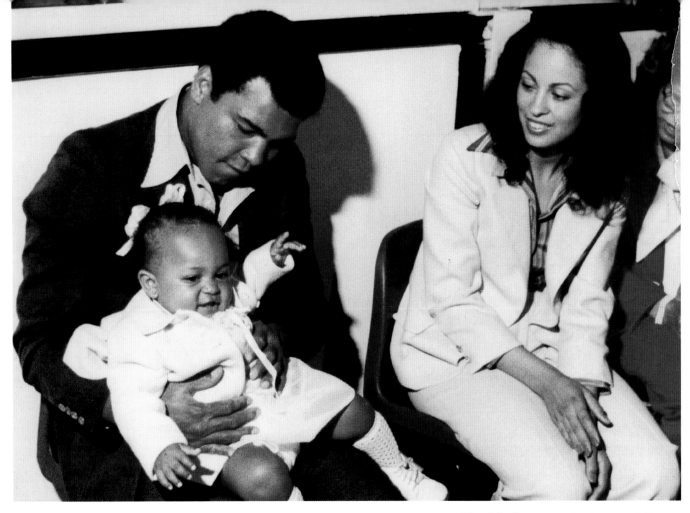

Ali and family. *Tyne and Wear Archives and Museums*

For years, many commentators in the press criticized Ali's religion and even refused to call him by his new name. When former champion Floyd Patterson called him Cassius Clay during the run-up to their bout, Ali responded by calling the fellow African American "The white man's champion," and openly taunted him during a dominant twelve-round beating. After another black challenger, Ernie Terrell, referred to him as Clay, Ali called him an "Uncle Tom" and then battered him badly for a full fifteen rounds, repeatedly shouting "What's my name?" between punches. When critics said he was cruel, Ali revealed their hypocrisy: "I'm out to be cruel," he shot back. "That's what the fight game is all about."

In 1967, Ali refused to be drafted for the Vietnam War (*see* **Vietnam**, *page 194*). He was openly critical of the war and mocked the notion of white men sending black men to fight yellow men to protect land they stole from red men. The federal government denied him conscientious objector status and convicted him of draft evasion. Ali was stripped of his title and banned from boxing for three years during the prime of his career. The impact of Ali's stance was so profound that it helped convince Martin Luther King Jr. to speak out against the war. Ali returned to the ring in 1970, shortly before the US Supreme Court unanimously overturned his conviction.

Nicknamed "The Greatest," Ali regained the heavyweight title in 1974, a decade after first winning it. During his heyday in the early to mid-1970s, he traveled the world, fighting championship bouts in far-flung locations, such as the African nation of Zaire and the Philippine capital of Manila. Wherever he went, Ali was revered not just as a boxer or American celebrity, but as a global citizen. He was arguably the most famous man in the world, an idol to hundreds of millions of people. In 1978 he became the only fighter to win the undisputed title for a third time.

At century's end, countless media outlets recounted his vast influence. *Sports Illustrated* proclaimed him "Sportsman of the Century," and he was later given the Presidential Medal of Freedom. But he wasn't just an American phenomenon. In 1999, the British Broadcasting Service proclaimed him "Sports Personality of the Century," with Ali receiving more votes than everyone else combined. In 2005, Germany awarded him the Otto Hahn Peace Medal in Gold for his work in civil rights, and he was granted honorary citizenship by the nation of Bangladesh. Muhammad Ali was a man of the world.

WALTER CRONKITE

THE TRUSTED CELEBRITY

Born in St. Joseph, Missouri, in 1916, Walter Cronkite began his career in journalism when he was just nineteen years old. During World War II, he emerged as one of the nation's top newspaper reporters with his coverage of fighting in North Africa and Europe. (*See* **Victory in Europe**, *page 224.*) Afterwards, he covered the war crime trials of former Nazis in Nuremberg, Germany, and the early days of the Cold War while he was stationed in Moscow.

In 1950, Cronkite made the jump from print media to television. Most of his work was hard news, but he also occasionally did feature pieces. From 1962 to 1981, he hosted the *CBS Evening News* and guided it to the top of the national ratings in 1967. During an era before cable television or the Internet, and with only three major television networks (CBS, NBC, and ABC), Cronkite's nightly national broadcast was America's most popular source of current events.

Portrait of Cronkite, 1985. *Nationaal Archief*

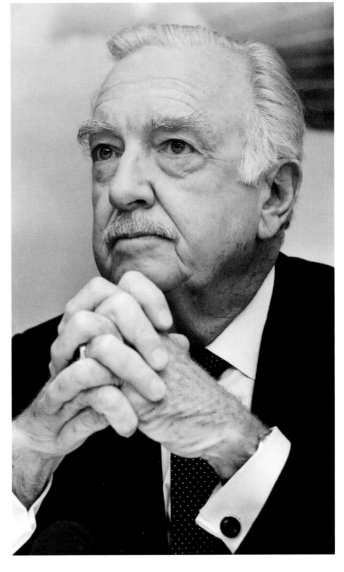

For millions of Americans, news of such momentous events as the death of President John Kennedy in 1963 and the moon landing in 1969 was intimately tied to Walter Cronkite's coverage. And as Cronkite became ever more associated with historic events in America, he transformed into a new kind of celebrity: famous not for what he did but for how he connected Americans to famous events and people.

Cronkite's definitive sign off at the end of each broadcast—"And that's the way it was," followed by the date—signaled confidence and definitiveness, and the American public embraced him. He soon earned the nickname "the most trusted man in America," being named as such in a national poll. Cronkite's influence was so profound, that he was no longer just a news reporter but a newsmaker in his own right.

On February 27, 1968, he delivered a news editorial that criticized the Vietnam War, challenging government claims of impending victory (see **Vietnam**, *page 194*).

"It is increasingly clear to this reporter that the only rational way out then will be to negotiate, not as victors, but as an honorable people who lived up to their pledge to defend democracy, and did the best they could," he told America. Instead of winning the war, he warned, the United States was, "mired in stalemate."

Cronkite's critique against the Vietnam War was hardly the first, but because of his stature, it carried tremendous weight. Afterward, President Lyndon Johnson was reputed to have said: "If I've lost Cronkite, I've lost Middle America." The quote may be apocryphal, but it aptly illustrates Cronkite's impact.

From his desk at CBS, Cronkite supported the space program, bolstering its popularity (*see* **Beyond the Stars**, *page 95*). He revealed the sordid details of the Watergate scandal (*page 201*), which culminated in Republican President Richard Nixon's resignation. And during the Iran hostage crisis of 1979 to 1980, he reminded Americans of Democratic President Jimmy Carter's inability

to free the hostages, contributing to Carter's declining poll numbers and eventual re-election loss. In early 1980, Cronkite modified his traditional sign off, saying: "And that's the way it was, January 16, 1980, the fiftieth day of captivity for the American hostages in Tehran." He kept up the tally after each broadcast through all 444 days of captivity.

Two months after the hostages were freed, Walter Cronkite finally retired. The following year, he was awarded the Presidential Medal of Freedom.

opposite: Walter Cronkite in Vietnam, interviewing Professor Mai of the University of Hue for CBS. *Department of Defense/ Department of the Navy/US Marine Corps*

below: Cronkite at NASA's reduced-gravity simulator, Langley Research Center, 1968. *NASA*

MADONNA
AND CELEBRITY SEXUALITY

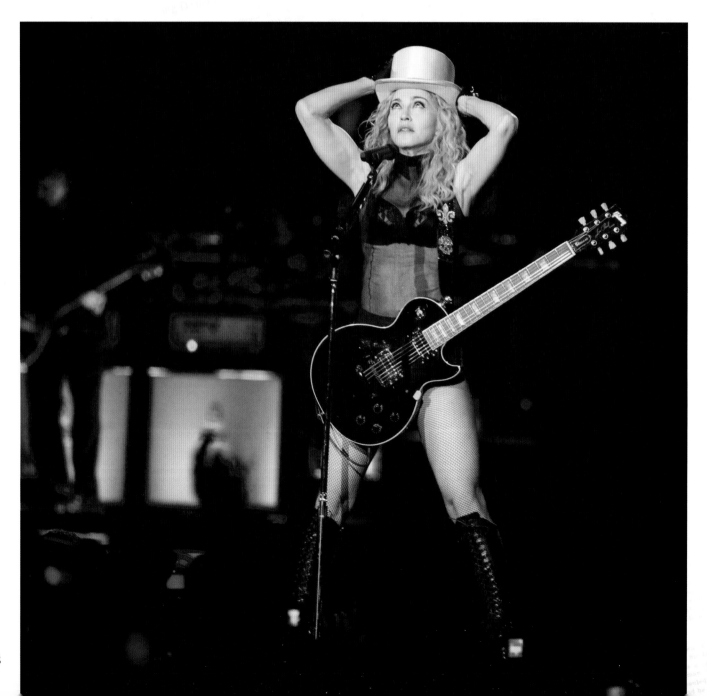

During the twentieth century, American culture developed a love-hate relationship with celebrity sexuality. On one hand, the public was immediately drawn to sexy celebrities, and celebrity sexuality became ever more open and racy as the decades passed. On the other hand, throughout the century, American culture also maintained restrictive sexual mores left over from the Victorian era. (*See* **Living**, *page 110*.) As much as popular culture wanted to revel in celebrity sexuality, there were also strict lines that, if crossed, could damage or even ruin a career.

For example, one of Hollywood's first sex symbols, silent-film star Clara Bow, was dogged by outrageous and false rumors about her supposedly lurid sex life. When Marilyn Monroe's nude photos were sold to the press in 1952, it was a scandal (*see* **Marilyn Monroe**, *page 34*). And throughout nearly the entire century, all gay celebrities needed to remain in the closet lest their careers be instantly destroyed; some, such as star actor Rock Hudson, even made sham marriages to avoid scrutiny and quash rumors.

Along the way, attitudes progressively softened, particularly after the Sexual Revolution of the 1960s and the LGBT rights movement of the 1980s. The lines celebrities could not cross were pushed further and further back, but they did not disappear. In 1983, Vanessa Williams became the first African American woman crowned Miss America, but was forced to relinquish her title after *Penthouse* magazine published nude photos of her taken several years earlier.

But during the closing years of the twentieth century, one celebrity more than any other used sexuality to advance her career, while also successfully challenging lingering rules about how far one could push the envelope: Madonna. She was born Madonna Louise Ciccone in Michigan in 1958, and her career as a singer began to take off in 1982, when she recorded several songs that became popular in New York City dance clubs. The following year, she had her first pop hit with "Holiday." A string of successful singles followed.

Madonna went on to sell three hundred million records worldwide and became the top-selling female recording artist of all time. And while her music was consistently dance-oriented pop, she repeatedly reinvented her celebrity image. But from her initial appearance as the Material Girl through seemingly countless later incarnations, one consistent theme in Madonna's public persona has been her open sexuality, which constantly nudged the boundaries of public acceptance.

During the 1980s and 1990s, Madonna seemed to go out of her way to push existing sexual strictures. What's more, she successfully used those cultural transgressions to build her celebrity instead of diminishing it. When her own early nudes were published by *Penthouse* only two years after the Vanessa Williams scandal, she used them to her benefit in a way that Williams had previously been unable to. In 1992, she published *Sex*, a book of provocative and explicit nude photos of herself. And a string of very public partners—including

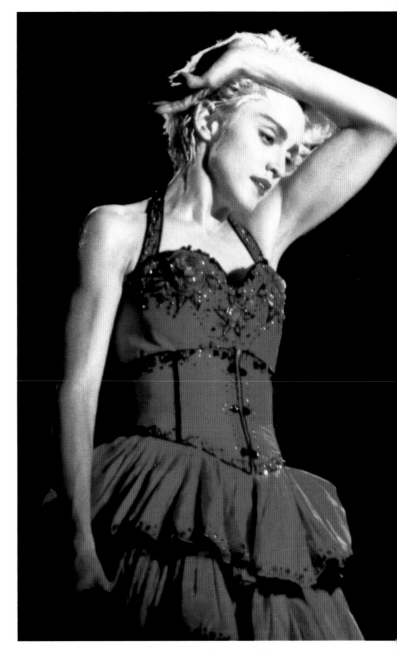

above: Madonna during the Who's That Girl tour, 1987. *Olavtenbroek/Wikimedia Commons*

opposite: Sex continues to be part of Madonna's public image. Here, she performs in Munich in 2009. *photoproject.eu/Shutterstock*

basketball star Dennis Rodman, actor Sean Penn, comedian Sandra Bernhard, political scion John Kennedy Jr., and baseball star Alex Rodriguez—helped further her reputation as a sexually free and daring icon.

For better or for worse, though the relationship is still love-hate, the sexuality of American celebrities is now open to the twenty-first-century public in ways that would have been unimaginable a hundred years ago. Perhaps more than anyone else, Madonna swayed American culture in that direction at the tail end of the twentieth century.

DISCOVERY & INNOVATION

During the colonial era, Great Britain intentionally passed laws and regulations that hampered the development of industry in its North American colonies. From the Crown's perspective, the colonies' purpose was simply to supply raw materials that could be refined into finished goods back in Britain. And so the early American economy was dedicated almost entirely to natural resource extraction.

The US industrial revolution began in earnest after the colonies gained their independence. Factories began to dot the new nation's small coastal cities. But industrialization was a slow process. In the early nineteenth century, America was still overwhelmingly rural. A vast majority of the population lived either on farms or in small towns, and most production came from independent craftsmen who worked by hand, often from home.

As the century unfolded, the United States urbanized at a steady pace. Cities grew in number and size, and factories became an ever more common part of the urban landscape. By midcentury, the industrial revolution was in full swing.

Even then, American factories and many of their products were rudimentary by today's standards. The spread of inanimate power, such as electricity, was still years in the future; factories relied on the muscle and sweat of people and animals to get things done. Likewise, most machinery was still basic. Products were typically still made by hand with simple tools, and thus, no two objects were ever exactly alike. In essence, many nineteenth-century factories were large warehouses where workers of various skills plied their trade.

Modern mass production has many identifiable facets. Some of the most fundamental include factories that feature sophisticated machinery operating with extreme precision, the production of uniform parts that are fully interchangeable, and massive shop floors where each clock-punching assembly line worker is dedicated to one small piece of a tremendously complex industrial puzzle. In the United States, all of these features of mass production finally came together during the early twentieth century, when the United States leapfrogged Great Britain and France to become the world's leading industrial economy.

World War I served as a coming-out party for American industrial might. With every developed nation fully mobilized to fight the war, the scope of US industry became undeniable, even as the United States only joined the conflict near the end of the fighting. Older European empires could no longer deny the superiority of America's industrial economy.

The 1920 US census illustrated the changes that had reshaped the country. It revealed that, for the first time, a majority of Americans lived in cities, and that manufacturing had overtaken agriculture as the largest chunk of the US economy.

World War II was another turning point. After the war, the world's other developed economies lay in ruins. Now the United States, which had not suffered the ravages of invasion, stood alone, unrivaled as an industrial power. No other nation could even come close to competing. What followed was a quarter century of unmatched prosperity.

By the 1970s, American industry was in decline, as good-paying blue-collar jobs were lost to mechanization and to foreign competition. By century's close, manufacturing had shrunk to less than 15 percent of the nation's economy. However, the total US economy was so large that even this reduced fraction still constituted the world's biggest industrial sector, producing more than a quarter of all global manufacturing.

Even as heavy manufacturing continued its slide in the United States, American researchers led the way in new, high-tech areas such as computers and medical engineering. Researchers at American universities, government labs, and corporations made, and continue to make, astounding breakthroughs.

Thus, from start to finish, the twentieth century was an era of substantial discovery and innovation in America. From manufacturing to science and technology, American ingenuity continued to reshape the nation and the world, changing people's lives in profound ways.

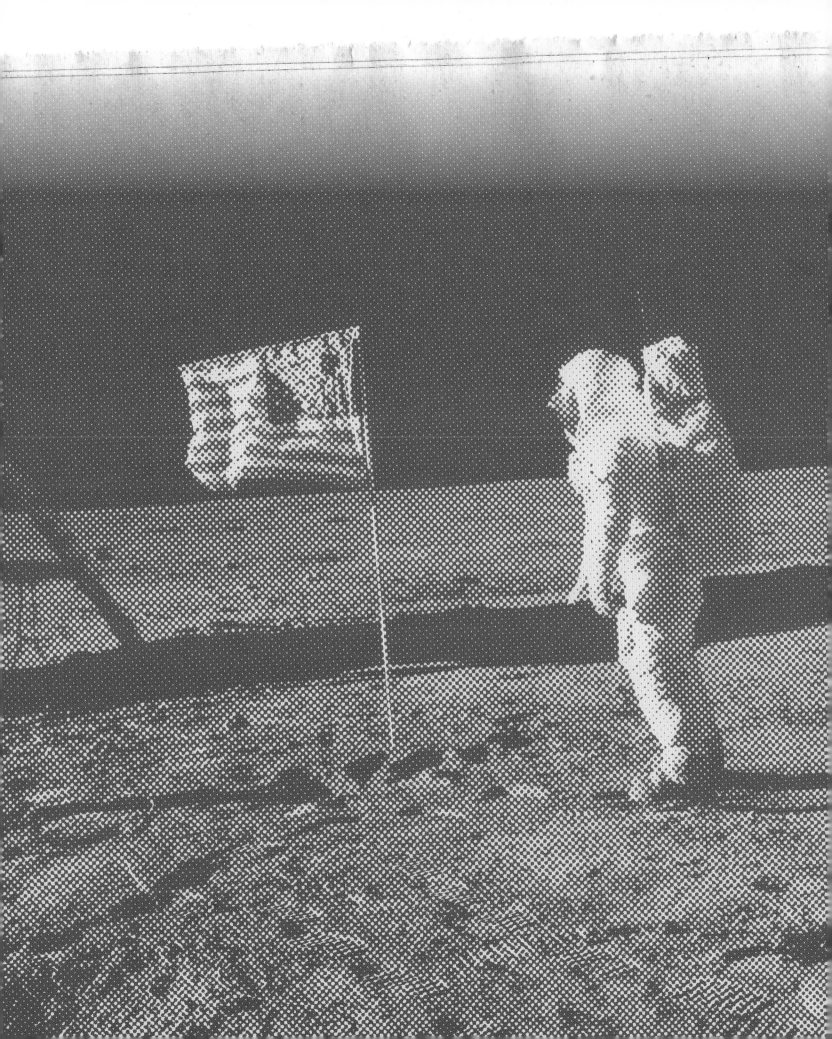

LET THERE BE ELECTRIC LIGHT

When contemplating life-changing inventions, Americans often imagine an individual genius tinkering in his workshop until chancing upon a brilliant idea. The truth is that most modern innovations are the result of many talented and dedicated people working over long stretches of time, and often in different places, all of them contributing some small piece to a larger puzzle before the big breakthrough finally emerges. One such invention was the electric light.

Before electricity, most lighting came from candles or oil lamps, the latter fueled by animal oil (often whale), and later petroleum. Lighting by fire was dangerous, particularly in an era when most homes and buildings were made of wood. Moreover, lamp oil smelled terrible as it burned. People dreamed of a safe, clean, unscented source of light.

Electric light bulbs date back to the early nineteenth century in Europe— Italian inventor Alessandro Volta, from whom we get the word *volt*, had produced a glowing wire as early as 1800. Working incandescent bulbs were first seen in Europe in the 1830s. However, they would not become a common feature of modern life until the twentieth century.

The basic design revolved around the concept of incandescence: heating an object until it emits light. A glass bulb had the air sucked out of it to create a vacuum. Inside, a filament was heated to the point of producing light. During the nineteenth century, dozens of scientists and inventors in the United States and Europe worked to refine the electric light bulb, but none of the early bulbs were commercially viable. They were either too expensive to produce, required too much power, or simply had too short a lifespan before they burned themselves out.

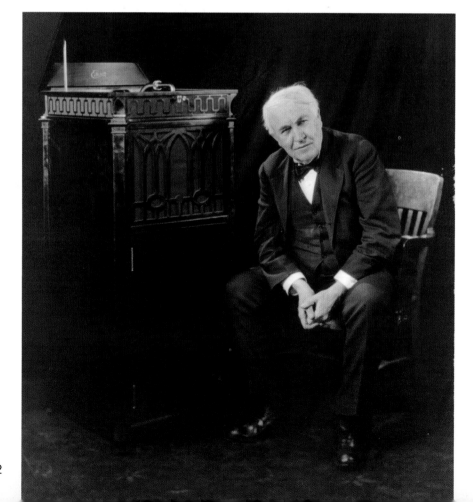

left: Edison and his phonograph, 1921. *Library of Congress*

opposite page: Edison and his searchlight cart, 1915. *Smithsonian Institution*

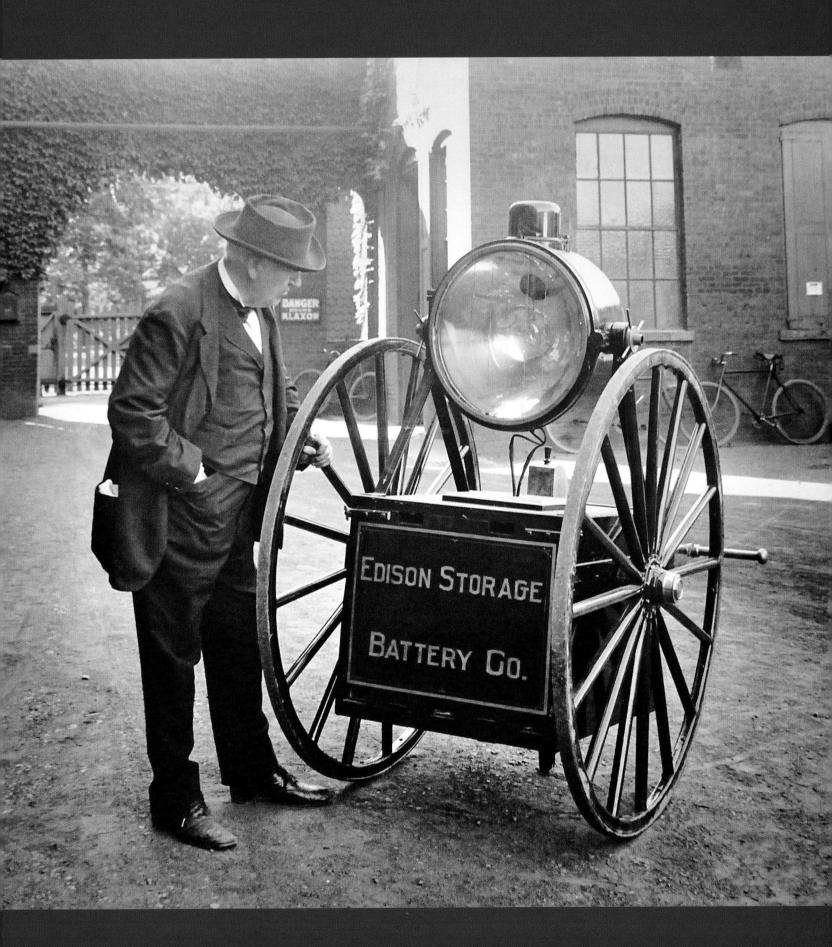

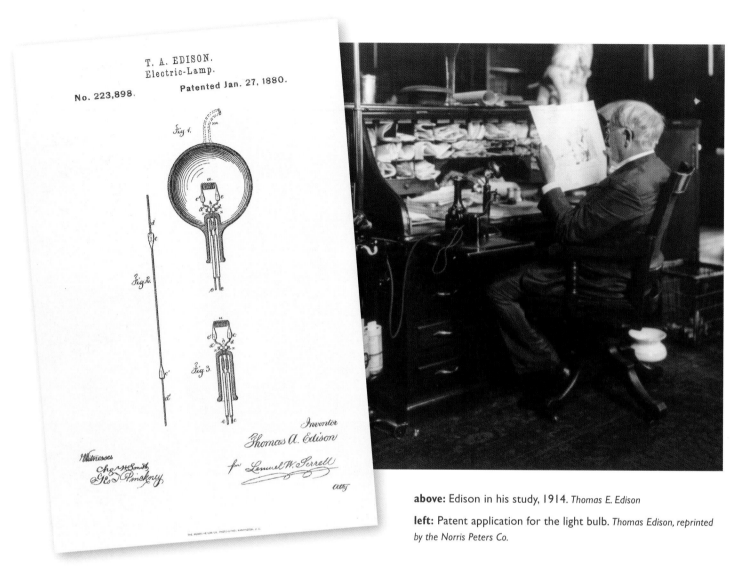

above: Edison in his study, 1914. *Thomas E. Edison*

left: Patent application for the light bulb. *Thomas Edison, reprinted by the Norris Peters Co.*

By 1879, however, Thomas Edison's lab in New Jersey had developed a filament of carbonized bamboo thread that could last up to 1,200 hours.

In 1904, two Hungarian scientists patented the tungsten bulb. Tungsten filaments would become the standard, allowing new bulbs to last longer and produce brighter light than earlier models.

Two years later, General Electric made several improvements to the tungsten filament and began marketing it in America. In 1915, American Irving Langmuir doubled the efficiency of light bulbs when he filled them with inert gas instead of creating a vacuum within the bulb.

But before the electric light could become commonplace, electricity needed to be commonplace. As the twentieth century opened, cities were just beginning to build up their electrical infrastructures.

Electric streetlights began to replace gas street lamps. New homes and buildings were built with wiring, and eventually older homes were retrofitted and connected to the growing electrical grid.

And electricity changed everything.

An array of new appliances fundamentally altered day-to-day living. Refrigerators, vacuum cleaners, washing machines, radios, telephones, and a host of other products made possible by electrification

modernized living in ways that had previously been unimaginable.

Progress was steady but slow. It wasn't until 1925 that half of US homes had electricity. Electrification in rural areas became more widespread in the 1930s and 1940s, particularly with the rise in hydroelectric power flowing from dam-building projects. By midcentury, oil-burning lamps were a thing of the past, and candles were largely relegated to birthday cakes. And today, most Americans cannot imagine a world without electric lights, which are ubiquitous and powerful.

Chances are you're reading this book under an electric light right now.

A PICTURE IS WORTH A THOUSAND WORDS

THE BROWNIE CAMERA

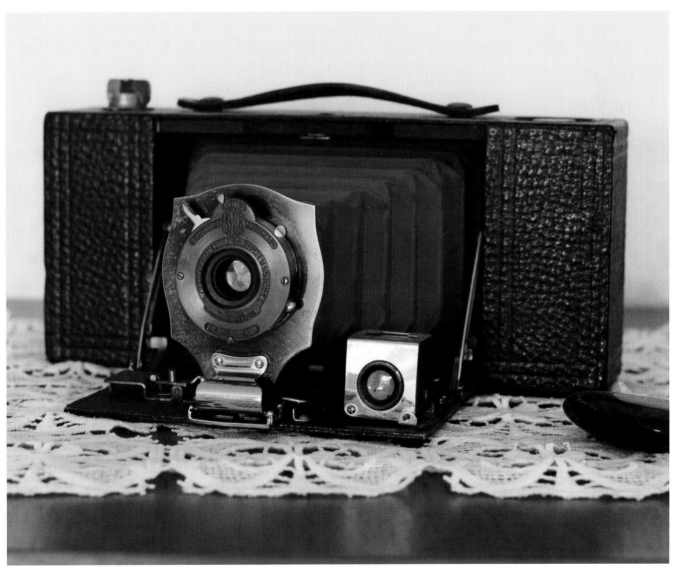

above: Eastman Kodak Brownie Automatic. *Sebastian Rittau/Creative Commons*

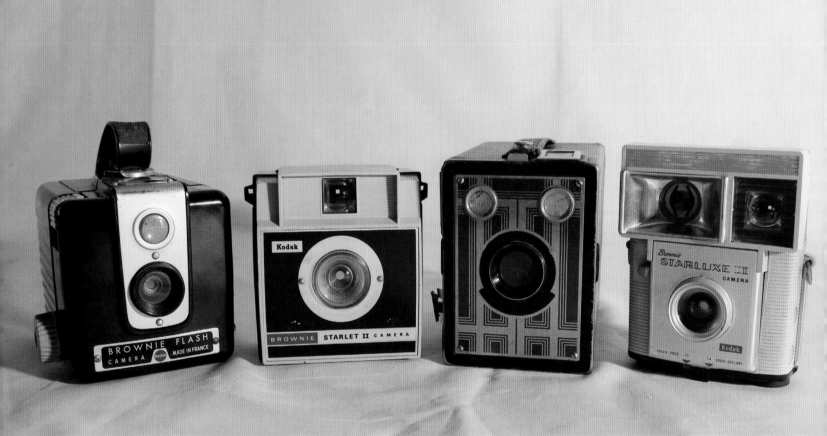

Today, nearly every cell phone has a sophisticated digital camera that instantly produces high-quality pictures, which can then be shared around the world electronically with a few taps of the screen and reproduced ad infinitum. Producing motion-picture footage is just as simple.

However, during the nineteenth century, capturing a still photograph was a complex and expensive processes. There were several different technologies, but all of them required the subject to pose perfectly still for an extended period of time, lest the image come out blurry. Cameras were large, unwieldy, and expensive. And developing negatives into paper images was a complicated skill involving malodorous chemicals.

All this added up to photography often being reserved for special occasions. Common workers rarely had the money to spare, and even for the well-to-do, having individual or family portraits taken was rare. When sitting for a photographer, people dressed up and took the occasion seriously. No smiling!

In February of 1900, however, the Eastman Kodak company of Rochester, New York, introduced the world's first cheap and easy-to-use handheld camera: the Brownie. It was by far the simplest camera most people had ever seen.

Kodak's sales slogan was "You push the button, we do the rest." Instead of being cumbersome, the camera was relatively small and lightweight; the body was actually a cardboard box. The user held it at their waist, stared down into the viewfinder, aimed, and clicked a switch to shoot.

Developing film was still a laborious, technical process. But Kodak offset this by offering affordable development services. Simply drop off your film at one of their stores, and then return a few days later to pick up your finished pictures.

In addition to being easy, the Brownie was affordable. The initial version of the camera sold for just $1 (about $25 in today's money). For fifteen cents, owners could purchase a cartridge with six exposures, which was easy to load and could be done even in daylight.

This was, of course, a far cry from modern photography. Subjects had to remain still or the final image would blur, and the developed photograph produced by Kodak was only two and one-quarter square inches. Nevertheless, photography was no longer the exclusive domain of professionals. Just about anyone with a dollar and a dream could purchase a Brownie, take pictures, and see the results. The Eastman Kodak company had brought photography to the masses.

Americans quickly learned to smile for the camera.

above left: Detail of the Kodak Brownie film box. *Håkan Svensson/Creative Commons*

above right: Postcard advertising a Kodak film drop-off center in Knoxville, Tenn. *Standard Souvenirs and Novelties Inc./Boston Public Library*

opposite: Various Kodak Brownie models. *Clément Bucco-Lechat/Creative Commons*

FROM A TO B
THE NEW YORK CITY SUBWAY

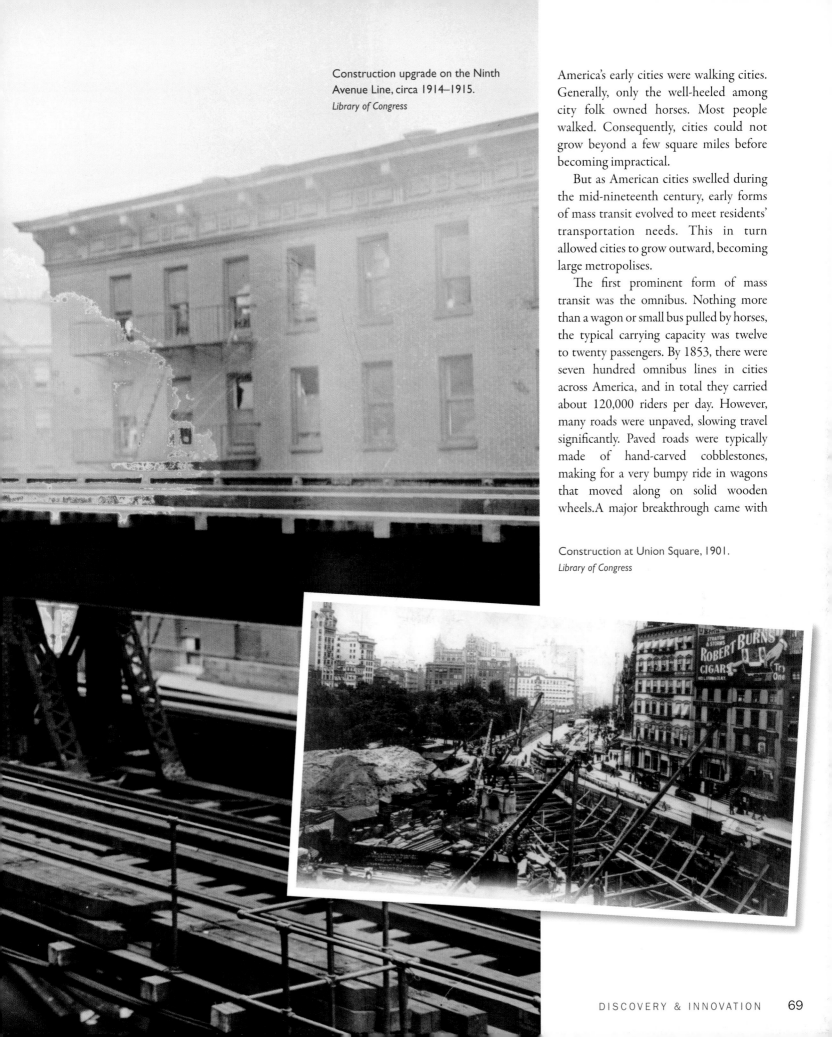

Construction upgrade on the Ninth Avenue Line, circa 1914–1915.
Library of Congress

Construction at Union Square, 1901.
Library of Congress

America's early cities were walking cities. Generally, only the well-heeled among city folk owned horses. Most people walked. Consequently, cities could not grow beyond a few square miles before becoming impractical.

But as American cities swelled during the mid-nineteenth century, early forms of mass transit evolved to meet residents' transportation needs. This in turn allowed cities to grow outward, becoming large metropolises.

The first prominent form of mass transit was the omnibus. Nothing more than a wagon or small bus pulled by horses, the typical carrying capacity was twelve to twenty passengers. By 1853, there were seven hundred omnibus lines in cities across America, and in total they carried about 120,000 riders per day. However, many roads were unpaved, slowing travel significantly. Paved roads were typically made of hand-carved cobblestones, making for a very bumpy ride in wagons that moved along on solid wooden wheels. A major breakthrough came with

steel tracks. Trolleys were horse-drawn omnibuses on rails. By the mid-1880s, there were 525 lines in three hundred cities. Horses had the unfortunate habit of doing what horses do, whenever they want to do it, polluting city streets and forcing pedestrians to dodge the large brown clumps. Horses also got tired. Overworked, they sometimes expired on the job.

The first electric trolley debuted in Richmond, Virginia, in 1888. Electricity quickly replaced horses. By 1902, 97 percent of urban transit was electrified, and two billion passengers annually rode over twenty-two thousand miles of track in cities throughout the nation. Steam-powered railroads had become an important part of American transportation beginning in the 1830s. However, these massive vehicles were impractical for transportation in American cities, which often featured small, crooked roads. By the end of the nineteenth century, electric trolleys dominated urban transit, while steam-powered locomotives were the backbone of regional and transcontinental travel.

America's biggest city, New York, had begun looking for ways to incorporate railroads as early as the mid-nineteenth century. First came a rail line that followed the Hudson River and catered to early commuters. In the 1870s, New York City introduced the elevated platform. Full-sized trains, using electricity instead of steam and drawing current from a live third rail, rambled above the city's streets. Other cities, such as Chicago and Boston, would follow this model.

At the start of the twentieth century, New York City pioneered a new method of train transit. An army of workers dug up city streets, built massive tunnels, and laid tracks underground for full-sized trains. On October 27, 1904, the New York City subway made its debut.

Eventually the system would grow to include 468 stations and 656 miles of track for commercial use. Today, the system operates twenty-four hours per day, seven days a week. In 2013, it handled more than 1.71 billion passenger rides, making it the busiest transit system in the Americas, and the seventh largest in the world.

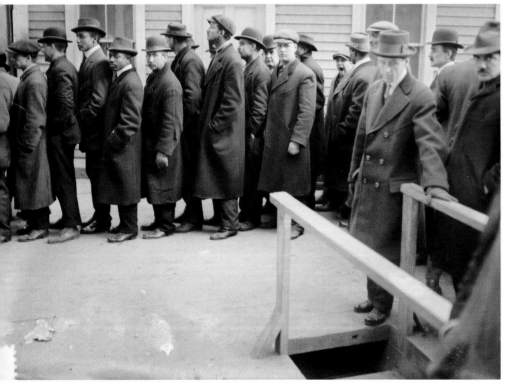

above: Groundbreaking ceremony, circa 1910–1915. *Library of Congress*

left: Hopefuls applying for subway work. *Library of Congress*

A MAN, A PLAN, A CANAL
PANAMA

The dream of a direct water route from Europe to Asia is as old as Christopher Columbus who, after stumbling into the Americas, refused to believe he wasn't in Asia. Subsequent European explorers in the Americas eagerly searched for a water route to connect the Atlantic and Pacific, but to no avail.

By the time of the Lewis and Clark expedition (1804–1806), everyone knew the Rocky Mountains separated North America's vast river systems. But knowing little of those distant peaks, President Thomas Jefferson sent explorers westward, hoping they would find an easy portage. In a sense, Columbus's dream, or at least a very modest vestige of it, finally died when the Corps of Discovery gazed upon the mighty Rockies.

Without a northwest passage, ships from Europe and the east coast of America needed to go all the way around South America to reach the Pacific. The other option was to unload passengers and cargo in Central America, where they could portage across the Isthmus of Panama to the Pacific coast. But travel through the thick jungle was difficult, and tropical diseases were a real danger.

A 1912 map of the Panama Canal (not drawn to scale). *Boston Public Library, Norman B. Leventhal Map Center*

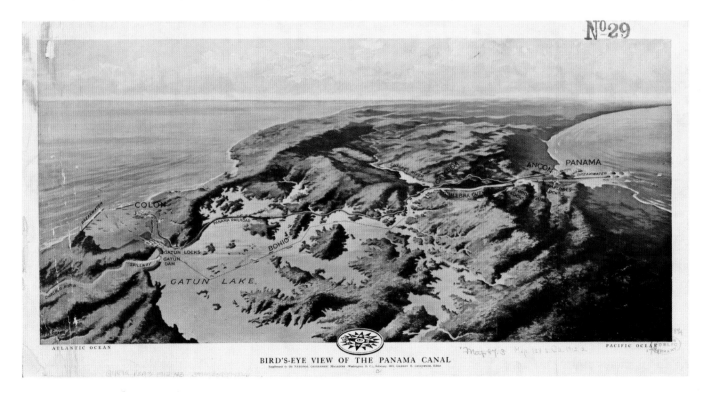

BIRD'S-EYE VIEW OF THE PANAMA CANAL

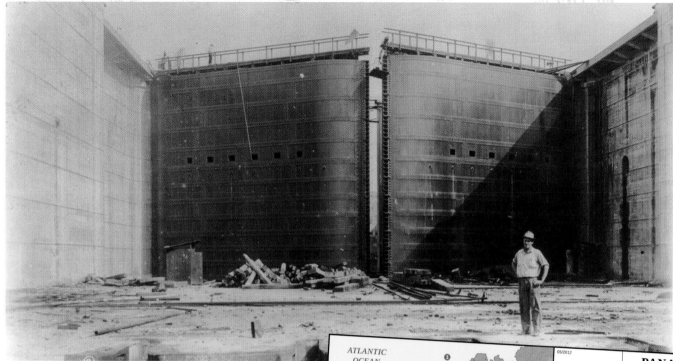

In 1855, a railway was built across Panama, which was then a northern province of Colombia. This made travel easier and speedier, but it still involved disembarking and reloading, and did nothing for ships that needed to move from ocean to ocean.

During the 1880s and 1890s, a French company attempted to build a canal across Panama. The project was led by Ferdinand de Lesseps, who had overseen construction of the Suez Canal in Egypt. However, cost overruns and engineering problems led to the company's bankruptcy. A second French company also foundered.

The idea of a canal across Panama was a minor obsession of Theodore Roosevelt, president from 1901 to 1909. At his desk one day, he penned a dedicatory palindrome, reading the same forward and backward: A MAN A PLAN A CANAL PANAMA.

A treaty negotiated between Colombia and the United States in 1903 would have granted the US perpetual rights to the Canal Zone in Panama. However, the Colombian Senate balked at these terms and refused to ratify it. Roosevelt responded by supporting an armed revolution by Panamanian separatists. US warships blockaded Colombia, preventing its navy from putting down the revolt, and the US quickly recognized the new nation of Panama.

This act of imperial aggression was an example of Roosevelt's gunboat diplomacy in Latin America. Officials from the renegade province signed the treaty, and Panama became an American protectorate (colony) until 1939.

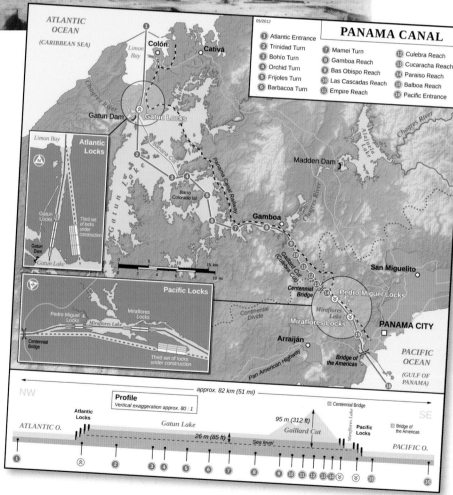

top: The Panama Canal under construction, 1913. *Library of Congress*

above: Map of the Panama Canal. *Thomas Römer/OpenStreetMap data*

After buying out the French and acquiring the Panama railroad, the United States spent a decade finishing the canal. The federal government oversaw the massive project, which proved to be a marvel of modern engineering and brute force. A combination of cutting-edge American technologies and a huge pool of local and immigrant labor combined to excavate 170 million cubic yards of material from the ground.

The Panama Canal opened in 1914 and revolutionized global shipping.

The canal is considered small by modern standards. For example, it is too small for large tankers, which must still circumnavigate the western hemisphere. However, the Panama Canal handles about fifteen thousand ships per year.

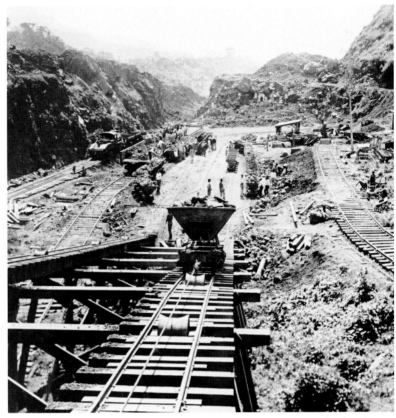

right: Excavation and dirt removal, Panama Canal, 1907. *Library of Congress*

below: SS *Kentuckian* in the Panama Canal, circa 1914–1920. *Library of Congress*

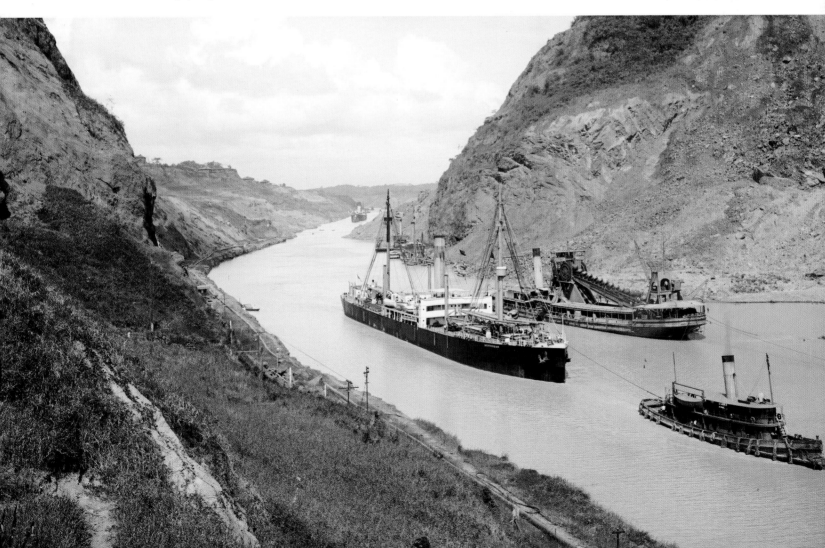

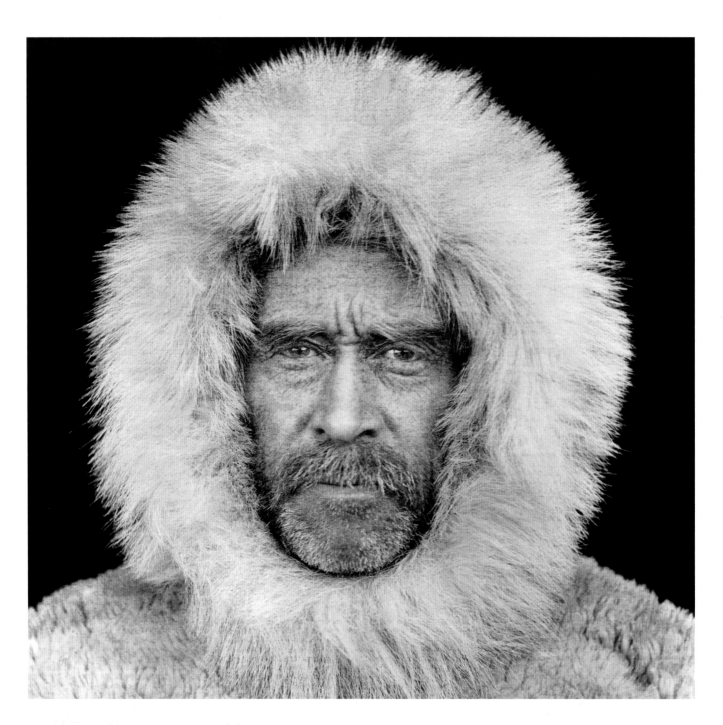

ROBERT PEARY
REACHES THE NORTH POLE

During the nineteenth century, European and American explorers traversed the globe, rounding out the map of the world by reaching the last places unknown to them. Whereas many of those places had indigenous populations and were merely unknown to Europeans and Americans, one of the very last places they ventured to was a discovery in the true sense, a place where no human being had ever set foot: the North Pole.

Having grown up in Maine, American Robert Peary became enamored with the idea of arctic exploration while working for the Navy in the jungles of Nicaragua. He began his explorations by traveling to northern Greenland in 1886 and soon decided to pursue the North Pole.

As Peary made half a dozen exploratory expeditions to the arctic during an eighteen-year period, his most trusted companion was Matthew Henson. An African American naval engineer from Maryland, Henson had been traveling the world since the age of twelve. As Peary's partner, he would be invaluable.

Aside from being an exceptionally skilled traveler, Henson forged good relations with the Inuit (Eskimo) people of the far north. He learned their language, and the Inuit shared with Henson invaluable information about the

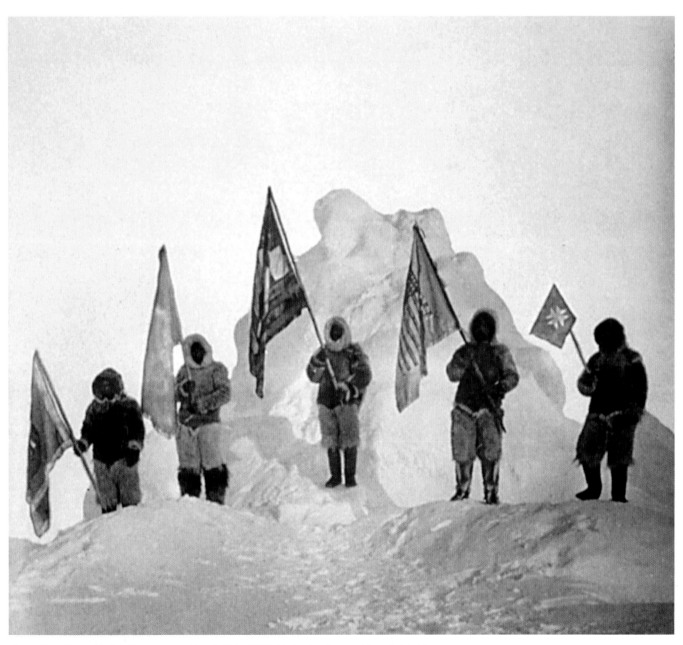

above: The Peary Sledge Party at the North Pole, 1909. *National Archives and Records Administration*

opposite: Self-portrait by Robert Peary at Cape Sheridan, Canada, 1909. *Robert Peary/Public domain*

region and its environment, such as the importance of traveling in late winter and spring while the ice was still firm, instead of during the tempting warmer summer months. They also taught the Americans the finer points of arctic technologies such as dog sleds, furs, and igloos, all of which would prove vital.

By 1906, Peary and Henson had already gone farther north than anyone before them. On March 1, 1909, they set out from Canada's Ellesmere Island, accompanied by twenty-three men, 133 dogs, and nineteen sleds. They streamlined the expedition by shedding supplies and companions as they advanced.

On April 6, 1909, Peary and Henson reached what they estimated to be the North Pole, though they may have actually been a bit off. As they planted an American flag, they were accompanied by only four Inuit companions: Oatah, Egingwah, Seegloo, and Ookeah.

Upon their return, both men confronted new difficulties. Peary faced having his thunder stolen by another man who claimed to have reached the North Pole a full year earlier. Publicizing a picture that later proved to be a hoax, the man had actually come up many miles short. However, it would take five years before Peary's expedition was verified by Congress as having been the first to reach the North Pole.

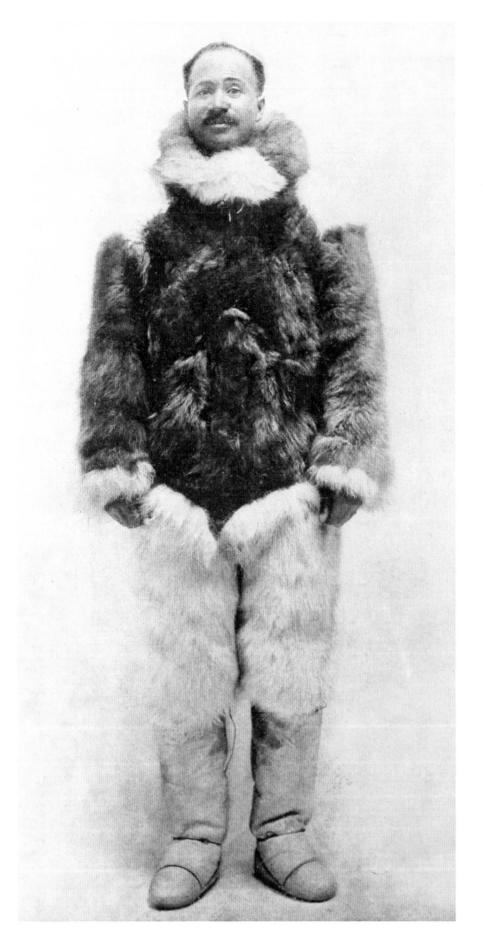

Matthew Henson, who accompanied Robert Peary on seven voyages, was the first African American Arctic explorer. *Unknown*

THE MODEL T

HENRY FORD'S ASSEMBLY LINE AND THE AFFORDABLE AMERICAN CAR

Ford Motor Company assembly plant, 1921. *La Nación*

Michigan native Henry Ford did not invent the automobile. As with the light bulb, the car was developed over many decades by several people in both Europe and America. As early as 1807, Frenchman François Isaac de Rivaz had drawn up plans for an automobile that ran on an internal combustion engine. By the late nineteenth century, "horseless carriages" went from curios to expensive toys for the wealthy, on both sides of the Atlantic. In the United States, the Duryea Motor Wagon Company, founded in 1893 by two Massachusetts brothers, was the country's first automobile manufacturing company.

What Henry Ford did was to make cars relatively affordable for the first time, putting them within reach of middle-class consumers. And in order to make that possible, Ford built a factory in Detroit that was so efficient and productive that scholars now recognize it as the first example of truly modern mass production.

Henry Ford had been involved in several ventures during the turn of the century before founding the Ford Motor Company in 1903. Five years later, Ford introduced its breakthrough automobile: the Model T. Compared to other cars, the Model T was a bargain at only $825 (about $20,000 in today's money). And as Ford improved its mass production efficiency, the car's price dropped in succeeding years. The Model T was also comparatively easy to drive and inexpensive to repair.

Always seeking to lower the car's price tag, Ford dispensed with anything he deemed frivolous, such as color choices. As he coyly bragged, a customer could "have a car painted any color that he wants, so long as it is black."

Ford also tightly managed his massive work force, devising strategies for getting the most out of them. His relentless quest for increased productivity and efficiency led him to develop a labor management philosophy known as Fordism. The three guiding principles were to standardize production so that all parts are identical and made through machines and molds

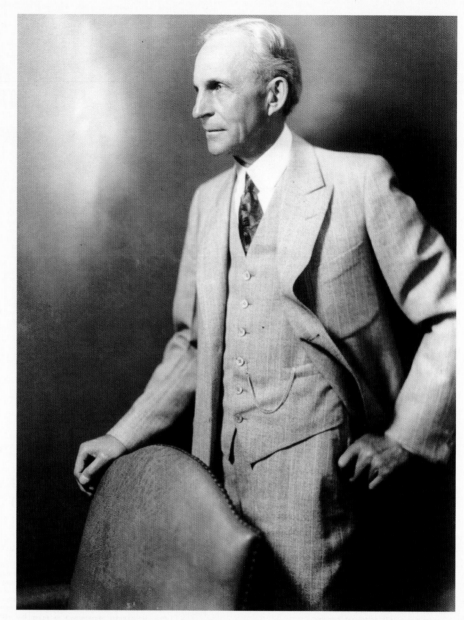

Henry Ford, circa 1934. Library of Congress

instead of by skilled craftsmen; to introduce special-purpose tools and assign workers specific, repetitive tasks, allowing low-skilled assembly laborers to produce a complex finished product; and to pay workers a living wage to boost morale and spur sales.

In 1913, Ford became the first manufacturing company with a moving assembly line; workers sat in front of a conveyor belt that moved the parts along from one to the next; the factory utilized over thirty-two thousand different tools. All of this led to a huge boost in efficiency and production.

The following year, Ford sold over a quarter million vehicles. He then doubled his workers' wages to $5 daily (about $120 today), far and away the highest pay for semi-skilled factory workers anywhere in America. His thousands of workers could now afford to buy the product they made, a concern that other industrialists rarely considered, which proved good for business. They were now loyal customers as well as employees.

By 1918, half of all cars in the United States were Model Ts.

By the mid-1920s, however, Ford's stubbornness was causing him problems.

Competitors, among them General Motors, offered innovations such as consumer credit plans, changing styles, and luxury options. GM customers could even buy cars in a variety of colors.

Ford refused to adapt and sales slipped. Ford would never again retake GM as the leading automotive manufacturer, but the company's innovations remain the backbone of modern manufacturing.

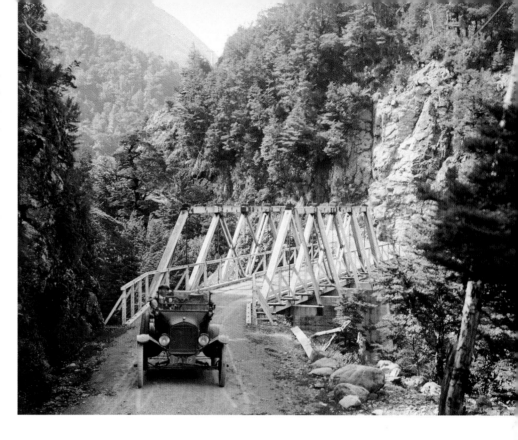

right: The Model T in the 1920s. *Leslie Hinge/ National Library of New Zealand*

below: Michigan-based Thunderbird assembly plant, 1965. *Unknown*

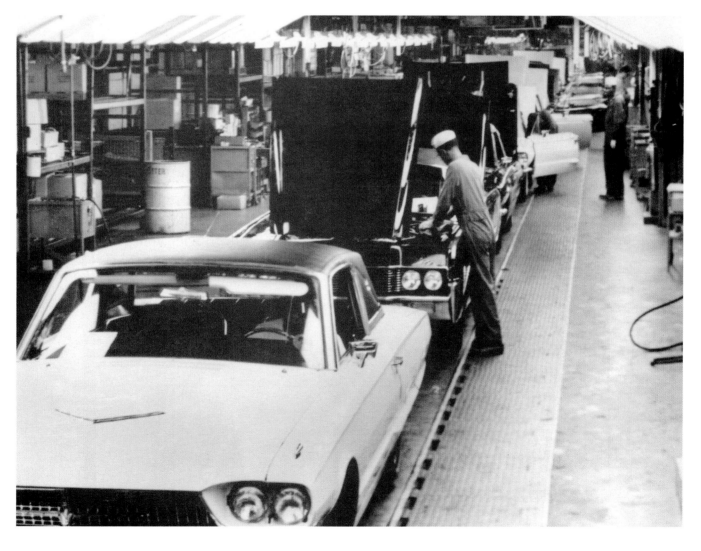

CHARLES RICHARD DREW
FATHER OF THE BLOOD BANK

Each year, nearly ten million Americans roll up their sleeves and give blood because they see it as an important civic duty. And afterward they leave, slightly light headed, full of juice and cookies, and satisfied that their small sacrifice may one day help save the life of a stranger.

The Red Cross blood donation system in which millions of Americans participate was the brainchild of Dr. Charles Drew. Charles Richard Drew was born in Washington, D.C., in 1904 to a middle-class African American family. His mother was a teacher and his father was a carpet layer. He earned an athletic scholarship (he lettered in four different sports) to Amherst College in Massachusetts, where he was also a standout student.

After graduating in 1926, Drew spent two years working as a biology instructor to save money for graduate school. He then moved to Montreal to study medicine at McGill University. Earning degrees in medicine and surgery, he graduated in 1933, finishing second in a class of 127.

Drew did his medical internship at Royal Victoria Hospital. It was during this time that he began his research on blood transfusions. After his father's death, he returned to Washington in 1935, where he taught at Howard University Medical School and practiced surgery at Freedmen's Hospital.

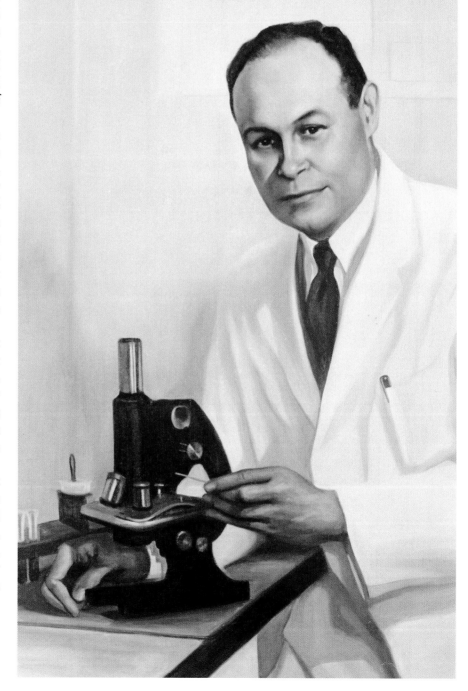

Charles R. Drew.
National Archives and Records Administration

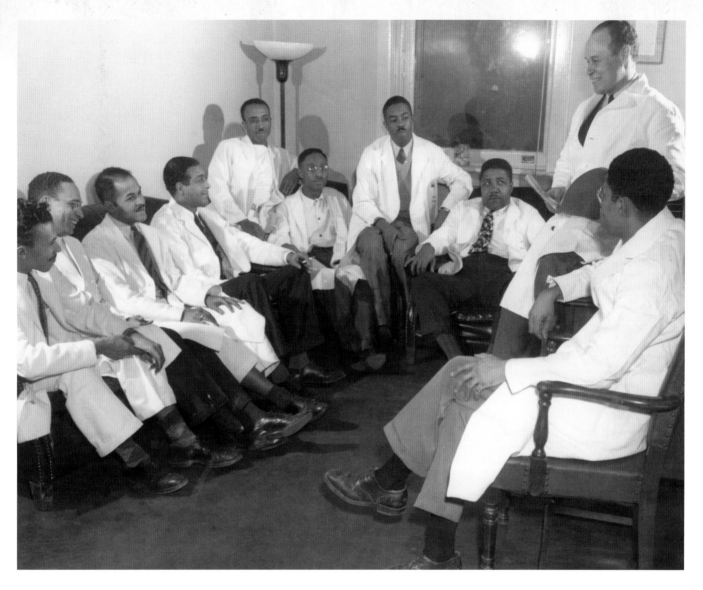

Drew (far right, atop table) with colleagues at Howard University, circa 1945.
National Library of Medicine

In 1938, Drew earned a Rockefeller Fellowship to study at Columbia University. While there, he furthered his research on blood, finding that plasma (blood without the blood cells) could be processed and preserved more easily than whole blood. This enabled blood to be "banked" for future use. Drew also found that plasma could be dried and successfully reconstituted for future use. Drew's research led to his becoming the first African American to earn a doctorate from Columbia.

In 1940, as war raged across Europe, Drew was one of the doctors in charge of "Blood for Britain," a program in which Americans donated blood for British soldiers and civilians. In New York, he created the first central blood donation and processing center. He oversaw the testing of blood and instituted measures to prevent its contamination.

The following year, Drew established the American Red Cross's blood bank system. However, when the US military insisted on segregating black people's blood, Drew resigned in disgust.

Drew died in a car accident in 1950. He was forty-five years old.

Today, the medical establishment requires upwards of forty-one thousand pints of blood per day to meet the needs of its patients. This quotient is easily met thanks to the kindness and generosity of millions of Americans and was made possible by the research of Dr. Charles Drew.

UNBREAKABLE

THE NAVAJO CODE TALKERS OF WORLD WAR II

Military intelligence, the gathering and relaying of information, is vital to any war effort. To prevent information from falling into enemy hands, soldiers and diplomats have long relied on codes and ciphers to keep their plans secret.

Mathematics is usually the basis for devising complex codes. However, it has vulnerabilities. If mathematics is used to build a code, then mathematics can often be used to crack it.

During World War I, the United States military experimented with a different approach. After Germany had broken the American code, at least nineteen Choctaw Indian soldiers developed a new one based on the Choctaw language. Used late in the war, their code was not broken.

During World War II, the United States developed a more ambitious code based on American indigenous languages. Navajo, Comanche, and various Pueblo speakers such as the Hopi were recruited, and each group of Native speakers created a complex code in their own language.

An ordinary word such as "egg" might be the code for "bomb." But code talkers did not simply say "egg" in an indigenous language. Rather, they would say a series of indigenous words, each representing a letter. When arranged, the coded letters would spell "egg" in that language, which in turn meant "bomb."

Indigenous codes supplemented conventional codes. Code talkers were often deployed near or on the front lines, transmitting messages while under direct fire. The job was especially dangerous because the enemy could triangulate radio transmissions to determine the code talkers' locations, making them direct and highly valuable targets.

Used in both Europe and the Pacific, the indigenous codes were never broken by enemy forces.

The experiences of Native code talkers varied. Some had eagerly volunteered to fight. Others were drafted. Many had attended federal schools as children, where they had been forbidden from speaking their languages on pain of corporal punishment (*see* **Cultural Genocide**, *page 160*). Ironically, being

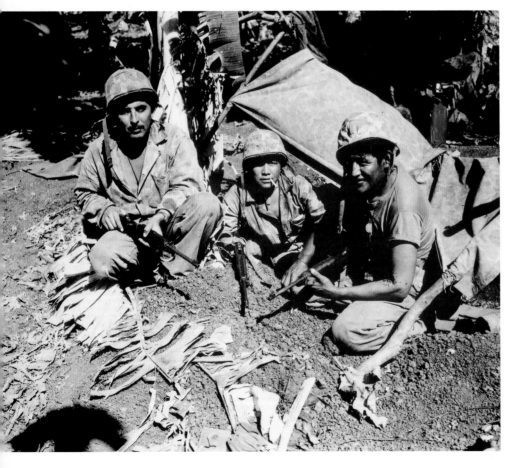

left: Navajo code talkers with marines on Saipan, 1944. *Department of Defense*

opposite page: Dan Akee, World War II veteran and Navajo code talker.
Grand Canyon NPS, Erin Whittaker

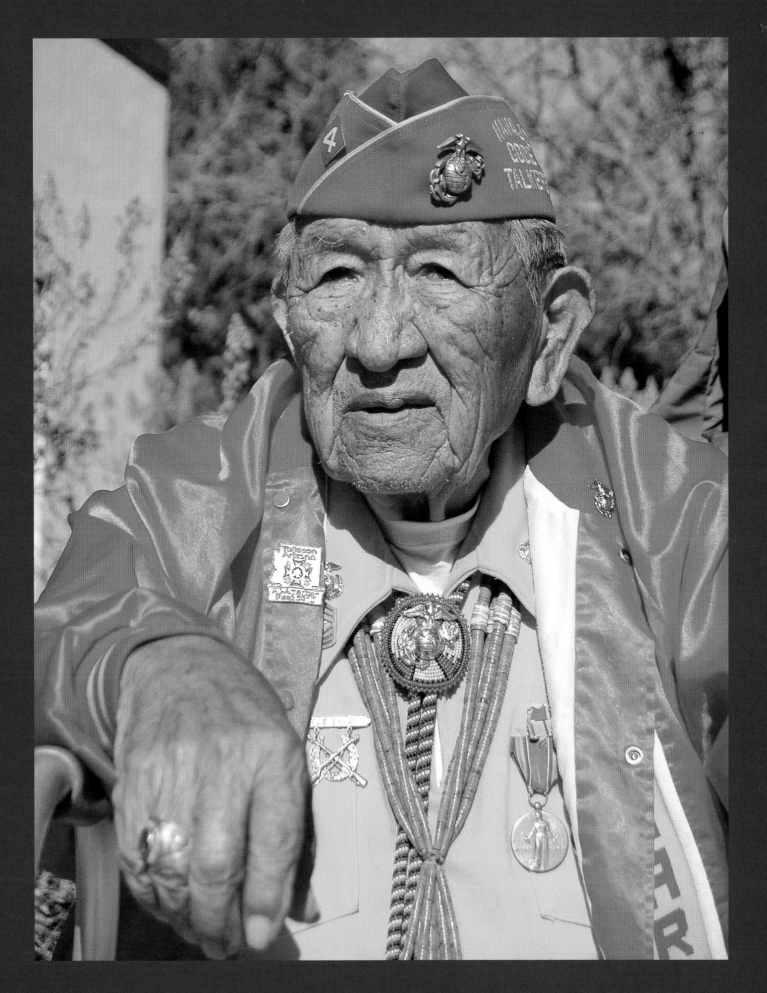

disobedient in government schools would later make them valuable to the government as Native speakers, and thus as a crucial element of the war effort.

On the whole, Indian men served in the military at a higher rate than any ethnic group in the United States. But for many of them, defending their Native lands was at least as important, if not more so, than defending the United States.

As one elderly code talker reminisced: "I like to think among my Indian Native people that I defended their religion, their belief, their land, their stories." Another said that he eventually learned the non-Native people of America "are my people too."

After the war, many veteran code talkers returned home to find that anti-Indian racism had not abated, and their special contributions to the war effort were all but ignored. By the late twentieth century, however, the broader public had come to recognize the special contribution that the Indian code talkers had made to the war effort.

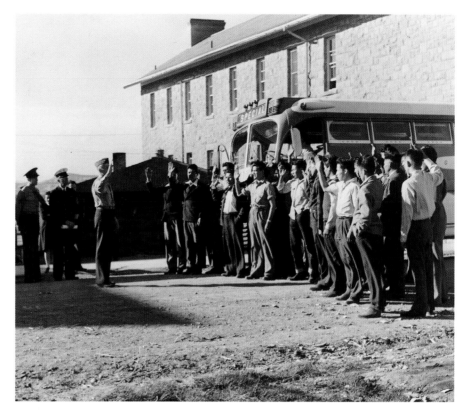

above: Swearing in of the first twenty-nine Navajo US Marine Corps code talkers at Fort Wingate, New Mexico. *Department of the Interior/Bureau of Indian Affairs/Navajo Area Office*

below: Chairman of the Joint Chiefs of Staff Gen. Peter Pace, US Marine Corps, with Navajo code talkers. *Staff Sgt. D. Myles Cullen, US Air Force*

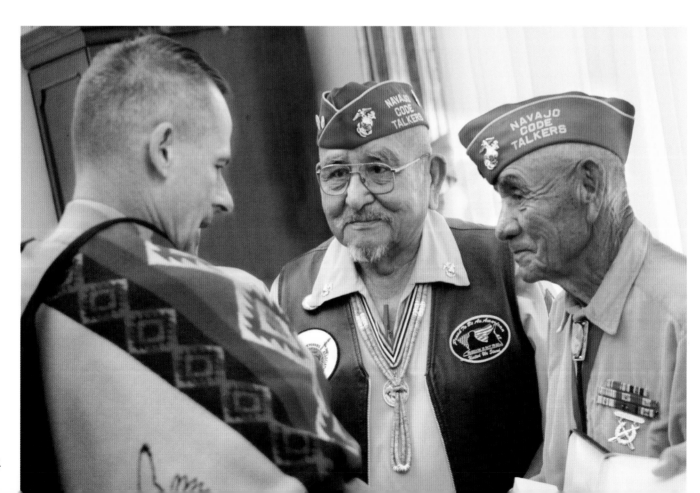

SPLITTING THE ATOM

THE NUCLEAR AGE

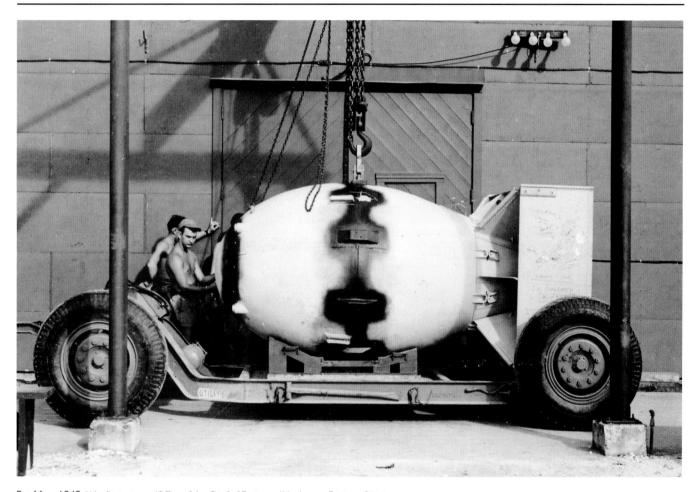

Fat Man, 1945. *War Department/Office of the Chief of Engineers/Manhattan Engineer District*

On August 2, 1939, President Franklin Roosevelt received a letter from the world's most famous scientist: Albert Einstein. It discussed the recent work of physicists Leó Szilárd and Enrico Fermi on splitting uranium atoms, and noted the plausibility of setting off a "nuclear chain reaction in a large mass of uranium, by which vast amounts of power" could be generated. Such technology could lead to "extremely

powerful bombs of a new type." And Nazi Germany was already stockpiling uranium. These developments, Einstein warned, "seem to call for watchfulness and, if necessary, quick action on the part of the administration."

The letter had actually been written by Szilárd and another physicist; Einstein had agreed to sign it in order to get the president's attention. The ploy worked.

On June 28, 1941, Roosevelt issued Executive Order 8807, which would lead to the formation of the Manhattan Project. Overseen by American scientist Robert Oppenheimer, the Manhattan Project was a vast research and development enterprise spread across the United States. The heart of it was Los Alamos National Laboratory in northern New Mexico, which opened in 1943.

Relying on scientists from around the world, including many European refugees, the program successfully tested an atomic weapon in 1945. In August, the United States dropped atomic bombs on the Japanese cities of Hiroshima and Nagasaki, effectively ending World War II; in each case, a single bomb obliterated the city. Roughly two hundred thousand people were killed, either immediately from the blasts or from the lingering effects of radioactive fallout.

The world had never seen such power. But American elation over ending the war soon turned to fear when the Soviet Union acquired atomic weaponry (*see* **The Atomic Specter**, *page 187*).

In 1953, the United States upped the ante when it successfully tested the first thermonuclear device. Early atomic bombs were based on the principle of fission: splitting a large, unstable, radioactive atom such as uranium or plutonium. But the new hydrogen bomb, or H-bomb, was based on nuclear fusion.

As opposed to the splitting of a large atom, fusion is the blending together of two small atoms, hydrogen being the smallest. Drawing on the same dynamics that produce the sun's heat, the amount of energy unleashed by a thermonuclear bomb was one thousand times that produced by the bombs dropped on Japan. An atomic fission explosion was needed just to generate the power required to set off a fusion reaction.

If nuclear bombs threatened a global holocaust, nuclear power seemed to offer the promise of clean energy. Nuclear reactors don't contribute to climate change, and there is a near endless supply of fissile materials. However, there are also serious problems.

Radioactive waste produced by nuclear reactors remains deadly for millennia, and the threat of accidents is very real. There have been one hundred nuclear power plant accidents around the world since 1952, including the 1979 crisis at Three Mile Island in Pennsylvania; the deadly 1986 meltdown in Chernobyl, Russia; and the near nuclear catastrophe in Japan after a tsunami walloped the nation in 2011.

Nevertheless, there are currently well over four hundred active nuclear reactors in thirty-one countries around the world, including one hundred in the United States. All combined, they produce 13 percent of the world's electricity.

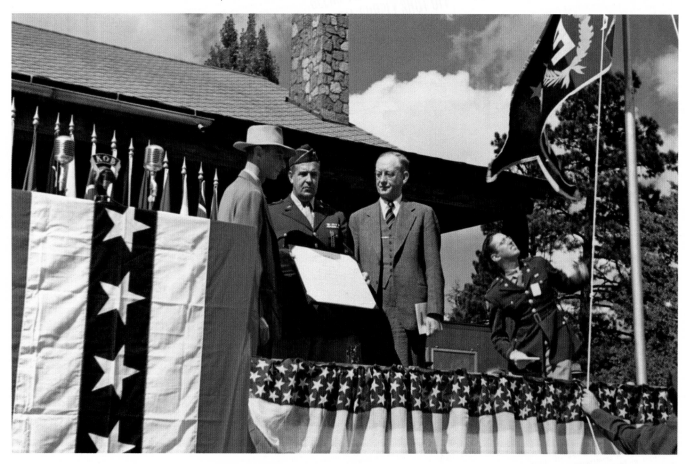

Robert Oppenheimer (left), Leslie Groves (center), and Robert Sproul (right) during a 1945 ceremony presenting the Los Alamos Laboratory with the Army-Navy "E" Award—an honor recognizing excellence in the production of war equipment. *Los Alamos National Laboratory*

top: The control room and operator's chair at the Hanford B Reactor, the first large-scale nuclear reactor ever built. *US Department of Energy*

left: Gamma radiation detectors at the Las Vegas National Research Center, 1972. *Environmental Protection Agency*

WALT DISNEY
Founding an Entertainment Empire

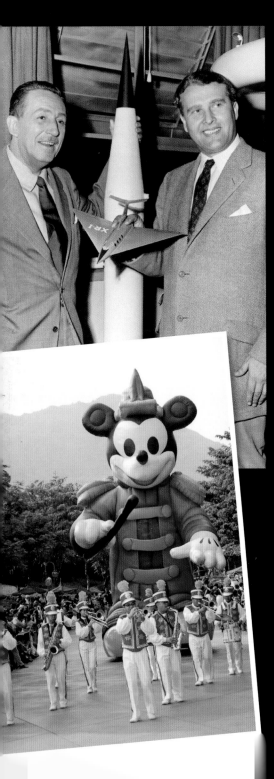

Walter Elias "Walt" Disney used a mouse to build an empire.

Born in 1901, Walt Disney established himself as an animator as a young man in Kansas City. In 1923, he and his brother Roy moved to Hollywood and founded a small studio.

Building on an earlier character named Ike the Mouse, Walt Disney and partner Ub Iwerks cocreated Mickey Mouse in 1928. Mickey and an early version of Minnie Mouse debuted in a black-and-white silent short called "Plane Crazy." It was shown to test audiences, but failed to land a distributor.

After several more silents, which also were not released, Mickey appeared in a "talkie," 1929's "Steamboat Willie." The first animated film with fully synchronized sound, the seven-minute short was an instant success. Disney, who would supply the voice of Mickey for nearly twenty years, was on his way.

During the early 1930s, other popular characters joined the Disney stable, including Goofy and Donald Duck. Disney also had a second successful series of animated shorts called Silly Symphonies. In 1932, Mickey Mouse earned Disney the first of what would eventually be twenty-two

Academy Awards from among fifty-nine nominations (and counting).

Already boasting the nation's leading animation studio, in 1934 Disney began work on an animated feature film. Skeptics called it Disney's Folly. The project took three years and nearly bankrupted its creator. But in late 1937, he released *Snow White and the Seven Dwarfs*. The first animated feature film in color, it was a huge success. The highest-grossing film of 1938, *Snow White* pioneered yet another genre of animated film.

After the success of *Snow White*, Disney built a large, new studio in Burbank, California. The feature films *Pinocchio*, *Fantasia*, *Bambi*, and *Dumbo* soon followed.

By the 1940s, animated shorts featuring Mickey Mouse and other characters had been eclipsed by Warner Brothers' stable of Looney Toons, particularly its animated star Bugs Bunny. Looking to get the most from feature films, Disney successfully rereleased *Snow White* in 1944, establishing a seven-year rerelease cycle for its animated features films and continually capitalizing on new audiences of young children during the Baby Boom.

In 1950, Disney augmented his animated productions with live-action films, beginning with *Treasure Island*. A string of hits followed, including *20,000 Leagues Under the S...*

top: Walt Disney and Dr. Wernher von Braun, then Chief, Guided Missile Development Operation Division, at Army Ballistic Missile Agency (ABMA) in Redstone Arsenal, Alabama. *NASA*

In 1955, Disney moved into the new medium of children's television programming. *The Mickey Mouse Club*, which featured a cast of child actors called the Mouseketeers, ran until 1959 (and again from 1989 to 1996) and launched the careers of such future stars as Annette Funicello, Britney Spears, Christina Aguilera, and Justin Timberlake.

The same year *The Mickey Mouse Club* debuted, Disney expanded operations into live entertainment with the opening of the Disneyland amusement park in Anaheim, California. It was immediately the world's most successful theme park and remains so to this day. Disney World opened in Florida in 1965, and today the company owns fourteen theme parks around the world.

By 1960, the Disney enterprise had become arguably the nation's first multimedia corporate empire. Ventures in film, television, and live entertainment combined to make Disney one of the world's most recognized brands.

Corporate expansion continued after Disney's death in 1966. Today, The Walt Disney Company also operates in radio, music, publishing, and online media. The world's second-largest broadcasting and cable company, Disney owns the American Broadcasting Company (ABC) and its subsidiaries, among them ESPN. Disney now boasts nearly two hundred thousand employees and total corporate assets exceeding $80 billion.

Fireworks outside of Cinderella's Castle at Walt Disney World's Magic Kingdom Park. *Candace Lindemann/Creative Commons*

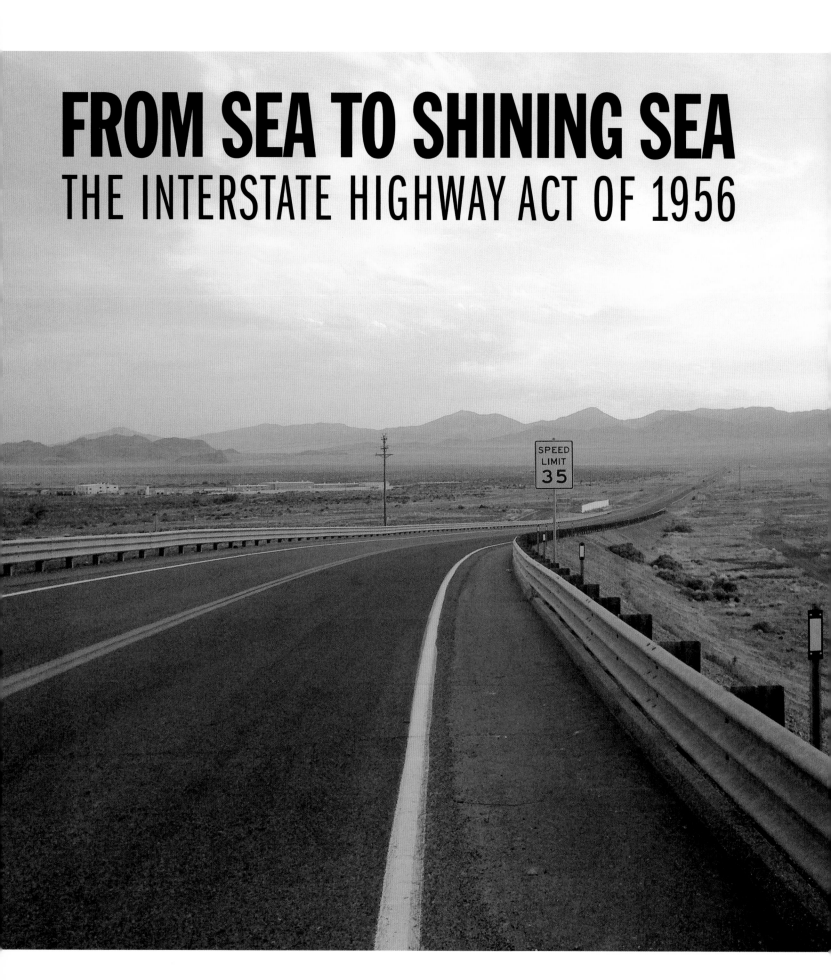

FROM SEA TO SHINING SEA
THE INTERSTATE HIGHWAY ACT OF 1956

SPEED LIMIT 35

After returning from Europe at the end of World War I, the US Army sponsored the 1919 Transcontinental Motor Convoy. Nearly three hundred soldiers drove a group of eighty-one motorized vehicles from Gettysburg, Pennsylvania, to San Francisco. For 3,251 miles, the convoy wound along the Lincoln Highway, America's rudimentary, haphazard web of paved roads. It took sixty-two days.

A young lieutenant named Dwight Eisenhower was part of the convoy. Memories of impassable roads and a two-month trip that averaged barely fifty miles per day would stick with him.

During World War II, Eisenhower was the supreme commander of US forces in Europe (*see* **Victory in Europe**, *page 224*). It was there that he witnessed firsthand the German autobahn, a sophisticated network of modern highways. Adolph Hitler had used the autobahn to launch his successful *blitzkrieg* attacks: waves of lightning-fast, motorized, armored infantry that had subdued nearly all of Europe.

When Eisenhower was elected president in 1952, he remembered both the fiasco of the 1919 transcontinental convoy and the devastation unleashed by Hitler's autobahn. In 1954, he announced his plan to build a transcontinental interstate highway program in the United States.

To promote the new interstate highways, Eisenhower not only talked about improving US military defenses but also touted the highways' potential benefits to average Americans. With good roads, fresh produce from Florida could be trucked up to New England in a day's time, he noted.

In 1956, Congress passed the National Interstate and Defense Highways Act. It initially allocated $25 billion for the construction of forty-one thousand miles of highway over a ten-year period. The federal government would use gas taxes to pay for 90 percent of the cost, and states would cover the other 10 percent.

The new interstate highways were designed for speed, featuring restricted access (on and off ramps), and *minimum* speeds of forty miles per hour. Construction was a modern engineering marvel, but came at high human costs. Road planners used eminent domain to seize lands for road construction. Thousands of farms were bifurcated by four-lane highways. And neighborhoods in scores of cities across America were leveled to make way for the new roads.

left: The Lincoln Highway: America's first transcontinental highway for automobiles. *Famartin/Creative Commons*

below: Highway tunnel construction, 1935. *Department of the Interior/National Park Service/Scotts Bluff National Monument*

Most often, poor and working-class minority neighborhoods were destroyed, dividing cities even further along racial and economic lines.

However, the roads also proved to be a major economic stimulus. Initial jobs in construction were followed by booms in numerous industries, including trucking, petroleum, automotive, motels, and restaurants. Many states also built or improved state and local highways during this time, further contributing to the rise of car culture in America.

Today, the US interstate highway program stands as the largest public works program in world history, both in terms of cost and physical size. There are nearly forty-seven thousand miles of road crisscrossing the nation. The cost of initial construction was nearly $129 billion, but regular maintenance has pushed the total beyond a trillion dollars and rising.

right: Dwight D. Eisenhower in 1959. *White House*

below: Interstate Highway status map, 1976. *Federal Highway Administration*

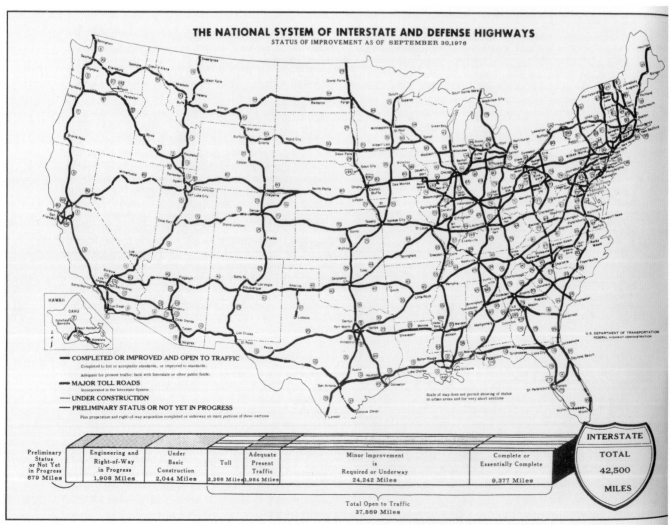

THE NATIONAL SYSTEM OF INTERSTATE AND DEFENSE HIGHWAYS
STATUS OF IMPROVEMENT AS OF SEPTEMBER 30, 1976

━━━ COMPLETED OR IMPROVED AND OPEN TO TRAFFIC
Completed to full or acceptable standards, or improved to standards.
Adequate for present traffic; built with interstate or other public funds.

▬▬▬ MAJOR TOLL ROADS
Incorporated in the Interstate System

▬▬▬ UNDER CONSTRUCTION

▬▬▬ PRELIMINARY STATUS OR NOT YET IN PROGRESS
Plan preparation and right-of-way acquisition completed or underway on many portions of these sections

U.S. DEPARTMENT OF TRANSPORTATION
FEDERAL HIGHWAY ADMINISTRATION

Scale of map does not permit showing of status in urban areas and for very short sections

| Preliminary Status or Not Yet in Progress 679 Miles | Engineering and Right-of-Way in Progress 1,908 Miles | Under Basic Construction 2,044 Miles | Toll 2,266 Miles | Adequate Present Traffic 1,984 Miles | Minor Improvement is Required or Underway 24,242 Miles | Complete or Essentially Complete 9,377 Miles | INTERSTATE TOTAL 42,500 MILES |

Total Open to Traffic
37,869 Miles

MR. SALK'S GIFT

JONAS SALK CURES POLIO

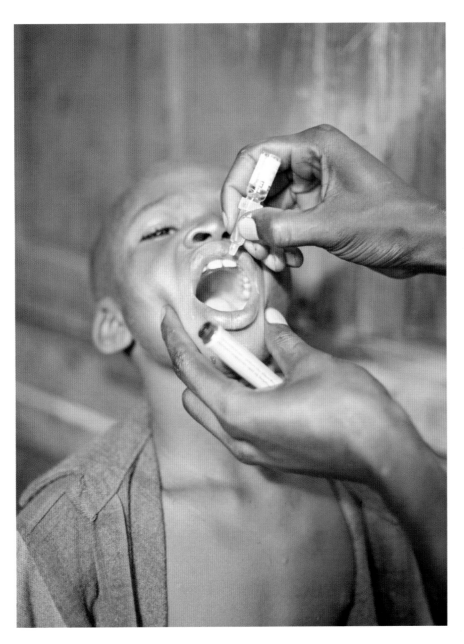

Polio vaccination in Conakry, Guinea. *Julien Harneis/Creative Commons*

President Franklin Roosevelt was partially paralyzed for most of his adult life, requiring crutches or a wheelchair to get around (a fact that was generally hidden from the public). Though researchers now believe it unlikely, during his lifetime, polio was thought to be the cause.

After World War II, polio haunted America. Each summer, epidemics of the disease would sweep across the nation, causing death and paralysis. Most victims were children. At the plague's height in 1952, there were 58,000 recorded cases in the United States that led to 3,145 deaths and 21,269 people left paralyzed to some degree.

To fund research for a cure, in 1938 Roosevelt founded the National Foundation for Infantile Paralysis, later known as the March of Dimes. The man who would eventually lead the search to find a cure was Dr. Jonas Salk.

Born in New York City to Jewish immigrants, Salk earned his medical degree from New York University. However, quotas limiting the hiring of Jewish doctors were common at the time, making it difficult for him to find a job after medical school.

During World War II, Salk pioneered a highly successful influenza vaccine. After the war, he took a position at the University of Pittsburgh. He was in need of funding, and the March of Dimes

above: Dr. Jonas Edward Salk at Copenhagen Airport, 1959. *SAS Scandinavian Airlines*

right: President Gerald Ford announces the National Swine Flu Immunization Program. Also shown are Salk (left) and Secretary of Health, Education, and Welfare F. David Mathews (right of Ford). *Gerald R. Ford Presidential Library and Museum/National Archives and Records Administration*

contacted him because of his prior work on the flu. In 1948, Salk began working on a vaccine for polio. Polio is a viral disease, and since human bodies build up immunities to viruses after being exposed, vaccines composed of mild strains can be developed. However, finding a workable strain of the virus, the right amount of it, and a viable delivery system can be difficult.

With annual panics about polio overtaking the nation every summer, Salk attracted national attention for his work. In the summer of 1952, he injected several dozen mentally handicapped children with an experimental version of his vaccine. He, his wife, and their three sons were also among the first people to be inoculated.

By the time the vaccine was ready for extensive field trials in 1954, one hundred million Americans had donated money to the March of Dimes. That year, an army of 20,000 public health workers, 64,000 school employees, and 220,000 volunteers administered the vaccine to 1,800,000 school children.

On April 12, 1955, Salk's polio vaccine was declared to be safe and effective. The announcement was broadcast across the country on television and around the world on radio. Some fifty-four thousand doctors watched live in movie theaters across America. Polio was finally defeated in the United States.

Salk stood to make a fortune from his discovery. He chose, however, to be a philanthropist instead, donating his vaccine to the world. When asked in a television interview who owned the patent, he responded, "There is no patent. Could you patent the sun?"

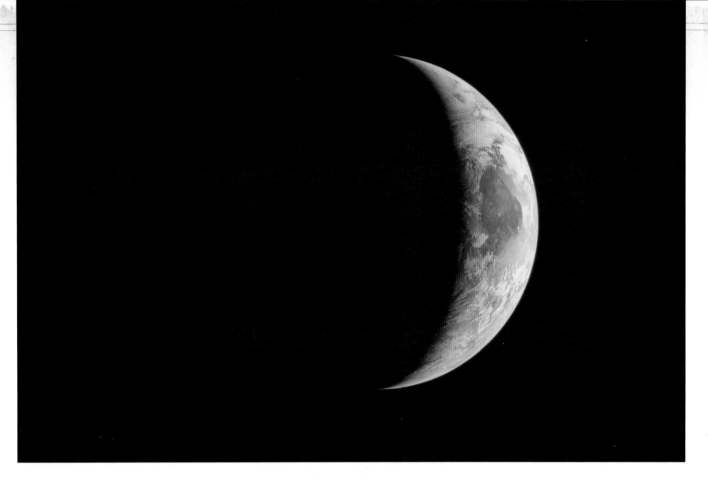

BEYOND THE STARS

THE MOON LANDING

In 1969, the United States attained perhaps the most miraculous technological achievement in all of human history, accomplishing what had only been dreamed about in boyhood science fiction tales: it put a man on the moon and brought him home again.

After World War II, the Cold War competition between the United States and the Soviet Union had quickly heated up. The nuclear arms race (*see* **The Atomic Specter**, *page 187*) was soon mirrored by a space race.

In 1957, the Soviet Union launched Sputnik, the first manmade satellite to orbit the Earth. Sputnik was visible in the nighttime sky, and many Americans went into a panic. The following year, President Dwight Eisenhower founded the National Aeronautics and Space Administration (NASA). From that moment, the United States aggressively pursued a space program.

Photograph taken from Apollo 11 during the first lunar landing mission, 1969. *NASA*

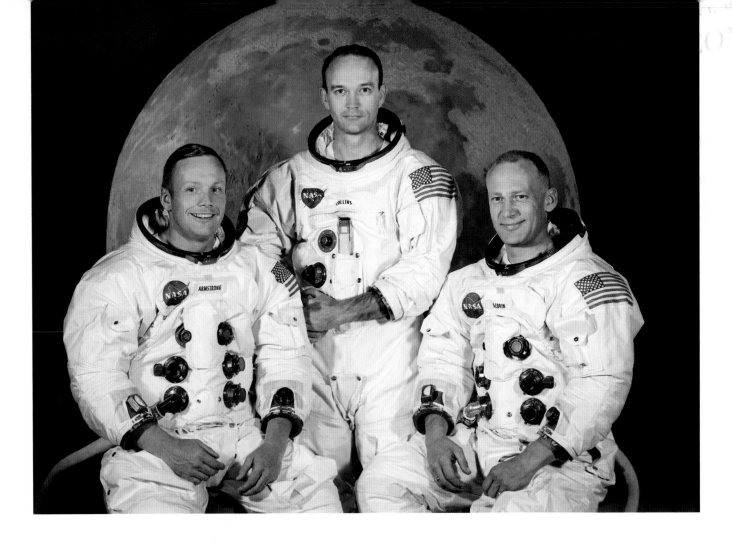

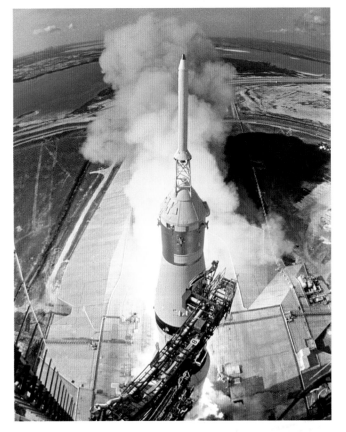

above: Neil A. Armstrong, commander; Michael Collins, command module pilot; and Edwin E. Aldrin Jr., lunar module pilot. *NASA*

left: Apollo 11 liftoff. *NASA*

In 1961, the Russians again bested the Americans when Soviet cosmonaut Yuri Gagarin became the first person to journey into space and complete a full orbit of the Earth. President John Kennedy responded by challenging Congress. Before the decade was over, he said, the United States should achieve the goal "of landing a man on the moon and returning him safely to the Earth."

The race was on.

After a series of successful missions into space, NASA began planning the Apollo 11 space flight to the moon. Three astronauts were selected for training: Commander Neil Armstrong, Command Module Pilot Michael Collins, and Lunar Landing Module Pilot Edwin "Buzz" Aldrin. By 1969, they were ready.

On July 16, a Saturn V rocket lifted off from the Kennedy Space Center in Florida. The event was broadcast live around the world, and President Richard Nixon supplied commentary from the White House. After propelling a manned, three-part module into outer space, the Apollo's Saturn rocket separated from the

module and fell back to Earth as planned. The module embarked on a three-day journey through space toward the moon.

After reaching the moon, Armstrong and Aldrin moved from the Command Module into the Lunar Module and landed it on a part of the moon's surface known as the Sea of Tranquility. Armstrong went first. Wearing his iconic space suit, Armstrong descended a ladder, planted his foot on the moon, and misspoke the line he had previously rehearsed for the occasion: "One small step for a man, one giant leap for mankind."

Understandably nervous, Armstrong accidentally forgot to say "a."

Aldrin soon joined Armstrong. Altogether, their module was on the moon for over twenty-one hours, during which time the two astronauts planted a US flag and collected rock samples.

Afterward, they rejoined Collins in the Command Module and began the return trip to Earth. On July 24, the module landed in the Pacific Ocean. It had been eight days, three hours, eighteen minutes, and thirty-five seconds since the initial launch, but the astronauts were safely home. Americans had "slipped the surly bonds of Earth" and accomplished the stuff of dreams.

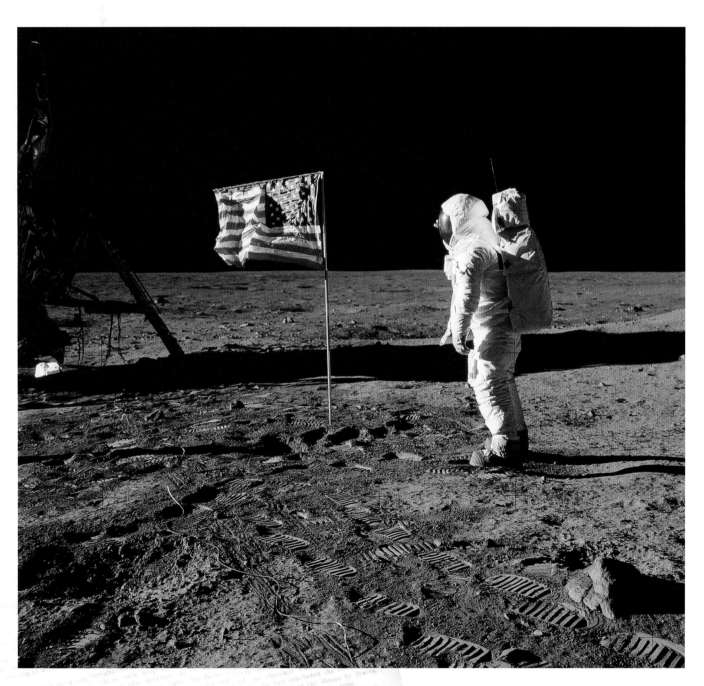

Aldrin salutes the US flag on the lunar surface. *NASA*

SOUP CANS AND CELEBRITY

ANDY WARHOL'S POP ART EXPLOSION

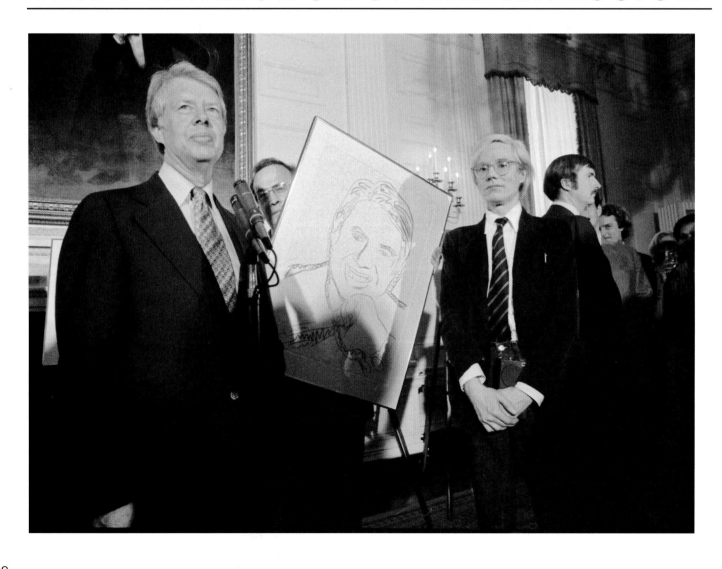

Perhaps no artist forced Americans to think about the question of what art is more than Andy Warhol.

Warhol was born Andrej Varhola Jr. to Slovakian immigrant parents in Pittsburgh, Pennsylvania, in 1928. A sickly child, he was frequently bedridden and scoffed at by his peers. He developed an early interest in drawing and in collecting pictures of movie stars.

After studying commercial art at Carnegie Institute of Technology, Warhol moved to New York City and began a career as a magazine and advertising illustrator. During the 1950s, he gained notoriety for his drawings in a popular shoe campaign. He was then hired to do freelance design for record album covers.

Around this time, Warhol also began exhibiting his work at art galleries. During the early 1960s, he helped launch the pop art movement, using well-known elements of popular culture as the subject of his art.

Modified images of celebrities, such as Marilyn Monroe (*see page 34*), and common objects, such as Campbell's soup cans and dollar bills, challenged people to wonder what exactly is or is not art. Could things not normally thought of as art, such as a Coke bottle, be modestly (or immodestly) reworked into art? Are commercial illustrations for advertising also art? Is anything an artist makes and calls "art" art?

Warhol opened a New York studio called The Factory, its very name challenging people to reconsider how art is produced and to question the supposed divisions between what is and is not art. The Factory became a popular, round-the-clock hangout for artists, celebrities, and an assortment of unconventional characters whom Warhol called the Superstars, some of whom became vaguely famous merely through their association with him. During this time, Warhol also worked with the influential avant-garde rock band Velvet Underground, led by Lou Reed.

In 1968, a mentally ill Factory hanger-on named Valerie Solanas attempted to assassinate Warhol. He barely survived the shooting. Afterward, he put tighter controls on The Factory and admitted to being more disengaged from humanity.

During the 1970s, Warhol further blurred the divide between art and industry by becoming more entrepreneurial. By now a world-famous artist, he catered to rich patrons eager to pay extraordinary sums for commissioned portraits, which were also viewed as financial investments. Subjects included former Beatle John Lennon and the Shah of Iran and his wife. During the 1980s, a new wave of successful artists cited Warhol as an important influence.

When Andy Warhol died in 1987, his reputation among critics and the public was as divisive as ever. Was he a brilliant conceptual artist who turned a mirror on society or a crass opportunist? Either way, Andy Warhol had helped innovate a new and lasting form of art.

above: Patrons interact with *Silver Clouds*, an installation originally conceived of by Warhol in 1966 and still actively exhibited. *Sskerchief/Creative Commons*

opposite: Jimmy Carter with Andy Warhol at a reception for inaugural portfolio artists, 1977. *National Archives and Records Administration*

below: Andy Warhol Bridge in Warhol's hometown of Pittsburgh, Pennsylvania. *Daderot/Public domain*

DAWN OF THE COMPUTER AGE

THE COMMODORE 64

Commodore 64 motherboard. *Gona.eu/Creative Commons*

In a 1936 paper entitled "On Computable Numbers," British mathematician Alan Turing first proposed the concept of a digital computer. After World War II, he built the Automatic Computing Engine (ACE), one of the first computers to store an electronic program.

The first American computer was called ENIAC (Electronic Numerical Integrator and Computer). Designed and funded by the US Army, it was built in secret by the University of Pennsylvania. ENIAC was completed and made public in 1946. The press dubbed it "The Great Brain."

Containing more than 170,000 vacuum tubes, ENIAC weighed thirty tons and had a footprint of 1,800 square feet. It ran continuously from 1947 to 1955. One of its first programs analyzed the plausibility of designs for a thermonuclear bomb (*see* **Splitting the Atom**, *page 85*).

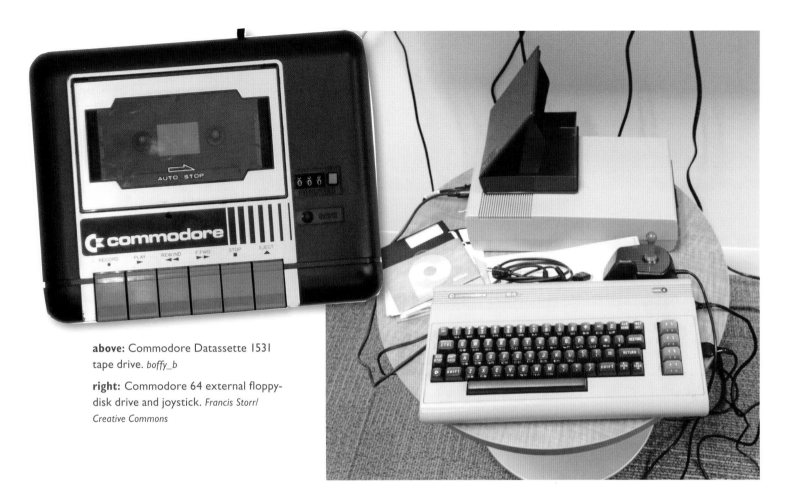

above: Commodore Datassette 1531 tape drive. *boffy_b*

right: Commodore 64 external floppy-disk drive and joystick. *Francis Storr/ Creative Commons*

As electronics improved and large vacuum tubes gave way first to transistors and then to integrated circuits, computers became smaller and faster. By the 1970s, the first home computers had begun to appear. Extremely rudimentary compared to modern models, the machines offered by companies such as Apple, Commodore, Tandy, Atari, and IBM catered mostly to hobbyists.

In January of 1982, Commodore introduced its C64 model. Affordable, easy to use, and offering new features, the Commodore 64 attracted consumers like nothing before it. By the mid-1980s, it had captured between 30 and 40 percent of the home computer market. In an era when sales were typically measured in the thousands, the C64 would eventually sell somewhere between ten million and seventeen million units.

Computers of this era were incredibly basic by today's standards. The C64 was named such because it boasted all of sixty-four kilobytes of RAM (memory). By comparison, the text for this book (not including the images), written with a modern word-processing program, totals more than five hundred kilobytes of data.

But by the standards of its time, the C64 was superior to other home computers in many ways, and it quickly captured the public's imagination. The C64 offered superior graphics and sound. It featured new games, sophisticated for their time. It was available in retail stores, not just specialty computer and electronics stores. And the C64 also cost half as much as the Apple II; the latter was $1,200, (nearly $3,000 in today's money), though it included a monitor and disc drive, which the C64 did not.

The runaway success of the C64 provided a blueprint for companies and set the standard for what consumers expected from a computer: affordable, easy to use, and fun as well as practical.

Commodore had another success with its 1987 Amiga model. However, by the early 1990s, it had been overtaken by competitors, and the company folded in 1995.

Yet the impact of the C64 is hard to overstate. More than any other device, it changed the way Americans thought about computers. Previously perceived as large, expensive, complex machines for scientists, computers were now seen as affordable technology for common people.

A 2008 poll found that, even though the iconic C64 computer had been off the market for nearly two decades, it still had 87 percent brand recognition among consumers.

INFORMATION SUPERHIGHWAY

THE INTERNET GOES MAINSTREAM

In 1960, computers were still quite primitive by today's standards—enormous machines with only a tiny fraction of the computing power found in today's smartphones. Nonetheless, they were a revolutionary breakthrough, allowing mathematicians and scientists to process complex calculations in what seemed like miraculously fast times.

As computers improved and proliferated, the US federal government began research on tying computers together into a larger network so they could share digital information. By the early 1970s, a series of networks had been built, mostly in the United States. Among them was Advanced Research Projects Agency Network (ARPANET), which had been funded by the US Department of Defense.

On October 29, 1969, the first ARPANET connection was made with the linking of computer systems at the UCLA School of Engineering and a nonprofit research institute in Menlo Park, California. Next, a mathematics center at UC Santa Barbara linked up, followed by the University of Utah graphics department. By the end of 1971, fifteen sites were connected.

While ARPANET was one of several computer networks in America at the

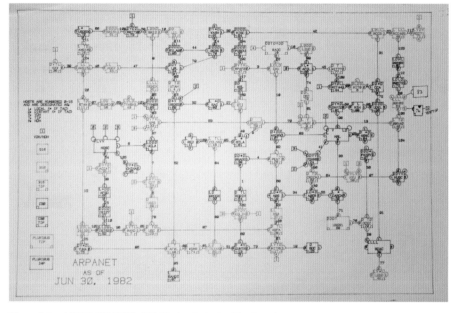

Map of the ARPANET, 1982. *BBN Technologies/public domain*

time, various nations were also developing computer networks. But international collaborations were rare, and among them, it was ARPANET that would eventually transform into the Internet.

One reason for ARPANET's evolution was how it handled digital packet switching, that is, the grouping of data into workable-sized blocks, called packets, which can be digitally transmitted. ARPANET created protocols for digital packet switching that eventually led to

internetworking. Internetworking is the connection of various computer networks into a larger network.

By 1974, two scientists had coined the term *Internet* as a shorthand for such transmissions. In 1981, the National Science Foundation (NSF) developed the Computer Science Network (CSNET), which allowed for ARPANET's expansion. Funding for the expansion was made possible by congressional legislation sponsored by then Tennessee senator

and future vice president Al Gore. The following year, various Internet protocols were standardized, facilitating the development of a worldwide computer network.

In 1986, the NSF linked supercomputers from various American universities and research institutes, further advancing the Internet's reach. During this time, the Internet expanded rapidly to Europe and then to Asia.

On March 12, 1989, British scientist Tim Berners-Lee authored a paper outlining a proposal for what would become the World Wide Web. Looking to improve computer communication at CERN, the Swiss physics lab where he worked, he quickly realized the larger possibilities.

The following year, Berners-Lee and Belgian computer scientist Robert Cailliau suggested using hypertext "to link and access information of various kinds as a web of nodes in which the user can browse at will." By the end of the year, they had built and successfully tested the first modern website.

Also in 1990, the US federal government decommissioned ARPANET and began commercializing the Internet in the United States. By 1995, that process was complete, eliminating restrictions on commercial traffic, and the Internet as we now know it began to emerge.

right: The first Internet router. *Steve Jurvetson/Creative Commons*

below: The front panel of the very first Interface Message Processor (IMP), an early version of what we know today as a router. *Andrew Adams/Creative Commons*

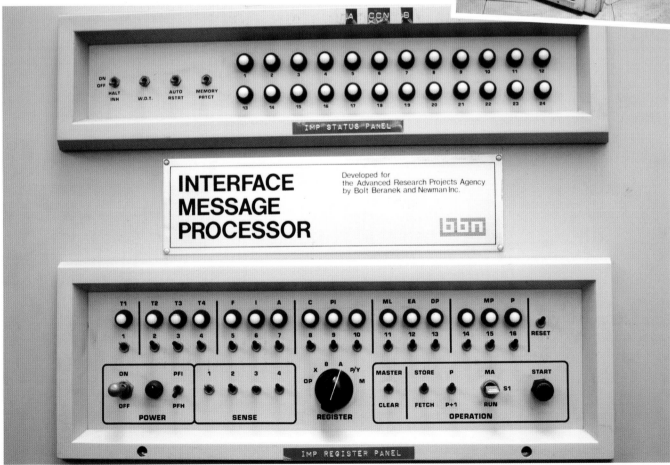

MOBILE PHONES
THROUGH THE DECADES

mproving upon the innovations of European researchers, in 1876 American Alexander Graham Bell obtained the first patent for a telephone that sent electrical currents over wires. Soon, telephone poles strung with lines were stretching across the continent.

Landlines, as they would later be known, revolutionized human communication. But in order not to miss an important call, one had to patiently wait by the phone, which was wired to the wall. Encountering a busy signal while trying to reach someone was a common frustration. Eventually,

MT-800M形1号自動
...000M Type No. 1 Ca

above: A car phone made in Japan in 1978.
Momotarou2012/Creative Commons

right: Father of the cell phone Dr. Martin Cooper poses with a DynaTAC prototype, invented in 1973. *Rico Shen/Creative Commons*

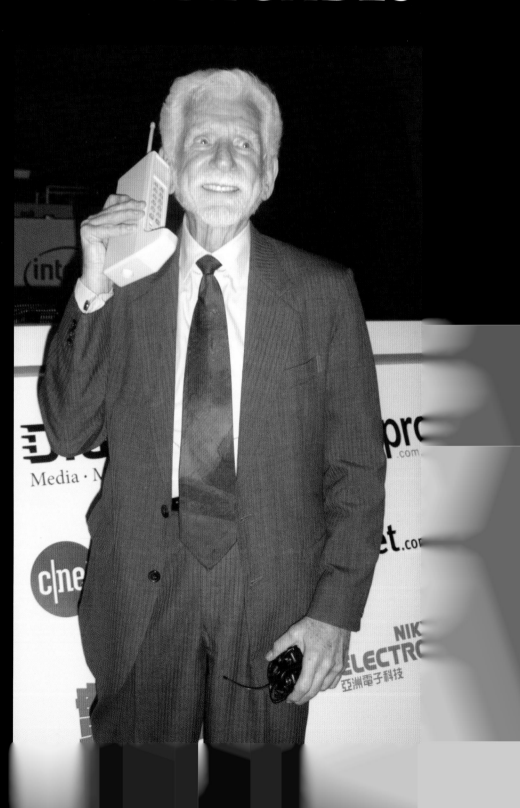

improvements such as push button numbers, answering machines, call waiting, and cordless landline phones would enhance service.

In his 1948 novel *Space Cadet*, science fiction writer Robert Heinlein (see **The Final Frontier**, *page 140*) described a portable phone that a character in Colorado retrieves from his pocket to talk to his father in Iowa. It was one of the first images of a modern mobile phone. In 1958, writer and inventor Arthur C. Clarke optimistically predicted that "personal transceivers" would be widely available by the mid-1980s.

Portable communications devices had in fact existed since the early twentieth century. Transmitting radio waves, they were bulky and limited. After World War II, governments and corporations around the world began working toward the development of a truly mobile telephone. However, by the 1960s, the idea of a portable phone still seemed futuristic enough that the popular spy sitcom *Get Smart* (1965–1970) mocked the idea by having Agent Maxwell Smart talk on a comical looking "shoe phone."

In 1973, the US company Motorola demonstrated the first handheld cellular telephone. It weighed more than four pounds. It was also in need of a network over which to communicate. In 1979, the Japanese company NTT launched the first commercial cellular network.

These first-generation (1G) devices were still analog, greatly limiting the size of networks. The second generation of cellular phones (2G), introduced by the Finnish company Radiolinja in 1991, were digital, opening up the possibility of enormous networks. In 2001, NTT introduced 3G, which

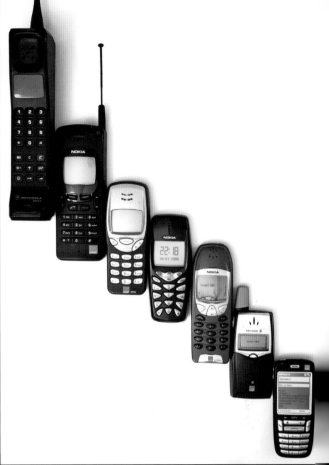

The evolution of the mobile phone, from left to right: Motorola 8900X-2, Nokia 2146 orange 5.1, Nokia 3210, Nokia 3510, Nokia 6210, Ericsson T39, HTC Typhoon. *Anders/public domain*

allowed for the high-speed transmission of data. However soon that network too began to fill up.

As cellular phones transformed into minicomputers, smartphones demanded more bandwidth, particularly fo streaming services. Two different 4G systems emerged to offer ultra-broadband Internet service: WiMAX, whic began in South Korea in 2007, and Long Term Evolution (LTE), which opened in Norway and Sweden two years later. And now the race for 5G, which will offer more band width and faster speeds, has begun. Networks are ex pected to start offering 5G in the 2020s.

Since that day in 1876 when Alexander Graham Bel first uttered the words, "Mr. Watson, come here, I want to see you," the telephone has evolved from a wired device requiring operator assistance to nothing less than a portable computer. Today, less than half the world's population has access to the Internet. However, approximately three-fourths of all humans own a cellular phone.

A soldier uses a satellite phone to establish field communications in Bosnia, 1999. *Staff Sgt. James V. Downen Jr. US Army*

FROM *PONG* TO *PAC-MAN*
VIDEO GAMES AND ARCADES

In 1952, British graduate student Alexander Douglas wrote a computer program as part of his doctoral thesis at the University of Cambridge. The program was called OXO, and it allowed two people to play tic-tac-toe on a TV monitor. Hardly an improvement over a pad and pencil, it was nonetheless the first modern video game.

The first coin-operated video game, called *Computer Space*, debuted in 1971. It used a computer to generate images on a black-and-white TV monitor and appeared in the 1973 science-fiction film *Soylent Green*. In 1972, Magnavox offered the first home video game console, called Odyssey. It attached to a television, and players plugged in data cartridges to access

several dozen simple sports, shooting, and word games.

That same year, Atari introduced an arcade game called *Pong*. Gaming arcades had been dominated by pinball machines, but *Pong* was a large cabinet containing a television screen. Pong invited players to simulate a two-dimensional game of table tennis. Each player spun a dial to move a

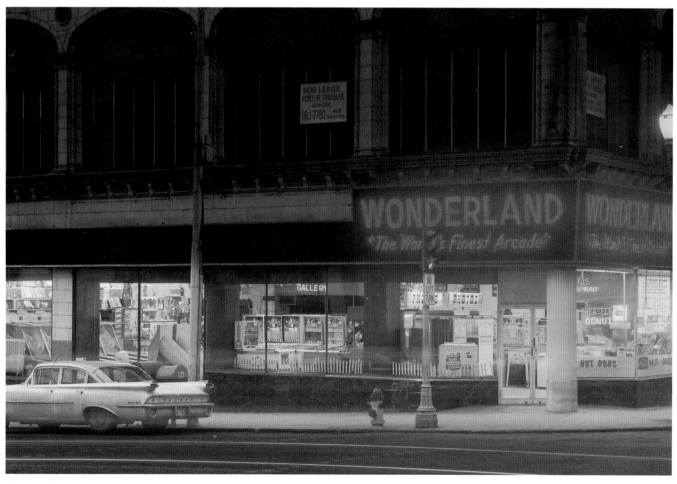

above and opposite: Wonderland Arcade, Kansas City, Missouri, 1968. *National Archives and Records Administration*

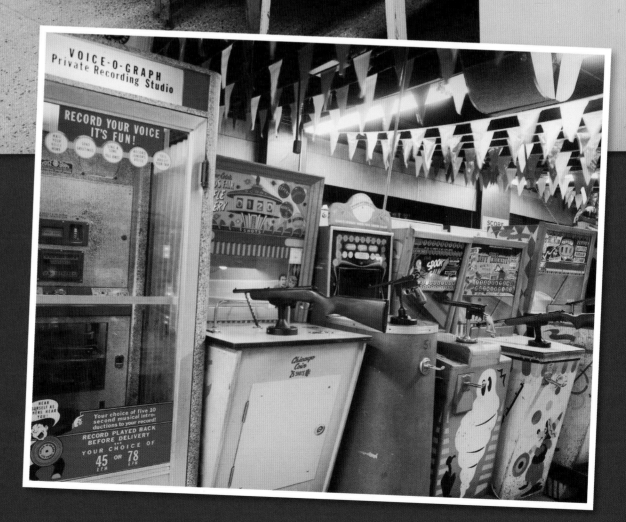

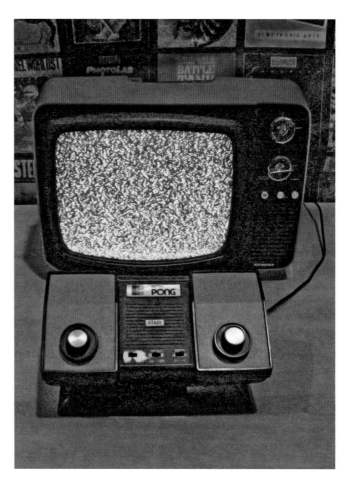

The game *Ali Baba and the Forty Thieves* playing on an Apple II.
Steven Walling/Creative Commons

Atari's 1976 *Hockey Pong* game. *Staffan Vilcans/Creative Commons*

line (the paddle) up and down, thereby knocking a small square (the ball) back and forth. A pleasant *pong* sound was emitted with each stroke.

Pong was the first successful arcade video game, attracting legions of fans. Atari introduced a home version in 1975. It was an instant fad, solidifying the home video game market. A flood of imitators soon followed.

In 1978, Taito introduced *Space Invaders*. With two buttons to move left and right, and a third for shooting aliens, the game became a fixture in arcades. Dozens of cabinet video games followed, their graphics becoming increasingly sophisticated. When Taito licensed a home version of *Space Invaders* to Atari, sales of Atari's game console system quadrupled.

During the late 1970s and early 1980s, arcade video games became an international phenomenon. Dozens of different games attracted loyal followers who competed for coveted high scores. The most successful was the *Pac-Man* franchise.

First introduced in 1980, *Pac-Man* players manipulated a joystick to manage a frantic chase through a maze. A smiley-faced avatar gobbled dots while trying not to be killed by ghosts. The game became ubiquitous. Emblematic of the craze, musicians Buckner & Garcia released a novelty album entitled *Pac-Man Fever*. In 1982, the eponymous single reached number nine on the US pop chart.

An updated version of the game called *Ms. Pac-Man* appeared in 1983. Eventually, 115,000 *Ms. Pac-Man* cabinets would be produced, and it

became the most successful arcade video game of all time.

By 1983, video games had ballooned into a $3.2 billion global industry, as hundreds of new arcade games appeared. However, many were low quality, and the bubble soon popped. By 1985, the industry had shrunk to a measly $100 million. The golden age of video arcades was over, and most of them shuttered.

But in 1987, the Nintendo home gaming system became extremely popular. The industry was renewed as video games moved almost entirely into homes.

ROBERT JARVIK'S ARTIFICIAL HEART

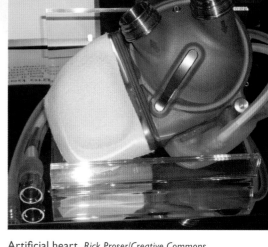

Artificial heart. *Rick Proser/Creative Commons*

In *The Wizard of Oz*, the Tin Man puts his faith in Dorothy. He joins her, the straw-brained Scarecrow, and the Cowardly Lion on a journey down the Yellow Brick Road in search of the mighty wizard, whom he hopes will finally give him the heart he's never had. After much travail, all of the characters' wishes come true. But if there had been no wizard, the Tin Man might have turned to Dr. Robert Jarvik.

Raised in Connecticut, Jarvik earned a master's degree in medical engineering from New York University and a medical degree from the University of Utah. In 1971, he was hired by Dutch physician and inventor Willem Kolff, who had invented the dialysis machine—a medical device that processes bodily functions for patients suffering from kidney failure.

While working for Kolff at Utah's artificial organs program, Jarvik focused on developing an artificial heart. Other researchers had already made important strides. During the 1950s, machinery was developed that could keep a patient alive while the heart was stopped during surgery. In the 1960s and 1970s, numerous researchers placed artificial hearts in animals, with successful results varying from a few hours to a few days. In 1969, Domingo Liotta and Denton Cooley successfully implanted a mechanical heart in a man that lasted for sixty-four hours, after which time it was replaced by a live heart transplant.

Jarvik was assigned to work on the most recent model of artificial heart. Developed by Clifford Kwan-Gett, it had kept a lab animal alive for ten days. Jarvik eventually came up with a model known as the Jarvik-7.

Jarvik gained widespread recognition in 1982 when Dr. William DeVries placed a Jarvik-7 artificial heart in a retired dentist named Barney Clark. The story captured the nation's imagination. DeVries and Jarvik gave frequent press conferences providing updates on Clark's condition. The patient required frequent hospital visits before dying after 162 days. But he had lived longer than any prior artificial heart patients.

The second patient to receive a Jarvik-7, William J. Schroeder, had a series of strokes after two weeks, leaving him in a vegetative state. However, he lived for the better part of two years.

Jarvik eventually struck out on his own, forming a company to produce artificial hearts: Symbion, Inc. However, he eventually lost control of the company in a corporate takeover. Later, he came under criticism for doing paid television advertisements promoting an anticholesterol drug. It was outside Jarvik's research area; the ad was misleading (an image of Jarvik supposedly rowing a boat was performed by a body double); and he later admitted to not having taken the drug until becoming a paid spokesman for the company.

But Jarvik's legacy was set. Although the device is never a permanent solution, an updated version of the Jarvik-7 is still used as a surgical bridge, keeping patients alive until they can receive donor heart transplants. Now known as the SynCardia CardioWest Total Artificial Heart, it has been used in nearly a thousand patients.

Total Artificial Heart　　　　**Human Heart**

Graphic of the SynCardia temporary Total Artificial Heart. *SynCardia Systems Inc.*

LIVING

After the Civil War (1861–1865), a new urban middle class emerged in America. Commonly known as the Victorians, these prosperous, patriarchal families were typically headed by a new kind of worker that hadn't existed much before: highly educated men who held good-paying, white-collar jobs.

Wedged between the growing mass of impoverished blue-collar workers on one side and a small class of super wealthy industrialists and financiers on the other, middle-class Victorians often aped the rich while chiding the poor. This tension led to one of America's first culture wars. Though a much smaller percentage of the national population than today's middle class, the Victorians had an outsized influence because of their relative wealth and political power. This buoyed their effort to foist their own cultural values onto the lives of immigrants and the poor.

Mostly Protestant, native-born Americans of northern European descent, the Victorians fretted over the leisure-time pursuits favored by the poor and working classes, particularly the growing numbers of Catholic, Eastern Orthodox, and Jewish migrants from southern and eastern Europe. Drinking alcohol, attending professional sporting events, and treating Sunday as a "day off" instead of the Lord's Sabbath were just some of the activities that upset the Victorians, and they tried to eliminate much of this "deviant" behavior.

In the short run, the Victorians often got their way. They outlawed alcohol, first in many counties and states, and then across the nation with the Eighteenth Amendment and the subsequent Volstead Act in 1920. They also passed local "blue laws" that banned many work and commercial activities on Sunday, ranging from shopping at stores to US mail delivery. By the 1920s, however, Victorian culture was being eclipsed.

During the Roaring Twenties, new pastimes and ideals that directly challenged older Victorian mores became increasingly popular. Listening to African American music (jazz) and attending the movies or professional sporting events went from unseemly to acceptable. Young urban women in particular began doing all kinds of things that Victorians considered scandalous, such as smoking cigarettes, cutting their hair short, wearing clothing that revealed more than their face, and going on unchaperoned dates.

Many Victorian cultural values have long since faded, and some of their views now seem whimsical or extreme; very few Americans would still be aghast if you used the wrong fork for your salad or would consider a first kiss the equivalent of a formal marriage proposal. But the tension of that earlier culture war continued to echo down through the twentieth century.

Over the decades, civil rights, women's rights, youth culture, the sexual revolution, and other social movements and political issues contributed to new cultural conflicts. Some issues, particularly those related to sex, are still controversial. But more often than not, Americans have been able to move past their differences, embrace new attitudes, and find common ways to express themselves and enjoy their leisure time.

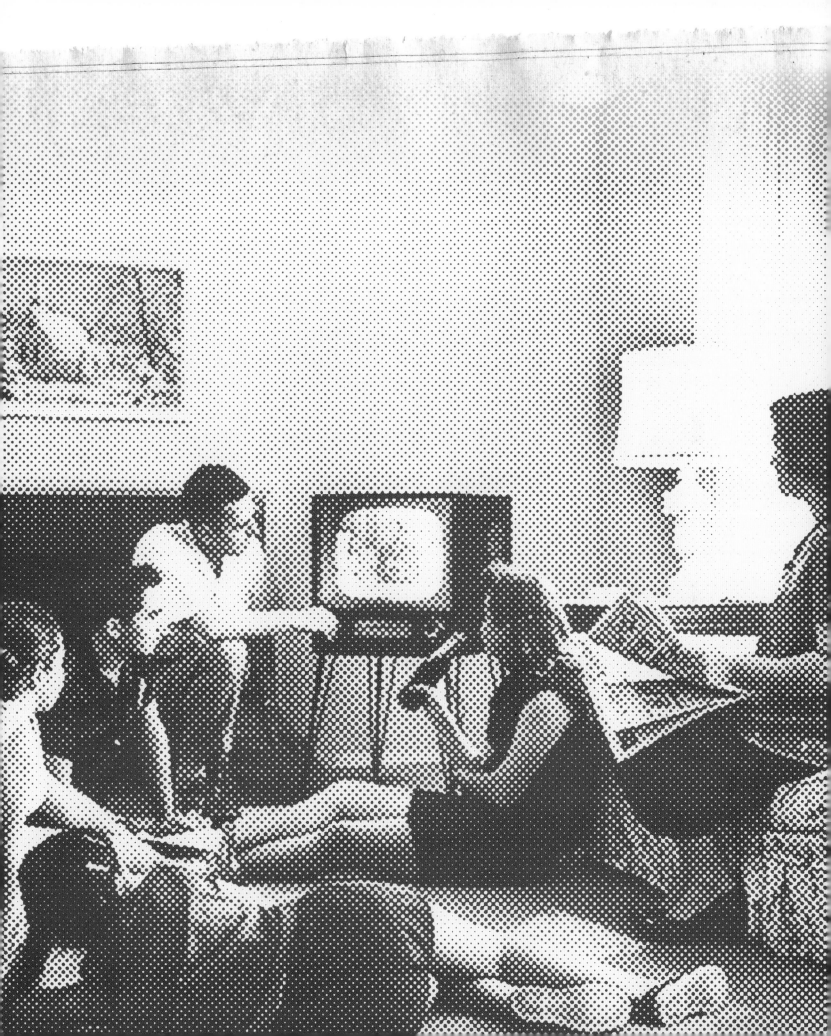

TAKE ME OUT TO THE BALL GAME

THE FIRST WORLD SERIES

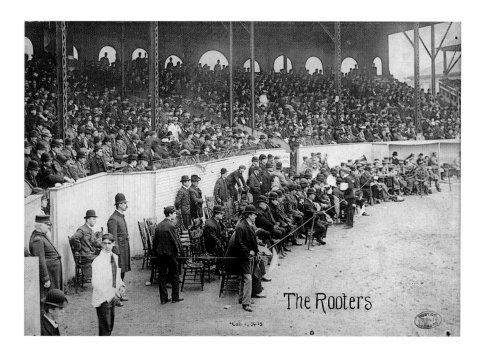

For most of the twentieth century, baseball was the undisputed king of American spectator sports. Nothing was considered more American than a man taking his family to a ball game. However, back at the turn of the century, professional baseball's reputation was a bit more scurrilous.

The crowds attending games were made up almost entirely of working-class men, and they could be a rowdy bunch. Organized "drinking clubs" were often a team's most vocal and loyal supporters. The players themselves were largely from poor backgrounds, and pro sports offered them a chance to escape a life of back-breaking labor in the mines or factories.

Off the field, many players were known for their drinking, womanizing, and carousing. On the field, rumors of immoral behavior were also rampant. Paid a fraction of today's salaries, ballplayers were susceptible to bribes; it wasn't unusual for gangsters and gamblers to pay players to throw games. Game-fixing plagued the sport, eventually becoming a national scandal in 1919 when eight members of the Chicago White Sox were accused of throwing the World Series.

Needless to say, the Victorians did not think much of professional baseball. But the early twentieth century was a turning point for the game.

During the nineteenth century, the National League had emerged as the most successful among many professional baseball leagues around the country. But in 1901, the American League came on the scene as a second major league, ready to challenge the National League for supremacy.

For two years, the two leagues competed bitterly off the field, raiding players from each other's clubs. But in 1903, the National and American leagues began a rapprochement, realizing that they were both there to stay and could perhaps make more money by working together instead of against each other.

After the 1903 season, the first meeting between pennant winners for either league was held when the Pittsburgh Pirates of the National League faced off against the Boston Americans (later Red Sox) of the American League in a best-of-nine game series. It was the first modern World Series, and upstart Boston bested Pittsburgh five games to three.

In 1904, George Brush, owner of the National League's New York Giants, boycotted the World Series, refusing to let his club face the Boston Americans, who again won the AL. Brush complained about a lack of rules on how the money would be split and where the games would be played. He also feared facing his new American League rival in New York City, the Highlanders (later the Yankees), who were not overtaken by the Boston Americans until the very last day of the season.

The press lambasted Brush for his cowardice, for backing out, and for depriving fans of another World Series. Afterward, the two leagues drew up formal rules for an annual meeting of pennant winners.

There were still some rough spots ahead, such as the 1919 Black Sox scandal. But after the inaugural World Series of 1903, professional baseball was well on its way to becoming "the national pastime."

A DAY AT THE PARK

THE CREATION OF THE US NATIONAL PARK SERVICE

When President Ulysses S. Grant signed a law on March 1, 1872, creating Yellowstone National Park, it was a revolutionary act. Located mostly in northwestern Wyoming, as well as in parts of Montana and Idaho, Yellowstone wasn't just the first national park of the United States—it was the first national park anywhere in the world, and it represented a new idea about what America could be.

Americans had previously understood the natural world almost exclusively as something "wild," and believed its only purpose was to be developed either through permanent settlement or the harvesting of resources (farming, ranching,

insets: left: The NPS flag. *National Park Service;* **right:** Promotional poster for the Department of the Interior, National Park Service. *J. Hirt, Work Projects Administration*

below: Panoramic drawing of Yellowstone National Park by Heinrich C. Berann. *Heinrich Berann, National Park Service*

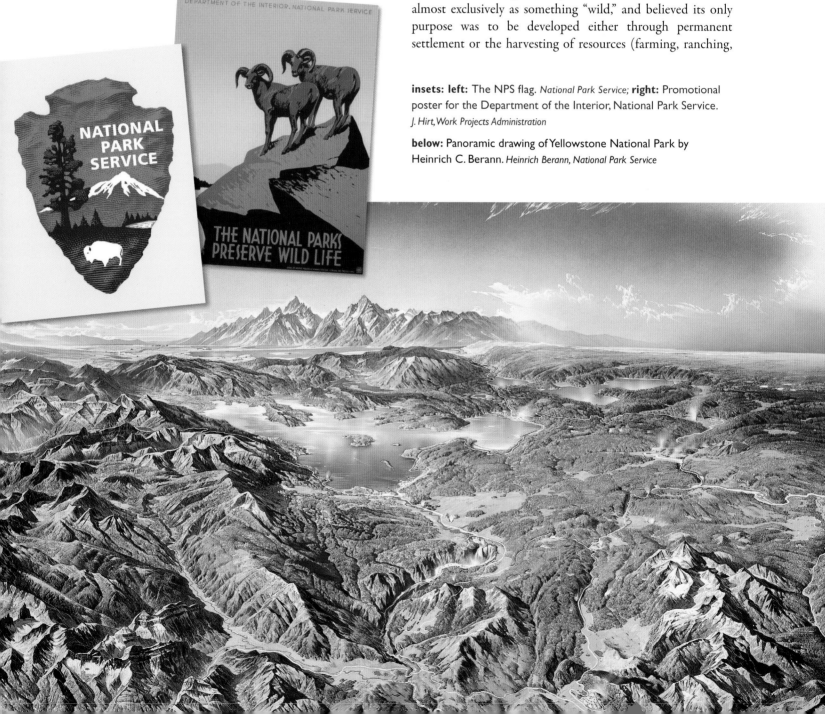

Glacier National Park, Montana. *Ansel Adams, National Park Service*

lumbering, mining, and so on). But with the creation of Yellowstone National Park, two million acres of American land were set aside simply because of their natural beauty. The park was to be spared the fate of being torn down and remade by settlement or businesses. Rather, the 1872 bill proclaimed the land "a public park or pleasuring-ground for the benefit and enjoyment of the people."

At first, the new approach to creating and managing US national parks was haphazard. No more were created until 1890, when Congress added two national parks in northern California: the forests, cliffs, and waterfalls of Yosemite and the towering, ancient redwoods of Sequoia National Park.

After several more national park designations during the early twentieth century, Congress finally passed the National Park Service Organic Act, which President Woodrow Wilson signed into law on August 25, 1916. The bill created a new agency within the Interior Department—the National Park Service. It put all existing and future national parks under the purview of the NPS, authorizing it "to conserve the scenery and the natural and historic objects and wildlife therein . . . for the enjoyment of future generations."

Among the parks under the stewardship of the NPS are some of the most famous places in America: the Grand Canyon, Death Valley, the Petrified Forest, Joshua Tree, the Everglades, the US Virgin Island of St. John in the Caribbean, the Saguaro Cactuses of Arizona, Glacier National Park in Montana, Acadia National Forest in Maine, Grand Teton in Wyoming, Shenandoah in Virginia, Carlsbad Caverns in New Mexico, and the tallest mountain in North America, Denali, in Alaska (a.k.a. Mt. McKinley).

Today there are a total of fifty-nine US national parks. The National Park Service oversees all of them, ensuring that their natural beauty and habitat are preserved and providing services for visitors.

In addition to US national parks, the NPS also oversees a host of other national sites, including national battlefield sites, national historic sites, national memorials, national monuments, national lakeshores and seashores, and national preserves, reserves, scenic trails, and recreation areas.

All told, Americans and tourists from around the world make about 63 million visits to US National Parks each year and over 320 million visits to all of the sites administered by the National Park Service.

WORLD'S FAIRS
IN AMERICA

n 1851, London hosted an event touted as the Great Exhibition of the Works of Industry of All Nations. Better known as the first world's fair, it was a celebration of industry and empire. During that summer, cutting-edge industrial technologies were displayed within a massive and magnificent iron-and-glass structure called the Crystal Palace.

After the Crystal Palace exhibitions, various nations began to hold their own world's fairs. Philadelphia became the first American city to host one in 1876. Atlanta, Boston, and New Orleans followed suit during the 1880s.

As the twentieth century neared, world's fairs became increasingly popular in the United States and imperial nations of Europe. They provided

Right: WPA poster for Sea Cliff, New York, with the 1939 New York World's Fair in the background. *Works Progress Administration*

Below: The Ford Motor Building at the 1935 World's Fair. *Library of Congress*

host cities and nations a chance to showcase their wealth, culture, and industrial might. Millions of tourists flocked to these sprawling events, which for several months offered a variety of mesmerizing entertainment. Visitors could spend days at a world's fair, which was part museum, part carnival, part theater, and part chest-thumping nationalism.

Popular activities included staring at futuristic gadgets, wandering through the massive fairgrounds, and marveling at ostentatious architectural achievements. For example, the Eiffel Tower of Paris, the Space Needle of Seattle, and Balboa Park of San Diego all debuted at world's fairs. The first Ferris wheel appeared at the 1893 Chicago fair.

An uglier side of the fairs was the era's racism. Supposedly inferior people from around the world were displayed in living dioramas. Mostly white audiences gawked at "savage" Africans, Asians, and American Indians, often impoverished people of recently conquered areas who were paid paltry sums to pose as exotic specimens. Also gathering large audiences were celebrations of colonial warfare, particularly live re-enactments of American or European soldiers defeating Indian or African opponents. Buffalo Bill's Wild West Show (see **Buffalo Bill Cody**, *page 10*) was a popular example of such military theater.

As the United States grew in wealth and power, hosting world's fairs became a popular way for civic leaders to highlight their cities. During the first half of the twentieth century, cities across America took their turn hosting world's fairs, some of them more than once. Major world's fairs were held in Philadelphia (1876, 1926), Chicago (1893, 1933) Omaha (1898), Buffalo (1901), St. Louis (1904), Portland (1905), Seattle (1909, 1962) San Diego (1915, 1935), San Francisco (1915, 1939), and New York City (1939, 1964).

By the mid-twentieth century, racial portrayals of people were more sensitive and informative, and the displays of technology had shifted toward imaginative futurism. For example, the 1939 New York fair focused on cultural exchanges and featured an exhibit called The City of Tomorrow.

By the 1990s, American interest in world's fairs had faded. The last one hosted by the US took place in New Orleans in 1984, though world's fairs continue to be held

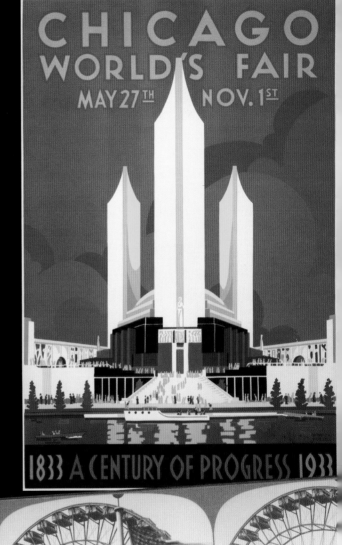

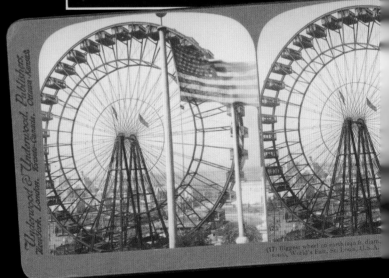

top: Poster designed by Weimer Pusell for the Century of Progress World's Fair in Chicago, 1933. *Library of Congress*

above: The biggest wheel on earth at the St. Louis World's Fair, 1904.

THE ROARING TWENTIES
FLAPPERS AND WISE GUYS

above: One of many "radio craze" stunts during the Roaring Twenties: a Brooklyn couple gets married at the American Radio Exposition in New York during a live broadcast on station WEAF, 1922. *Underwood and Underwood*

opposite: Portrait of a flapper, entitled *Where There's Smoke There's Fire*, by American artist Russell Patterson (1893–1977). *Library of Congress*

During the turn of the twentieth century, the older Victorian culture dominated many aspects of American life. Among the growing white middle and upper classes, Mainline (as opposed to Evangelical) Protestant religiosity was complemented by conservative attitudes about sex, discipline, thrift, self-restraint, hard work, and women's roles in society. To be sure, there had always been challenges to certain Victorian ideals, particularly from non-Protestant immigrants and some women. But from the end of the Civil War (1865) all the way through the end

of World War I (1919), Victorian culture was pervasive and influential.

However, a full and lasting challenge finally came about during the decade that came to be known as the Jazz Age or the Roaring Twenties. During the 1920s, many groups that had previously been marginalized, including immigrants, women, and African Americans, began shaping American culture in ways that were previously unthinkable.

In many ways, the changing behaviors and attitudes of young women were the most noticeable. As more and more young, single

working women lived in America's growing cities, they cast aside the conservative social values of earlier generations and redefined American femininity. With some disposable income and more independence than their mothers or grandmothers could have imagined, they set about making the most of city life.

Reflecting these new ideas were young women known as "flappers," who waited longer to marry and have children, and rejected many conservative Victorian styles and mores. Instead of colorless, Victorian attire that often covered every

part of a woman's body except her face, young urban women began wearing dresses that exposed their legs, arms, and even some of their chests. Known for their risqué behavior, flappers raised eyebrows by going out with men on unchaperoned dates and participating in wild new dances such as the Charleston. Other signs of rebellion included wearing makeup, flashy jewelry, short haircuts such as the popular "bob" style, and doing things that were considered "manly," such as driving cars, smoking cigarettes, and drinking alcohol.

For rebellious young men of the era, sometimes known as "wise guys," common activities included attending spectator sports, gambling, visiting jazz clubs in black neighborhoods, and illegal drinking. Indeed, one of the ironies of the "Roaring" Twenties is that it was a dry decade. The last great cultural victory of the Victorians was the Eighteenth Amendment (1919), which made the sale and consumption of alcohol illegal in the Unites States (*see* **A Dry Nation**, *page 170*).

Despite Prohibition, however, the signs of changing times and the decline of Victorian values were evident immediately. The Roaring Twenties kicked off with a major liberalization of women's roles in American society when Congress ratified the Nineteenth Amendment, guaranteeing American women the right to vote. And of course Prohibition failed; historians estimate that, despite the ban, per capita alcohol consumption in the United States actually increased during the Roaring Twenties, before the amendment was repealed in 1933.

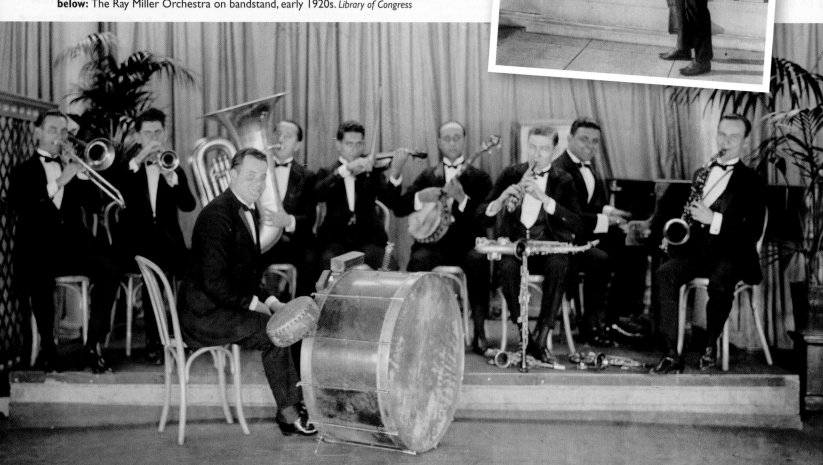

right: Flappers do the Charleston outside of the US Capitol along with Rep. T. S. McMillan of Charleston, South Carolina. *Library of Congress*

below: The Ray Miller Orchestra on bandstand, early 1920s. *Library of Congress*

THE HARLEM RENAISSANCE
AFRICAN AMERICAN CULTURE GOES MAINSTREAM

The ratification of the Thirteenth Amendment to the US Constitution in 1865 officially ended slavery. The Fourteenth (1868) and Fifteenth (1870) Amendments guaranteed African Americans citizenship and voting rights. However, as the postwar reconstruction of the South unraveled during the 1870s, many legal protections became hollow promises. By the 1890s, all of the southern states had enacted systems of Jim Crow apartheid. New state laws left African Americans socially segregated, politically oppressed, and economically impoverished.

From 1910 to 1930, 1.6 million African Americans fled the South for greater freedom and economic opportunity in the North, where booming industry created job openings. And while racism was prominent in the North, and that region was also highly segregated by custom instead of law, conditions there were generally less oppressive than in the South.

By the 1920s, African Americans had established thriving neighborhoods in cities across the Northeast and Midwest, and black people began to transform their formerly rural culture amid the hustle and bustle of the nation's growing urban centers. New forms of African American ideas, literature, music, and the arts emerged in what came to be known as the Harlem Renaissance.

Named for what would soon be the nation's largest black neighborhood—the chunk of northern Manhattan called Harlem—the movement was driven by energetic and creative African American artists and intellectuals in cities across the nation. New artistic and intellectual visions of African American life came from writers such as Zora Neale Hurston, Langston Hughes, and Jamaican immigrant poet Claude McKay; artists such as William H. Johnson, Leslie Bolling, and Beauford Delaney; musicians such as Duke Ellington, Fats Waller, and Louis Armstrong (*see page 40*); and intellectuals such as W. E. B. Du Bois, Ida Tarbell, and Jamaican immigrant Marcus Garvey.

While the Harlem Renaissance is now recognized as one of the most important artistic and intellectual movements in American history, at the time it met with mixed responses

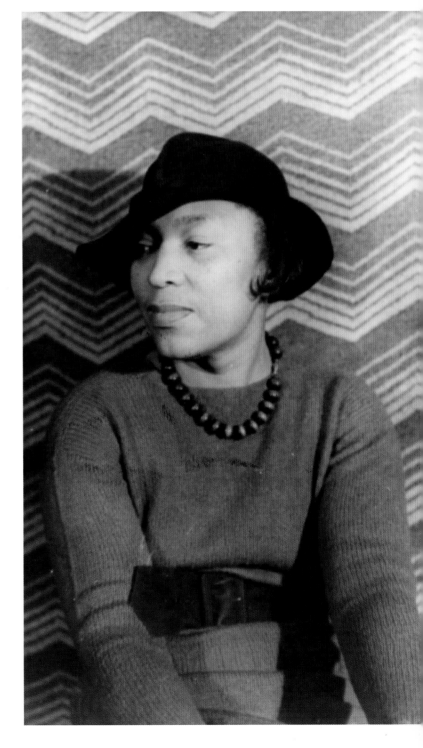

Portrait of Zora Neale Hurston by Carl Van Vechten, 1938.
Library of Congress

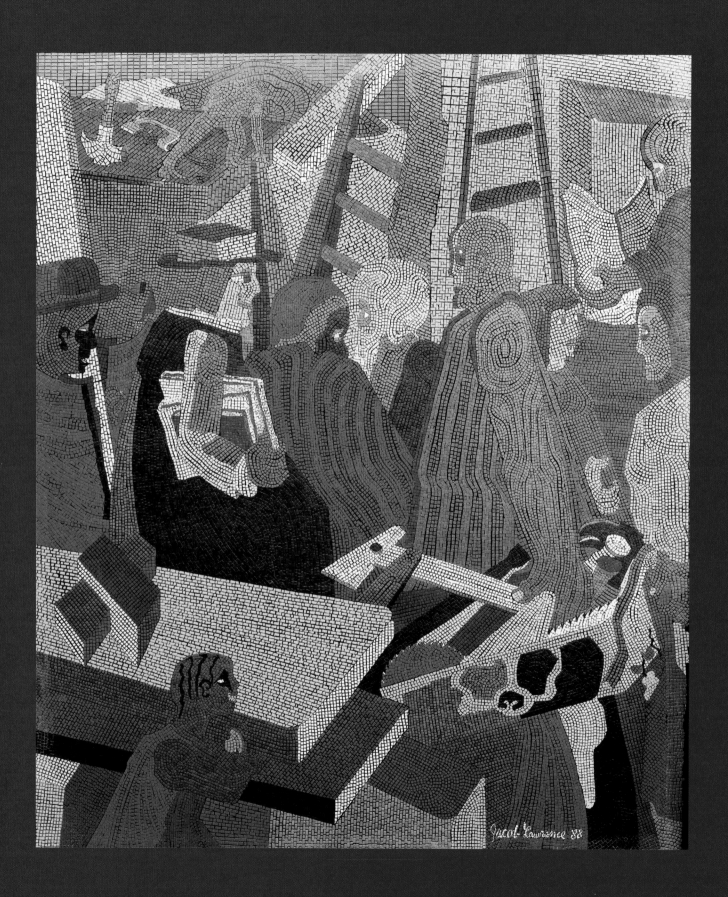

from the broader American public. White Americans were most receptive to new African American innovations in music, as jazz became the soundtrack of the Roaring Twenties. And some artists and thinkers, such as Hughes and Du Bois, were widely recognized during their lifetimes.

However, racism influenced popular attitudes, slowing widespread acceptance of black cultural and intellectual innovations. Many leading lights of the Harlem Renaissance were either criticized or simply ignored by the larger, mainstream culture. For example, Hurston's work was not rediscovered until the 1970s, some fifteen years after her death.

But despite their mixed reception at the time, the artists and thinkers of the Harlem Renaissance brought African American culture into mainstream America for the first time. Black influence on American music was immediate, profound, and long lasting. And the impact of African American writers, thinkers, and artists, while not always recognized at the time, had in fact begun to shape American culture and continues to do so today.

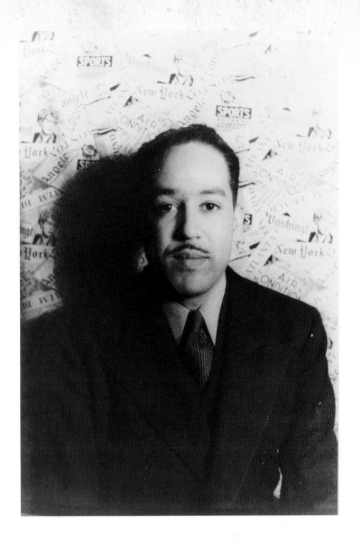

opposite: Artist Jacob Lawrence's ceramic tile mosaic *Community*, Queens, New York. *Library of Congress*

right: Portrait of Langston Hughes by Carl Van Vechten, 1936. *Library of Congress*

below: Duke Ellington, Cat Anderson, and Sidney De Paris in New York City, circa 1946, photographed by William Gottlieb. *Library of Congress*

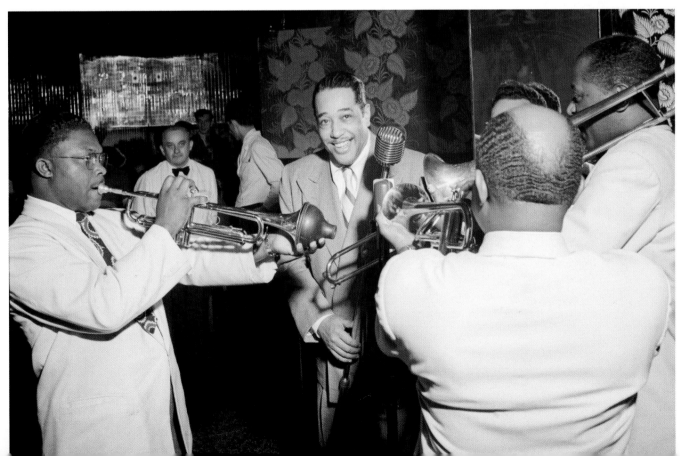

LAUGHING
THROUGH TOUGH TIMES

Depression-Era Comedies

The Roaring Twenties had witnessed changing cultural attitudes, growing cities, and, perhaps most of all American economic prosperity. National wealth had increased like never before. Powered by the advent of cheap electricity, American manufacturing surged, most notably with the rise of the car industry. Meanwhile urban consumers reveled in newfangled inventions like vacuum cleaners, radios, and refrigerators, available on easy credit. Indeed, during his 1928 campaign, future president Herbert Hoover could say with a straight face that he believed Americans were, "in sight of the day when poverty will be banished from this Nation."

But by the time the decade had ended, it all seemed like a dream. As the 1930s opened, the United States spiraled into the worst economic calamity in world history, a global financial meltdown known as the Great Depression.

During this era of stunning national poverty, the United States economy was crippled from late 1929 until the nation began mobilizing for World War II ten years later. The economy ground to a near halt, and by 1933, national unemployment was at nearly 25 percent. The nation was overwhelmed. Easily the toughest times Americans had faced since the Civil War, the Great Depression was a grim decade by any measure. Amid the anguish and frustration, millions of Americans sought solace from movie theaters, a cheap form of entertainment that could alleviate one's fears and sadness for a few hours. Comedies were particularly popular.

During the 1930s, directors like George Cukor, Frank Capra, and German immigrant Ernst Lubitsch tapped into the American pulse, countering anxieties with a wide array of Hollywood comedies. Screwball comedies such as Capra's *You Can't Take It with You* featured fast-paced

George Cukor, photographed at his home in Los Angeles. *Allan Warren*

witty dialog and absurd situations. Romantic comedies such as Lubitsch's *Trouble In Paradise* (1932) centered around oddball couples fighting to make their way and their fortune. And sentimental, inspirational films like those featuring child star Shirley Temple (*see page 22* told stories of poor people overcoming the odds to find happiness and some degree of fortune.

There were also biting commentaries. The Marx Brothers, among others, specialized in lampooning the rich, whom they often portrayed as haughty and buffoonish. Preston Sturges's 1942 satire *Sullivan's Travels* follows Joel McCrae as a successful Hollywood director who is tired of making shallow, screwball comedies and longs to direct a "serious" film. But after eating in soup kitchens, sleeping in homeless shelters and being wrongfully convicted of a crime and sentenced to hard labor, he comes to appreciate the importance of laughter in the lives of people who have little else.

left: Ernst Lubitsch and his wife, Helene Kraus.
Library of Congress

below left: A telegram from Harpo Marx to John F. Kennedy, July 14, 1960. *National Archives and Records Administration*
below right: Julius Henry "Groucho" Marx. *Library of Congress*

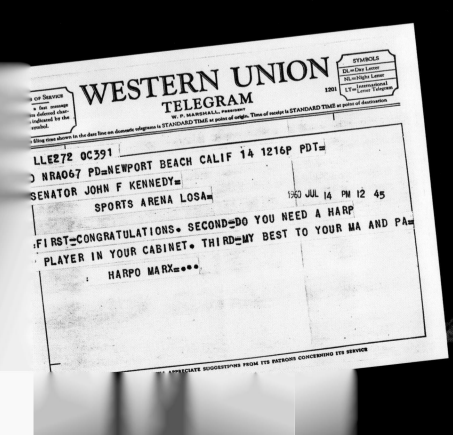

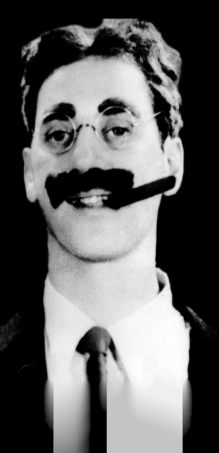

THE FIRESIDE CHATS
FDR, THE FIRST MASS MEDIA PRESIDENT

On March 12, 1933, newly elected President Franklin D. Roosevelt did something no other chief executive had ever done before. He sat down in front of a bank of radio microphones and said, "My friends, I want to talk for a few minutes with the people of the United States."

Roosevelt was not in fact the first president to go on live radio; several of his predecessors had already done so. But FDR was the first president to address the American people in an accessible and approachable manner. Instead of adopting a formal or stuffy demeanor

to read an obviously prepared speech in a serious voice, he spoke with simple words, in a common dialect, and an avuncular tone.

The topic on the night of March 12 was important. Banks across the nation were folding, and in an era before federal

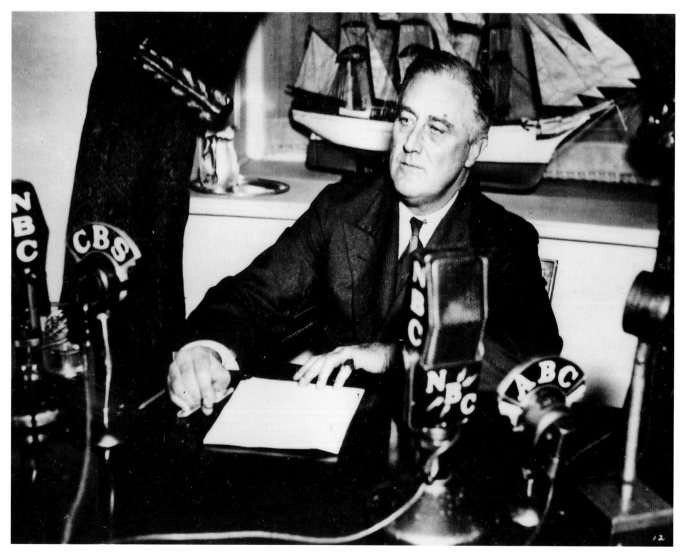

Franklin D. Roosevelt's fireside chat, 1935. *National Archives and Records Administration*

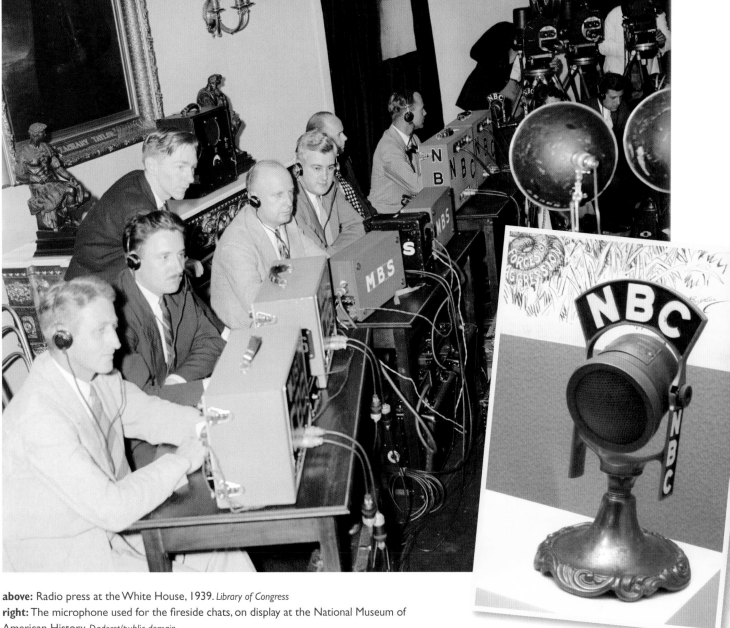

above: Radio press at the White House, 1939. *Library of Congress*
right: The microphone used for the fireside chats, on display at the National Museum of American History. *Daderot/public domain*

insurance, people lost everything if they did not withdraw their money before a bank went out of business. This had led to panics in which people lined up to pull out all of their money for fear of losing it. Such panics doomed banks to fail since they usually did not have enough cash reserves to pay out all of their account holders at once. By the time Roosevelt took office, more than nine thousand US banks had failed, and hundreds of thousands of Americans had lost their savings.

On March 6, in one of his first acts as president, FDR had ordered a bank holiday, forcing all banks to close for several days. On March 9, Congress passed and Roosevelt signed the Emergency Banking Act, which directed the Federal Reserve to effectively insure American bank accounts. And on the evening of March 12, FDR took to the airwaves.

Roosevelt told the American public that the complexities of the banking crisis "ought to be explained for the benefit of the average citizen." And he assured them that he had implemented a plan to head off further bank failures. "You people must have faith," he implored them. "You must not be stampeded by rumors or guesses. Let us unite in banishing fear . . . Together we cannot fail."

The president only spoke for nine minutes, but it was an enormous success, as millions of Americans tuned in. The speech resonated, panics largely ended, and the banking crisis was finally over.

During his twelve-plus years as president, Roosevelt went on the radio to make thirty-one "fireside chats," so-called because families would often gather to listen around the radio as if it were the family hearth. Through these relatively informal talks, FDR ushered the nation through the Great Depression, the rise of global fascism, and World War II. In so doing, he set the pattern that all future presidents and most politicians have since followed: using mass media to engage Americans in an informal and approachable manner.

TRUTH, JUSTICE, AND THE AMERICAN WAY

THE BIRTH OF SUPERMAN

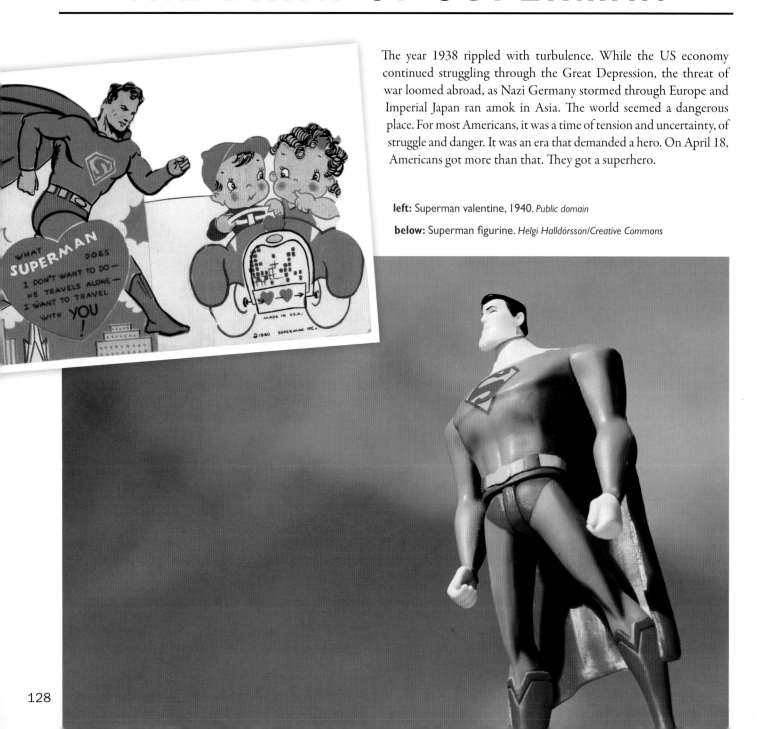

The year 1938 rippled with turbulence. While the US economy continued struggling through the Great Depression, the threat of war loomed abroad, as Nazi Germany stormed through Europe and Imperial Japan ran amok in Asia. The world seemed a dangerous place. For most Americans, it was a time of tension and uncertainty, of struggle and danger. It was an era that demanded a hero. On April 18, Americans got more than that. They got a superhero.

left: Superman valentine, 1940. *Public domain*

below: Superman figurine. *Helgi Halldórsson/Creative Commons*

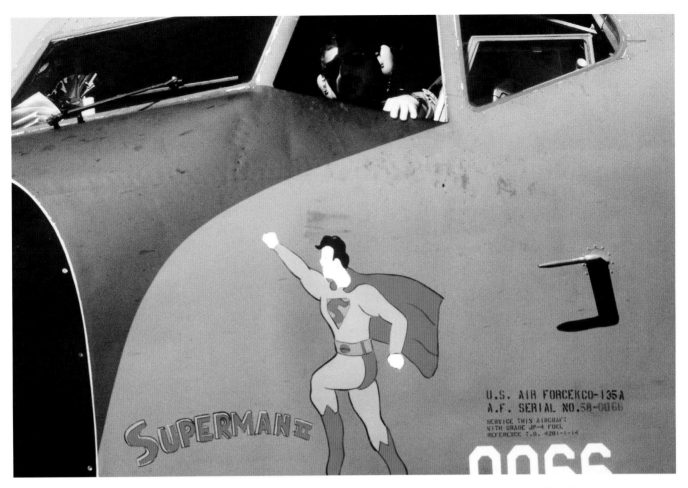

A *Superman II* illustration on a 42nd Bombardment Wing KC-135A Stratotanker aircraft during Operation Desert Shield. *National Archives and Records Administration*

That day marked the debut of Superman, published by National Allied Publications (later DC Comics) in *Action Comics* No. 1. The brainchild of Jerry Siegel and Joe Shuster, two high school friends from Cleveland, Superman was an instant success. The following year the character had its own self-titled comic series. By 1940, it had been turned into a successful radio program, which would run for eleven years. The 1940s also saw various film representations of Superman, both live action and animated. During the 1950s, it was a successful TV show starring George Reeves. In the 1980s, Christopher Reeve (no relation) assumed the title role for a string of successful movies. All the while, the comic book version continued successfully.

Siegel and Shuster's role in producing the character soon diminished. They had sold the rights to Superman to National in 1939 for $130 and a contract to produce the strip. At first they opened a studio, earned a salary, and hired artists and writers to help flesh out the strip. However, Shuster's eyesight began to fail, and his ability to work declined. And in 1943, Siegel was drafted to serve in World War II. With Superman's massive success, Shuster and Siegel's earnings were soon a minuscule fraction of the millions that National was reaping, which would be a source of contention and lawsuits for decades to come.

Nevertheless, under the guidance of Siegel, Shuster, and their successors, Superman quickly established the superhero format. The character's double life as mild-mannered news reporter Clark Kent, who was humble and at times even shy; the complicated and chaste love interest, fellow reporter Lois Lane, whom he longed to show just how special he was; his Achilles heel, kryptonite; the arch-villain, among many, Lex Luthor; even the tight-fitting body suit and cape: all of it became the model for the superheroes that followed. From Batman to Spider-Man and beyond, all of them were, to some degree, based on the Man of Steel.

But more than that, Superman, with the iconic S emblazoned on his chest, came to represent ideal American values and manhood during the mid-twentieth century. Honest, humble, and polite, he selflessly worked to help all of mankind, overcoming his own flaws as well as every obstacle that befell him. Superman, the orphan from Krypton and farm boy from Kansas, became the ultimate American.

LET IT SWING

BIG BAND

During the turn of the twentieth century, black and white musicians combined elements of their respective musical heritages to create a new and distinctly American form of music: jazz. By the 1920s, the new art form had taken the nation by storm. The first truly national form of popular music, jazz was so pervasive that the Roaring Twenties was nicknamed the Jazz Age. As with any successful artistic movement, jazz evolved over time.

By the 1930s, Big Band (sometimes called swing) was the most popular form of jazz. The music featured bandleaders who led large orchestras in complex musical arrangements. Some songs were instrumentals, others sung, but all of them featured distinct melodies and improvisational solos by lead musicians as the orchestra wove a musical tapestry behind them.

below: A couple does the jitterbug at a Benny Goodman concert in Oakland, California, in this 1940 photograph by Rondal Partridge. *National Archives and Records Administration*

opposite: Cab Calloway at Columbia studio in New York City, 1947. *Library of Congress*

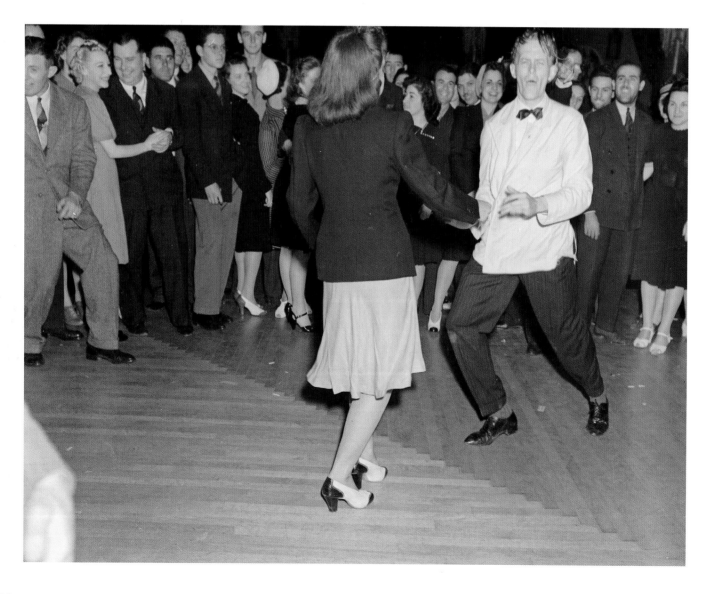

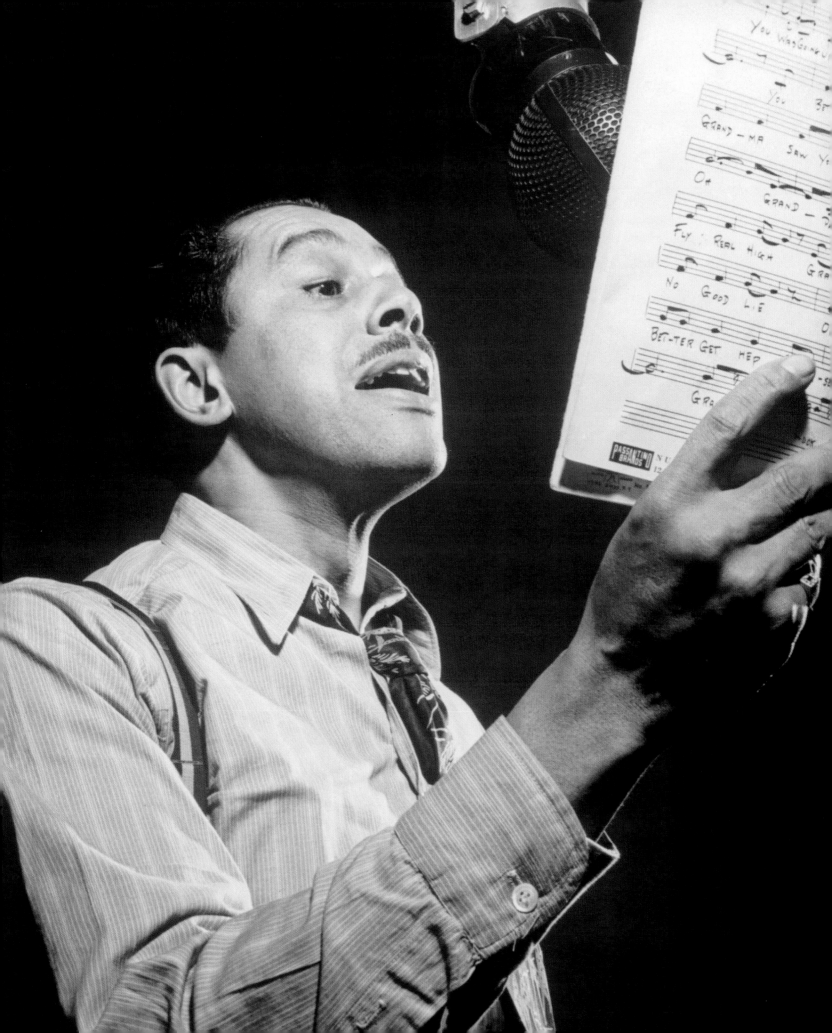

The most successful bandleaders and arrangers of the era are among the most influential and accomplished musicians in American history, including Duke Ellington, Benny Goodman, Count Basie, Glenn Miller, Artie Shaw, Cab Calloway, Jimmy and Tommy Dorsey, Fletcher Henderson, and Earl Hines.

Big Band music also helped establish a strong culture of dance in America. Many young men and women were eager to "cut a rug" with hip new dances like the jitterbug and the Lindy Hop. Couples frequently wore distinctive outfits, women's dresses flaring as they spun, men often sporting tailored suits, such as the colorful and baggy zoot suit. Dance marathons became a fad—couples dancing into the wee hours and even into the following day until only one couple remained on the floor.

As a central component of American culture during the 1930s and 1940s, jazz reflected American attitudes about race. For the most part, jazz bands and the audiences they played to were segregated. However, several factors allowed jazz to be a vehicle for challenging racial

left: Ella Fitzgerald, 1940. *Library of Congress*

below: The Isham Jones Orchestra, 1922. *Library of Congress*

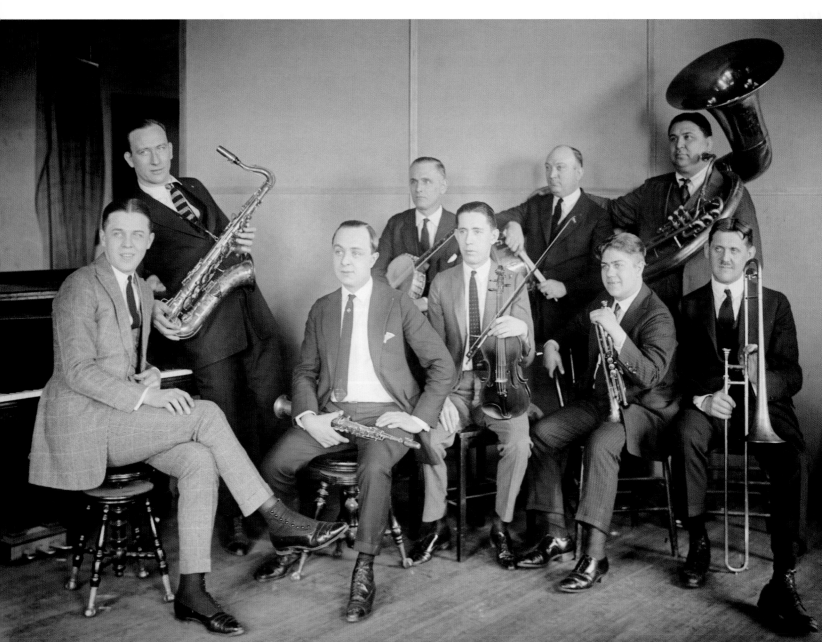

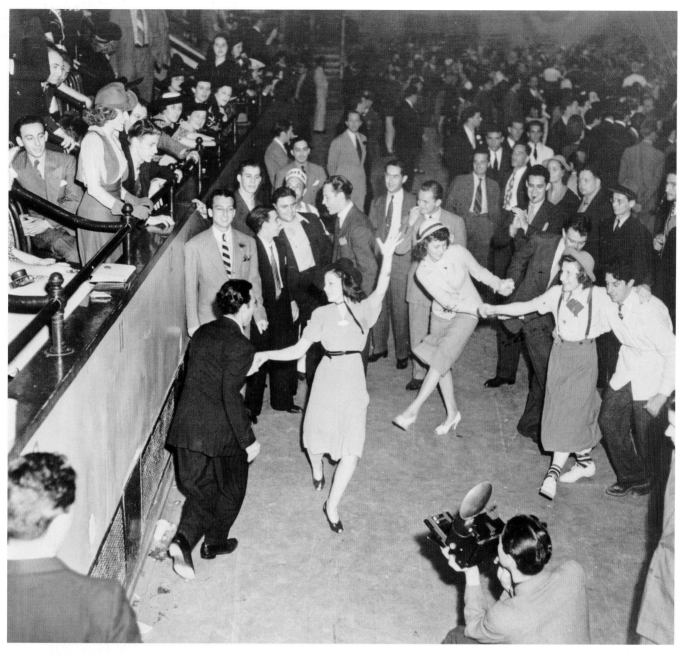

Jitterbug dancing, 1938. *Library of Congress*

segregation, including the mixed nature of jazz's cultural origins; the mutual respect musicians had for fellow composers, arrangers, and players of this exceptionally complex musical form; and the massive popularity of jazz music, which cut across all racial lines.

Of course jazz could not overcome American racism, and indeed, some jazz musicians were themselves racist. But when a white bandleader like Benny Goodman hired black musicians like pianist Teddy Wilson, vibraphonist Lionel Hampton, and guitarist Charlie Christian, or played in segregated venues to black audiences, it made an important, positive statement on the potential of future American race relations.

Jazz continued evolving, and swing eventually declined in popularity. During the 1950s, big bands gave way to small combos, swing was eclipsed by the jazz movement known as bop, and jazz lost out as the preferred music of young people to a new form of mixed black/white music: rock-and-roll. However, Big Band would forever remain the soundtrack for a generation of Americans who had come of age during the Great Depression and World War II.

THE BOOB TUBE
TELEVISION

Nowadays, few Americans still remember a time without television. However, at the end of World War II, most Americans had never even seen one.

In 1946, there were over 1,600 regional and local radio stations across the United States. By contrast, there were only six TV stations. For those too young to remember TV before cable and satellite, to say there were only six stations doesn't mean everyone in America had six stations. It means there were literally a total of six local stations, of which viewers could receive only those that were local to their city (if there were any): there were three stations for people in New York City, one in Philadelphia, one in Chicago, and one in Albany, New York. The rest of America had no television reception. Consequently, in 1945 there were only about seven thousand working television sets in the United States.

above: A man and a television receiver, 1930. *Library of Congress*

right: A boy poses proudly with his television set, 1952. *John Atherton/Creative Commons*

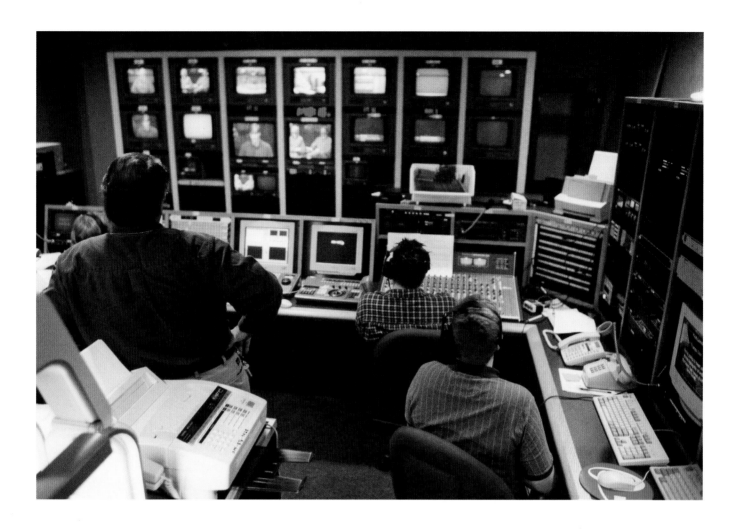

above: Video production workers in studio studying bank of monitors showing camera views. *US Fish and Wildlife Service*

left: Charles Francis Jenkins, one of the American inventors of television.
Library of Congress

However, Americans marveled at the new medium, and television expanded rapidly. By 1948, about 172,000 American households had a TV set. As stations sprang up around the country in cities of all sizes, television reception became accessible to more and more people. The number of households with sets had ballooned to more than fifteen million in 1952. By 1955, that number more than doubled to thirty-two million, or approximately three-fourths of all US households. By the end of the decade, 90 percent of American homes had at least one TV set.

As television assumed its place in US households after the war, critics and commentators wondered what the new medium would bring to American society. Many hoped for educational programming, and some even dreamed it could further American democracy by contributing to a better informed citizenry. Before long, however, it became clear that television broadcasts would mostly be dedicated to shallower pursuits.

The air belongs to the people, and so the public airwaves over which radio and television broadcast were the property of the American people, with the federal government as their guardian. Most access to the airwaves, however, was not reserved for public purpose. Rather, it was auctioned off to private corporations whose primary concern was earning profits.

The first networks, NBC and CBS, had originated as radio broadcasters. After jumping to television, they were soon joined by upstart ABC. The Big Three found that simple entertainment such as situational comedies, variety shows, and soap operas had more appeal than serious news or educational content. Before long, the networks offered mostly entertainment, and Americans responded positively. For example, when sitcom stars Lucille Ball and Ricky Ricardo welcomed their new baby, Little Ricky, on a January, 1953, episode of their popular show *I Love Lucy*, forty-four million Americans watched. The following day, far fewer people tuned in for President Dwight Eisenhower's inauguration.

Critics howled, labeling TV with derisive nicknames like the Boob Tube and the Idiot Box. Congress responded in 1967 by passing the Public Broadcasting Act, which created the Corporation for Public Broadcasting, the Public Broadcasting Service (PBS), and National Public Radio to bring Americans quality programming. But of course, here in the twenty-first century, reality shows and sporting events still get the big ratings.

A family watching television, circa 1958. *National Archives and Records Administration*

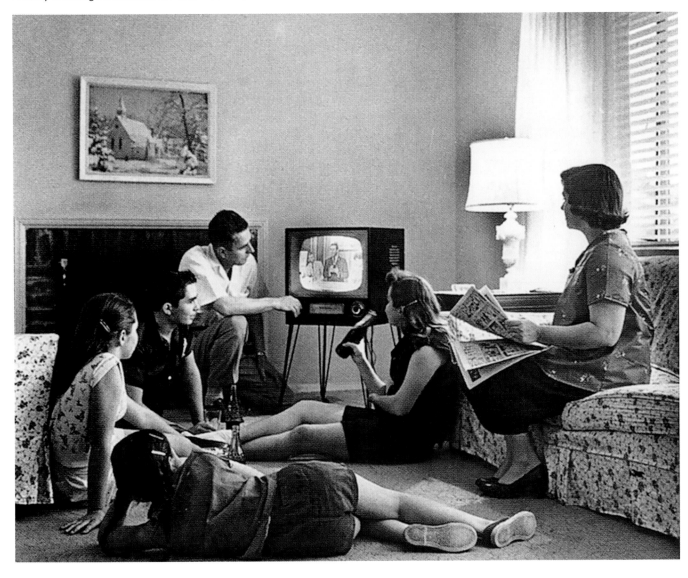

SLIPPIN' 'N' SLIDIN'
POSTWAR FADS AND TOYS

Window shoppers outside a toy display, 1940. *Library of Congress*

After World War II, the United States entered a period of prolonged economic prosperity. With the rest of the world in shambles from the war, America dominated the global economy like no nation before or since. As the middle class expanded, more and more families boasted more and more expendable income.

At the same time, American families grew with the Baby Boom (1946–1964),

a spike in the national birthrate after the depression and war. With many families bigger than they had been in decades, and better off than they had ever been before, parents began to spend more money on their wee ones. But there's a big difference between what parents want their child to have and what the child wants.

To a large degree, Baby Boomers were the first generation of children to be

treated as consumers who decided what to buy for themselves. The idea of kids as consumers was fairly new, but American businesses were quick to capitalize. Radio and television shows, along with magazines designed for especially children, provided ideal venues for advertising directly to children.

As all of these factors came together during the 1950s, the result was a

above: Tin toy car.
Alf van Beem/public domain

left: World War II–era doll
and toy furniture at the
Maritime Child Development
Center, Richmond, California.
Library of Congress

growing line of products designed for and marketed directly to the large new cohort of middle-class children. Consequently, one fad after another emerged as the next crop of school children pined for the latest toy, game, or junior fashion statement.

An early fad came from the fictional children's TV program about frontiersman Davy Crockett. The show made coonskin caps a must-have for many boys. At the trend's peak during the 1950s, five thousand hats were being sold per day.

In 1958, the Wham-O toy company struck gold by selling nothing more than a simple, plastic circle that children could swing around their waists. In only four months, Wham-O sold twenty-five million Hula-Hoops. Sales topped one hundred million in just two years' time.

During the 1960s, corporations continued honing in on the child market, marketing became sharper, and more fads for various games and toys appeared. Some fads, though wildly popular, lasted relatively briefly. Childhood entertainments that included the pogo stick and the Slip 'N Slide captured children's imagination for a decade or less and then faded. Some, such as the infamous game of Jarts, or lawn darts, were simply dangerous.

Other fads transcended generations. The Etch A Sketch, Nerf balls, and G.I. Joe dolls for boys (later to be called action figures) all maintained their popularity into the twenty-first century. In 1965, Mattel introduced the most successful doll of all time: Barbie.

By the 1980s, cynical marketers were producing television shows that were little more than advertisements for toys. Many parents began to rebel, but the backlash was temporary. Today, businesses use a more sophisticated model of cross-promotional platforms to market food, toys, games, and dozens of other products to children more effectively and more subtly, as every parent already knows.

above: The Etch A Sketch Animator 2000. *Recapatcha/Creative Commons* **top:** The Slip 'N Slide. *Imokurnotok/public domain*

THE FINAL FRONTIER

Star Trek, Star Wars, and the Rise of Sci-Fi/Fantasy

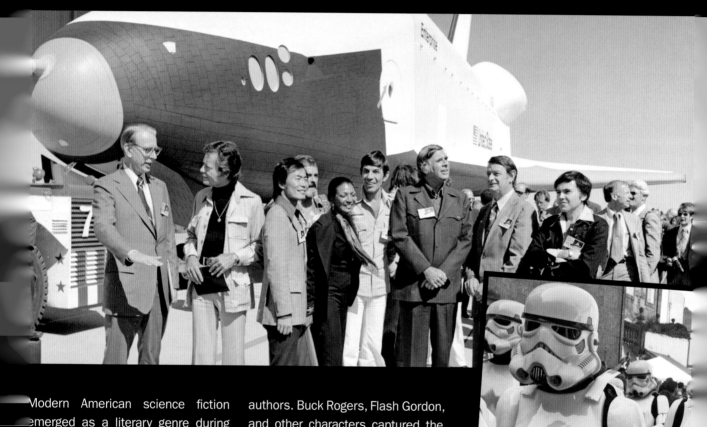

Modern American science fiction emerged as a literary genre during the early twentieth century. Sci-fi stories were predominantly featured in magazines such as *Amazing Stories* and *Astounding Science Fiction*, which were collectively nicknamed "pulps" after the inexpensive, low-quality paper they were printed on. Writers such as Edgar Rice Burroughs (who also penned the Tarzan series) and Hugo Gernsback, for whom the most prestigious science fiction award is named, were important early

authors. Buck Rogers, Flash Gordon, and other characters captured the American imagination first in print then later in radio and B movies.

Early on, science fiction was seen as young adult literature, mostly adventure stories for boys. However, by midcentury, a new generation of writers such as Isaac Asimov, Robert Heinlein, and Arthur C. Clarke began to innovate "hard" science fiction. During what came to be known as the Golden Age of Science Fiction

top: Cast members of the original *Star Trek* television series pose in front of the Space Shuttle *Enterprise. NASA*

inset: A parade of Star Wars Imperial Stormtroopers. *Amaianos/Creative Commons*

writers emphasized actual scientific innovation as the basis for their futuristic speculations.

Science fiction quickly found audiences in film and television. During the Cold War, typical plots featured rocket ships headed to outer space and flying saucers landing on Earth. But sci-fi could also be a vehicle for serious social commentary. The 1956 film *Invasion of the Body Snatchers* was an allegory for Red Scare paranoia, while the TV program *The Twilight Zone* (1959–1964) questioned various social values.

During the 1960s, tales of unambiguous progress, which were common in science fiction and Westerns, began to lose their appeal. Many Americans sought more complicated stories that reflected the complexities of a modern society divided by civil rights and Vietnam. In 1966, a new sci-fi TV program reflected those challenges.

Creator Gene Rodenberry had actually sold *Star Trek* to TV executives as a Western set in outer space, but the show quickly proved to be much more than that. The multiracial characters and morally complex story lines challenged Americans to consider a future in which progress was based more on overcoming fear of the unknown than on violent conquest. At times, it was more than many Americans were prepared to accept. Some southern TV stations refused to air a 1968 episode showing an interracial kiss between Captain Kirk and Lieutenant Uhura.

Star Trek's ratings were wanting, and the show was cancelled after just three seasons. However, during the 1970s, it became a national phenomenon through syndicated repeats. Its success paved the way for George

Lucas's 1977 blockbuster film *Star Wars*. One of the most successful movies of all time, *Star Wars* relied on many established sci-fi tropes, while also adding an element of vague spirituality.

The runaway success of *Star Wars* and its sequels led to a boom in science fiction on the big and small screen alike. A franchise of *Star Trek* films and TV spinoffs followed, as did many other original shows and movies.

But in science fiction literature, the 1980s witnessed a new breed of story lines. Atmospheric cyberpunk stories by writers such as William Gibson portrayed a dystopian future. Instead of being a vehicle for advancement, advanced technologies were a prominent feature of a corrupt and oppressive society. Science fiction had grown up. Instead of adventure stories for boys, it had become a dire warning to adults.

above: Painting of Isaac Asimov. *Rowena Morrill*

left: Science-fiction author William Gibson at a signing for his novel *Forbidden Planet. Nikki Tysoe*

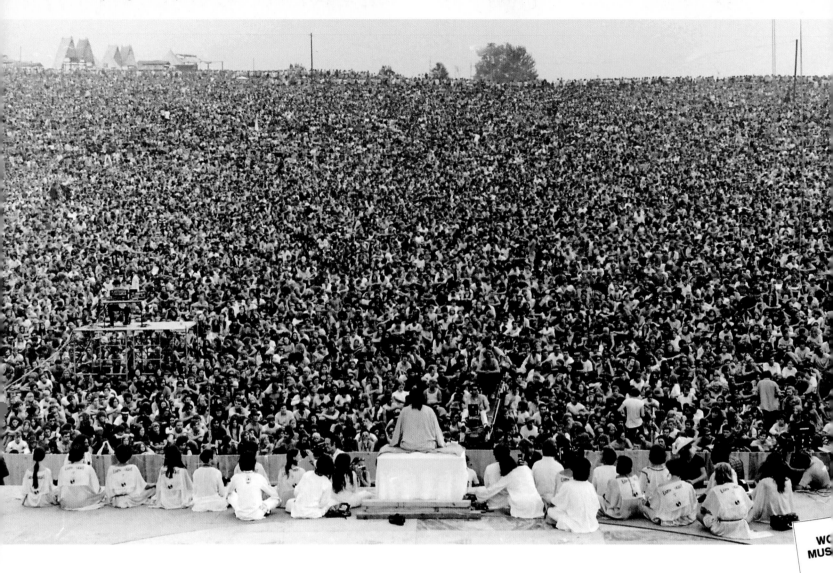

Swami opening ceremony, Woodstock, 1969. *Mark Goff/public domain*

WOODSTOCK
THE PSYCHEDELIC MOMENT

During the 1960s and early 1970s, the postwar US economy was at its peak. Good-paying jobs were plentiful, and the national poverty rate would reach its historic low point in 1972. However, this time of economic prosperity also saw the nation rocked by grave social and political concerns.

The civil rights movements confronted American racism, demanding legal and political equality as well as increased economic opportunities for minorities. The women's liberation movement challenged deeply rooted sexism, demanding equal opportunities and treatment for women. And as the United States imposed a draft, stationing more than half a million troops in Vietnam by 1968, more and more Americans began opposing the war.

The era of unprecedented American economic prosperity was thus also a time of public rallies, marches, and protests. Amid this discontent, a youth counterculture movement arose in Northern California during the mid-1960s. Its members were called hippies.

The hippie movement began as a subculture of Baby Boomers who were influenced by the Beat counterculture of the 1950s and the social activism of the 1960s. Hippies championed peace, love, and understanding as the antidotes to what they saw as the gravest social ills: violence, greed, and closed-mindedness. Labeling well-groomed, middle-class Americans as "squares," hippies developed a distinctive counterculture lifestyle to mark themselves as different.

Bell-bottom jeans, fringed buckskin, long hair for men and women alike, and flowery, garish colors were their fashion. Rock music was their soundtrack. Stressing open-mindedness, they viewed marijuana and even LSD as positive, mind-expanding drugs. Their permissive attitudes about sex helped advance the sexual revolution. They critiqued organized Western religion and embraced, often naively, a hodgepodge of Asian and American Indian spiritual traditions. They railed against the pursuit of money, started communes, and made sharing a central value. Their primary political issue was opposition to the Vietnam War, and many hippie men resisted the draft.

The hippie movement started to go mainstream in the summer of 1967, which they declared to be the Summer of Love. In June, the Monterey Pop Festival brought together not only the nation's top rock acts, but also folk, blues, and R&B musicians, and even classical Indian sitar player Ravi Shankar. By 1968, the hippie movement was prominent on the East Coast as well.

In August, 1969, the hippie counterculture reached its peak with the three-day Woodstock Music and Arts Festival in upstate New York. Some three hundred thousand people attended the outdoor festival, which featured top music acts, widespread drug use, and lots of mud due to rainstorms. A subsequent movie about the event was a hit in theaters, helping the hippie movement become even more popular.

By 1970, however, corporate America was ready to cash in as the hippie subculture went mainstream. Hippie styles and cultural affectations became commonplace. Ironically, what had once been a small, countercultural movement *against* the mainstream was increasingly co-opted by it.

above: The crowd at Woodstock, 1969. *Mark Goff/Public domain*

left: *Ramparts* magazine advertisement for the Aquarian Exposition at Woodstock, 1969. *Public domain*

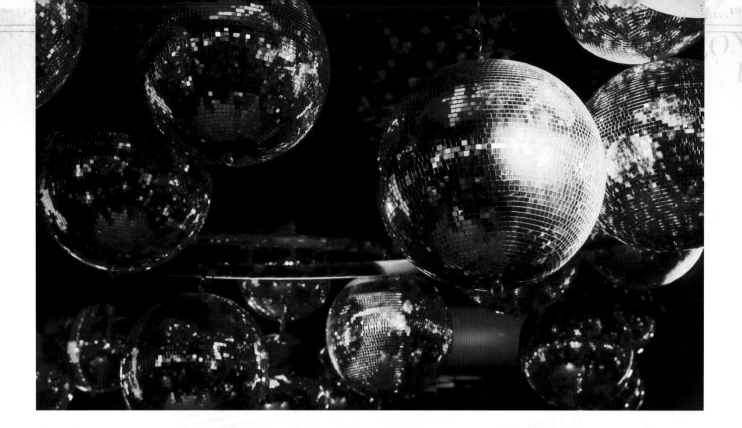

Disco balls—emblems of the dance movement. *Manfred Werner/Creative Commons*

DISCO

RISE OF THE MODERN DANCE CLUB

Even though rock-and-roll is rooted in black musical traditions that featured many talented female performers, by the late 1960s, modern rock music had taken on a decidedly white male persona. The vast majority of rock stars were young white men, and many flaunted their sexuality, but only in a male heterosexual way. By the end of the decade, the rock scene was also largely devoid of dancing as intimate venues gave way to large concert arenas.

During the mid-1970s, a type of music called disco offered an alternative to the macho hard rock music that was increasingly seen as something by and for straight white guys.

The word *disco* was adapted from the French word for dance clubs—*discothèque*—and disco music was meant to be danced to. A blend of early 1970s funk, R&B, Latin, and pop music, it maintained a steady beat that encouraged dancing.

Musicologists debate what the first disco song was. "Love Train" by the O'Jays not only incorporated many elements of what would soon be identified as disco

music, but was also a number-one smash hit in 1972. The next year, The Hues Corporation released "Rock the Boat," which also eventually climbed to number one and would later be recognized as an early classic of the genre. Shortly thereafter, Carl Douglas's "Kung Fu Fighting" and George McCrae's "Rock Your Baby" became international sensations.

Essential to the rise of disco's growing popularity was the spread of its namesake dance clubs. Appearing first in New York City and Philadelphia in the early 1970s, the clubs largely attracted African Americans, Italian Americans, Latinos, LGBT people, and women, all of whom wanted to dance rather than rock. Club DJs mostly spun up-tempo records, and some of the most successful club songs began slowly crossing over into mainstream hits. "Rock the Boat" was a club hit in 1973, but didn't top the pop chart until the following year.

By the mid-1970s, disco music steadily entered the mainstream, and discos popped up in cities around America. Disco music began challenging rock for popular

supremacy as such acts as Donna Summer and KC and the Sunshine Band began dominating the charts.

Hollywood capitalized on the trend with the wildly successful 1977 movie *Saturday Night Fever*, starring John Travolta. Even more popular was the film's soundtrack, which sold over fifteen million copies, was the number one album for twenty-four consecutive weeks, and remained on the charts for well over two years. Soon disco was so ubiquitous that even established rock acts like the Rolling Stones and Rod Stewart felt compelled to release disco material.

But with success came saturation and backlash. Soon disco was everywhere, sometimes in absurd or laughable ways, such as the 1976 gimmick song "Disco Duck." Meanwhile, some young white males reacted with hostility. "Disco sucks!" became a battle cry of those defenders of rock who felt threatened by disco music and culture. A particularly ugly example of the backlash was Disco Demolition Night, a promotion at a 1979 Chicago White Sox baseball game that went horribly awry. After a rock radio DJ blew up a mound of disco albums, fans spontaneously rioted, damaging the field and much of the stadium.

By 1980, the disco craze had begun to fizzle, and disco was commonly mocked in popular culture. But despite the backlash, disco's legacy was secured. Dance clubs were established as a regular feature of American urban culture, minority and female artists were now poised to find a place for themselves in the pop charts, and the popularity of disco music itself, much of which was high quality despite occasionally over-the-top arrangements, experienced several resurgences beginning in the 1990s.

above: Donna Summers shrine in San Francisco. *torbakhopper/Creative Commons*

below: Isaac Hayes dancers, Chicago, 1973. *National Archives and Records Administration*

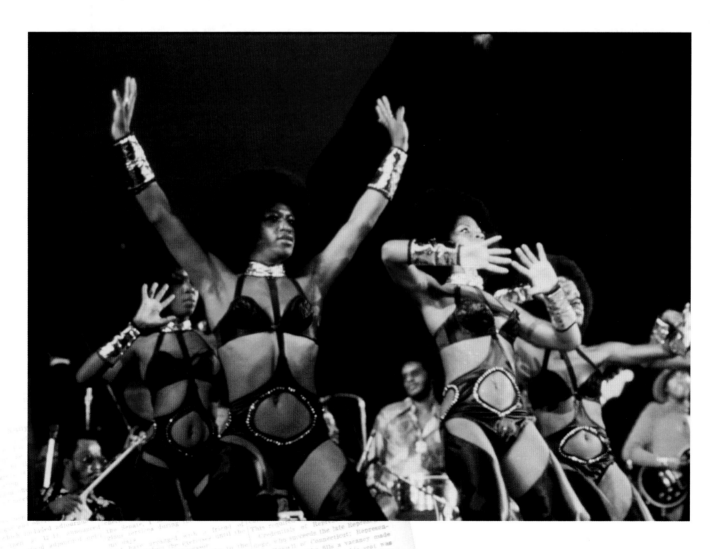

PUNK

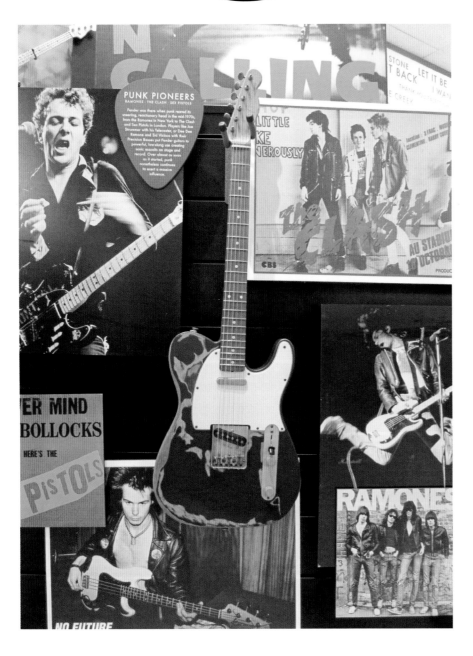

YOUTH CULTURE GETS ANGRY

During the social and political upheavals of the 1960s, the hippie culture critiqued mainstream society and offered peace, love, and understanding as the cure. By the 1970s, however, the hippie movement had been co-opted by the same mainstream society it had criticized, neutering it of its social and political critiques, and eventually transforming it into another passing fad.

As hippie subculture declined in the early 1970s, another alternative youth subculture emerged, one that was also highly critical of mainstream American society and intimately tied to rock music. But the new youth rebels, soon to be known as punks, held very different attitudes than the hippies and offered different responses to the troubles of modern society as they understood it.

Punk music and culture has its roots in the United States and Great Britain. One of the earliest and most influential places was southeast Michigan. The Stooges,

Punk memorabilia at the Fender Visitor Center. *Mr. Littlehand/Creative Commons*

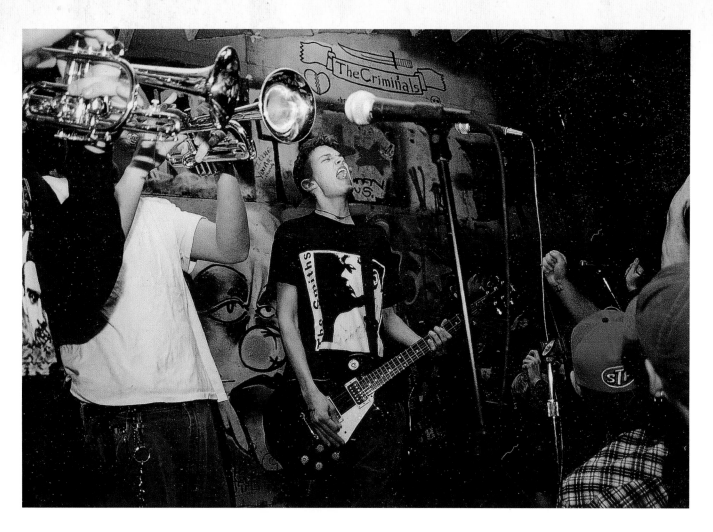

fronted by singer Iggy Pop, and the MC5 were hard-driving rock bands that played loud and fast while sneering at the delicacies of hippie culture. Spurred on by anger and testosterone, they challenged audiences instead of pandering to them. Iggy Pop's confrontational stage antics included wild contortions, screaming, dancing and/or fighting with the crowd, nudity, and cutting himself on stage.

By the mid-1970s, New York City had become a hub for the new movement. In particular, the club CBGB (which, oddly enough, originally was an acronym for country, bluegrass, and blues) featured bands such as the denim- and leather-clad Ramones, who played loud, stripped-down rock music.

Meanwhile, Great Britain was developing its own punk scene. While the music was similar, British punk sometimes featured overtly political lyrics and developed a fashion sense of ripped denim, leather and studs, piercings, wild hair colors, and the iconic Mohawk haircut. In 1979, English band the

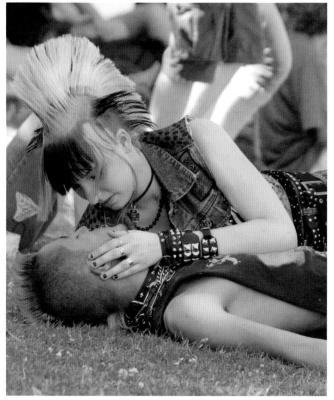

above: Punk band Link 80 performing in Berkley, California, in 1997. *Clarkandellen/Creative Commons*

left: A punk couple in the grass. *Patrick/Creative Commons*

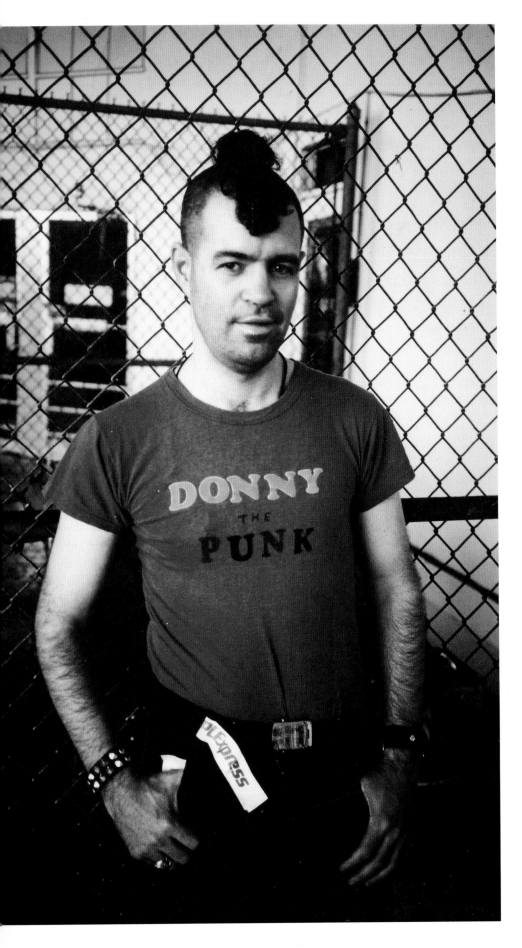

Sex Pistols released perhaps the most influential punk album, *Never Mind the Bollocks, Here's the Sex Pistols.*

The Sex Pistols went out of their way to insult mainstream British culture, mocking such sacred cows as the Queen of England. The band was at once an international sensation and shockingly scandalous, captivating fans while outraging and alienating others. In 1979, when bassist/singer Sid Vicious died from an overdose of heroin his own mother had purchased for him, punk was further stigmatized in the eyes of many social critics.

During the late 1970s and early 1980s, the punk subculture spread throughout cities across America. Eighties American punk was in many ways more influenced by the British scene than the New York scene. Violent mosh pit dancing became commonplace at clubs, the music was louder and angrier than ever, and many lyrics were overtly political, critical of both nationalistic Conservatives and insipid Liberals. Los Angeles became particularly influential as the home to bands such as Black Flag and X.

Unlike the hippie movement or disco, punk's overt anger and hostility toward the mainstream culture prevented it from becoming completely co-opted and popularized. When record companies tried to capitalize on the trend, they tempered down the music and rebranded it new wave, which quickly evolved into a new form of pop music that had little to do with its punk roots. And while various elements of mainstream culture eventually adopted punk fashion, punk music and politics largely remained an underground movement as it continued to inspire various artists and intellectuals into the twenty-first century.

Stephen Donaldson, a.k.a. Donny the Punk, in 1984. Donaldson was known for his writing on punk-rock subculture and political activism. *Tom Cahill/Creative Commons*

TWO TURNTABLES AND A
MICROPHONE

BREAK DANCING AND RAP

The origins of break dancing are murky, but oft-cited contributing factors include tap dancing, the Lindy Hop, Kung Fu movies, and James Brown's 1969 hit "Get On the Good Foot." What's clearer is the dance's birthplace: the asphalt streets of the Bronx during the final days of the 1960s.

Much of the Bronx was mired in poverty, particularly the southern portion that was home to African American and Puerto Rican communities. The young men and women of these neighborhoods came of age during the post-civil-rights Black Power/Black Pride movement. Out of this emerged b-boying, b-girling, and breaking: interchangeable terms for a phenomenon the mass media would call break dancing.

Breaking is now considered one of the original elements of hip-hop. Dance moves such as the "toprock" and "downrock," "power moves," and "freezes" all appeared around the same time that DJ Kool Herc, a Bronx-based Jamaican American DJ, started spinning records at neighborhood

Break dancer. *Usien/Public domain*

Break dancers in San Francisco. *Cam Vilay/Creative Commons*

block parties. Touted as the father of hip-hop, Herc's signature sound came from his ability to loop the rhythmic breakdowns on dance records, creating catchy, danceable, repetitive bass lines.

In the early days of breaking, it was more than a dance. South Bronx street gangs incorporated breaking into disputes over turf. Break "battles" provided an opportunity for young men to show off their physical prowess. Something between combat and mediation, these competitions included dance-offs, in which encircled crews attempted to outdo each other's moves and tactics by showing off their finely honed styles and well-practiced routines.

Breaking is a highly physical and acrobatic dance. With three-step and six-step moves, weaving limbs, and body suspensions, it requires speed, endurance, and strength. The style quickly grew in popularity and soon made inroads into mainstream culture. By the mid-1970s, it was sweeping through New York City's club scene, turning venues like Manhattan's Roxy into hip-hop meccas.

Despite the dance catching on globally, New York remained a solid hub, with hip-hop dance groups such as the New York City Breakers and Rock Steady Crew making long-term careers out of their "pop-and-lock" abilities. The Rock Steady Crew scored a record contract with Virgin in 1984 and its song "Hey You (The Rock Steady Crew)" reached number thirty-eight on the US dance chart.

During the early 1980s, breaking exploded in popularity, becoming a national and then international fad. However, it was more heavily commercially exploited than movements such as the hippie movement and disco music before it, and it soon reached a saturation point. As the dance became ubiquitous in popular culture, its image changed. The low-budget movie *Breakin' 2: Electric Boogaloo* (1984) was emblematic of this shift, being panned by critics and becoming a cult classic for all the wrong reasons.

Breaking's popularity had waned greatly by the mid-1980s, but it never vanished. Considered a reputable sport, as well as a popular dance, breaking tournaments and competitions can still be found today as far away as Germany and Japan.

YUPPIES

ON THE GO DURING THE GO-GO EIGHTIES

Michael J. Fox with wife Tracy Pollan in 1988. Fox played Alex P. Keaton, the quintessential yuppie-in-the-making, on the hit TV show *Family Ties*. *Alan Light/Creative Commons*

After World War II, Americans enjoyed a prolonged period of measured economic growth. Since the mid-1970s, however, the US economy has witnessed a series of booms and busts.

First, good-paying manufacturing jobs were lost to mechanization and foreign competition. Then, the international oil cartel OPEC embargoed the United States from 1973 to 1974. The ensuing gas crunch led to rising prices (*see* **Gas Crunch**, *page 199*). The result was a rare combination that economists termed stagflation: economic stagnation from high unemployment and inflation caused by the oil embargo. By 1980, the nation had slipped into a full-blown recession.

However, after the first postwar slump came the first postwar boom. In 1982, the US economy began roaring back to life and surged for the remainder of the decade. During the Go-Go Eighties, as they came to be known, American popular culture celebrated the return to economic prosperity and international power. Nationalism and American pride grew, as seen in such popular films as *Rambo* and *Red Dawn* (the latter of which was the first movie to ever receive a PG-13 rating) and a slew of imitators that followed.

As the economy hummed, conspicuous displays of wealth also became fashionable. Many Americans had put the grave social and political concerns of the sixties and seventies behind them. Eighties society celebrated the new wealth. In popular culture, self-interest replaced social activism as an admirable goal. As the iconic movie villain Gordon Gekko said in the 1987 film *Wall Street*, "What's worth doing is worth doing for money."

Emblematic of the change was Jerry Rubin. A radical antiwar activist during the 1960s and 1970s, by the 1980s he had remade himself into a clean-cut businessman. An early investor in Apple Computers, the former hippie was a millionaire by the time the Go-Go Eighties got going.

above: Senator Gary Hart, known during his 1984 presidential campaign as America's "yuppie candidate." *Department of Defense*
bottom: The cast of *Thirtysomething* at the governor's table of the 1988 Emmy Awards. *Alan Light/Creative Commons*

Rubin disavowed his radical past, and publicly debated Abbie Hoffman, a former colleague and activist. He claimed the creation of wealth is what would actually make the world a better place, and he derided the drug use and sexual promiscuity of the counterculture.

The premier symbols of this fast-paced, money-hungry lifestyle were the yuppies: young urban professionals who were eager to climb the corporate ladder and cash in on the nation's growing wealth. These young, upper-middle-class, white-collar workers were bent on success. Along the way, they set new fashion trends and became a symbol either for new American success or selling out, depending on one's point of view. Of course "young" was relative; 1984 presidential contender Gary Hart, age forty-seven, was called the yuppie candidate.

Used as a compliment, yuppie could indicate prosperity, vitality, and style. As an insult, it labeled someone as shallow, selfish, and crass. But by the end of the decade, the debate had become moot. In 1990, the boom gave way as the United States slipped into another recession, making the pursuit of wealth seem less plausible to many.

GRUNGE

GENERATION ANXIETY

A new cohort of American children was born after the post–World War II Baby Boom finally came to an end in 1965. They weren't the Greatest Generation, who had survived the depression and World War II. They weren't the subsequent Baby Boom, which created a demographic bulge in the nation's population and grew up amid the postwar prosperity and tensions of the Cold War, civil rights, and Vietnam. Nor were they the later Millennial generation, who would grow up during the turn of the century, the digital revolution, and in a nation transformed by September 11.

Without a central American identity to call its own, in many ways the generation of Americans born between roughly 1965 and 1980 seemed to fall through the cracks. They grew up in fluctuating, mediocre economies instead of rampant prosperity or epic depression. They came of age in a post-Vietnam, post–civil rights, post-Watergate, pre-9/11 America, when the nation's moral imperative seemed vague, and even confused at times. And they found their way into adulthood in an analog era of rising divorce rates, often left to their own devices in the days before the advent of helicopter parents, bike helmets, play dates, or cell phones.

Fewer in number than either the Boomers that preceded them or the Millennials who followed, for a long time they didn't even have a name. Eventually dubbed Generation X, they seemed to some observers to lack the fierce commitments of the Boomers, much less those of the Greatest Generation, which had been raised by the Victorians only to survive the Great Depression and World War II. Often raised by another in-between

Jerry Cantrell of Alice in Chains. *Alberto Cabello/Creative Commons*

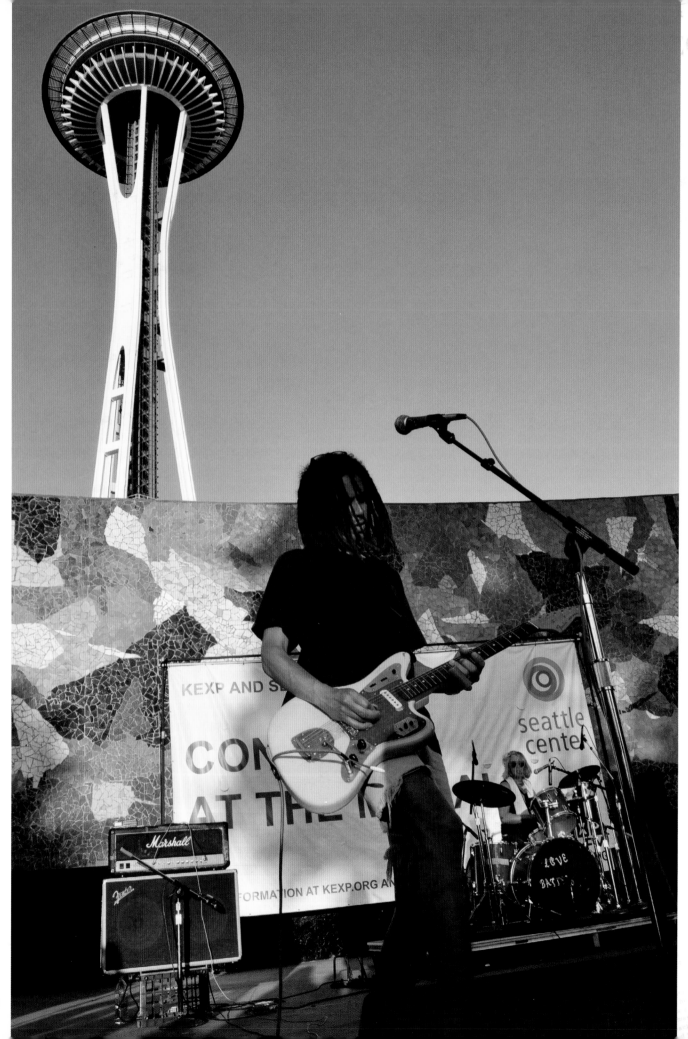

above: Pearl Jam. *Flickr user Make Lemons/Creative Commons*

right: The Seattle music scene exhibit at the EMP (Experience Music Project) Museum. *Razvan Orendovici/Creative Commons*

opposite: Kevin Whitworth performs with Love Battery at the Mural Amphitheatre, Seattle Center. *Joe Mabel/Creative Commons*

set, the so-called Silent Generation of Depression and War babies, Gen Xers seemed uninterested in the generational divide that had often split the Boomers from their parents and grandparents.

If anything, Generation X seemed to be marked by cynicism, detachment, dark humor, and a blend of anxiety and resignation. And when their brief moment to dominate the popular culture arrived, it reflected both their intensity and their disinterest.

Low-budget, breakthrough films such as *Clerks* and *Slackers* portrayed characters who were comedically realistic about their low expectations. Meanwhile, the gritty grunge movement emerged from the underground music scene. Bands rejected overproduced pop music,

turning to punk for inspiration while still maintaining a strong sense of melody and song structure. Musicians also set the fashion trend, forsaking stylish outfits for simple jeans, T-shirts, flannels, and unkempt hair.

Grunge exploded into a national phenomenon in 1991 when bands Nirvana and Pearl Jam dominated the airwaves. In particular, Nirvana's lead singer and songwriter, Kurt Cobain, seemed to offer a voice for Gen X: angry yet funny, jaded yet thoughtful. But his 1994 suicide at the age of twenty-seven shocked the nation and signaled the movement's demise.

As grunge declined, so too did rock-and-roll. Having dominated American music for more than forty years, it began

giving way to hip-hop and dance music. In many ways, the Gen X movement was over.

But emblematic of their approach to life, many Gen Xers just shrugged and moved on, symbolized by Nirvana drummer Dave Grohl, who emerged from Cobain's shadow to front his own successful band, the Foo Fighters, for the next twenty years.

LET IT RIDE

CASINO CULTURE

On December 26, 1946, mobster Benjamin "Bugsy" Siegel opened the Flamingo Hotel and Casino in the sleepy desert town of Las Vegas, Nevada. Unlike the rural, no-frills casinos then typical of Vegas, the Flamingo was an opulent showplace. It was also immediately in the red, and the Mafia "dispatched" Siegel the following year.

However, Siegel's dream soon came to posthumous fruition. Other Las Vegas investors followed his model, using ostentatious casinos to build an international tourist industry. By the 1960s, Las Vegas had become a mecca for gamblers and vacationers.

Vegas casinos built their reputation as all-around adult playgrounds. Draped in flashy neon, they lured patrons with

above: The Nugget Casino, which opened in 1954. *Michael Holley/public domain;* **inset:** Casino tables at the Tropicana, Las Vegas. *Matthäus Wander/ Creative Commons*

cheap rooms, cheap meals, swimming pools in the desert sun, health spas, national headline acts, adult-themed entertainment, and, of course, gambling.

Casinos were the heart of the Vegas experience, and hotels were designed to keep patrons headed there. For example, hotel rooms were often stylish, but typically lacked a large TV or other amenities that might encourage patrons to dally there. Walking from point A to point B anywhere in a hotel usually meant walking through the central casino, which was a maze of gaming tables and slot machines. Open 24-7, the casino walls had no clocks or windows to distract customers, and scantily clad waitresses brought food, cigarettes, and even free alcohol directly to gamblers at tableside.

As Vegas casinos changed hands from legendary organized crime syndicates to large corporations during the 1970s, "Sin City" maintained its virtual monopoly as America's adult playground. But that would soon change. In 1976, New Jersey legalized casino gambling in the seaside resort town of Atlantic City, which was best known as the home of the Miss America pageant and for lending its street names to the board game Monopoly. Atlantic City followed the Vegas model, making flashy casinos along its famed boardwalk the center of its gambling culture. But with its somewhat remote location and no legalized sports betting, Atlantic City remained the junior East Coast partner to Vegas.

The real catalyst for spreading casino culture across America actually came from a small Indian tribe in Florida. In 1979, the Seminole tribe began running high-stakes bingo games, with pots as large as $10,000. It was wildly successful, and other tribes in other states soon followed the Seminole blueprint.

A series of lawsuits ensued as states tried to shut down the tribal operations. But in the case of *California v. Cabazon Band of Mission Indians* (1987), a federal court ruled that states could not prohibit legalized gambling on

The Las Vegas Strip. *Shutterstock/Joseph Sohm*

Indian lands. The next year, Congress passed the Indian Gaming Regulatory Act, which recognized tribal rights, but also forced tribes to negotiate compacts with the state governments, which were increasingly eager to get their cut of the action. A boom in Indian casinos soon followed.

There are now several hundred casinos in the United States, ranging from massive operations like the Pequot Indian nation's

Foxwoods Casino in Connecticut to small card rooms and slot machine halls scattered across rural America. Some are on Indian reservations, but many others are not, as numerous states have since liberalized their gambling laws.

Here in the twenty-first century, casino culture is part of the fabric of American culture. And all of it is still modeled, to some degree, on Bugsy Siegel's flashy show palace in the desert.

STRUGGLE

The thirteen original United States comprised a poor nation by the standards of Europe. Overwhelmingly rural, it was a country of farmers and tradesmen, common laborers and slaves. However, over the course of the nineteenth century the nation would radically transform.

During its first eleven decades, the United States would grow some eight times in physical size, at the expense of Indian nations; grow nearly twenty times in population, largely through foreign immigration; suffer over six hundred thousand dead in a bloody civil war to preserve the Union and end slavery; and become the wealthiest and most powerful industrial nation on the face of the Earth.

While the United States boasted wealth, power, and prestige far beyond the reach of any other nation during the twentieth century, such successes often came with a price. American history is not a tale of unadulterated success. Along the way, many Americans faced many struggles. Oftentimes they found a way to overcome tremendous obstacles. But sometimes they had to merely make do, and other times they lost more than they could afford.

Some obstacles, such as epidemic diseases or natural disasters, seemed like cruel twists of fate. Some obstacles, such as economic downturns or foreign invasions, were manmade disasters that had the potential to unite Americans through common hardship. And some obstacles, the ones that at times make for uncomfortable discussions, were foisted upon Americans by other Americans in ways that we now recognize as unjustifiable.

Whether natural or manmade, directed or seemingly random, well known or mysterious, righteous or villainous, mighty struggles have periodically impeded the American dream. With varying success, Americans have worked hard to overcome the kinds of obstacles we pray our children should never have to face.

There is much in the story of twentieth-century America that is triumphant and worthy of our celebration. But there are also darker chapters that must be remembered if we are to be true to the American dream of building a more perfect union.

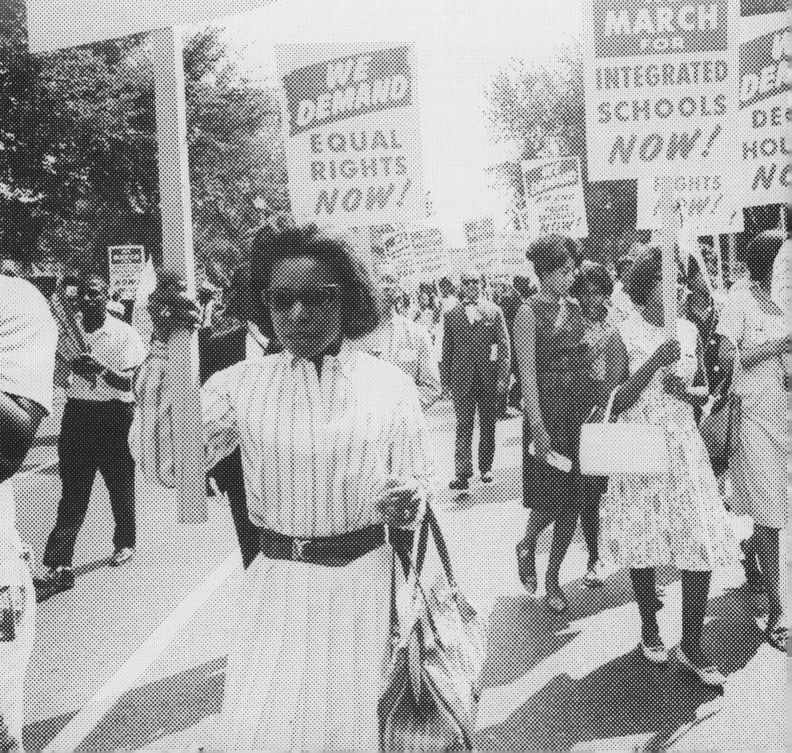

CULTURAL GENOCIDE

INDIAN BOARDING SCHOOLS

As the original thirteen states quickly stretched westward across the North American continent, expansion came at the expense of Indigenous peoples who had lived on the land for thousands of years. Through diplomacy and sometimes warfare, they resisted. But in the end, the United States was too powerful. Indian nations had lost most of their lands by the end of the nineteenth century, and were generally confined to small parcels called reservations.

At the time, many Americans mistakenly assumed that American

Girls praying at Phoenix Indian School, Arizona, 1900. *National Archives and Records Administration*

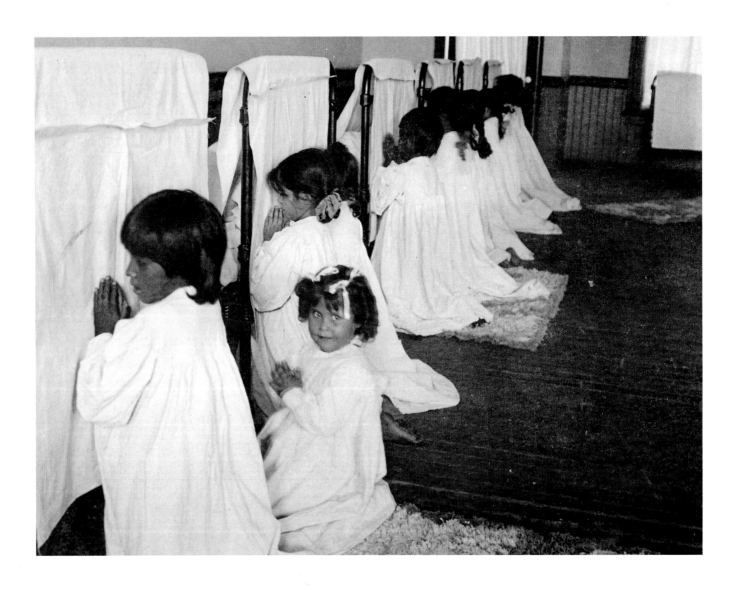

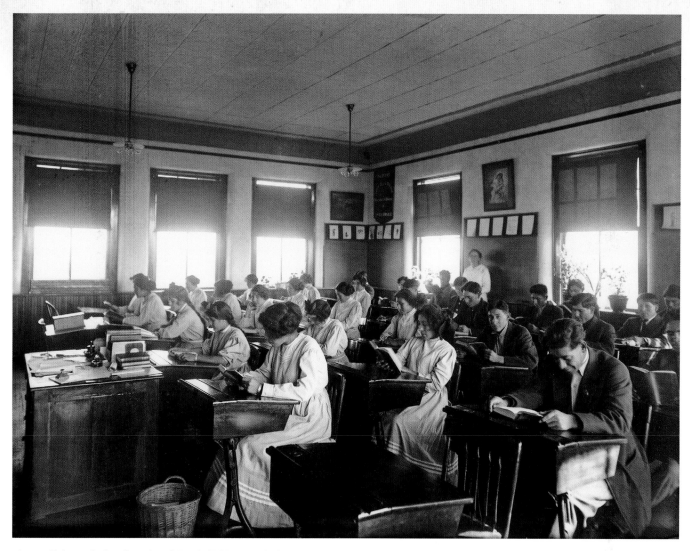

above: Chilocco Indian Boarding School, Oklahoma, 1913. *National Archives and Records Administration*

below: Chilocco School, 1909. *National Archives and Records Administration*

Indians would simply disappear. Popular racist theories claimed that supposedly "savage" Indians could not coexist with "civilization," and that they would either blend in or go extinct like the dodo bird.

Consequently, many white reformers who styled themselves as "friends of the Indian" sought to help Native people adapt to American culture, by force if necessary, believing they would otherwise face physical extinction. "Kill the Indian to save the man" was a popular slogan, and a rallying cry for those who proposed a program of what amounted to cultural genocide against Indian societies.

Generally termed assimilation, this large-scale assault on Indian cultures and societies took numerous forms and had supporters in both the public and private sectors, many of whom earnestly believed they were doing the best thing for Indians. White America generally agreed that there was an "Indian

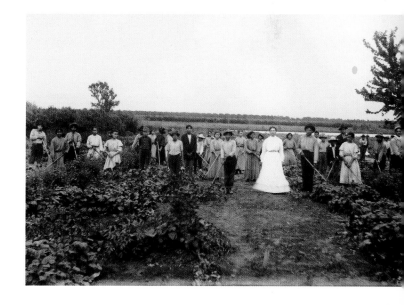

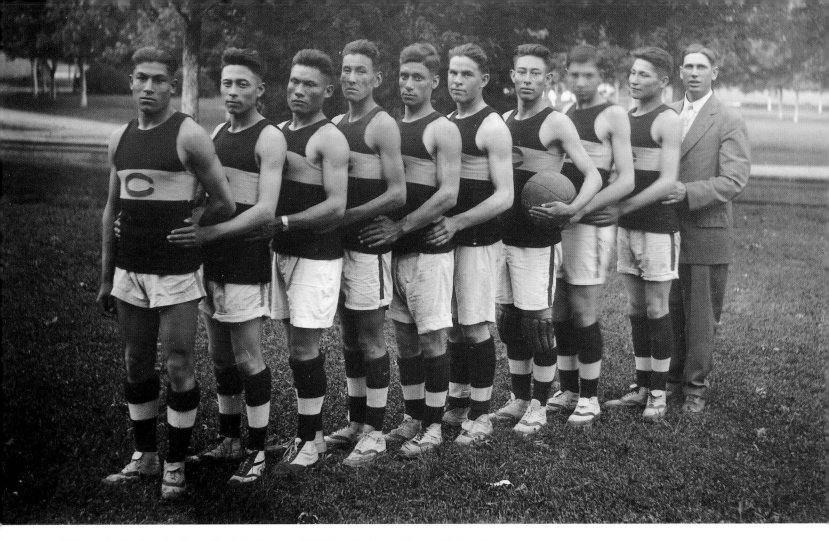

Chilocco Indian Boarding School basketball team, 1909. *National Archives and Records Administration*

problem" that such reformers sought to fix by whitewashing Indian cultures.

A major assimilation program was the new system of schools founded by the federal government. Some, such as the Carlisle Indian School in Pennsylvania or the Haskell Institute in Kansas, were distant boarding schools that received students from around the country. Some boarding schools were located on the reservations themselves. Some of the reservation schools were day schools with hours similar to today's schools. Many reservations also had private, Christian day schools. All of them had a common agenda: to erase all vestiges of Indian cultures from young children.

At government schools, only English was permitted; Indian children were forbidden from speaking their indigenous languages and were physically punished if caught doing so. Indian religions were also banned, and church attendance was often compulsory. The educational curricula stressed the superiority of American culture and denigrated Indian history and societies. Particularly at many of the boarding schools, students lived regimented lives of tight schedules and strict orders; at some, boys even wore military uniforms. Along the way they also received a basic formal education.

Indian reactions to the schools varied. Some parents were happy their children had an opportunity to adjust to the new American ways. Others were dubious, but often deeply impoverished and sent their children to the schools knowing that at least they would be fed. And some resisted, not wanting their children subjected to these cultural attacks. Those parents faced government repression. Federal officials would sometimes withhold food until parents handed over their children. Other times, Indian children were simply kidnapped, rounded up as soldiers held their parents at gunpoint.

Some children prospered in the schools, while others rejected the experiences. Diseases were also a problem, and each boarding school had a graveyard. Most of the students survived, however, and typically left the schools conflicted about the experience.

In 1934, government policies changed, although a full erasure of repressive policies did not occur until reservations finally gained control of their own schools in the 1960s and 1970s.

US COLONIALISM
THE PHILIPPINE WAR

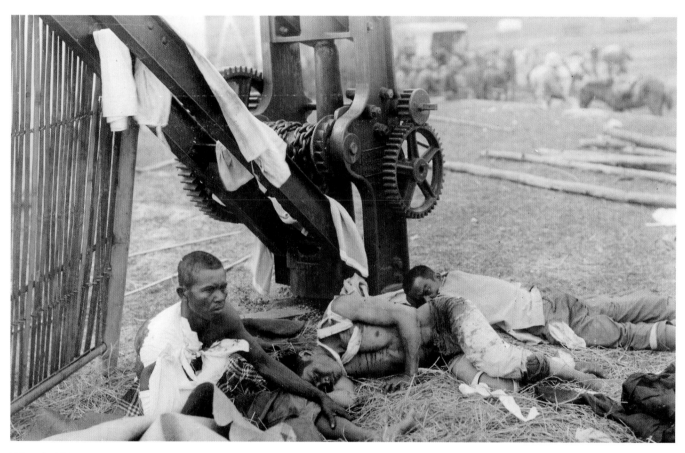

Wounded Filipino revolutionaries, ca. 1899. *National Archives and Records Administration*

In 1898, after having already conquered North America, the United States established itself as a global power by quickly dispatching Spain in the Spanish-American War. Fought simultaneously on both sides of the world, the conflict in Cuba garnered most of the attention. But just as important was the fighting that took place in the Philippines.

An archipelago of islands south of China, the Spanish colony was seen by American businesses as a possible gateway to trade with lucrative East Asian markets. But the islands had been under Spanish control for nearly four centuries, and Filipinos had been waging a war of independence since 1896.

Gaining local support had been crucial to US efforts to oust Spain. The US Navy defeated the Spanish fleet in Manila Bay while Filipino forces did most of the fighting on land. At war's end, Spain sold the Philippines to the United States for $20 million.

Having already formed the First Filipino Republic as a provisional revolutionary government even before the outbreak of the Spanish-American War, Filipino nationalists were not interested in trading one colonial master for another. Fighting between Filipino nationalist forces and the US military broke out in February 1899. In June, the Filipino Republic officially

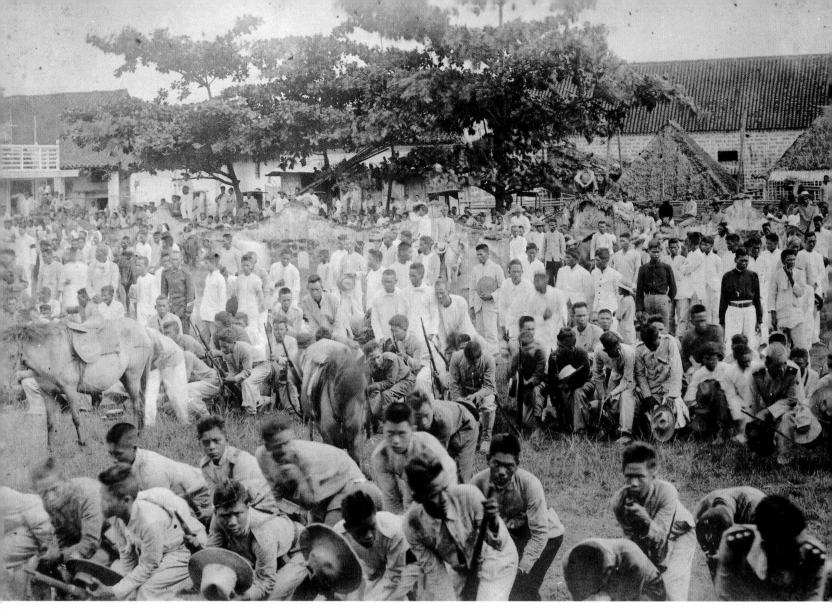

Philippine insurgents, ca. 1900. *National Archives and Records Administration*

declared war on the invading US forces. The United States had become mired in a war of colonial conquest that would last for three years and turn exceedingly vicious at times.

The US military quickly captured the capital of Manila. Outgunned, but with the advantage in manpower and home terrain, Filipino revolutionaries resorted to guerilla warfare. US commanders responded by taking actions against Filipino civilians. To prevent them from supporting the guerillas, US officials forced civilians into internment camps, where they died in droves as unsanitary conditions spread diseases. Other US tactics included burning food, destroying towns, and torturing prisoners.

The US military attempted to censor the press and pressured soldiers to recant their accounts of war atrocities. General Elwell Otis justified US war crimes by claiming the Filipinos had tortured US prisoners. However, the international press found that American POWs were treated very well.

Back home, American supporters of the war claimed the US was acting on behalf of the Filipino people by protecting them from predatory European empires and by offering to "lift up" the supposedly racially inferior Filipinos.

By 1903, the US victory was complete. American troops had suffered more than four thousand deaths, three-fourths of them from tropical diseases. Roughly a

quarter million Filipinos had perished, about 90 percent of them civilians.

Afterward, the United States ruled the Philippines as a colony with very limited self-rule. In 1916, Congress promised Philippine independence would occur sometime in the future. In 1935, the US granted the Philippines limited independence. Full independence was scheduled for 1944, but the 1941 Japanese invasion of the Philippines scuttled those plans. Japan's occupation lasted nearly four years.

Finally, in 1946, after nearly half a century of US colonial rule, American and Filipino leaders signed the Treaty of Manila, which formally acknowledged the Philippines' independence.

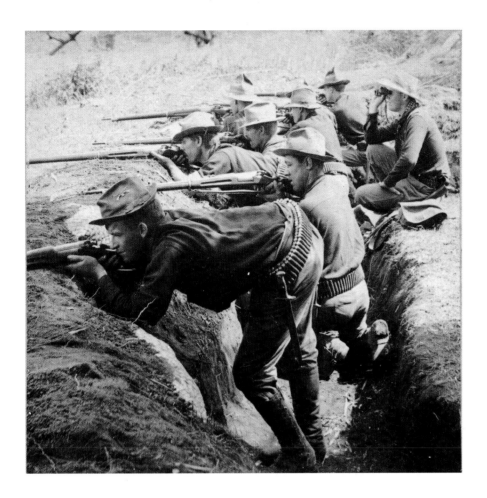

left: Americans entrenched against the Filipinos, circa 1910. *National Archives and Records Administration*

below: General Aguinaldo (seated, center) and ten of the delegates to the first Assembly of Representatives responsible for passing the 1899 Constitution of the Republic of the Philippines, ca. 1929. *National Archives and Records Administration*

WWI

REPRESSING GERMAN AMERICAN CULTURE

When the Great War (later known as World War I) erupted in 1914, the vast majority of Americans looked at it with a sense of detachment and no interest in joining what they saw as a strictly European conflict. In 1916, President Woodrow Wilson even successfully campaigned for re-election with the slogan "He Kept Us Out of War!"

But by the following year, the United States had been drawn into the largest and deadliest war the world had yet seen, siding with the British and French against the Germans. Once involved, Americans reached for new heights of nationalism.

All Americans were expected to support the war effort. The federal

left: An advertisement encouraging the purchase of war bonds. *National Archives and Records Administration*

below: US Food Administration advertisement. *National Archives and Records Administration*

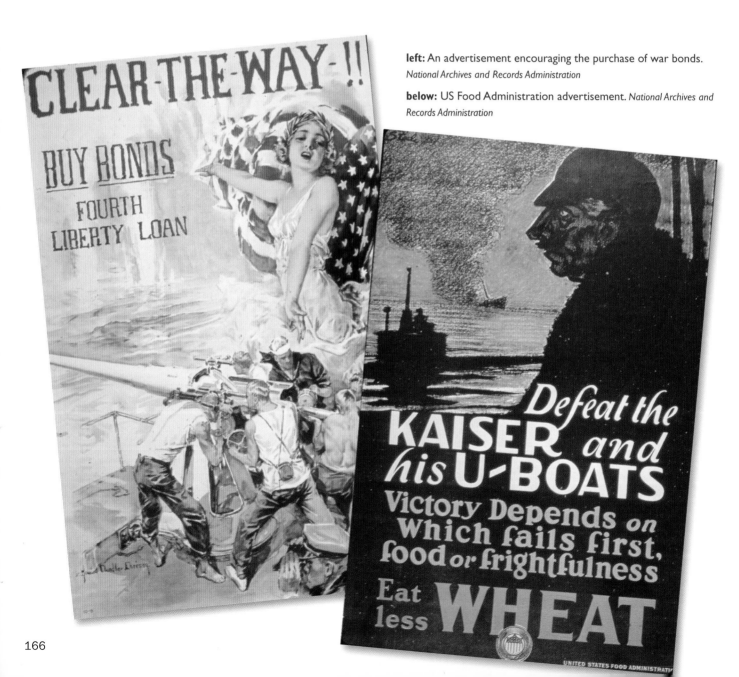

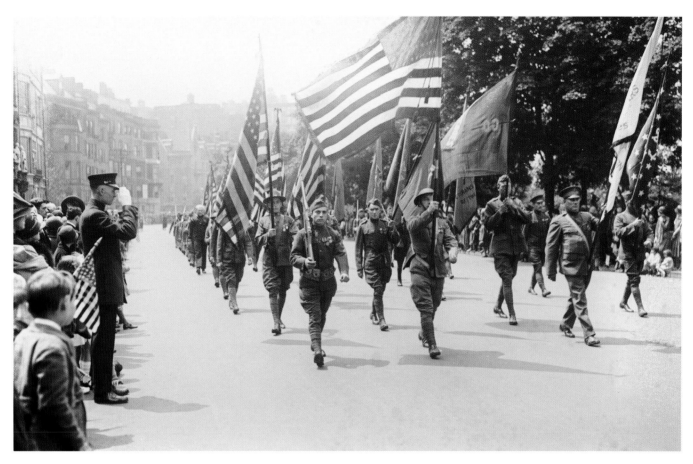

A parade for World War I veterans. *Library of Congress*

government opened its first-ever propaganda bureau. Most forms of dissent were banned. It was even against the law to advocate pacifism.

For German Americans, this created a particularly difficult circumstance. Germans are the single-largest group of ethnic immigrants in American history, more than seven million having arrived since the founding of the United States. The first large wave came during the 1840s and 1850s. Some two million had immigrated as recently as the last two decades of the nineteenth century, settling in cities and on farms.

German culture, arts, and institutions were thriving in early twentieth-century America, including German-language newspapers, churches, theaters, and schools. However, as war raged, anti-German hysteria swept the nation, and anything German was suspicious. Both the mainstream American society and federal and state governments worked to repress German American culture.

Many towns changed their German names, such as Berlin, Michigan, which became Marne. Countless German street names in cities and towns across the country were also changed. Many major orchestras refused to play music by German composers such as Richard Wagner or even Beethoven. School districts throughout America banned teaching the German language. German words were scrubbed from popular culture: frankfurters became hot dogs; hamburgers became Salisbury steak; German Shepherds became liberty dogs or Alsatians; even German measles was briefly dubbed liberty measles.

Individual acts of direct violence and oppression also occurred. For example, a German man in Illinois was lynched; a German pastor in Minnesota was tarred and feathered; and a schoolteacher in Maine was fired for giving a German person driving lessons.

Meanwhile, the federal government made it illegal to send German-language letters through the mail. More than four thousand German Americans were arrested on suspicion of supporting Germany's war effort.

By war's end in 1919, German-language culture in America had been decimated. Most German-language newspapers and schools had either closed or changed to English; most churches had switched to English services; and many German Americans had changed the German names of their businesses, or even changed their own surnames to sound more English, such as changing Schmidt to Smith.

A SICK NATION

THE INFLUENZA EPIDEMIC OF 1918-1919

World War I was known for its trench warfare, with soldiers hunkered down for long stretches in deep, muddy ditches that ran for miles. Sanitation issues were a major problem, and outbreaks of disease were common.

Toward the end of the war in Europe, a virulent strain of influenza spread through military personnel on both sides. Soldiers brought back the disease, known popularly as the Spanish Flu or "the Grippe," to their home countries all around the world after the war ended, setting off a global pandemic.

Within a year's time, more people had died of the flu than had been killed in battle during the Great War. Total figures are impossible to know with certainty, but approximately one-third of the world's population eventually became infected. At least fifty million people, and even perhaps as many as one hundred million, succumbed to the disease from late 1918 to early 1920.

America was not immune. The Spanish flu was a particularly strong strain (an early strain of H1N1). Researchers later found that it had a propensity for infecting the lungs, which in turn could lead to pneumonia and unusually higher mortality rates. While typical flus had a mortality rate of less than 0.001 percent (that is, less than one in one thousand cases), the Spanish flu killed about 2.5 percent of Americans who contracted it (about one in forty). And whereas influenza deaths were generally fatal only to the very young or very old, even people in their prime were susceptible to the Spanish Flu; Americans between the ages of fifteen and thirty-four who caught the bug were twenty times more likely to die than their peers who had contracted other strains of flu.

In the United States, this new strain of influenza was first reported in Kansas in March of 1918. In August, Boston was one of three cities around the world where the pandemic exploded. By the end of September, the disease had spread across the nation and the world. Early twentieth-century medicine was incapable of dealing with the virus, and Americans coped as best they could. Many people took to wearing masks to cover their mouths. In warm weather, indoor institutions sometimes moved outdoors in hopes of preventing the disease's spread, with the occasional schoolroom or even courthouse conducting business in the open air. Some charities and local governments opened tent camps for the infected—effectively quarantining them from larger populations—hoping that fresh air might keep the bug from spreading. Institutions ranging from mail delivery to garbage pickup temporarily collapsed in many places as workers were struck down.

By the time the disease had run its course in 1919, nearly 700,000 Americans were dead. In comparison, about 116,000 Americans had died in World War I.

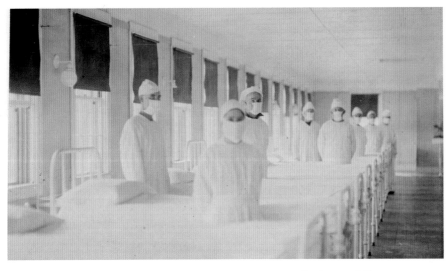

above: Influenza ward at the US Naval Hospital in Mare Island, California, 1918. *US Navy Bureau of Medicine and Surgery* **opposite:** The Red Cross Emergency Ambulance Station in Washington, D.C., 1918. *Library of Congress*

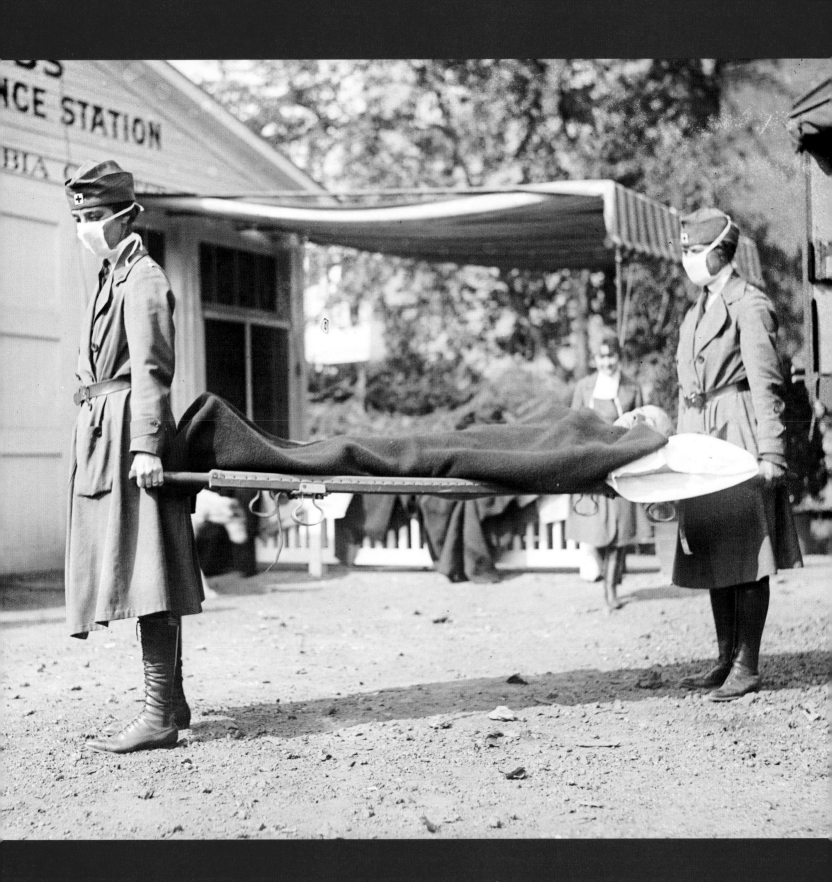

A DRY NATION
PROHIBITION

Temperance movements aiming to outlaw alcohol in America date back to the nineteenth century. In 1851, Maine became the first US state to prohibit alcohol, though the ban was repealed five years later. Soon thereafter, sectional conflict and the Civil War overshadowed prohibitionist efforts

After the war, the Woman's Christian Temperance Union (established in 1873) and the Anti-Saloon League (1893)

campaigned to have individual states outlaw alcohol. First came Kansas in 1880. Others followed.

Prohibition was most popular among religious, Protestant, native-born Americans, particularly in rural areas. Immigrants, urbanites, Catholics, and Jews were most likely to oppose the bans. Consequently, most of the dry states were in the South and West, as much of the Northeast and Midwest resisted.

By 1919, the movement had plateaued, with twenty-six of forty-eight states "dry." Already seeking a national ban, activists formed the Prohibition Party. With former Indiana Governor J. Frank Hanly topping the ticket, they unsuccessfully challenged incumbent President Woodrow Wilson in the 1916 election.

Energized supporters pushed for a constitutional amendment to ban alcohol, and America's entry into World War I in 1917 was a turning point. Beyond preaching about the supposed immorality of drinking, activists now capitalized on the war to promote their cause. Prohibitionists dubiously claimed that grain earmarked for alcohol production could otherwise be used to make loaves of bread to feed American soldiers in Europe. Amid the fervor of war, the message resonated.

Over Wilson's veto, Congress mustered a supermajority to pass the Eighteenth Amendment in December of 1917. The bill then went to the state governments for ratification. In January,

above: A Prohibition-era spigot (circa 1925) confiscated in Highland, Washington, pictured on display at White River Valley Museum. *Joe Mabel*

left: Detroit police inspect equipment found in a basement brewery. *National Archives and Records Administration*

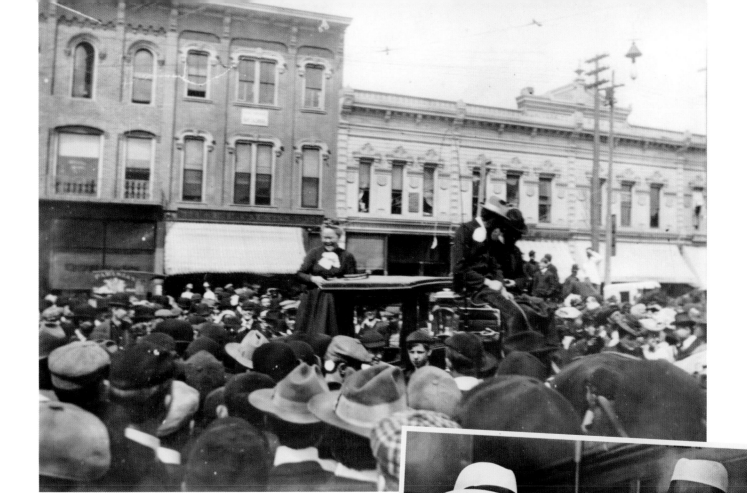

above: Prohibition crusader Carrie Nation in Ann Arbor, May 3, 1902. *Courtesy Wystan Stevens/Creative Commons*

right: Former Prohibition officers Izzy Einstein and Moe Smith, New York, 1935. *Library of Congress*

Mississippi became the first state to approve it. A year later, Nebraska became the thirty-sixth state to do so, thereby ratifying the amendment. As momentum grew, every state except for Connecticut and Rhode Island eventually approved it.

Prohibition was controversial from the start and remained unpopular in many places. Some cities, such as Baltimore, rarely bothered enforcing it. Throughout the country, the illegal production and sale of alcohol became a major criminal enterprise. While the Roaring Twenties (*see page 118*) were officially dry, alcohol was nonetheless ubiquitous.

The black market in illegal alcohol was a high-risk, high-profit venture that lured organized crime. Early drug runners, called bootleggers, smuggled alcohol from Canada and Mexico, and violent turf wars plagued cities and towns.

Illegal bars, known by such regional slang as "blind pigs," "blind tigers," and "speakeasies," sprouted up in every major city; even in rural America, where the prohibition movement was strongest, homemade moonshine liquor was popular. Ironically, historians estimate that per capita alcohol consumption actually *increased* during the prohibition era.

The loss of government revenue from the taxation of legal alcohol became an issue once the Great Depression descended upon the nation in late 1929. In late 1933, with the support of newly elected President Franklin Roosevelt, the Twenty-first Amendment was ratified, officially repealing the Eighteenth. The matter was again up to individual states.

Oklahoma maintained its ban until 1959. Mississippi remained a dry state until 1966. And to this day, several dozen individual counties in various states continue to ban the sale of alcohol.

A POOR NATION
THE GREAT DEPRESSION

The Great Depression of the 1930s was the worst economic catastrophe in world history.

The Roaring Twenties (*see page 118*) seemed like a time of prosperity in the United States, but there were fundamental economic troubles lurking underneath the glitzy surface. The decade opened with American farmers falling on hard times. Increased competition from European farmers after World War I was compounded by the withdrawal of federal subsidies. Farmers responded by overproducing, and agricultural prices dropped, worsening matters.

Meanwhile, American cities were booming, but underlying problems shadowed the industrial sector as well. Like farmers, factory owners were also overproducing. Factories churned out new products such as refrigerators, vacuum cleaners, and radios. But a great disparity between rich and poor limited American consumers' ability to purchase the nation's industrial output.

The richest 1 percent of Americans owned 60 percent of all the wealth. The savings of the richest sixty thousand families exceeded the savings of the twenty-five million poorest families. Most American workers were poorly paid and could only afford to buy new products with access to easy credit. But at the end of the decade, the credit bubble dried up, leaving a surplus of industrial goods.

In addition to the credit bubble, there was also a stock bubble. Speculation on Wall Street was rampant. The stock

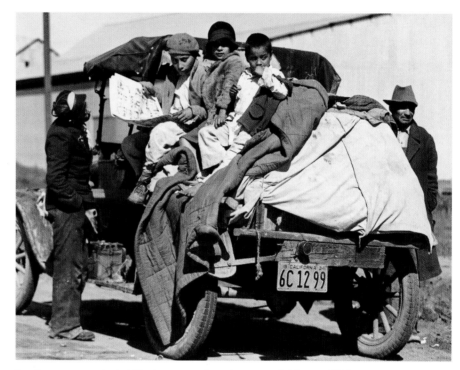

Immigrants at rural rehabilitation camps for migrants in California, 1935. *Library of Congress*

evaluation of many publicly traded companies far exceeded their actual value. And on Black Tuesday, October 29, 1929, the stock bubble popped. Traders began selling off stocks, and their values plummeted. By week's end, investors had lost $9 billion, more money than the nation had spent fighting World War I.

Investors panicked and things got worse. Two months later, the stock market had lost $40 billion, or 60 percent of its total value. As companies lost customers and access to investment, they laid off workers. Unemployed workers bought

fewer goods, making it more difficult for companies to sell their products, leading to yet more layoffs. The US economy entered a death spiral.

For the remainder of Herbert Hoover's presidency (1929–1933), the economic situation worsened. Corporate profits dropped 90 percent as one hundred thousand businesses failed. The US economy shrank by half. Almost six thousand banks closed, and, since accounts were not insured, many people lost their entire savings. (*See* **The Fireside Chats**, *page 126*.)

For three years, about one hundred thousand workers were laid off every week. By 1933, national unemployment had nearly quintupled from just over 5 percent to nearly 25 percent. Thirteen million workers couldn't find a job, while another thirteen million had to settle for part-time work, meaning almost half the work force could not find full-time employment. In Detroit unemployment was at 50 percent. In New York City alone, there were over one million unemployed people.

In an era before welfare, social security, minimum wage, or other government safety nets, the results were cataclysmic. Charities were quickly overwhelmed. In 1932, New York City hospitals reported 29 people dead of starvation and 110 from malnutrition, many of them children.

In 1933, President Franklin Roosevelt implemented the New Deal, a wide-ranging series of programs designed to revive the economy. Things steadily improved. By 1937, unemployment had fallen from thirteen million to nine million. But that year, the economy slipped backwards again.

Massive economic stimulation was required to end the Depression. However, the private sector was incapable of making such investments, and federal politicians worried about reining in government deficits. Their hand was finally forced by World War II.

International threats swept away concerns about balanced budgets. In order to mobilize for and fight a two-front war, the federal government engaged in massive deficit spending. The US economy roared back to life. Preoccupied with war, which demanded many sacrifices, most Americans did not yet realize it, but the Great Depression was finally over.

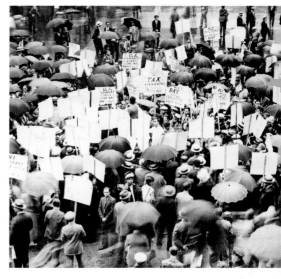

above: Depositors gather outside the Bank of United States after its failure, 1931. *Library of Congress*

below: Unemployed men lined up outside a Chicago soup kitchen opened by Al Capone, 1931. *National Archives and Records Administration*

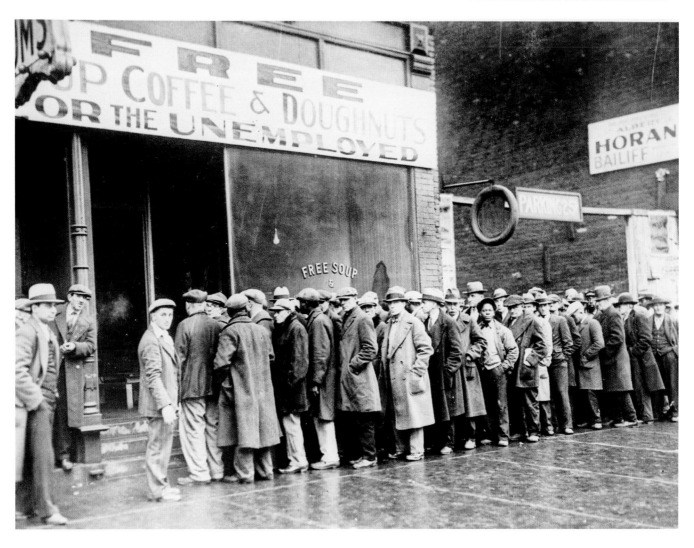

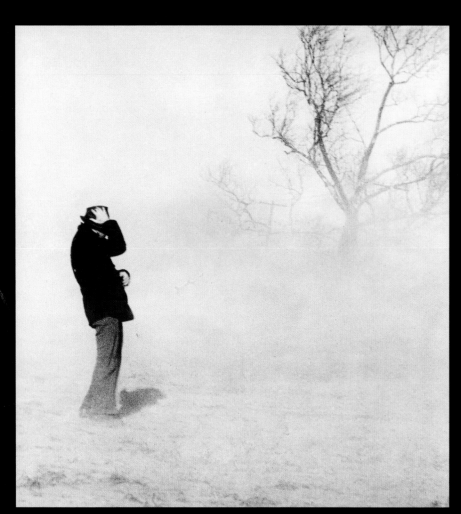

A man caught in a Great Plains dust storm, ca. 1934–1936. *National Archives and Records Administration*

THE DUST BOWL

"When it rains, it pours." So goes the old saying about bad to worse. But what about when it doesn't rain at all?

The Roaring Twenties were already tough times for many American farmers. Then in 1930, the Great Depression hit, plunging the entire nation into economic despair. If that weren't bad enough, during the 1930s, the central part of the nation experienced a major drought that led to one of the worst natural disasters in American history. The region was devastated as millions of pounds of topsoil literally blew away, in what came to be known as the Dust Bowl.

Of course the Great Depression didn't cause the Dust Bowl; that was just unlucky timing. And even the drought that triggered the Dust Bowl wasn't severe enough to have explained it alone. The true causes of this environmental disaster were manmade and dated back half a century.

The Great Plains are semi-arid. They are not as dry as a desert, but not as wet as the humid, forested East. Precipitation is limited, and the natural environment features tall, deeply rooted grasslands. Trees grow mostly along rivers and creeks.

For thousands of years, Indigenous peoples farmed the plains, but only along rivers where there was sufficient water. The vast swaths of drier grassland were usually reserved for hunting game, mostly the millions of bison that stormed back and forth across the plains.

But after the US conquest of the region, with Indians reduced to reservations and the buffalo nearly exterminated, American settlers began ranching and even farming much of the Great Plains. Many believed in the mythical aphorism "The rain follows the plow," that is, if farmers plowed up

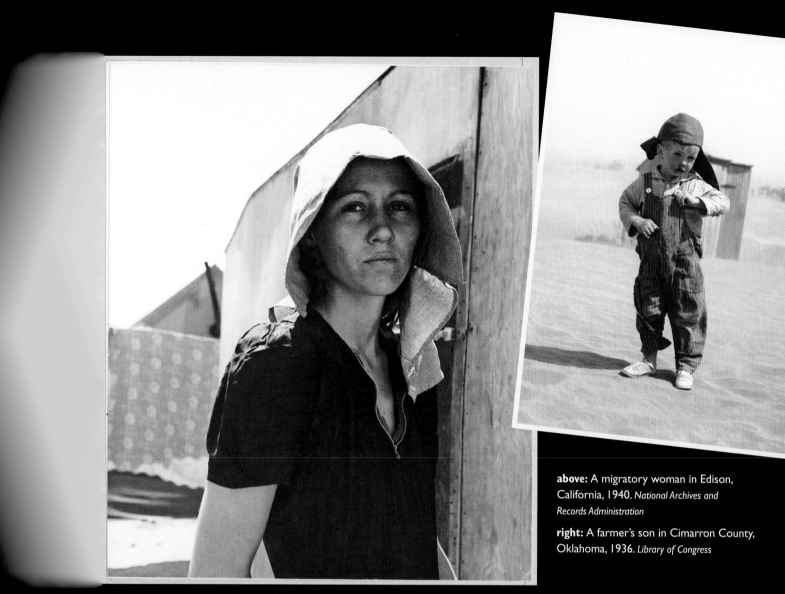

above: A migratory woman in Edison, California, 1940. *National Archives and Records Administration*

right: A farmer's son in Cimarron County, Oklahoma, 1936. *Library of Congress*

the prairie, rain would fall as a result. It was wishful thinking.

Rainfall on the plains typically cycles in and out of relatively wetter and drier periods. The wetter periods supplied barely enough rain for turn-of-the-century farming. The drier periods did not. Duped by occasional wet years and lured by cheap land, farmers spread across the plains. The problem was not merely that crops suffered from time to time; the real issue was that when farmers uprooted the natural grasses, or ranchers overgrazed them, the soil became endangered. Indigenous Great Plains grasses grow

six to twelve feet in height and sprout from root systems that run just as deeply into the earth. Those intricate root systems held together the tough Plains topsoil, known as sod.

When settlers, known as sodbusters, ripped up the grasslands and replaced them with rows of corn and wheat, they left the topsoil vulnerable to severe erosion from the ceaseless Great Plains wind. And when drought did return in the 1930s, the results were catastrophic.

Humans and animals alike were caught up in massive dust storms that engulfed entire towns. Dust covered

everyone and everything. Respiratory ailments became common. Vast sections of the southern and central plains turned barren as topsoil blew away. Fields dried up and livestock starved to death.

The federal government ordered that some of the most marginal land be returned to grass. But after the war, farming on the plains continued. Today, irrigation is vital, much of it coming from underground aquifers that allow the Great Plains to be the world's breadbasket. But at current rates of use, the aquifers will someday run out.

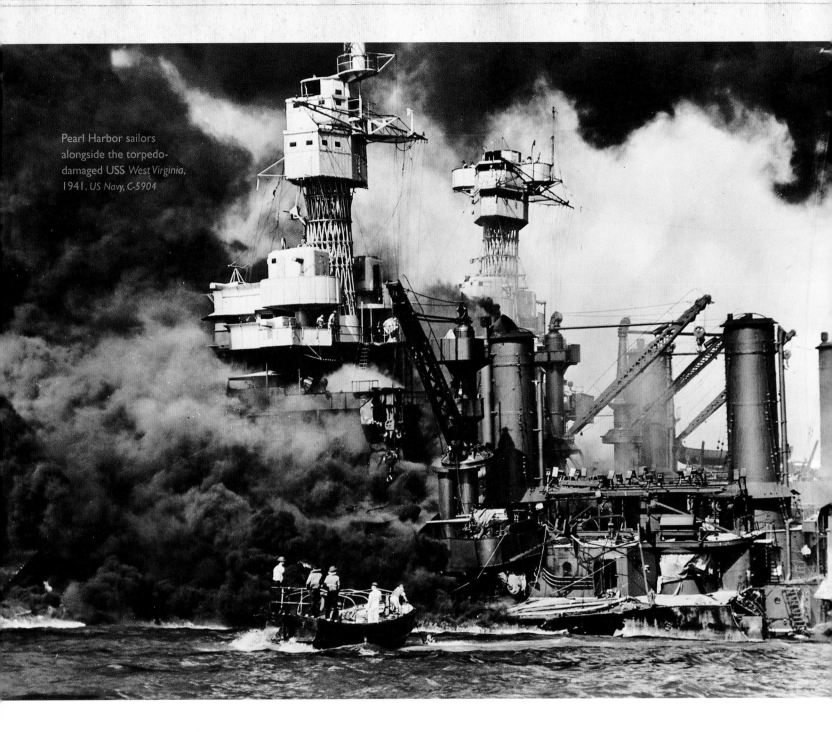

Pearl Harbor sailors alongside the torpedo-damaged USS *West Virginia*, 1941. US Navy, C-5904

A DAY OF INFAMY
PEARL HARBOR

September 11, 2001, is a date that no one who witnessed it will ever forget. The events of that day seemed unimaginable to many: the United States suffering a deadly surprise attack on its own soil. But older Americans remembered having endured something equally violent and startling.

December 7, 1941, was a day that, as President Franklin Roosevelt intoned, would live in infamy. On that date, the United States was inextricably dragged into World War II after the Empire of Japan launched a surprise attack on the US Navy stationed at Pearl Harbor, Hawai'i.

While the attack on Pearl Harbor was a complete shock to most Americans, conflict between the two nations had been brewing for some time. Japan had begun to industrialize and modernize its economy during the late nineteenth century. Looking to compete with the European empires that had carved up much of the world and siphoned wealth from their colonies, Japan began spreading across Asia during the 1930s. If it could not claim new colonies for itself, it simply would take older ones from France, Great Britain, and Holland.

In many ways, Japan's early imperial activities were no more immoral or exploitative than Europe's. However, the United States maintained close relations with Great Britain and France. Thus, when Japan began to seize places such as Indochina (Vietnam, Laos, and Cambodia) from the French and Burma from the British, the US sided with its European allies.

The United States responded to Japanese aggression with a series of trade embargoes. In May of 1940, President

right: Office for Emergency Management, War Production Board propaganda poster, circa 1942. *National Archives and Records Administration*

below: Soldiers atop an impromptu machine gun nest in aftermath of Pearl Harbor bombing, 1941. *US Army Signal Corps/US Army Military History Institute/US Army Administration*

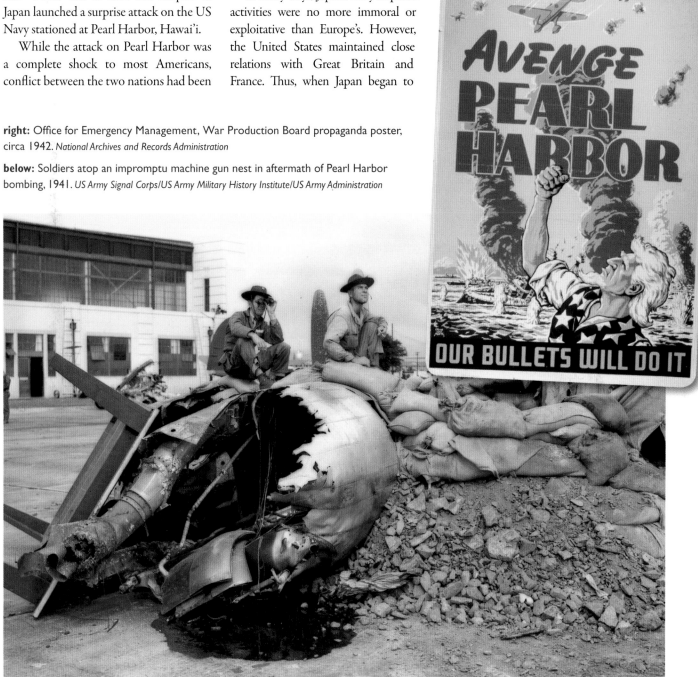

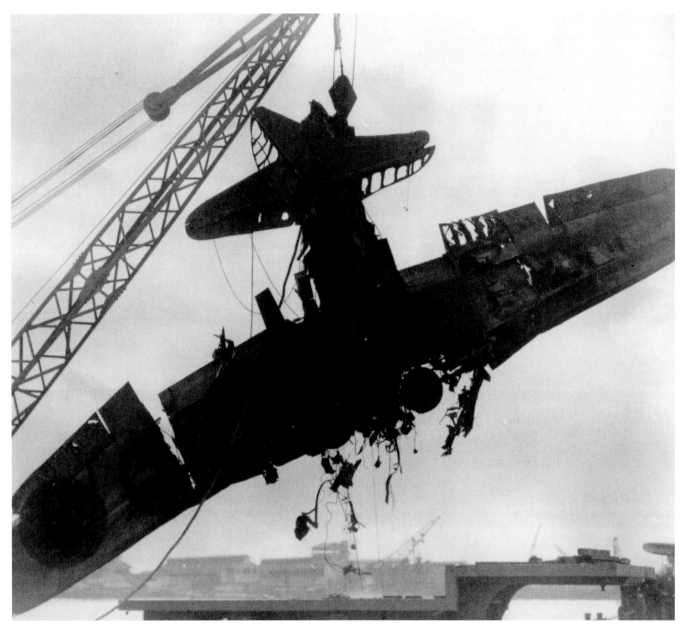

A Nakajima B5N Type 97 level/torpedo bomber from the Imperial Japanese Navy aircraft carrier *Kaga* is hoisted from the waters of Pearl Harbor, 1941. *US Navy*

Roosevelt moved the permanent base of America's Pacific fleet from the state of California to the territory of Hawai'i. It was a clear warning. The following month, the United States stopped selling aviation fuel to Japan. In September, it stopped selling them scrap iron. The next day, Japan joined the Axis, becoming formal allies of Adolf Hitler's Germany and Benito Mussolini's Italy.

The United States added more and more products to the embargo. Then, in the summer of 1941, it stopped selling oil to Japan. Japan depended on the United States for 80 percent of its oil, and had only one year's reserves. The move threatened to cripple the Japanese economy. The US also froze all Japanese assets in America and demanded that Japan cease its Asian expansion and withdraw from China. The United States had thrown down the gauntlet.

But Japan's government was dedicated to overseas expansion. After internal debates, it decided to launch the surprise attack. The goal was to knock the US Navy out of the Pacific and hope that once the United States was drawn into the war, it would focus on supporting its European allies against Germany.

On December 7, 2,403 Americans died and another 1,178 were wounded. The United States responded by waging two wars at once—one in Europe, the other in Asia. The Japanese gambit had failed. A little more than three and a half years later, Japan lay in ruins and surrendered unconditionally to the United States.

AMERICAN
CONCENTRATION
CAMPS

THE INTERNMENT OF JAPANESE AMERICANS

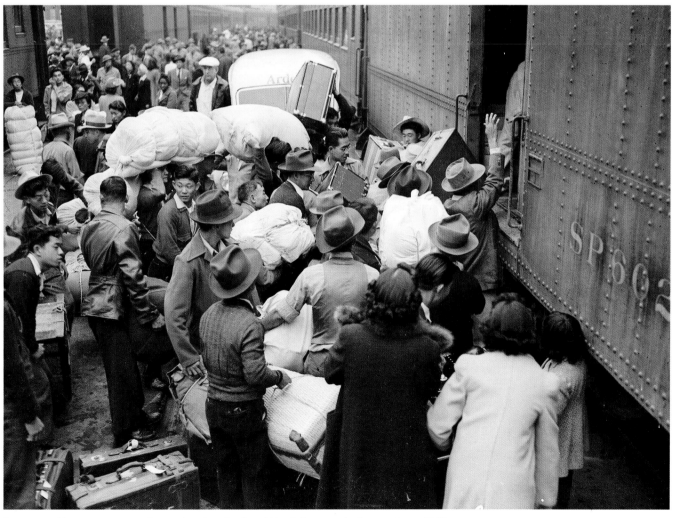

Evacuees of Japanese ancestry leaving Los Angeles for a War Relocation Authority center, 1942. *National Archives and Records Administration*

During World War I, German Americans experienced substantial repression as war hysteria rippled through society (*see* **World War I**, *page 166*). During World War II, however, German Americans fared much better than before, even as the United States again fought Germany. This time, it was Japanese Americans who bore the brunt of wartime paranoia after Japan's attack on Pearl Harbor. And the levels of oppression they faced reached new and frightening heights.

Severe anti-Asian racism was still commonplace in America. Japanese Americans, even those born here, were often seen as "foreign." After Pearl Harbor, anti-Japanese racism fueled fears that Japanese Americans would spy for Japan. On February 14, 1942, President Franklin Roosevelt issued Executive Order 9066, which authorized federal officials to round up Japanese Americans, including US citizens, and remove them from the Pacific Coast, where most of them lived.

In June, with little time to prepare, 120,000 Americans of Japanese descent in California, Oregon, and Washington were ordered to assembly centers. Many scrambled to find last-minute storage, sell off their possessions at discounted rates, and otherwise make arrangements for homes and businesses. The makeshift assembly centers were in locations such as horse racetracks and fairgrounds that were quickly circled with barbed wire.

From there, refugees were shipped to permanent internment camps in remote, mostly faraway places like Idaho, Wyoming, and Arkansas. Not to be confused with Nazi death camps, these were concentration camps for forcibly interning large populations, a not-uncommon wartime practice during the turn of the century (*see* **US Colonialism**, *page 163*). Facilities were typically old barracks or shacks the inmates built themselves. Conditions were crowded, placing strains on family life. Armed guards patrolled from watchtowers.

Eventually, Japanese Americans had several opportunities to leave the camps.

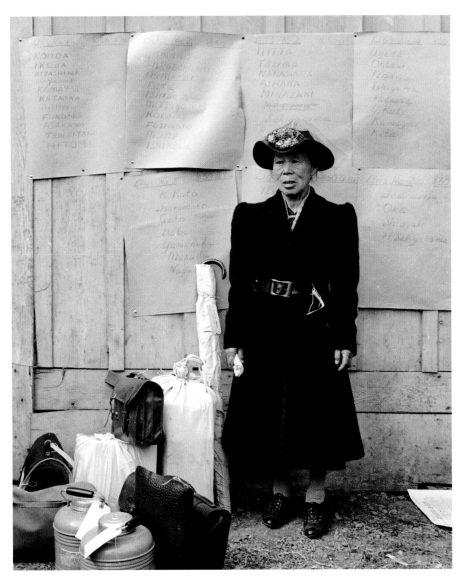

A woman awaits an evacuation bus in Centerville, California, 1942. *National Archives and Records Administration*

Working nearby for paltry wages was one option. Students who gained acceptance to college could also leave, though many schools refused to admit Japanese American students. And most incredibly, the United States soon asked the same people it had just imprisoned to sign up and fight for it. Some did. Eventually, male prisoners age eighteen to forty-five were subject to the draft.

During the war, the United States Supreme Court heard three separate cases on the constitutionality of internment. In each case, the court sullied its legacy by justifying internment, calling it a wartime necessity.

Meanwhile, despite being three thousand miles closer to Japan, hardly any of the nearly 158,000 Japanese Americans in Hawai'i were interned. Why? Because they comprised one-third of the islands' population; interning them would have crippled Hawai'i's economy and war effort. They were largely left alone and remained loyal, thereby putting the lie to paranoid fears about disloyal Japanese Americans.

After the war, some former internees moved east, refusing to return to the West Coast. Those who did return typically found their property had been stolen. They had to start over. An early effort at compensation by President Harry Truman's administration

was underfunded and ineffective, and many people received little or nothing. Redress took decades.

In 1988, President Ronald Reagan signed the Civil Liberties Act, which led to official letters of apology signed by President George H. W. Bush and one-time $20,000 payments to survivors or their immediate heirs. More than four decades after internment ended, 82,219 Japanese Americans eventually received over $1.6 billion in reparations.

right: Middle-school class at Tule Lake Relocation Center, Newell, California, 1942.
National Archives and Records Administration

below: Santa Anita Assembly Center, 1942.
National Archives and Records Administration

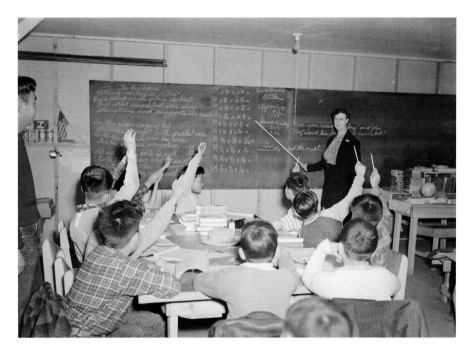

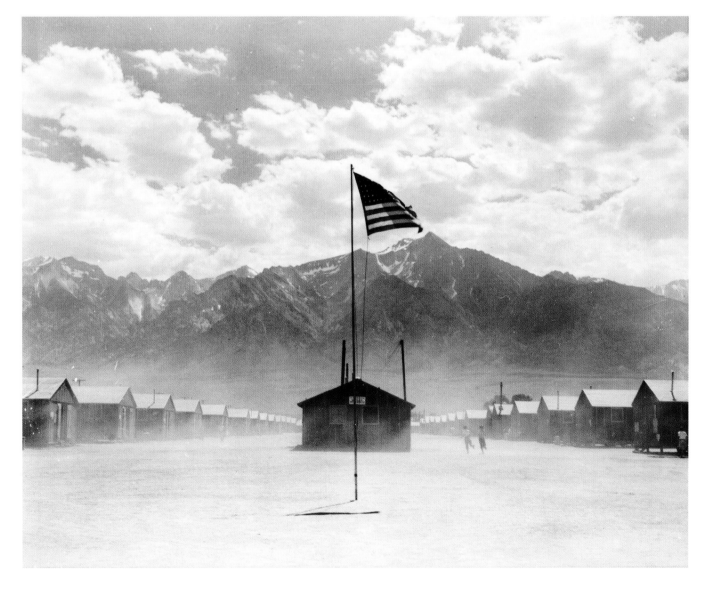

RED SCARE HYSTERIA
THE ROSENBERGS' EXECUTION

During World War II, the United States and the Soviet Union put aside earlier differences and joined forces to beat back Nazi Germany. But after the war ended, relations quickly deteriorated. By 1947, the two superpowers had locked horns in a hotly contested international competition known as the Cold War, which would last for some four decades.

In America, anti-Soviet and anticommunist sentiments mushroomed to new heights. The late-1940s and early 1950s were a period known as the Red Scare. At times, fear and hatred of communism and the Soviet Union moved beyond reason into outright paranoia. In 1949, Americans were understandably shocked when the USSR became the only nation other than the United States to develop the atomic bomb. Doubting that the Russians could have developed it so quickly on their own, many suspected espionage.

On July 17, 1950, federal officials arrested Julius Rosenberg, an electrical engineer for the US Army Signal Corps. He was charged with passing atomic secrets to the Soviets. Less than a month later, his wife, Ethel, was also arrested and charged with assisting his espionage activities. Gravely disillusioned with capitalism during the Great Depression, like thousands of other people, the Rosenbergs had joined the American Communist Party in the 1930s. That in and of itself was not a crime. But Julius Rosenberg had in fact spied for the Soviets during the war. Now he was being fingered by two other men who had recently been arrested themselves for espionage.

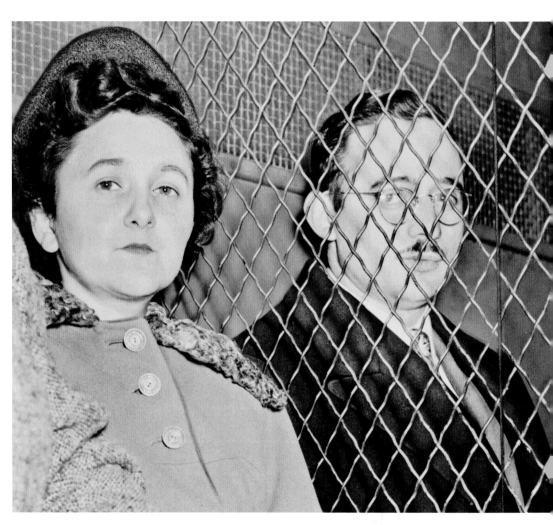

Julius and Ethel Rosenberg at the US Court House following their guilty verdict, 1951.
Library of Congress

One of the informants was Ethel's brother, David Greenglass. Facing serious jail time, he and his accomplice struck a deal. They admitted their crimes and then agreed to share information about other high-ranking spies.

However, Rosenberg had not actually had access to the Manhattan Project, which had developed the first atomic bomb (*see* **Splitting the Atom**, *page 85*). Ethel was sympathetic to the communist cause, but she had no access to any government documents.

It was actually Greenglass and a fugitive German physicist named Klaus Fuchs, who had worked on the Manhattan Project,

who obtained atomic secrets and passed them on to the Russians. And it was David who, after getting arrested, eventually marked his sister and her husband as spies.

At the federal grand jury hearing, Ethel's sister-in-law Ruth Greenglass testified against the Rosenbergs, claiming Julius had recruited her and her husband to be communist spies. The Rosenbergs were indicted. Later, documents showed FBI chief J. Edgar Hoover had gone after Ethel despite a lack of strong evidence against her, hoping that fear of orphaning their two sons would cause the couple to crack. However, they refused to name names.

At that point, the Greenglasses were convinced to change their stories. They now testified that David had passed atomic information directly to Julius, who had had Ethel type it all up.

On March 29, 1951, the Rosenbergs were convicted of espionage. A week later, Judge Irving Kaufman sentenced them both to death.

As details about the complications in their case became more widely known, a global protest movement to prevent their execution emerged. But it was for naught. Julius and Ethel Rosenberg were electrocuted on June 19.

right: Cross-section sketch of an atomic bomb produced by David Greenglass for evidence in the Rosenberg trial, 1951. *National Archives and Records Administration*

below: David Greenglass, 1950. *Library of Congress*

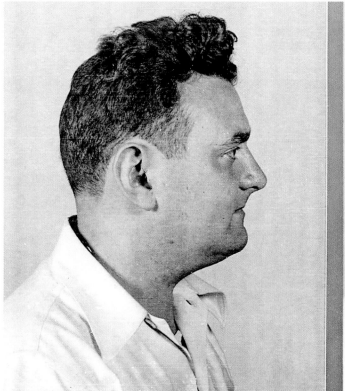

KOREA
THE FORGOTTEN WAR

Soldiers outside an orderly tent in Anyang, South Korea, circa 1952. *Captain Claxton Rayl Creative Commons*

During US involvement in World War II from 1942 to 1945, the United States essentially fought and won two wars at once: with the help of Britain and Russia against Nazi Germany and largely by itself against Imperial Japan.

US involvement in the Vietnam War lasted from the 1950s to the 1970s. It was America's longest war and also one of its most controversial, having defined a generation. (*See* **Vietnam**, *page 194.*)

In between those two conflicts was the Korean War. During three years of fighting, over thirty-five thousand Americans would die, along with several hundred thousand Chinese troops and roughly one million Koreans. Yet, compared to World War II and Vietnam, Korea has largely been ignored in the American public memory.

After World War II, the United States and the Soviet Union jointly occupied Korea, dividing it into north and south. But

above: A US Air Force Douglas C-124A Globemaster II on an airfield in Korea. *National Museum of the US Air Force*

right: The crew of an M-24 tank along the Naktong River, 1950. *Sergeant Riley/US Army*

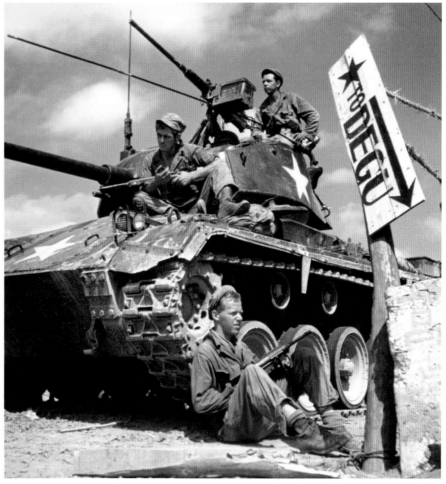

firm plans to reunite the country did not emerge. As Cold War tensions mounted, each superpower sponsored a favorable government in its half of the country, and, by 1948, each was claiming to be the legitimate government for all of Korea.

Warfare erupted on June 25, 1950, when the Soviet-sponsored North Korean army invaded the South, overwhelming nearly the entire country and driving South Korea forces to Pusan at the bottom of the Korean peninsula. The recently created United Nations condemned the invasion. Soviet officials misplayed their hand by boycotting the pivotal UN Security Council meeting. Had they attended, they could have singlehandedly vetoed a resolution to send UN forces to Korea. Instead, the resolution passed, and the United States supplied 88 percent of UN forces.

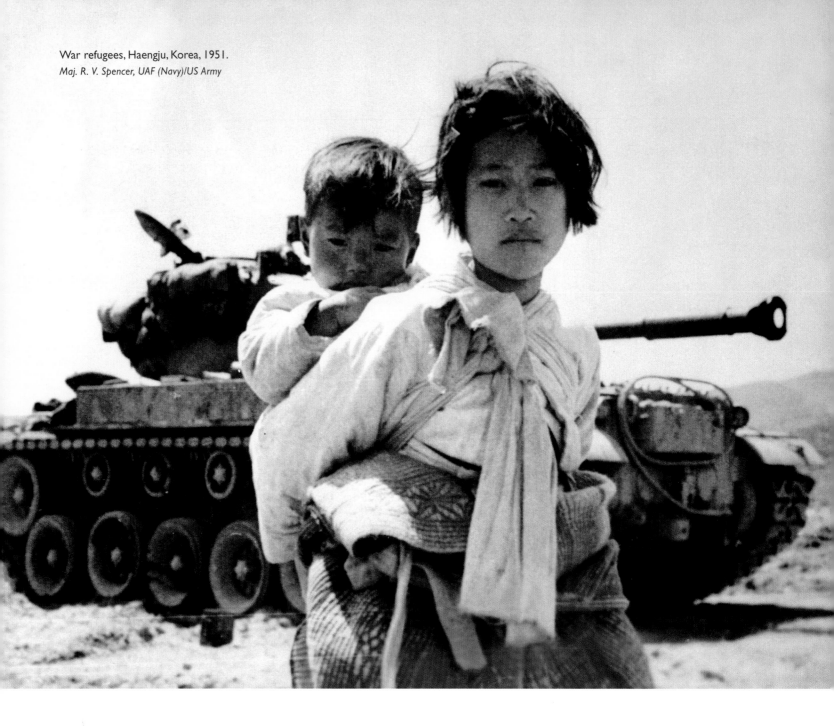

War refugees, Haengju, Korea, 1951.
Maj. R. V. Spencer, UAF (Navy)/US Army

The US-led United Nations counterstrike was a stunning success. After a daring, surprise amphibious landing at Inchon, UN troops joined South Korean forces at Pusan. The two columns drove the North Korean army northward all the way back to the Yalu River, within miles of the Chinese border.

At that point, communist China entered the war. It sent several million poorly equipped soldiers across the Yalu, forcing UN and South Korean troops to surrender most of their recent gains. The Soviets never involved their own troops, but sent arms and aid to the North Koreans.

By mid-1951, the fighting had settled into a stalemate. When US Army Gen. Douglas MacArthur publicly feuded with President Truman over war strategy—and advocated expanding the fighting into China and the use of atomic bombs—Truman relieved him of duty. In 1953, the two sides agreed to an armistice that kept the country divided at the thirty-eighth line of latitude, very near to where it had been divided before the fighting.

And while the memories of World War II and Vietnam are more vivid for many Americans, in some ways it is the Korean War that is still with us. The US military presence there has never ended. As of 2014, the United States still had nearly thirty thousand troops stationed in South Korea.

THE ATOMIC SPECTER

FEAR OF A NUCLEAR WAR

In August of 1945, the United States dropped atomic bombs on the Japanese cities of Hiroshima and Nagasaki (*see* **Victory in Asia**, *page 226*). In each instance, an entire city was leveled and nearly a hundred thousand people killed from just one bomb. The world had never seen a weapon of such immense power.

American scientists, many of them immigrants and war refugees, had solved the puzzle of the atom while working in Los Alamos, New Mexico (*see* **Splitting the Atom**, *page 85*). They had unleashed the unfathomable power of nuclear fission (splitting atoms). Thus, at the end of World War II, the United States was not only the world's wealthiest nation but unquestionably also the most powerful. This was, in part, because it held a

monopoly on the secrets of atomic power and the frightful weaponry that came with it.

Until 1949.

That year, the Soviet Union successfully tested its own atomic bomb. Suddenly, American culture went from supreme confidence to extreme dread. The Cold War had already begun, and now the United States' chief enemy also had the world's most powerful weapon.

A nuclear arms race between the two superpowers immediately ensued as both sides stockpiled atomic weapons. In 1952, US scientists moved on from the fission of large radioactive isotopes like uranium and plutonium to the fusion of the smallest atom: hydrogen. The leap in power was immense.

The new hydrogen bombs were up to a thousand times more powerful than the atomic bombs dropped on Japan just seven years before. And in addition to the blast's sheer power and scorching heat, all atomic weapons create fallout: the spread of radioactive particles that poison plant and animal life, in some cases for hundreds of years. Building on atomic radioactivity as a weapon, the US next developed the neutron bomb. It has a minimal blast compared to atomic and nuclear weapons, but specializes in spreading vast amounts of radioactivity.

As the United States advanced and built its nuclear arsenal, the USSR followed suit. For the duration of the Cold War, the entire world lived under the specter of a potential nuclear holocaust.

It was soon clear that if an actual war ever did break out between the United States and the Soviet Union, their nuclear weapons could destroy all human life on Earth.

At first, the US government tried to manage fears about nuclear warfare by insisting it was survivable. During the 1950s, school children were taught to hide under their desks in case of a nuclear attack, as if that would somehow save them. Thousands of families invested in well-stocked, underground, backyard bomb shelters, giving themselves the illusion of a safe haven until the worst of it had passed.

But by the 1960s, few still took seriously the prospect of surviving a nuclear holocaust. Instead, people took tenuous solace in ideas like MAD (mutually assured destruction): the notion that nuclear war would never happen because it was sheer madness, and the prospect of everyone dying would deter either side from allowing it to happen.

bottom left: An Office of Civil and Defense Mobilization exhibit at a local civil defense fair, circa 1960. *National Archives and Records Administration*

bottom right: A family-style fallout shelter. *National Archives and Records Administration*

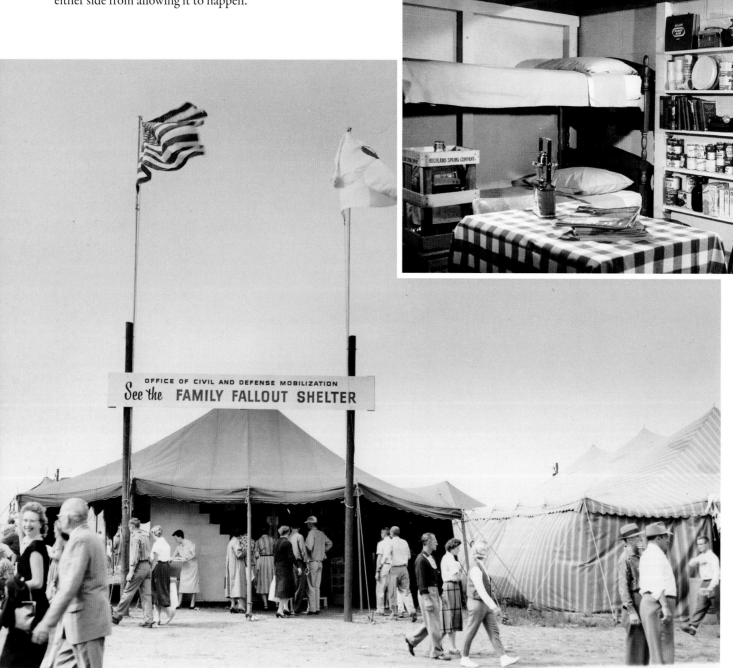

SEARCHING FOR THE
AMERICAN DREAM
THE 1963 MARCH ON WASHINGTON

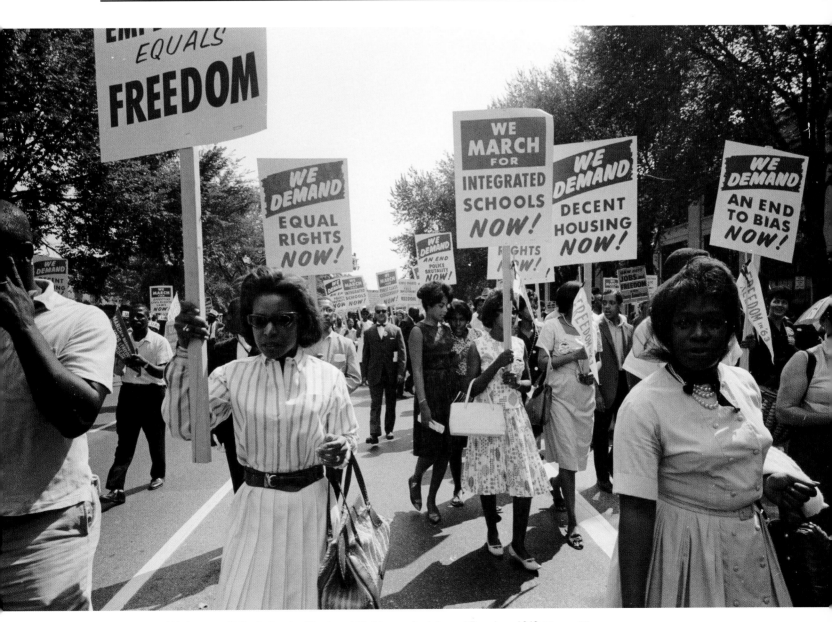

Protesters in Washington, D.C., during the March on Washington for Jobs and Freedom, 1963. *Library of Congress*

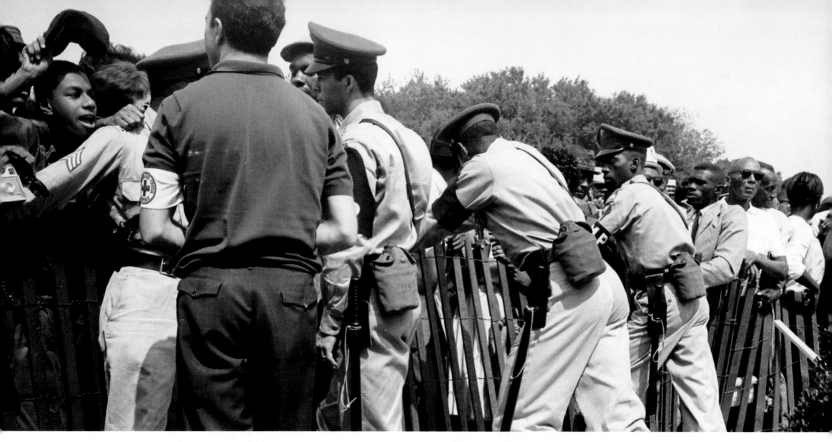

Police manage a crowd of African Americans during the March on Washington for Jobs and Freedom, 1963. *Library of Congress*

The African American struggle for full participation in the American dream is as old as America itself. During World War II, the African American press (even newspapers were segregated) trumpeted the Double V Campaign. *V* was for *Victory*, and the slogan meant victory abroad followed by victory at home; black Americans would fight in Europe and Asia, helping to defeat Germany and Japan, and then return home to fight for equality in America.

During the decade following the war, African Americans gained important victories, particularly in federal courts. Most notably, the 1954 US Supreme Court case *Brown v. Board of Education of Topeka, Kansas* not only declared segregated public schools to be unconstitutional. It also overturned the legal premise of "separate but equal," which had been the constitutional justification for legalized segregation in all manner of public accommodation.

But court victories did not translate into equality. There was a massive backlash by white supremacists, and in some places, federal troops had to be called in to oversee the desegregation of schools. Spurious laws were still used to deny most African Americans voting rights throughout the South. And economic opportunities were few and far between.

During the 1950s, public demonstrations became more common, organized by groups like Rev. Martin Luther King Jr.'s Southern Christian Leadership Conference. However, peaceful civil rights marchers were often met with vicious violence by both state officials and private individuals. As the national news devoted more and more coverage to these savage displays against peaceful men, women, and children, the nation's resolve was tested.

The 1963 march was planned by a combination of civil rights, religious, and labor groups. On June 22, planners met with President John Kennedy, who tried to talk them out of it, but they were undeterred. Kennedy finally acquiesced, and his administration helped with the planning. Momentum built as New York City, Chicago, and some corporations announced that their workers would get the day off on August 28.

Opponents tried a smear tactic that was often trotted out against the civil rights movement, claiming the march was a front for communist organizations. Various terrorist threats were received, and the American Nazi Party staged a protest.

But it was all to no avail. The march went forward and was broadcast live on television. There were more media on hand than there had been two years earlier for Kennedy's presidential inauguration.

On Wednesday, August 28, 1963, a quarter million people gathered on the National Mall in Washington, D.C., for the March on Washington for Jobs and Freedom, or as it would later be known, simply the March on Washington. Much of the nation was moved by the massive, peaceful protest. The highlight for many was Rev. King's closing "I Have a Dream" speech (*see page 235*).

In the end, the March on Washington was a huge success and contributed to the passage of the 1964 Civil Rights Act, which helped end Jim Crow apartheid.

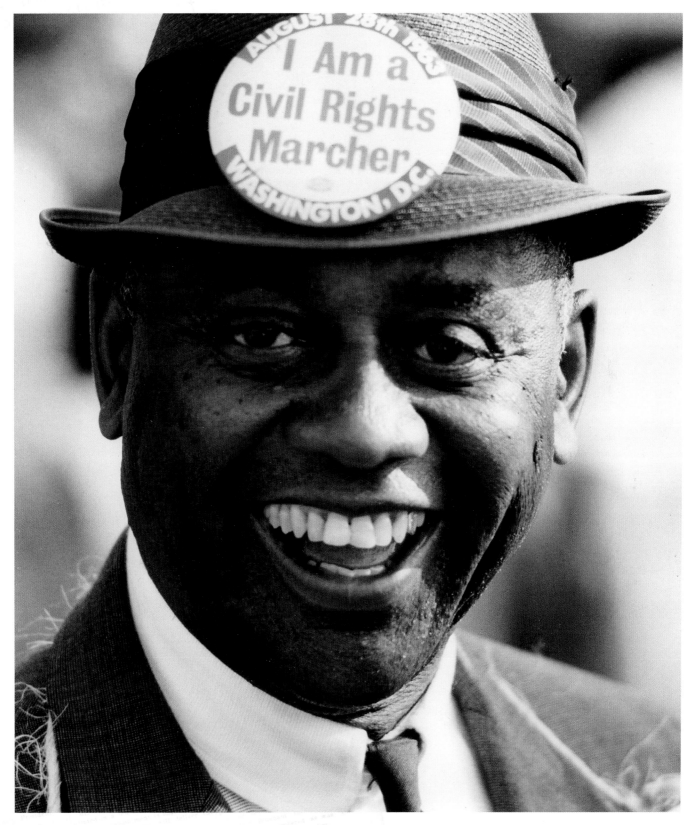

A demonstrator at the March on Washington *National Archives and Records Administration*

1968

The Year of Struggle

On the surface, the 1950s and early 1960s seemed like a time of peace and prosperity in the United States. But serious issues dogged the country.

By the mid-1950s, African Americans in the South had begun taking to the streets to protest the hellish racism and legally enforced segregation of Jim Crow apartheid. The backlash by white supremacists was fierce. Peaceful protestors were sometimes subjected to beatings, fire hoses, attack dogs, lynching, and bombings.

While the African American civil rights movement was based in the South, northern blacks also faced racism. Northern cities began erupting in 1964 when race riots shook New York and Philadelphia. Others followed. The next year, a major riot took place in the black Los Angeles neighborhood of Watts. Chicago exploded in 1966. The 1967 riots in Detroit were so bad that President Lyndon Johnson ordered in the US National Guard, and tanks rolled through the streets.

By then, another source of protest had engulfed the nation: the Vietnam War. Increasingly unpopular, the war sparked major demonstrations, which first appeared at colleges and universities such as Berkeley and Columbia, where students occupied buildings and forced shutdowns.

American society was already severely fractured as 1968 began. And then things got worse.

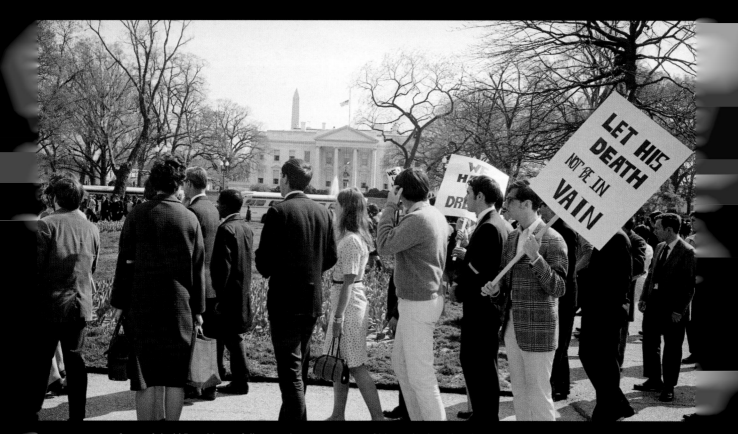

Demonstrators in front of the White House following the assassination of Martin Luther King Jr. *Library of Congress*

On April 4, a white supremacist named James Earl Ray assassinated civil rights leader Rev. Martin Luther King Jr. As much of the nation mourned, race riots ripped through more than one hundred cities.

On June 6, Robert F. Kennedy was assassinated on national television. The New York senator and younger brother of recently assassinated President John Kennedy, RFK was shot by a Palestinian Jordanian named Sirhan Sirhan, who opposed Kennedy's military support for Israel. Kennedy had just won the California Democratic presidential primary while running on an anti-Vietnam War platform. Seemingly on his way to winning the nomination, he was walking through a crowd of supporters when Sirhan gunned him down. The Democratic nomination went to Johnson's vice president, Hubert Humphrey of Minnesota, who supported the ongoing war in Vietnam.

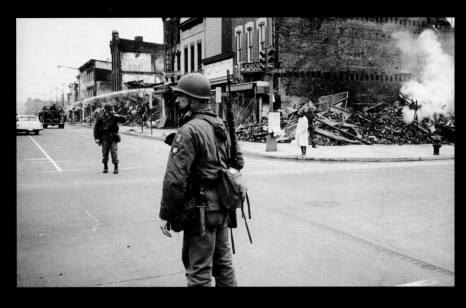

The Democratic Party national convention that summer was held in Chicago. The city was already a tinderbox. Race riots after King's death had left thirty-nine people dead. Now dozens of antiwar and civil rights protest groups arrived in the city.

Meanwhile, protestors inside the convention, many of them actual party delegates, held signs and shouted antiwar slogans. National TV crews covered the brewing chaos. Chicago police and security guards forcibly removed some protestors and roughed up CBS newsman Dan Rather when he tried to interview one.

Outside, protestors and police clashed. The situation soon turned violent. Some protestors damaged property, and police responded with extreme violence. As news crews inside got word of it, they sent cameramen outside to film.

Protestors, many of them bloodied and beaten, began chanting, "The whole world is watching!" Most of America was, at least, and millions of viewers were astonished as the Democratic Party officially nominated Humphrey while the streets echoed with violence.

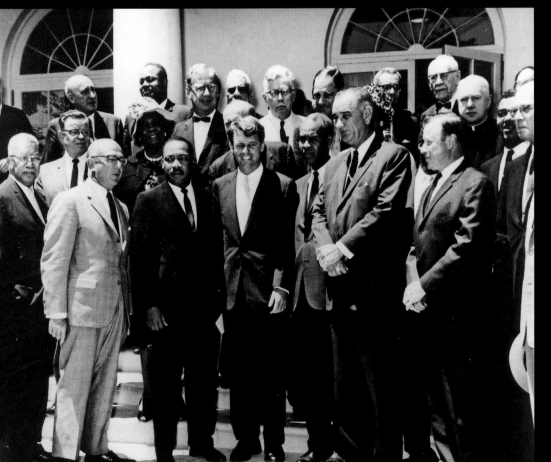

top: A soldier stands guard in Washington, D.C., on a street lined with the ruins of buildings destroyed during the riots following King's assassination. *Library of Congress,*

left: Civil rights leaders at the White House, 1963. *National Archives and Records Administration*

VIETNAM
THE LONGEST WAR

After World War II, local independence movements throughout Asia and Africa sought to cast off the oppressive yoke of European colonialism. In some cases, Europeans fought to maintain control of lucrative colonies. For eight years, France fought one such war for the Southeast Asian colony of Vietnam.

Vietnamese nationalist leader Ho Chi Minh, who had spent decades fighting for independence, sought support from the United States early on. But when the US declined, Ho turned to communist China for support, and the US threw its full backing behind France. During the early 1950s, France received roughly a billion dollars in US aid.

It was for naught. On May 7, 1954, French troops surrendered. Later that year, the United States oversaw negotiations of the Geneva Accords. Like Korea before it, Vietnam would be split north and south. Ho Chi Minh's national government ran the north, and a US-backed regime ran the south. National reunification elections were scheduled for 1956.

However, when it became apparent that Ho would win the election, the US-sponsored southern government refused to participate. Vietnam was now mired in a stalemate. The charismatic, popular Ho led the North while the South

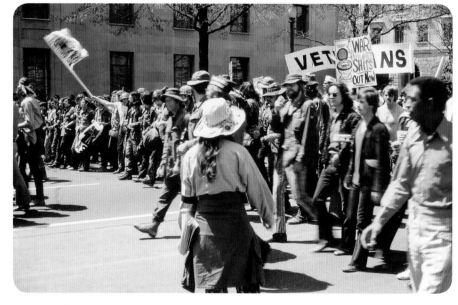

above: A 1971 antiwar protest in Washington, D.C. *Leena Krohn/public domain*

suffered under a corrupt and repressive government, which the United States was unhappy with, but felt compelled to support during the Cold War.

US aid to South Vietnam, which began with massive financial support, eventually included military advisers. Over time, those advisers began to participate directly in fighting between the two sides. By the end of the John Kennedy presidency in 1963, there were seventeen thousand US troops in Vietnam.

Under President Lyndon Johnson, American involvement spiked. Offering dubious claims of North Vietnamese attacks on American ships as justification, LBJ used the draft to enlist hundreds of thousands of Americans. By 1968, there were more than half a million US troops stationed in Vietnam. But having learned the lesson of Korea, Johnson would not let American forces invade the North, for fear of dragging China (which bordered Vietnam) into the war.

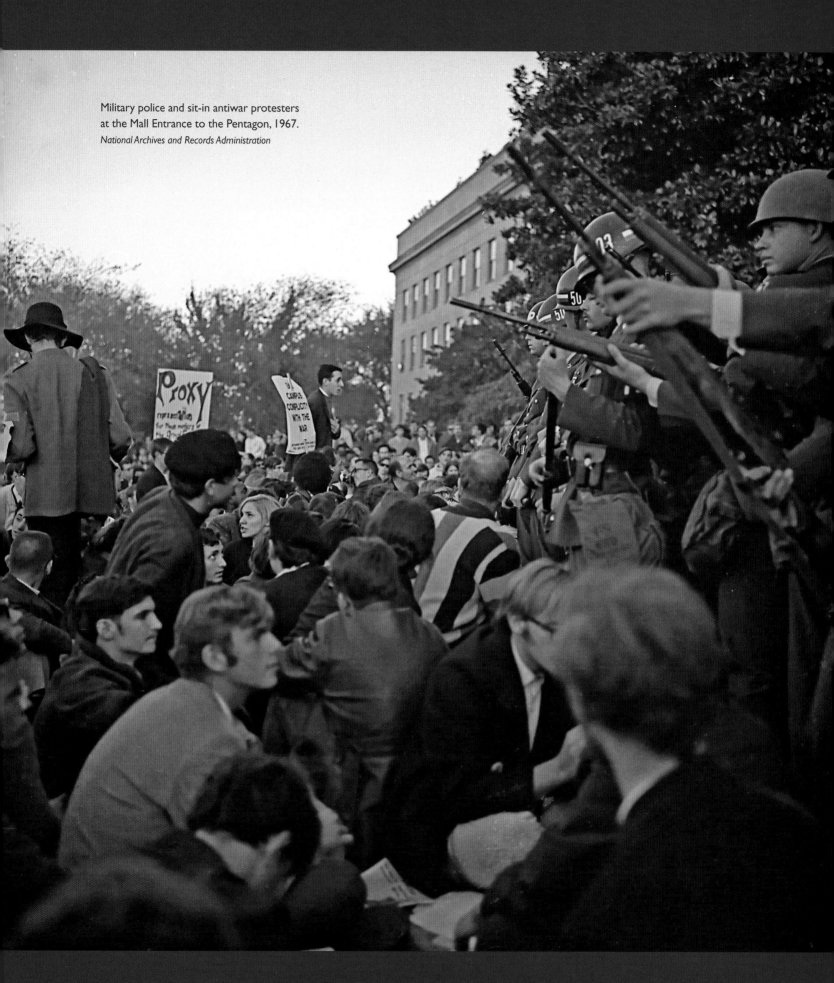

Military police and sit-in antiwar protesters
at the Mall Entrance to the Pentagon, 1967.
National Archives and Records Administration

By decade's end, Americans were sharply divided. Massive antiwar protests had become almost routine. Meanwhile, US and South Vietnamese forces proved incapable of effectively countering North Vietnamese guerilla attacks.

President Richard Nixon, in office from 1969 to 1974, reduced ground troops and the need for an unpopular draft by increasing bombing and assassination campaigns. The US would eventually drop more bombs on Vietnam than it did in all of World War II. Bombings also extended into neighboring Cambodia, which destabilized that nation and, ironically, led to a communist takeover. A quarter of the Cambodian population died in the ensuing slaughter.

US tactics also included the deforestation of Vietnam with a chemical defoliant called Agent Orange, which was later linked to birth defects in Americans and Vietnamese exposed to it, as well as the onset of cancer in Vietnam veterans. Most gruesome was the US use of napalm, a chemical gel that attached to people's flesh and burned them alive. Despite it all, American and South Vietnamese forces could not stop the communist North.

In 1975, President Gerald Ford ordered the final US evacuation, and the southern capital of Saigon soon fell. It was an expensive victory. Nearly a million Vietnamese had perished, while over fifty-eight thousand Americans had died.

After twenty-five years and six US presidents, America's longest war had finally ended in defeat.

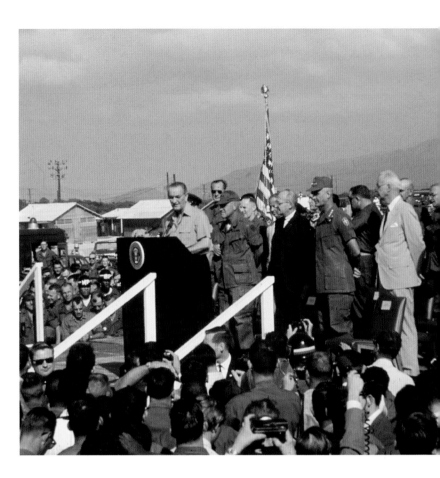

above: President Lyndon B. Johnson addresses US troops during a visit to Cam Ranh Bay, Vietnam. *National Archives and Records Administration*
below: Dedication ceremony at the Vietnam Veterans Memorial, Washington D.C., 1982. *Mickey Sanborn/US Department of Defense*

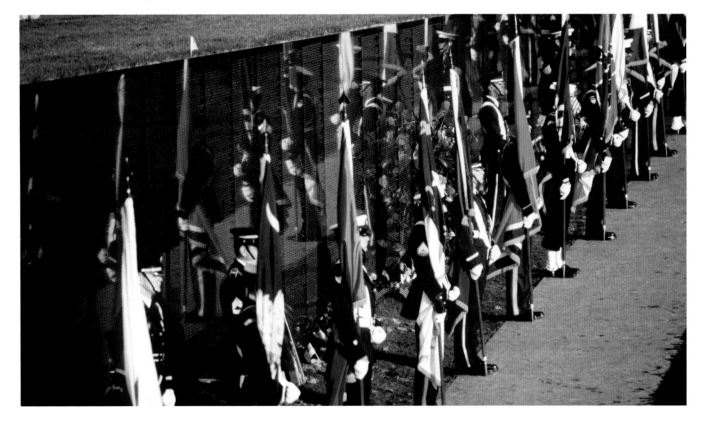

UPHEAVAL IN INDIAN COUNTRY

THE OCCUPATION OF WOUNDED KNEE

After more than half a century of direct colonial rule over Indian reservations (*see* **Cultural Genocide**, *page 160*), in 1934 the federal government began to ease its control. It finally rolled back campaigns to destroy Indigenous cultures and even granted reservation governments a degree of self-rule.

There are more than three hundred federally recognized tribes, pueblos, and rancherias in the United States. Each has its own government and no two are exactly alike; since the 1930s, Indian peoples' experiences with their governments have varied greatly.

One place where tribal government was often contested was the Pine Ridge Reservation in South Dakota, home of the Oglala Lakota Sioux people. Disputes over the Pine Ridge tribal council date back to 1933. Reservation Indians were divided, narrowly voting to accept a new tribal government based on a template promoted by federal officials.

Over the years, local discontent with the Pine Ridge tribal council system had waxed and waned. However, it hit a boiling point after the 1972 election of the new tribal council chairman, Richard "Dick" Wilson.

Wilson's brusque personality and dictatorial approach did not sit well with many. Critics accused him of nepotism and corruption. It wasn't long before opponents organized and began holding public protests against the chairman.

During this same period, the American Indian Movement (AIM) had begun making its presence felt on Pine Ridge. AIM was a strident, urban Indian protest organization of the Red Power era (akin to Black Power) that had kicked off in 1969 with the takeover of Alcatraz Island by Indian activists. It had recently brought its fiery rhetoric and

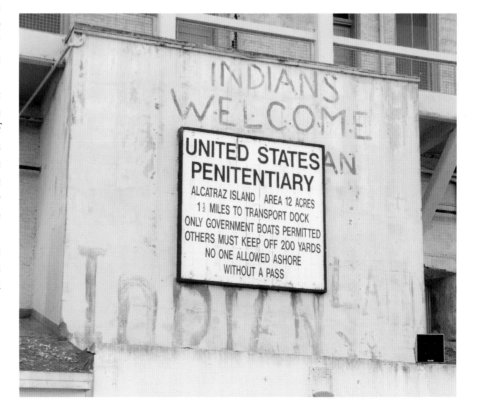

Graffiti remnants of the Native American Occupation at Alcatraz. *Wikimedia user Tewy/ Creative Commons*

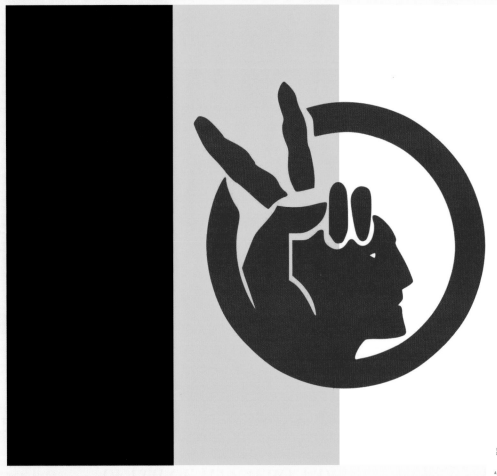

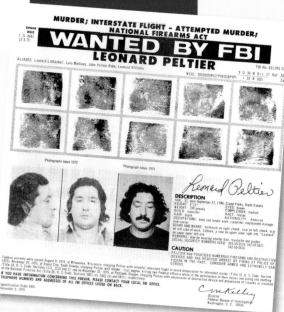

above: Flag of the American Indian Movement. *Public domain*

right: Federal Bureau of Investigation wanted poster for activist Leonard Peltier. *FBI*

confrontational tactics to protest a hate crime: the murder of an Oglala Lakota man in a town bordering the reservation. AIM members also supported local anti-Wilsonites on Pine Ridge, and a perfect storm was in the making.

When an impeachment trial failed to remove Chairman Wilson from office, his opponents decided to wage a major protest. But instead of doing so at tribal headquarters, which were now garrisoned by the FBI agents and US marshals that Wilson had summoned to the reservation, protestors opted to go to the village of Wounded Knee.

Located near the site of an 1890 massacre where the US Army had slaughtered nearly three hundred men, women, and children, Wounded Knee was a potent symbol not only to Lakotas, but to all Indian people. AIM joined

the procession, and protestors quickly took over the small hamlet. When surprised federal officials found out, they immediately surrounded Wounded Knee and cordoned it off.

What began as a local political protest had soon devolved into a series of firefights between AIM and well-armed federal forces. By the time the siege ended seventy-two days later, two Indians had been killed, one marshal was paralyzed, and the events at Wounded Knee had attracted national and international attention.

After Wounded Knee, Pine Ridge politics remained highly volatile for another three years. Wilson was re-elected in 1974 amid accusations of widespread electoral corruption. Both AIM and the FBI maintained their presence, exacerbating the violence.

In 1976, Wilson was voted out, AIM had gone into decline, and a degree of calm returned to Pine Ridge. However, periodic local protests against the reservation's tribal government have occurred from time to time, a reminder that, while conditions have since improved on many reservations, important issues remain.

GAS CRUNCH
THE OPEC EMBARGO

Gas shortage in Portland Oregon, 1973. *National Archives and Records Administration*

During the early twentieth century, the United States was the world's leading oil producer. However, after World War II, massive reserves were discovered and developed in the Middle East.

In 1960, five nations with large oil reserves formed an international cartel: the Organization of Petroleum Exporting Countries. Better known as OPEC, it quickly grew to a dozen members from around the globe, but its core is a half dozen Middle Eastern nations that supply a substantial amount of the world's oil.

The postwar US economy depended heavily on petroleum imports. By 1973, the United States was importing three million barrels of oil per day, much of it from OPEC. However, generally good relations with Middle Eastern governments, especially OPEC members, soured that year after war erupted between Israel and several of its Middle Eastern neighbors. When the United States chose to arm Israel, the Arab members of OPEC reacted by imposing an oil embargo on the United States beginning in October, 1973.

above: Lined-up cars waiting for gas, 1973. *National Archives and Records Administration*

left: Repurposed gas pump, 1973. *National Archives and Records Administration*

By the time the embargo was lifted the following March, the international price of a barrel of oil had quadrupled.

The effects of the OPEC oil embargo on the US economy were immediate and profound. As oil prices soared, the United States suffered a gas crunch. The price of a gallon of gas nearly doubled, and hoarding ensued as cars lined up at pumps. Filling stations closed because they were out of gas were not uncommon sights. Some stations used a three-color flag system to indicate whether gas was unrationed, rationed, or unavailable altogether.

The major gas rationing system limited vehicles based on their license plates. Plates that ended in an odd number could purchase gas on odd calendar days, while plates with even numbers on even days. Meanwhile, 90 percent of stations honored President Richard Nixon's request not to sell any gas on Saturday nights or on Sundays, leading to long lines on the other days.

The oil shortage affected the entire economy. Since most everything that Americans purchase is at some point trucked to a warehouse and/or a store, the price of gasoline is factored into the cost of most retail products.

Prices began rising as the nation was beset by inflation. Coincidentally, unemployment was also rising due to the loss of industrial jobs. The difficult combination of high unemployment and high inflation was a rare development referred to as stagflation.

The oil shortage also led to more practical problems, both serious and absurd. In December, millions of truckers waged a two-day strike. That same month, the state of Oregon banned Christmas lights. And when popular late-night talk show host Johnny Carson joked about a supposed toilet paper shortage, hoarding followed, and an actual shortage lasted for three weeks.

In the long run, OPEC's oil embargo boosted the energy conservation and environmental movements. Smaller cars with better gas mileage became more popular. In January of 1974, in an effort to lower fuel consumption, federal law mandated a fifty-five-mile-per-hour speed limit on all national highways. It remained in effect until 1987, when limits were allowed to rise to sixty-five. States did not regain the freedom to set their own speed limits until 1995.

WATERGATE

LOSING FAITH IN GOVERNMENT

On June 17, 1972, several men broke into an office at the Watergate Hotel in Washington, D.C. First reported as a burglary, over the next two years the break-in would mushroom into one of America's biggest political scandals and eventually culminate in the only instance of a sitting US president resigning from office.

The first sign of something bigger came when police found that the burglars possessed address books with a phone number for White House aide Howard Hunt. These were not common thieves. Nor was the victim a John Doe. The office belonged to Lawrence O'Brien, head of the Democratic National Committee. And 1972 was a presidential election year.

It turned out the burglars had actually been sent by the White House, and that this was not even their first break-in. Members of CREEP (Committee to Re-Elect the President), they had successfully broken into O'Brien's office three weeks earlier. Searching for any information that could help in the upcoming election, they had tapped the phone and photographed confidential documents. But when the phone tap malfunctioned, they returned to fix it and were caught.

Led by *Washington Post* reporters Carl Bernstein and Bob Woodward, the press doggedly worked the story. The *Post* reporters received information from a high-level source code-named Deep Throat. He was much later revealed to be Mark Felt, Associate Director of the FBI. Felt was outraged at the Nixon administration's various criminal activities.

The conspiracy went to the highest levels. CREEP was headed by Nixon's Attorney General John Mitchell, who had personally approved the break-in. As the dominos began to fall, more and more members of the president's inner circle were implicated, and it began to seem

top: The Nixon press conference releasing the transcripts of the White House tapes. *National Archives and Records Administration*

inset: ChapStick tubes outfitted with tiny microphones, discovered in Hunt's White House office safe following the Watergate break-in. *National Archives and Records Administration*

very likely that even Nixon himself had been aware of the break-in.

Despite mountains of circumstantial evidence, Nixon went to his grave denying he knew of the plans beforehand. However, he was fully briefed shortly after the arrests and had ordered the coverup. Nixon came up with nearly half a million dollars in hush money for the accused, and went so far as to illegally order the CIA and FBI to stop investigating the affair. But law enforcement and the press kept digging.

In May of 1973, Congress began holding its own hearings, which were broadcast live on TV and radio. Nixon resisted every step of the way. Eventually, the US Supreme Court ordered him to hand over secret audio recordings made in the Oval Office. When they finally showed up, crucial sections had been "accidentally" erased.

In July of 1974, the House of Representatives voted to impeach President Nixon on charges of obstruction of justice, resisting a subpoena, and constitutional violations concerning illegal wiretaps and misuse of the CIA, FBI, and IRS. In the votes of 27 to 11 and 28 to 10, Democrats were unanimous, and Republicans split almost evenly. Prominent Republicans,

including Henry Kissinger, George H. W. Bush, and Barry Goldwater, advised Nixon to resign instead of facing a trial in the Senate and disgracing the nation by becoming the only president forced from office.

When the incriminating audiotapes were released to the public on August 5, the pressure became overwhelming. On the evening of August 8, 1974, President Nixon went on national television to announce his resignation, while also maintaining his innocence. The next day, he and his wife boarded a helicopter, and Gerald R. Ford was sworn in as the new president.

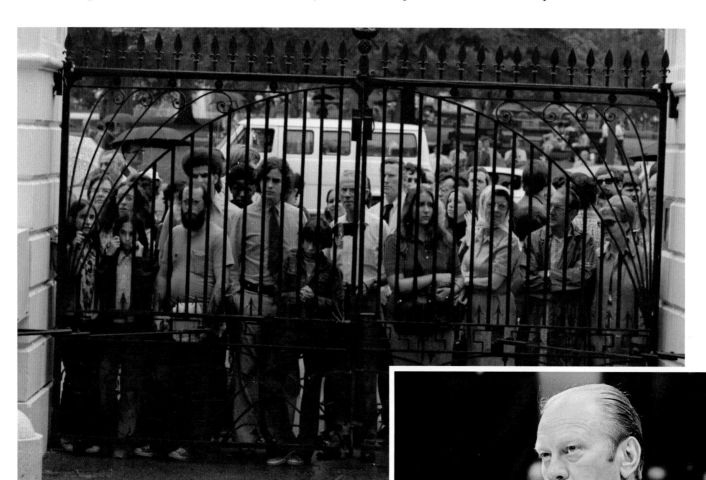

above: A crowd outside the White House gate the day of Nixon's resignation, 1974. *National Archives and Records Administration*

right: President Gerald Ford at the House Judiciary Subcommittee hearing on pardoning Richard Nixon, 1974. *Library of Congress*

A MODERN PLAGUE

"Don't listen to rumors about AIDS. Get the facts!"

Patti LaBelle

KNOW FOR SURE HOW YOU CAN GET IT, & HOW YOU CAN'T

CALL 1-800-342-AIDS

Public Health Service
U.S. Department of
Health and Human Services

American
Red Cross

AIDS

Human Immunodeficiency Virus (HIV) is the virus that causes Acquired Immune Deficiency Syndrome (AIDS). It most likely originated from Simian Immunodeficiency Virus (SIV), a similar virus found in West African primates. SIV is normally quite weak when infecting humans. However, its mutation into HIV has proven to be one of the deadliest viruses known to humanity.

HIV first appeared among humans in West Africa around the turn of the twentieth century. SIV probably evolved into HIV when circumstances allowed it to spread quickly among humans, allowing the virus time to mutate into HIV. One possible circumstance was the European conquest of West Africa, which led to high levels of prostitution that had not been present in the region before. Another possible circumstance was the reuse of unsterile needles during mass vaccination and antibiotic treatment programs in Africa after World War II.

A 1980s Public Health Service poster for AIDS awareness, featuring celebrity singer Patti LaBelle. *US National Library of Medicine, History of Medicine Division*

An AIDS vigil in Seattle, Washington, 1993.
Joe Mabel/Creative Commons

The first documented case of AIDS was recorded in the Congo in 1959. The first clinically observed case of AIDS in the United States occurred in 1981.

Early US cases were almost exclusively among drug users who passed the virus by sharing needles and gay men who passed it during sex. It can also move from mother to child during pregnancy or through breastfeeding.

At first, clinicians did not even have a name for the new disease. The American press quickly picked up on the connection to homosexuals and labeled it GRID: Gay-Related Immune Deficiency.

In the early 1980s, the LGBT rights movement was still in its infancy, and homophobia was a prominent part of American culture. Even as the official name changed to AIDS in 1982, in the popular culture it was already stigmatized as a "gay disease." Some extremists even claimed that AIDS was God's way of punishing homosexuals.

Slowly, attitudes began to change. In 1984, an eleven-year-old hemophiliac boy named Ryan White was expelled from his school in Indiana after contracting AIDS during a blood transfusion. His story shook the nation, and White became a poster child for fighting the disease. The death of beloved Hollywood star Rock Hudson from AIDS in 1985 was also a turning point. Hudson's homosexuality had been a carefully guarded secret until then.

In 1991, basketball legend Magic Johnson announced that he was HIV positive. More bigotry was exposed and challenged when some NBA players refused to play against Johnson, forcing him to retire.

All the while, LGBT activists challenged the pervasive bigotry. On October 11, 1987, the NAMES Project Foundation unveiled the AIDS Memorial Quilt on the National Mall in Washington, D.C. Larger than a football field, it was composed of nearly two thousand homemade panels, each with the name of a loved one who had died of AIDS. The following year, it was up to six thousand panels.

Changing attitudes coincided with increased federal funding for research. By the 1990s, AIDS was no longer the equivalent of a quick death sentence. Potent but expensive drugs have made the disease more manageable. But there is still no cure.

To date, about seven hundred thousand Americans have died of AIDS. Currently, more than a million Americans are HIV positive. By 2012, over thirty-five million people around the world had died, with another two million dying every year.

Protesters in Evansdale, Iowa, speaking out against the establishment of a local HIV-AIDS hospice, 1990. *Gitone/Creative Commons*

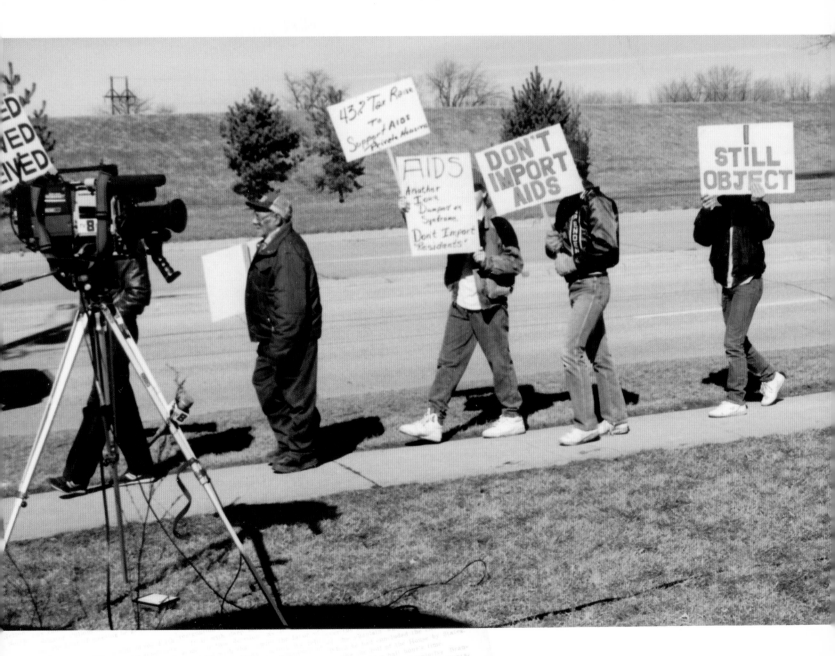

TRIUMPH

Nowadays, it's commonplace for Americans to think of their nation as the greatest on Earth—to express, in one way or another, the notion that we are "number one." However, that was not always the case.

Even the most successful and privileged Americans of the nineteenth century harbored no illusions about the United States' supposed preeminence. They may have cherished personal liberties, salivated at various opportunities, and lauded the merits of their newly formed republic, but everyone realized the United States was a young nation that was, in many ways, wanting. Nineteenth-century Americans struggled mightily with their nation's shortcomings and growing pains, including the carnage of the Civil War (1861–1865). And on the international stage, the United States was a very minor player, greatly overshadowed by distant European empires.

Rather, it was during the twentieth century that the United States emerged as the wealthiest, most powerful, and most influential empire in human history. All fifty stars had not yet spangled the national banner before the country began transcending its coastal borders and adding overseas possessions, ranging from Puerto Rico and Cuba in the Caribbean to the Philippines and Guam in the South Pacific. Meanwhile, the American economy, driven by industry and agriculture and fed by immigration and urban growth, boomed to unprecedented heights, surpassing all other nations. And American inventions reshaped the world while American culture redefined it.

American achievements came in many forms and from many corners. Sometimes it was talented people making the most of their abilities. Sometimes it was underdogs overcoming long odds. Sometimes accomplishments came with great fanfare. Sometimes their greatness was not recognized until much later. Sometimes people made the most of limited opportunities. Sometimes they rose to the occasion when unforeseen circumstances befell them. Some achievements dramatically improved the quality of life for people in the United States and around the world. Some merely brought smiles to people's faces. But whatever their form, circumstance, or impact, American triumphs throughout the twentieth century were plentiful and far reaching, helping the nation rise to new political, cultural, and economic heights.

Of course, not all was triumph and celebration. Along the way, there were mistakes and missteps, failures and frustrations, inequality and iniquity. However, despite various shortcomings and setbacks, the twentieth century witnessed unparalleled US triumphs, marking it as the American Century.

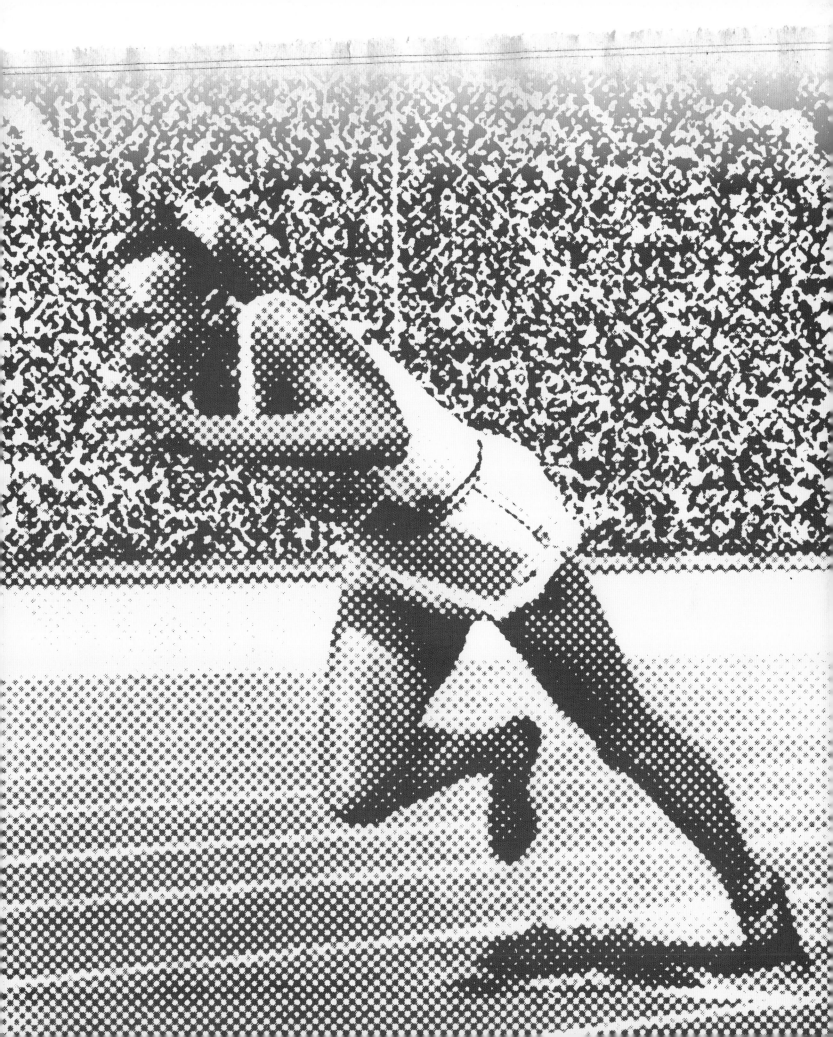

ELLIS ISLAND
THE GOLDEN DOOR

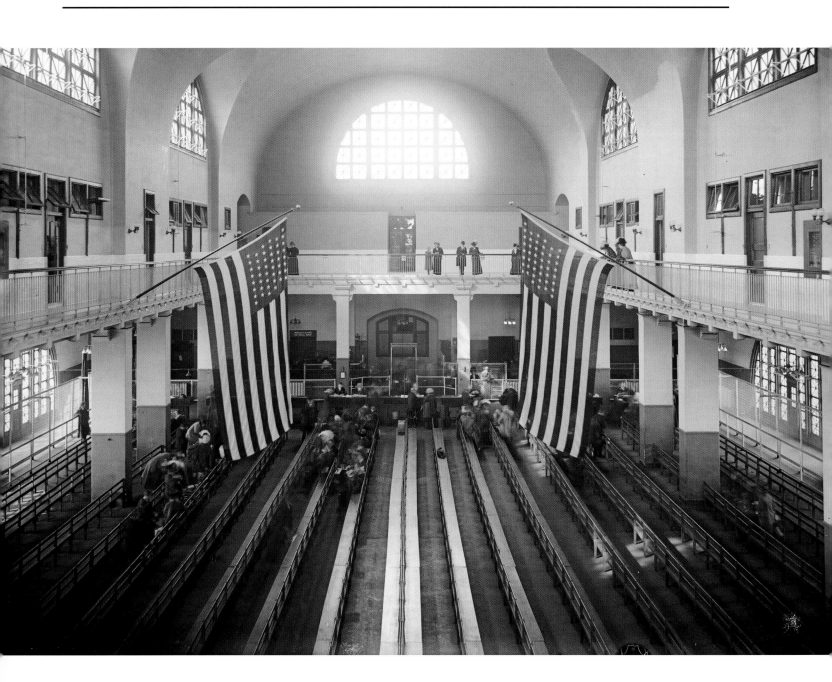

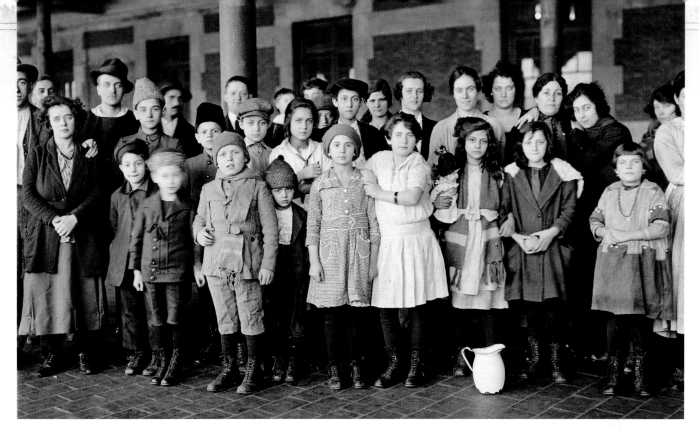

above: Immigrant children on Ellis Island, 1908. *Records of the Public Health Service* **opposite:** Ellis Island inspection room, circa 1908. *Library of Congress*

In 1876, France commissioned sculptor Auguste Bartholdi to commemorate the American centennial. Ten years later, Bartholdi had completed his statue. Made of copper and standing 151 feet tall, it was brought to Bedloe's Island in New York Harbor. There, it was mounted upon a 150-foot-tall, American-made stone pedestal.

Political speeches dominated the 1886 unveiling ceremony, most highlighting the friendly relationship between France and the United States. Then came a poem by Emma Lazarus, commissioned in 1883 to raise money to pay for the base. The crowd listened to her lines, which were also emblazoned upon the pedestal they had helped fund:

> *Give me your tired, your poor,*
> *Your huddled masses yearning to breathe free,*
> *The wretched refuse of your teeming shore,*
> *Send these, the homeless, tempest-tost to me,*
> *I lift my lamp beside the golden door!*

The poem received a smattering of polite applause. The unveiling ceremony for the Statue of Liberty was then returned to the politicians, who failed to realize that Lazarus's inscription was prophetic: the statue would quickly become the preeminent symbol of welcome for new immigrants to America.

Before 1850, immigration to the United States was largely unregulated. For the most part, anyone could just show up, and processing was left to the individual states. Due to its busy harbor, New York City was by far the largest port of entry. Other important entry points were Baltimore, Philadelphia, Boston, and New Orleans, all of which were busy entrepôts for trade.

During the 1840s, large waves of German and Irish immigration began to overwhelm New York's resources, and the state sought federal intervention. By 1855, federal policies for processing immigrants were in place.

Immigration to the United States was slowed by the Civil War (1861–1865), but a new wave began in 1880. Over the next forty years, more than twenty-three million people would come to the United States.

Around the world in general, this was an era of massive migration, particularly out of Europe. Millions also moved to countries such as Canada, Brazil, Argentina, and Australia. But none of those countries received anywhere near as many immigrants as the United States. For example, between 1901 and 1910, more people moved to the US than had moved to Canada over a one-hundred-year period (1821–1921).

In 1892, as the number of immigrants grew, the federal government opened a new processing center on Ellis Island in New York Harbor, less than a quarter mile from the Statue of Liberty. At its peak of operation, the facility received over eight thousand people per day.

Eventually, immigration restriction laws of the 1920s greatly stemmed the tide. Nonetheless, by the time Ellis Island closed in 1954, it had processed more than twelve million people.

In 1965, the old immigration port and the symbolic statue were officially joined together when Ellis Island became part of the Statue of Liberty National Monument, which is visited by more than three million tourists each year.

LET FREEDOM RING

AMERICANS GET TO VOTE FOR US SENATORS

As originally written, the US Constitution made few provisions for the election of national politicians. In fact, the only federal office citizens could vote for directly was the House of Representatives. Judges were appointed by the president. The president himself was officially voted into office by the College of Electors, whose members were appointed and not beholden to the people's votes (this is still the case). US senators were chosen by state legislators.

Often mislabeled a "democracy," it was actually a republic with modest democratic institutions the founders had designed. Qualified citizens would have limited input into choosing their national leaders.

The founders had drastically limited voter input because many of them feared the prospect of "too much" democracy. While they championed limited voter participation, they also worried that individual voters were corruptible. They were concerned about bribery and other forms of corruption possibly infecting the electorate and also feared the possibility of mob rule.

By the late nineteenth century, corruption had, in fact, become a prominent part of US electoral politics, but the main problem wasn't with the average voter. Rather, large corporations and wealthy businessmen had flooded the electoral system with money.

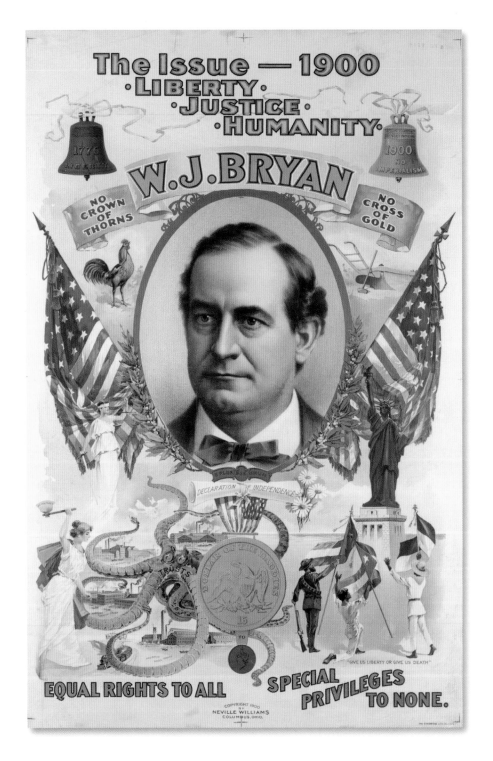

Campaign poster for William Jennings Bryan, who campaigned for the popular election of US Senator. *Library of Congress*

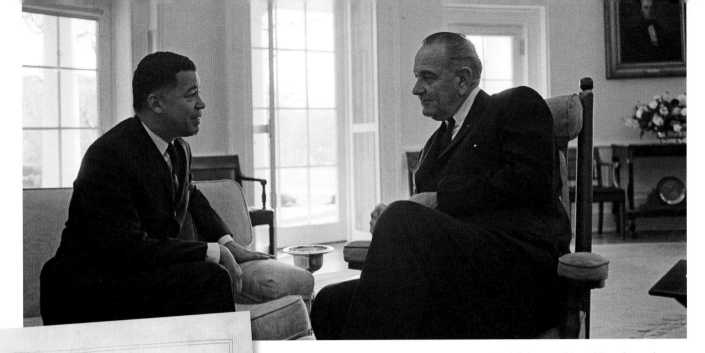

Sixty-second Congress of the United States of America;

At the Second Session,

Begun and held at the City of Washington on Monday, the fourth day of December, one thousand nine hundred and eleven.

JOINT RESOLUTION

Proposing an amendment to the Constitution providing that Senators shall be elected by the people of the several States.

Resolved by the Senate and House of Representatives of the United States of America in Congress assembled (two-thirds of each House concurring therein), That in lieu of the first paragraph of section three of Article I of the Constitution of the United States, and in lieu of so much of paragraph two of the same section as relates to the filling of vacancies, the following be proposed as an amendment to the Constitution, which shall be valid to all intents and purposes as part of the Constitution when ratified by the legislatures of three-fourths of the States:

"The Senate of the United States shall be composed of two Senators from each State, elected by the people thereof, for six years; and each Senator shall have one vote. The electors in each State shall have the qualifications requisite for electors of the most numerous branch of the State legislatures.

"When vacancies happen in the representation of any State in the Senate, the executive authority of such State shall issue writs of election to fill such vacancies: *Provided,* That the legislature of any State may empower the executive thereof to make temporary appointments until the people fill the vacancies by election as the legislature may direct.

"This amendment shall not be so construed as to affect the election or term of any Senator chosen before it becomes valid as part of the Constitution."

Champ Clark
Speaker of the House of Representatives.

Vice President of the United States and
President of the Senate.

In particular, US Senate seats were susceptible to corruption. Instead of having to buy hundreds of thousands or millions of voters, unscrupulous persons could put their man in the Senate by bribing just a few dozen state legislators. And such corruption was not uncommon; railroads and mining companies in particular were notorious for buying their men into the Senate.

During the Progressive Era (circa 1890–1920), millions of Americans rallied around the idea that they could improve society and that democratic government was the means to do so. Among the many different agendas that various progressive reformers advanced was an effort to clean up government corruption.

This era saw the rise of new democratic mechanisms in local and state politics that allowed citizens to bypass corrupt officials. Examples include the introduction of initiatives (passing new laws by popular referendum) and the ability to recall (remove) corrupt politicians from office, also by popular vote.

Disgusted by widespread corruption in the US Senate, reformers promoted the popular election of senators as a way to bypass the state legislatures that, at times, were too easily bought. By 1912, thirty-three states had implemented direct primaries for choosing senatorial candidates, thereby limiting the ability of monied interests to simply place their man in office.

As the movement for a constitutional amendment grew, politicians worried that a convention called by the states would be beyond their control. They feared the people's will.

Congress finally took action in 1912, passing a bill to amend the constitution. Within less than a years' time, three-fourths of the states had ratified the Seventeenth Amendment. As was the case with members of the House of Representatives, Americans could now vote to elect US senators.

TAKING THE GLOBAL STAGE

WOODROW WILSON VISITS EUROPE

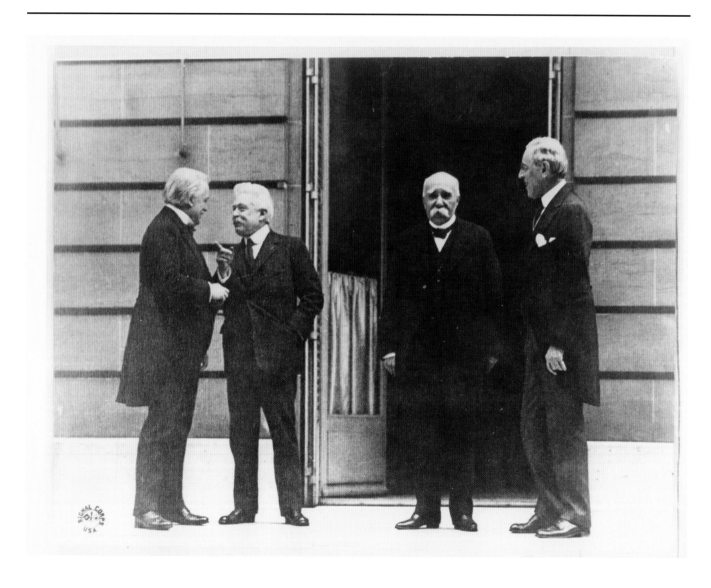

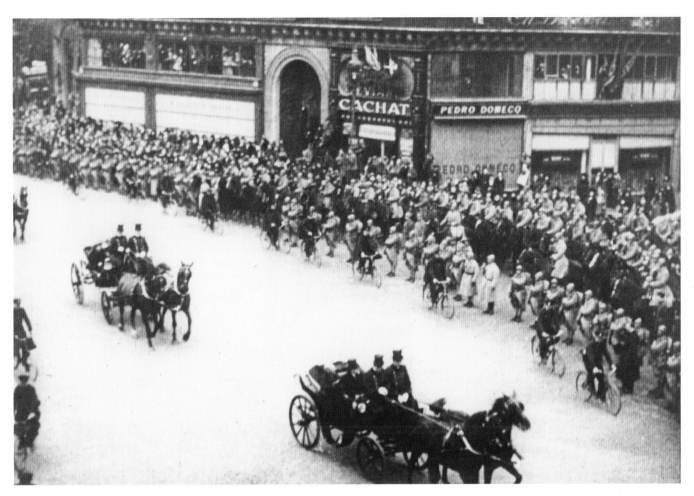

above: President Wilson's coterie parade, Paris, 1918. *Woodrow Wilson Presidential Library Archives*

opposite: The Council of Four at the Paris Peace Conference. Left to right: Lloyd George of Great Britain, Orlando of Italy, Clemenceau of France, and Wilson of the United States. *US Signal Corps/Woodrow Wilson Presidential Library Archives*

When George Washington stepped down from the presidency in 1797, he issued a farewell address in the form of a letter to the young nation. In it, he warned the republic to avoid becoming entangled in "the toils of European ambition, rivalship, interest, humor or caprice."

European empires posed a real threat to the new and struggling nation, which had only recently freed itself from Great Britain. Washington's advice was largely heeded during the ensuing century, and US foreign policy was often referred to as "isolationist."

To some degree, this was a misnomer. Many US politicians and business leaders did have expansionist ambitions, and the United States grew rapidly instead of merely looking inward. However, through the nineteenth century, US imperial

ambitions largely remained focused on the Americas: first conquering and dispossessing Indigenous nations, seizing a third of Mexico after the US-Mexican war, and then extending influence throughout the Western Hemisphere. Nevertheless, the United States did avoid many European entanglements.

US isolationism was put to the test during World War I. Initially, most Americans opposed joining what they viewed as just another war among European rivals, exactly the kind that Washington had warned them about. And President Woodrow Wilson publicly committed to keeping the United States out of the war, which began in 1914. Indeed, "He kept us out of war!" was one of Wilson's slogans during his successful re-election campaign of 1916.

Despite this, however, relations between the United States and Germany deteriorated, while US relations with Great Britain grew stronger. In 1917, Wilson called for a declaration of war against Germany, and Congress complied. American forces were in Europe the following year and would help break a stalemate. Over one hundred thousand Americans died in the war, though this was small compared to the millions of European soldiers who had perished.

In January of 1918, Wilson journeyed to Paris for treaty negotiations, becoming the first sitting president to visit the continent. Critics back home scoffed at the trip, calling him an egotist.

Upon arriving, Wilson issued his fourteen-point peace plan, a collection of high-minded goals to strive for after the

war ended. The Great War, he insisted, must have a higher moral purpose. His fellow heads of state at the conference (Georges Clemenceau of France, David Lloyd George of Great Britain, and Vittorio Orlando of Italy) were dubious. Clemenceau supposedly quipped, "Even Moses only had ten."

Not all of Wilson's ideas were incorporated into the treaties that emerged from the Paris Peace Conference, but he had a strong impact nevertheless. And the idea dearest to him was taken up by the other nations: a new international body designed to help prevent another world war. The League of Nations, forerunner of the United Nations, was founded in 1920. That same year, Wilson was awarded the Nobel Peace Prize (*see* **American Nobel Prize Winners**, *page 240*).

Ironically, the United States would be one of the few developed nations not to join the League. Isolationist currents still ran strong. Nonetheless, isolationism would never again be an unchallenged doctrine in US foreign policy. After various policy shifts during the interwar years, the United States emerged from World War II as a committed international player.

The signing of the Peace Terms at the Gallerie des Glaces (Hall of Mirrors), Versailles, France, 1919. *National Archives and Records Administration*

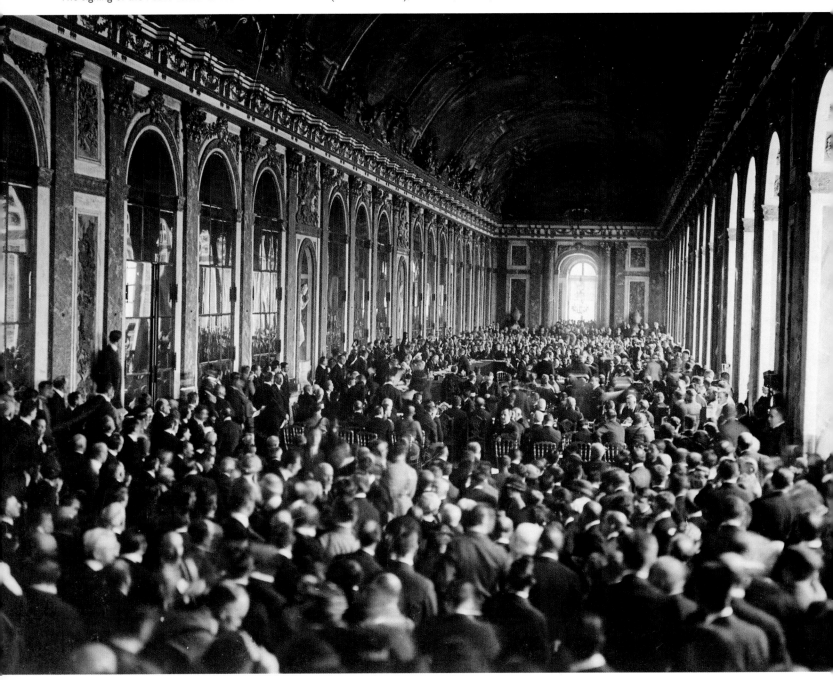

WOMEN'S SUFFRAGE

THE LONG ROAD TO THE NINETEENTH AMENDMENT

Women's efforts to be included in the new republic went back to that republic's origins. Abigail Adams had implored her husband, revolutionary leader and future president John Adams, to "remember the ladies" when it came time to devise a new nation. However, upon gaining their independence from Great Britain, none of the thirteen states allowed women to vote.

At the nation's first women's rights convention, held in 1848 in Seneca Falls, New York, delegates approved a Declaration of Sentiments that, among other things, advocated suffrage for women. The movement gained steam until it was overwhelmed by growing sectional tensions. The women's movement

left: Propaganda poster for the Artists' Suffrage League, circa 1910–1919.
Library of Congress

below: Cover of *Life* magazine, volume 61, no. 1582 (February 20, 1913). *Library of Congress*

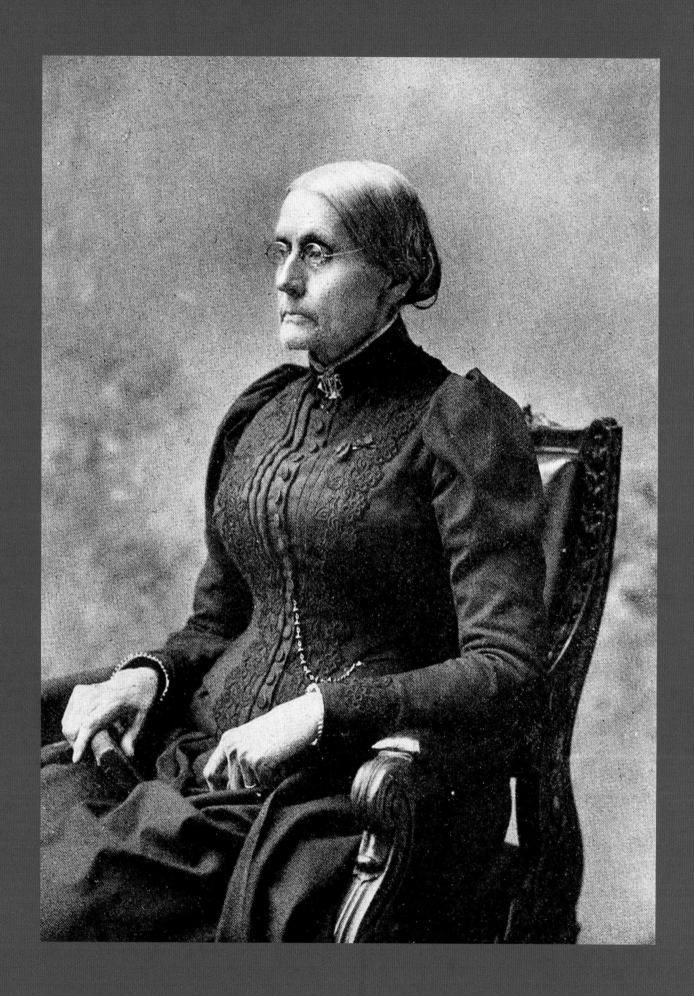

was centered in the North, and many advocates were also active in the antislavery movement. As war neared, many men in the antislavery movement pressured women to put the suffrage question on hold until the evil of slavery was banished.

After the Civil War ended in 1865, activist women again raised the issue. Susan B. Anthony and Elizabeth Cady Stanton founded the National Woman Suffrage Association (NWSA) in May of 1869. The group advocated for a constitutional amendment guaranteeing women the right to vote.

During the late nineteenth and early twentieth centuries, the map of American voting rights became a hodgepodge. Many states offered women a restricted franchise, allowing them to vote on such issues as school elections, or to vote in primaries but not in general elections. Western states and territories were generally more liberal, thirteen of them granting women full voting rights. Michigan and New York were the only eastern states to match them. Meanwhile, resistance was strongest in the mid-Atlantic and the South, where eight states did not allow women to vote at all.

In 1890, a merger of women's groups produced the National American Woman Suffrage Association (NAWSA). Led

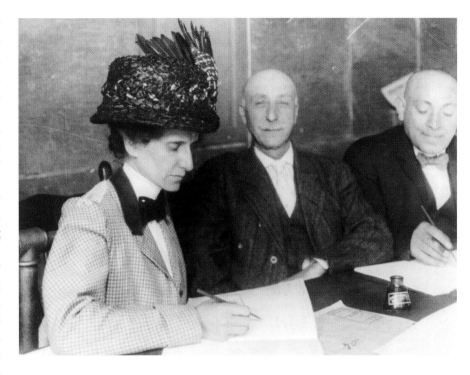

by Carrie Chapman Catt, beginning in 1900 the NAWSA adopted a moderate approach. The group lobbied governments, testifying at annual congressional hearings and organizing marches with thousands of women.

The National Women's Party (NWP), originally founded in 1913 by Alice Paul, used a different approach. Paul had split from Catt and now promoted civil disobedience. Among other things, NWP

members picketed in front of the White House for two years.

After the United States entered World War I, picketers were arrested for blocking traffic. Once in jail, many of the activists began hunger strikes. Paul and some others were subjected to forced feedings.

A bill to amend the constitution had been introduced in 1915, but it failed to pass. In 1918, with President Woodrow Wilson's support, it barely passed the House but came up two votes short in the Senate. In February of 1919, it failed by one vote. In May, Wilson called a special session of Congress, and in June it finally passed.

Approval by thirty-six states took more than a year. Tennessee tipped the balance in August of 1920, and the Nineteenth Amendment was ratified. Women were finally guaranteed the right to vote.

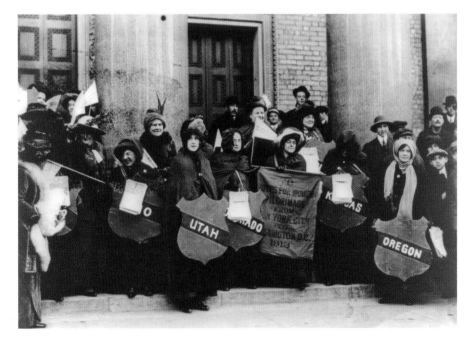

top: Edith Campbell registers to vote, circa 1912. *Library of Congress*

left: Suffragist march to Washington, D.C., 1913. *Library of Congress*

opposite: Susan B. Anthony, circa 1901. *Photographer unknown*

THE RACE AGAINST RACE

JESSE OWENS WINS FOUR OLYMPIC GOLD MEDALS

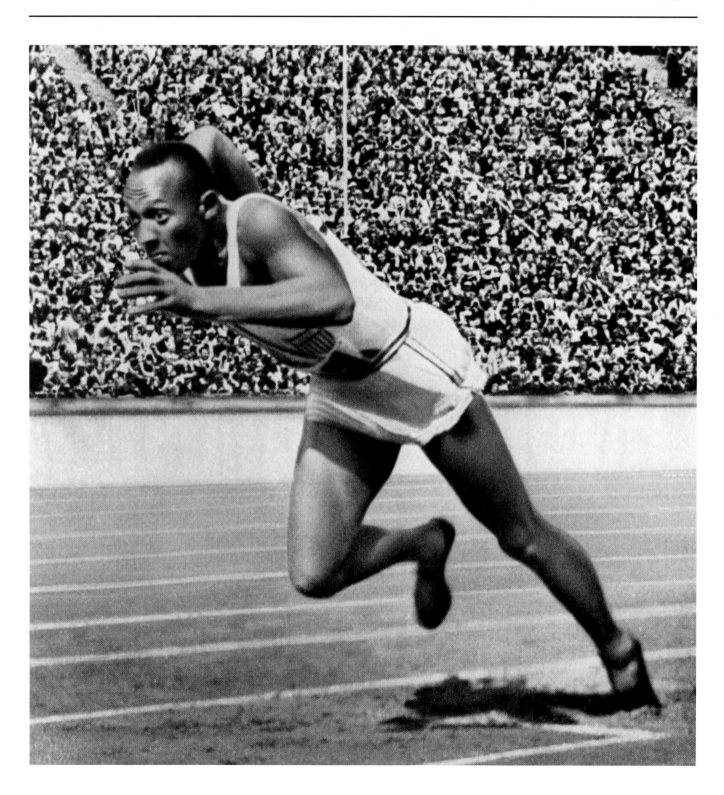

Although the United States would not enter World War II until late 1941 *(see* **A Day of Infamy***, page 176)*, strained relations with Nazi Germany began much earlier. Adolph Hitler had become Germany's dictator in 1934 and launched his expansionist programs the following year. In 1936, the same year the Summer Olympics were held in the German capital of Berlin, Hitler was ordering a military buildup on the French border.

Growing tensions in Europe were compounded by Nazi racism. Declaring the "Aryan race" (white, northern Europeans) to be the superior breed of humanity, Nazi propaganda scoffed at "inferior" darker races. With the Olympics approaching, Germany effectively barred Jewish and Romany (Gypsy) athletes from its own team, including even some world-record holders.

Berlin had been selected as Olympic host in 1931, before Hitler's rise to power. Now Holland, Sweden, the United Kingdom, France, and Czechoslovakia all debated boycotting the games. In the end they sent their athletes, though Spain and the Soviet Union did boycott.

There was also considerable debate on the issue in the United States. US Olympic Committee leader Avery Brundage opposed the boycott. Belonging to a Chicago athletic club that banned Jews, Brundage returned from a 1934 fact-finding mission to Nazi Germany claiming to have found no evidence of anti-Semitism. While many American Jews supported an Olympic boycott, many African Americans supported going to the games, believing that success by minority athletes would subvert Hitler's racial ideology. In 1935, over the objections of the US ambassador to Germany, the US Amateur Athletic Union narrowly voted to send an American team to the Berlin games.

The star of the US team was James "Jesse" Owens. After his family moved from Jim Crow Alabama to Ohio when he was nine years old, Owens had emerged as a track sensation. While attending Ohio State University, he was dubbed "the

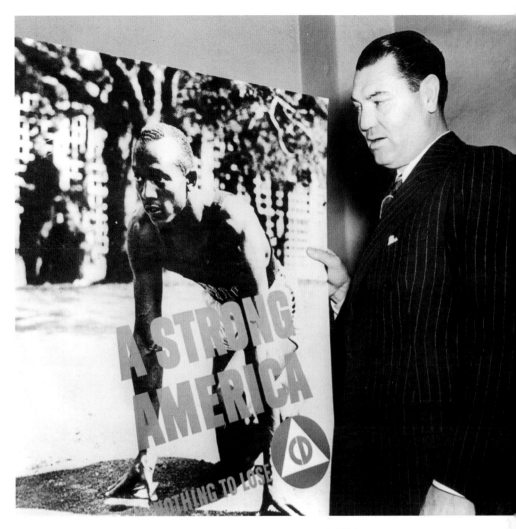

opposite: Jesse Owens breaks the two-hundred-meter race record, 1936. *Library of Congress*
above: American boxer Jack Dempsey poses with a Civil Defense poster featuring Jesse Owens, 1940. *Library of Congress*

Buckeye Bullet." During the 1935 Big Ten college track and field meet, Owens stunned the sports world by breaking three world records in a span of just forty-five minutes and tying a fourth later the same day.

At the Berlin Olympics, Owens earned gold medals on three consecutive days, winning the one-hundred-meter dash, the long jump, and the two-hundred-meter dash. In the two-hundred, the silver medalist was Mack Robinson, Jackie Robinson's older brother. Several days later, Owens became the first person ever to win four track and field gold medals in a single Olympics when the US team set a new world record in the 4×100-meter relay.

Americans reveled in Owens's victories, and he was welcomed home as a hero. But while symbolically defeating Nazi racism, Owens still had to endure American racism. Despite his moment of triumph, Owens was still subject to discrimination and segregation upon returning home. After a massive ticker-tape parade in Manhattan, Owens had to ride the freight elevator in the Waldorf-Astoria hotel to attend the reception held in his honor.

BUILDING A BLUE-COLLAR MIDDLE CLASS

THE GREAT SIT-DOWN STRIKE OF 1936-1937

During the nineteenth century, many Americans sank into poverty as independent, skilled tradesmen were replaced by poorly paid factory workers. More and more Americans worked long hours for starvation wages at difficult and often dangerous jobs.

During the turn of the twentieth century, millions of Americans turned to labor unions to improve their working conditions, but gains were erratic. Businesses typically resisted with tactics such as employing replacement workers to break strikes, locking out workers to break unions, and even resorting to violence with privately hired paramilitaries. Local, state, and federal governments often compounded matters by siding with industrialists, sometimes sending in police or even the army to break labor strikes.

In 1936, the United Auto Workers (UAW) was still a collection of small, regional locals. The UAW hoped to centralize into one national union

left: Speaker William B. Bankhead (left) and House Majority Leader Samuel Rayburn leave the White House after meeting with President Roosevelt to discuss the sit-down strike crisis, 1937. *Library of Congress*

below: A striker and his fiancée, Flint, Michigan. *Library of Congress*

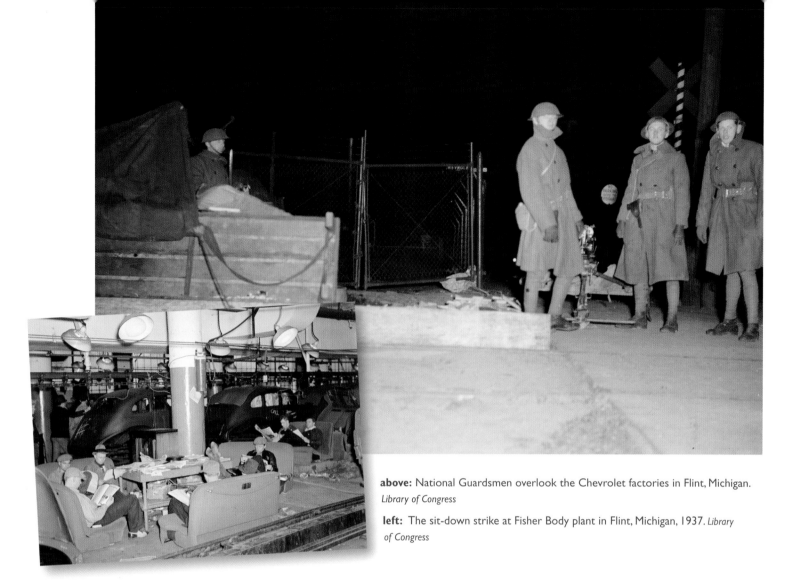

above: National Guardsmen overlook the Chevrolet factories in Flint, Michigan. *Library of Congress*

left: The sit-down strike at Fisher Body plant in Flint, Michigan, 1937. *Library of Congress*

by organizing workers at the world's largest automaker: General Motors, headquartered in Flint, Michigan. Only 122 of GM's 45,000 workers were unionized, and many of those holding union cards were actually spies for the company. GM also held sway over Flint politics.

Upon arriving in Flint, union organizers immediately faced death threats. Bypassing the existing, compromised union, organizers met in workers' homes and kept the names of new UAW members secret.

When a GM die plant in Cleveland went on strike on December 30, 1936, the UAW mobilized. On New Year's Eve, workers went on strike at the company's only other die plant, in Flint. Workers physically occupied the plant, preventing GM from removing equipment to set up elsewhere. Instead of picketing outside

the plant, some two thousand workers initiated the Great Sit-Down Strike, hunkering down inside the factory.

A county judge ordered the strikers out of the plant. The UAW exposed him for owning $200,000 worth of GM stock, and he was recused for conflict of interest. When police stormed the plant on January 4, workers beat them back. Women outside the plant broke windows to give strikers relief from the tear gas. Fourteen workers were struck by police bullets, but none died.

President Franklin Roosevelt refused to intervene. Michigan's governor, Frank Murphy, called up the National Guard and threatened to take the plant by force. When a second court injunction against the workers came down, the UAW ignored it and then staged a strike at another GM plant.

By the time the strike ended, workers had lived in the factory for over a month, supported by local businesses that fed and clothed them. On February 11, the UAW and GM signed a one-page agreement acknowledging the union. The workers had won.

While most developed nations now accept labor unions as a necessary part of the economic landscape, they remain controversial in the United States. However, organized labor would prove vital in establishing the new American middle class after World War II. More and more semi-skilled factory workers could now earn a middle-class wage, one of several factors that contributed to America's quarter century of postwar prosperity *(see* **Postwar Prosperity and the Rise of the Middle Class**, *page 228).*

SACRIFICE AND VICTORY

RAISING THE FLAG OVER IWO JIMA

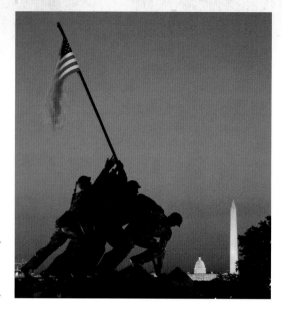

As US participation in World War II wore on from 1942 to 1945, Americans became accustomed to making sacrifices. By war's end, 420,000 Americans had been killed and another 670,000 seriously injured.

On the home front, the rationing of consumer goods became common as the government allocated valuable resources for the war effort. Items ranging from cars, gasoline, and silk stockings to food such as sugar, coffee, meat, cheese, and various canned goods had limited availability. Families received coupon books in the mail from the federal government. Rationed items could only be legally purchased when the buyer presented a government coupon to a merchant.

Meanwhile, thousands of men were making the ultimate sacrifice on the front lines. Millions volunteered for the armed forces, but it still wasn't enough. Seeking to enlist two hundred thousand men per month, the United States instituted a draft. Men aged eighteen to forty-five were eligible, and thirty-one million of them registered for the draft.

Amid the seemingly endless sacrifices, Americans searched for inspiration. Among the many moments they found, one in particular resonated throughout the nation.

For nearly two months, seventy thousand Americans had fought a bitter battle to take the island of Iwo Jima from Japanese forces that were dug in. By the time it was over, the United States would suffer 6,800 dead and nearly 20,000 wounded. It would be the deadliest battle in Marine Corps history and account for one-third of all marines killed in the war.

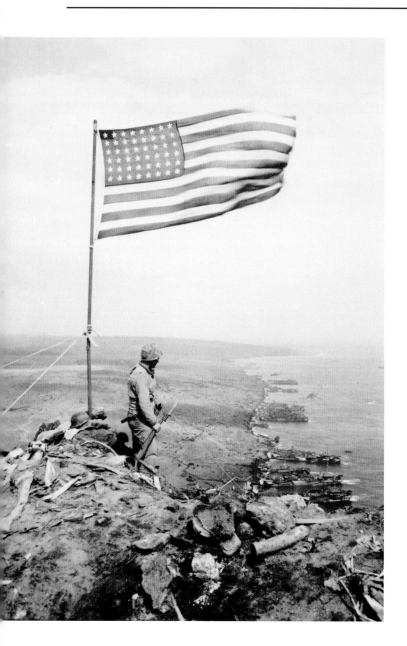

above: Iwo Jima Memorial, Washington, D.C. *Library of Congress*

left: The view from the crest of Mount Suribachi, with the flag over Iwo Jima, 1945. *National Archives and Records Administration*

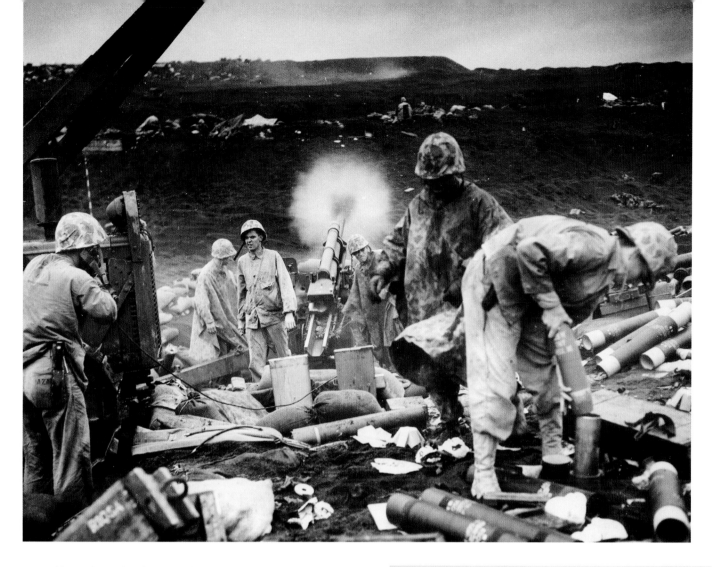

Halfway through, photographer Joe Rosenthal climbed the recently conquered Mount Suribachi. A US flag had already been raised, but now a marine commander ordered it taken down and replaced with a larger one. Rosenthal captured the moment as six men raised the new flag.

After Rosenthal's film was processed on Guam, the flag photograph hit the American press and immediately became an iconic image of the war. It was an instant sensation, inspiring millions of Americans with a sense of shared sacrifice and accomplishment. Three of the men in the photograph would not survive the battle. The other three were celebrities upon returning home. The federal government sent them on a tour around the country to encourage Americans to buy war bonds to fund the war effort.

In July, the US Post Office used Rosenthal's image on a stamp. It would do so again in 1995 to honor the fiftieth anniversary of the battle. In 1954, Felix de Weldon used the image as his model to sculpt the Marine Corps War Memorial, located next to Arlington National Cemetery. The photo has been reprinted in thousands of publications and is one of the most reproduced images of all time.

To this day, Rosenthal's picture remains the war's most famous image and, to many Americans, the most inspirational moment in American history.

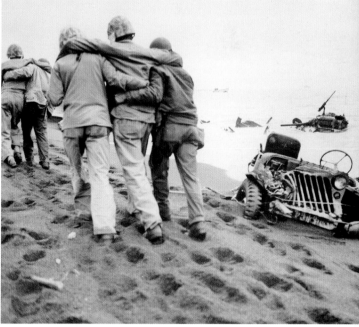

top: Marines of the 4th Division shell Japanese positions inland, 1945. *National Archives and Records Administration*

inset: Wounded marines are helped to an aid station by navy corpsmen. *National Archives and Records Administration*

VICTORY IN EUROPE

VE DAY

On December 8, 1941, the day after the attack on Pearl Harbor *(see page 176)*, Congress declared war on Japan. Japan's allies, Germany and Italy, declared war on the United States on December 11. Hours later, America responded in kind.

During the first half of 1942, the US and British navies used sonar and naval escorts to defend merchant ships under attack from German submarines. After a prolonged and costly action known as the Battle of the Atlantic, the Allies eventually sank enough German subs to open up safe shipping lanes across the ocean.

In November, while Russians weathered a fierce Nazi invasion, the US and British attacked German and Italian forces occupying North Africa, who retreated eastward, finally surrendering in Tunisia in May of 1943. In July, the US and Britain attacked the island of Sicily; after thirty-eight days, it was theirs. They then used the island as a launching pad to invade the Italian mainland.

Within two weeks of Allied forces beginning their march up the Italian peninsula, dictator Benito Mussolini had been toppled. Soon after, he was publicly executed. However, a hundred thousand German soldiers remained. A full conquest would take nearly two years.

The first Allied attacks on Germany itself came through the air. By the time the Italian campaign had begun, the Allies were bombing Germany around the clock. Early Allied casualties were high, but by 1944 German air defenses were largely destroyed.

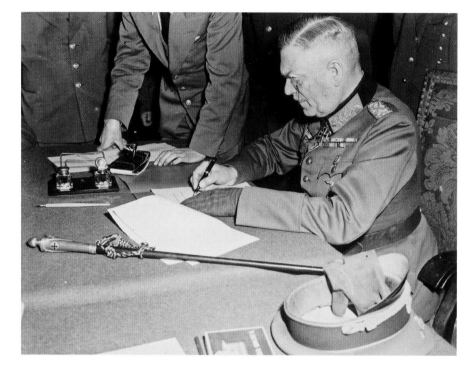

On June 6, 1944, the Allies finally moved to liberate France from Nazi control. D-Day began at dawn when three thousand Allied ships launched a surprise attack on northern France, and sixty thousand troops stormed the beaches of Normandy. Military intelligence was crucial, as the British broke the German code, enabling them to mislead the Germans about where the invasion would take place. Nevertheless, the Allies suffered heavy casualties, as German defenses kept them pinned to the beach for almost a month. On July 3, the US Army finally broke through and began a rapid advance. By August 25, they'd recaptured Paris.

Come autumn, the march to Germany was on. The last major German counteroffensive was the Battle of the Bulge, which ran through the winter. The largest engagement in US history, it utilized six hundred thousand American troops. Twenty thousand of them died.

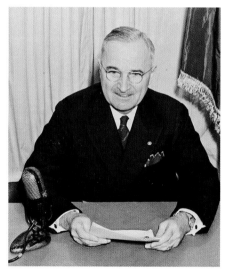

above: Field Marshal Wilhelm Keitel signs the ratified surrender terms in Berlin on May 7, 1945. *National Archives and Records Administration*

bottom: President Harry S. Truman announces the end of World War II in Europe, 1945. *National Archives and Records Administration*

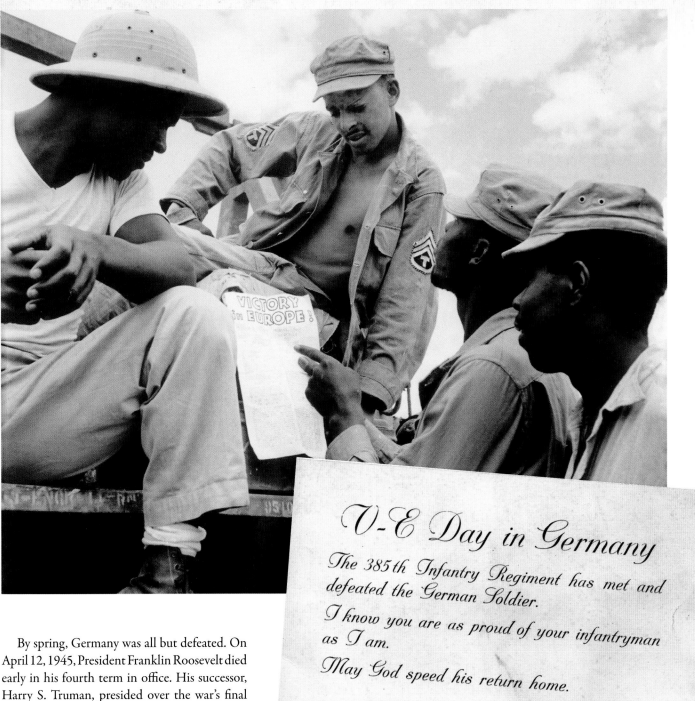

By spring, Germany was all but defeated. On April 12, 1945, President Franklin Roosevelt died early in his fourth term in office. His successor, Harry S. Truman, presided over the war's final months. On April 30, Adolph Hitler committed suicide as the Russian army approached from the east. They arrived first, the Americans and British shortly thereafter.

On May 8, 1945, VE day was announced: Victory in Europe. For that continent, the war was finally over. Now the United States turned its full attention to Asia.

V-E Day in Germany

The 385th Infantry Regiment has met and defeated the German Soldier.

I know you are as proud of your infantryman as I am.

May God speed his return home.

Peter W. Garland, Jr.
Lt Col, 385th Infantry Regt.
Commanding.

above: US troops in Burma read President Truman's Proclamation of Victory in Europe, 1945. *National Archives and Records Administration*

right: Card sent home to families of American GIs announcing the end of the war. *J. B. Frankel/public domain*

VICTORY IN ASIA

VJ DAY

After crippling the US fleet at Pearl Harbor (*see page 176*), Japan arguably possessed the world's most powerful navy. It ruled the Pacific unchallenged during the first half of 1942, setting up a ring of defenses stretching from Burma in the Indian Ocean to the tip of Alaska's Aleutian Islands.

In May 1942, the US Navy intercepted the Japanese navy in the Coral Sea. The battle was a draw, but it prevented Japan from invading Australia. In June came the turning point: the Battle of Midway.

When the two sides met one thousand miles west of Hawai'i, the Japanese boasted a superior fleet and naval air force, and battle-hardened pilots. However, the United States notched a decisive victory, in part because of superior naval intelligence— Americans had broken the Japanese code, learning the time and place of the attack and the composition of Japanese forces. The United States then launched a surprise attack. On June 4, the United States destroyed four Japanese aircraft carriers and 250 planes, killing many of its best pilots. Japan was now on the defensive.

After Midway, the United States employed a strategy of island hopping, digging Japanese forces out of the Pacific. In battles for islands such as Guadalcanal, Tarawa, the Solomon Islands, and Gilbert Islands, American forces faced entrenched defenders, and casualties were heavy on both sides.

Though Japan was in a state of retreat, the Japanese defense was fierce. Troops often fought to the death: when defeat was imminent, they sometimes committed suicide rather than surrender, or they launched suicide attacks.

As Japanese fuel reserves dwindled, suicide missions also came through the air; beginning in October of 1944, kamikaze bombers flew their planes into

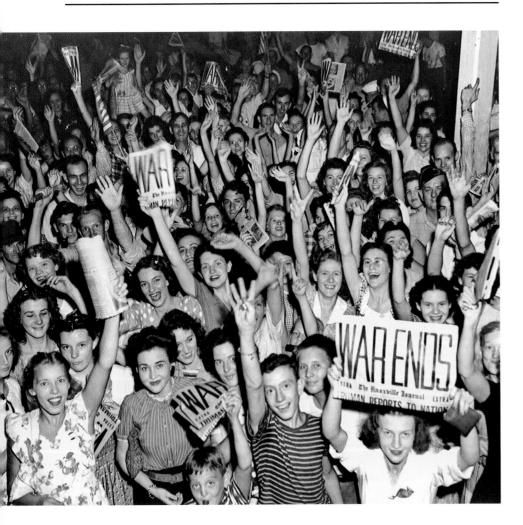

Residents of Oak Ridge, Tennessee, on VJ Day. Oak Ridge was one of the three main sites of the Manhattan Project. *Ed Wescott/ US Army*

US ships. During the last year of the war, 860 kamikaze pilots died, about one-fifth of them managing to hit American ships.

In the Battle of the Philippine Sea on June 19, 1944, the Japanese air force was all but annihilated. Saipan fell on July 9. On August 10, the United States recaptured Guam. By October, the United States controlled the Pacific Ocean.

After the United States conquered the Mariana Islands, American bombers could reach Japan. Well over one hundred thousand Japanese would die in the firebombing of Tokyo.

The battle for the Philippine island of Luzon began on January 25, 1945. By the time the island fell on June 30, most of the quarter million Japanese soldiers were dead, along with over one hundred thousand Filipino civilians. The battle of Iwo Jima (*see page 222*) rooted out Japanese air defenses that had been shooting down American planes. Meanwhile, the island of Okinawa was seen as a platform for an anticipated amphibian assault of the Japanese mainland. Following three months of fighting, Americans captured it on June 22, 1945.

After the United States invented the atomic bomb (*see **Splitting the Atom**, page 85*), the Allies issued the Potsdam Declaration, demanding Japan's unconditional surrender. Japan refused.

On August 6, 1945, the United States dropped an atomic bomb on the Japanese city of Hiroshima. Three days later, it dropped another on Nagasaki. At 7:00 p.m. on August 14, 1945, President Truman made the announcement: World War II was finally over. The nation was euphoric.

A two-day national holiday followed. But all was not celebration. Though the Allies had achieved victory, it had come at the cost of over 420,000 Americans who died in the war.

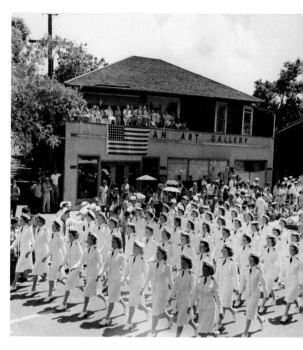

above: Pearl Harbor nurses march in a VJ Day Parade. September 3, 1945. *US Navy Bureau of Medicine and Surgery Administration*

below: New York City's Times Square on VJ Day. *National Archives and Records*

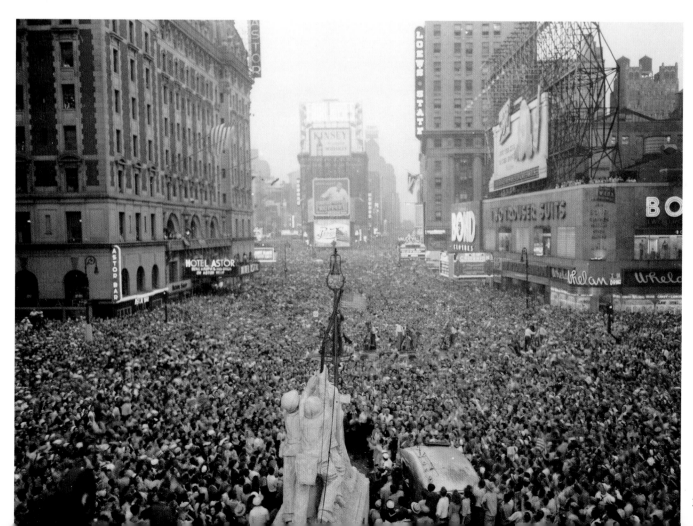

POSTWAR PROSPERITY AND THE RISE OF THE MIDDLE CLASS

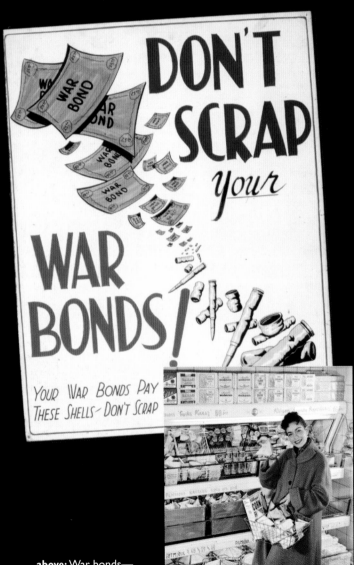

above: War bonds—the beginning of the golden era of American capitalism. *National Archives and Records Administration*

right: A housewife of the 1950s. *Tetra Pak*

After World War II, many of the world's leading economies were devastated. Europe and Japan lay in ruins. Only the United States had not suffered invasion. Further, mobilizing for the war had stimulated the nation's economy, slingshotting it out of the Great Depression and into an unparalleled era of prosperity.

The scope of US economic dominance after the war is difficult to overstate. During the late 1940s, the United States generated half of the world's entire manufacturing output. It produced 57 percent of the world's steel, 43 percent of its electricity, 62 percent of its oil, and 80 percent of its automobiles. With the American industrial economy roaring at war's end like never before, US unemployment stood at a minuscule 1.9 percent.

Nonetheless, America in 1945 was still very much a land of haves and have-nots. Although the United States was far and away the world's richest country, it still suffered from rampant poverty. About 30 percent of Americans, including most minorities, were poor. Even by 1947, well over 30 percent of homes had no running water, 40 percent had no flush toilet, 60 percent had no mechanical heating system (only a fireplace or stove), and 80 percent were heated by burning either wood or coal.

However, during the quarter century following the war, the United States experienced an unprecedented era of economic prosperity. Beyond America's enviable postwar position in the global economy, several factors helped foster the rise of the American middle class.

After the war, American consumers were sitting on a vast stockpile of wealth. Wartime shortages, rationing, and an ethos of self-sacrifice had translated into limited consumption. Workers had saved like never before. When the war ended, Americans collectively held nearly $140 billion in savings—or, on average, nearly $1,000 (more than $13,000 in today's money) for every man, woman, and child.

Suburban cul-de-sac, 1980. *Library of Congress*

Americans were ready to spend.

Big-ticket purchases, such as houses, appliances, and cars, helped fuel the economy and raise the standard of living for millions. Americans also spent money on smaller items, such as clothing, jewelry, toys, and various luxury items, many of which displayed social status and a new class consciousness. By the 1950s, many middle-class Americans felt the need to pursue the "good life," or at the very least to "keep up with the Joneses."

Meanwhile, American workers saw their wages rise. The economy was still based on blue-collar labor, with more than half of all jobs being in manufacturing, resource extraction, and agriculture. A growing share of workers was unionized, and many earned middle-class wages for the first time.

Thus, the nation's consumer class was stronger than ever; US consumers purchased America's industrial output (as did the rest of the world), and the economy surged. Instead of the boom-bust cycle that had marked the preceding 150 years, the United States witnessed a period of sustained growth.

Government spending also played a key role in sustaining prosperity. It had begun during the war, when federal spending jump-started several industries, including aircraft, electricity, electronics, chemicals, pharmaceuticals, food processing, and tobacco. After the war, massive government spending continued to stimulate the economy.

First came the GI Bill of Rights, a federal program to give vets a leg up. Passed in 1944, it offered them tuition money, low-interest business loans, insured home mortgages, and even unemployment benefits. By the time it ended in 1956, the government had spent tens of billions on the program, and 7.8 million vets had taken advantage of it.

Various federal and state road-building projects (see **From Sea to Shining Sea**, *page 190*) created jobs in construction. More importantly, the improved transportation system created sustained economic stimulation in areas such as trucking and automobiles.

And for forty years, the Cold War led the federal government to spend billions annually on military defense. The arms race (see **The Atomic Specter**, *page 187*) and the space race (**Beyond the Stars**, *page 95*) led to immense expenditures on defense contracts, even during peacetime. Armed conflicts in Korea and Vietnam further boosted military spending.

In 1973, the national poverty rate hit its all-time low at less than 12 percent, just as this unprecedented period of prosperity would begin to unravel. A more modest version of the old boom-bust cycle returned (see **Gas Crunch**, *page 199*).

Nonetheless, reaching and staying in the middle class was no longer just a dream—it was now the expectation of nearly all Americans.

SERVING SIDE BY SIDE

PRESIDENT TRUMAN DESEGREGATES THE US MILITARY

During World War II, over a million African Americans served their country. However, they did so as unequal members of a segregated military.

Although black and white soldiers had fought side by side during the Revolution and the War of 1812, the US armed services had been segregated since the Civil War.

During World War II, African Americans were segregated into all-black army units led by white officers. In the navy they were restricted to the low rank of steward's mates. And they had been completely banned from the US Marine Corps since 1798;

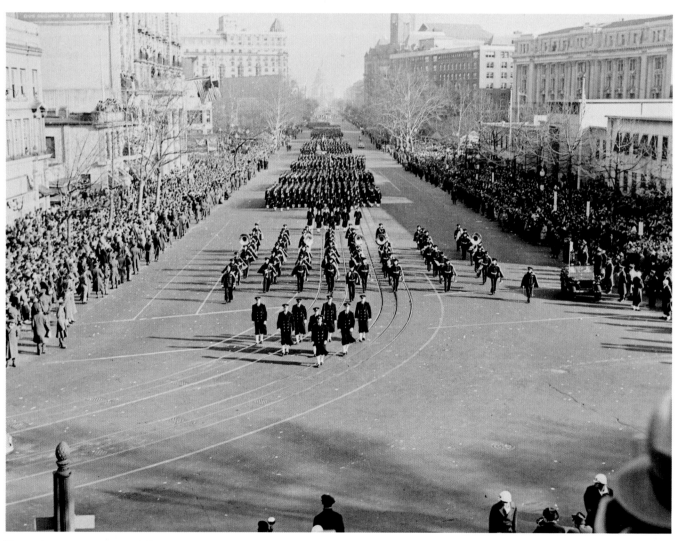

Truman's inaugural parade, 1949. *National Archives and Records Administration*

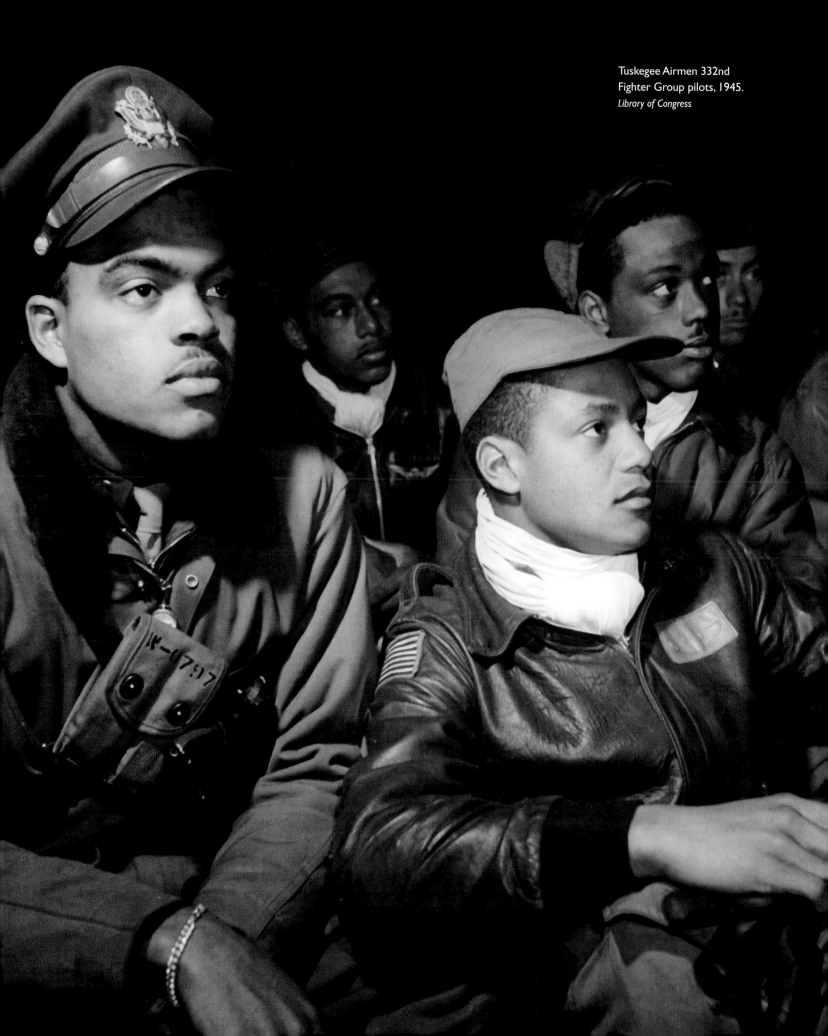

in 1942 they were allowed back in, serving in segregated units.

After the war, violence against African American veterans plagued the South. There were numerous instances of black vets, and occasionally their family members, being murdered by white mobs. Some were killed while still wearing their uniforms. In 1945, President Harry Truman had Secretary of War Robert Patterson appoint a commission to study the status of African Americans in the military. In April of 1946, it issued its report: "Utilization of Negro Manpower in the Postwar Army Policy."

Patterson's report suggested that restrictions on African American military personnel be removed and that they be given equal opportunity. But it did not recommend desegregating the armed forces. In essence, the report promoted a version of "separate but equal," the old justification for racial segregation.

As Truman pondered his next move, critics of integrating the US military claimed that such a move would damage soldiers' morale. It is the same argument opponents would use half a century later to justify maintaining the ban on gay service members.

At the end of 1946, President Truman formed a commission on civil rights. In late 1947, it submitted its report, entitled *To Secure these Rights*. The document took a hard line against racial segregation, calling for its banishment in America. The report specifically requested that the military end segregationist policies.

President Truman favored the dismantling of segregation and the advancement of civil rights. His options, however, were limited. The Jim Crow South still functioned as a de facto one-party region based on white supremacy. Despite being members of the president's party, southern Democrats made it clear they would kill any civil rights bill that came before a vote.

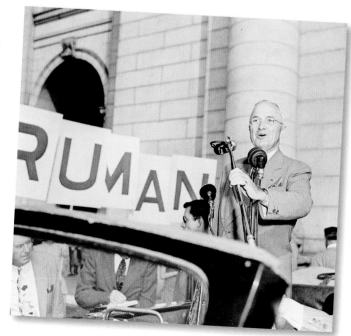

With congressional action unforthcoming, Truman used the power of the executive branch to bolster civil rights. He strengthened the Justice Department's civil rights division, appointed the first black federal judge, and appointed several African Americans to high-ranking positions within his administration.

As commander in chief, Truman could change the military without consent from Congress. On July 26, 1948, he issued Executive Order 9981, which desegregated the US military.

The order called it "essential that there be maintained in the armed services of the United States the highest standards of democracy, with equality of treatment and opportunity for all those who serve in our country's defense." EO 9981 banned discrimination in the US military on grounds of race, color, religion, or national origin.

Since that day, American military personnel of all races have again served side by side.

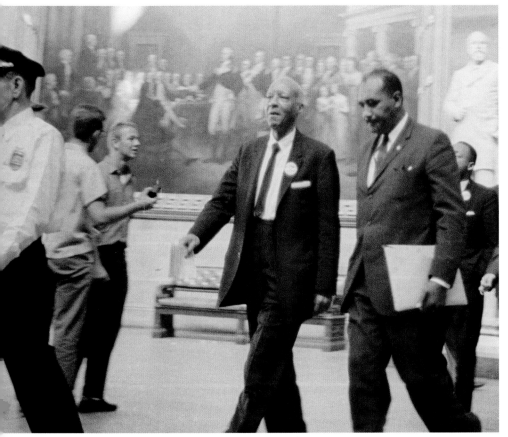

above: Truman speaks in Washington, D.C., 1948. *National Archives and Records Administration*

left: A. Philip Randolph and other civil rights leaders on their way to Congress during the March on Washington, 1963. *Library of Congress*

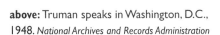

GIDEON'S TRUMPET

GIDEON V. WAINWRIGHT AND THE RIGHT TO A FAIR TRIAL

In the wee hours of June 3, 1961, someone broke through the door of the Bay Harbor Pool Room in Panama City, Florida. The burglar smashed a cigarette machine and a jukebox, stole $5 worth of change from the cash register, and absconded with some bottles of beer and soda.

Later that day, twenty-two-year-old Henry Cook fingered Clarence Earl Gideon for the crime. Cook told police he had seen Gideon leave the pool hall at five thirty that morning, with a bottle of wine and pockets full of change. Gideon was arrested later that day.

The fifty-year-old Gideon had already had a tough life, including numerous scrapes with the law. He had run away from home at age thirteen. As an adult, he was in and out of prison, doing stints in Texas, Missouri (twice), and Kansas—all for theft. At his trial, Gideon was too poor to afford a lawyer; when he asked the court to appoint

one for him, the judge apologized and informed him that Florida law only entitled defendants to a court-appointed lawyer if they were charged with a capital offense.

"The United States Supreme Court says I am entitled to be represented by counsel," Gideon insisted, but the judge denied his request. Gideon was convicted and sentenced to five years in prison.

Accessing the prison library, Gideon began working on an appeal. He had a strong case. The Sixth Amendment to the US Constitution reads, in part: "In all criminal prosecutions, the accused shall . . . have the Assistance of Counsel for his defence." While this was generally interpreted at the time as applying only to federal court cases, Gideon reasoned that the due-process clause of the Fourteenth Amendment (1868) made it applicable to state courts as well.

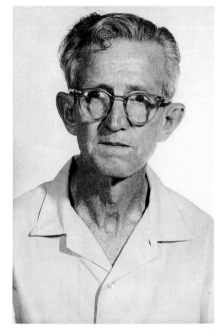

Clarence Earl Gideon mug shot, 1961.
State Archives of Florida, Florida Memory

Gideon's petition for certiorari to the
US Supreme Court, 1963. *National Archives
and Records Administration*

Writing in pencil on prison stationery, Gideon filed his appeal against the Secretary of the Florida Department of Corrections, H. G. Cochran. Eventually the case made it all the way to the United States Supreme Court, by which time Cochran had been replaced by Louis L. Wainwright.

On March 18, 1963, the court issued its unanimous opinion in the case of *Gideon v. Wainwright*. It held that "the right of an indigent defendant in a criminal trial to have the assistance of counsel is a fundamental right essential to a fair trial." The court declared that a "trial and conviction without the assistance of counsel" was unconstitutional.

Five months later, Gideon had a new trial. This time he had a lawyer.

Gideon's new lawyer cross-examined Henry Cook, revealing inconsistencies in his testimony and suggesting that Cook had been a lookout for the actual burglars. He also introduced other corroborating evidence attesting to Gideon's innocence. After deliberating for just one hour, the court found Clarence Gideon innocent.

As a result of *Gideon v. Wainwright*, every person is now entitled to a lawyer when appearing in criminal court. Three years later, in the case *Miranda v. Arizona*, the Supreme Court ruled that law enforcement officials must inform people of that right when they are arrested.

"I HAVE A DREAM"

MARTIN LUTHER KING JR.'S 1963 CIVIL RIGHTS SPEECH

The African American struggle for civil rights was a long, hard road. During the two decades following World War II, the movement won important legal victories, while marchers and protestors increasingly won the fight for hearts and minds; more and more Americans became disgusted by racial segregation and exploitation.

However, despite many legal victories and the changing tide of popular opinion, Jim Crow segregation remained entrenched in the South, as well as in parts of the West, where discriminatory laws often targeted Latinos and American Indians as well as blacks. Local and state governments often refused to honor court decisions, and civil rights workers faced violence from mobs and law enforcement alike, some of it fatal. But protestors were resilient and the marches continued.

The largest civil rights protest in American history took place on Wednesday, August 28, 1963. On that day, a quarter of a million people gathered on the National Mall in Washington, D.C., for the March on Washington for Jobs and Freedom—or as it would later be known, simply the March on Washington (see page 189). The day's highlight came with the closing speech by Rev. Martin Luther King Jr.

Speaking for fifteen minutes, King eloquently offered his version of the American dream. Citing the Constitution, the Declaration of Independence, and the Emancipation Proclamation, the speech came to be known by its frequent refrain: "I have a dream."

King's American dream was that people would be judged by the content of their character instead of the color of their skin. That black and white children

Martin Luther King Jr. and activist Mathew Ahmann at the March on Washington. *National Archives and Records Administration*

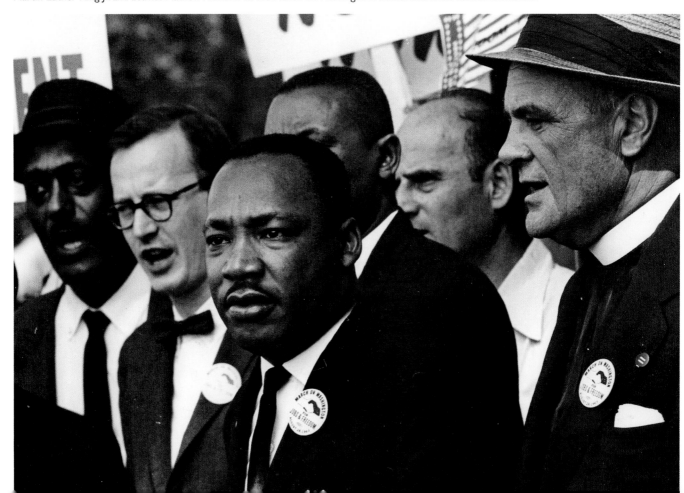

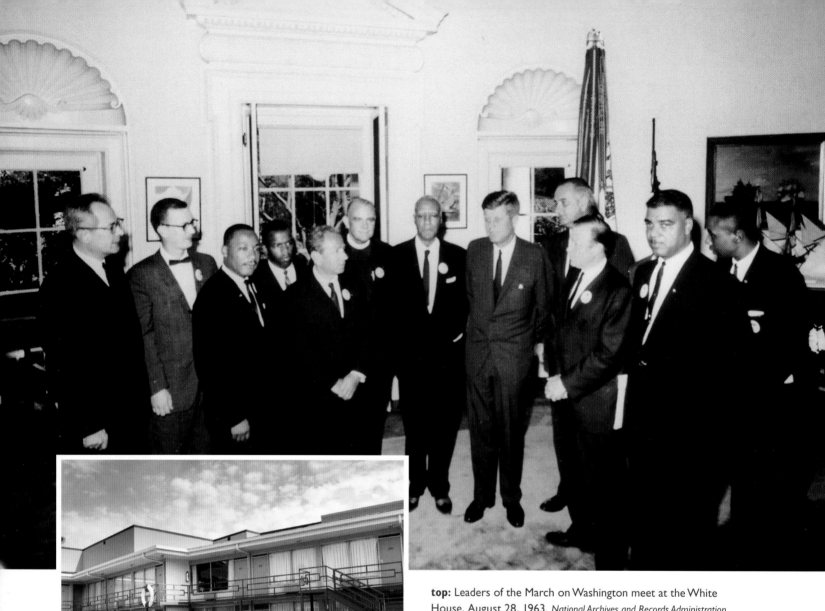

top: Leaders of the March on Washington meet at the White House, August 28, 1963. *National Archives and Records Administration*

inset: The site of the assassination of Martin Luther King Jr. at the Lorraine Motel, home of the National Civil Rights Museum, Memphis, Tennessee. *DavGreg/Creative Commons*

could join hands as brothers and sisters. That "the sons of former slaves and the sons of former slave owners will be able to sit down together at the table of brotherhood."

But King reminded the nation there was still a long way to go. He cited the failure of Americans to make good on the Civil War; slavery was over, but vicious, exploitative racism still infected society. "One hundred years later," he said, "the life of the Negro is still sadly crippled by the manacles of segregation and the chains of discrimination."

King also noted the disparity of widespread African American poverty during the era of postwar prosperity: "One hundred years later, the Negro lives on a lonely island of poverty in the midst of a vast ocean of material prosperity."

He closed by imploring Americans to manifest a fuller meaning of the cherished phrase "Let freedom ring!" When that happened, he said, Americans would "be able to join hands and sing in the words of the old Negro spiritual, 'Free at last! Free at last! Thank God Almighty, we are free at last!'"

King's speech is now recognized as one of the most eloquent and important in American history. The success of the March on Washington proved instrumental in Congress passing the 1964 Civil Rights Act, which dealt the death blow to legalized segregation and began the dismantling of Jim Crow apartheid.

CESAR CHAVEZ
AND THE UNITED FARM WORKERS

Benefitting from abundant sunshine, fertile soil, and complex irrigation systems, California's Central Valley is the nation's leading agricultural center. More than eighty thousand farms and ranches thrive in this naturally semiarid region, producing over four hundred different agricultural commodities, including dairy, fruits, nuts, vegetables, meat, and nursery plants.

In most cases, California's farmers have relied on an army of seasonal workers, particularly at harvest time. Migrant workers travel through the valley, picking produce so it can be packaged and shipped across the country and exported around the world.

Since the California agricultural industry first emerged, Mexican Americans and Filipino Americans have made up the bulk of these migrant agricultural workers. Historically, migrant farm laborers worked piecemeal, struggling to earn a living and facing arduous working conditions. California agribusiness consistently refused to recognize various unions that had begun organizing migrant workers during the twentieth century.

In September of 1965, the Agricultural Workers Organizing Committee (AWOC) organized a strike against large table grape growers in Delano, California. AWOC mostly represented Filipino American workers. A week later, the larger National Farmworker Alliance (NFA) also went on strike. Led by Dolores Huerta and Cesar Chavez, the NFA was composed mostly of Mexican

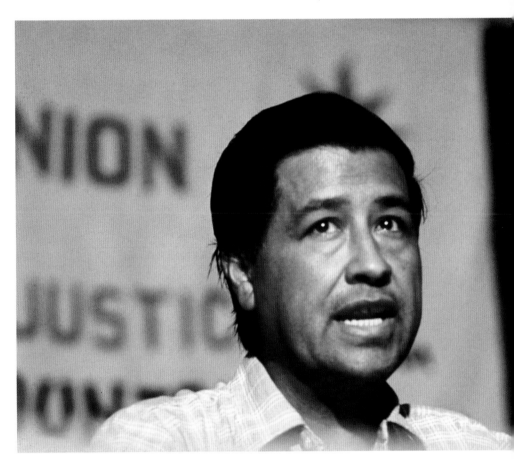

Caesar Chavez, 1972. *National Archives and Records Administration*

American workers. Soon AWOC and the NFA joined forces, forming the United Farm Workers (UFW). An effort to unionize agricultural workers in California's Central Valley, their strike would ultimately last five years.

Influenced by both the labor movement and the civil rights movement, the UFW employed a variety of tactics, including marches, boycotts, community organizing, and nonviolent

civil disobedience. While Huerta was the UFW's organizing force and chief negotiator, Chavez became the inspirational face of the union. Eventually the strike focused on the two largest grape growers in the region, Schenley Industries and the DiGiorgio Corporation.

To draw attention to the strike, on March 17, 1966, Chavez began a three-hundred-mile walk from Delano to the state capital of Sacramento, California.

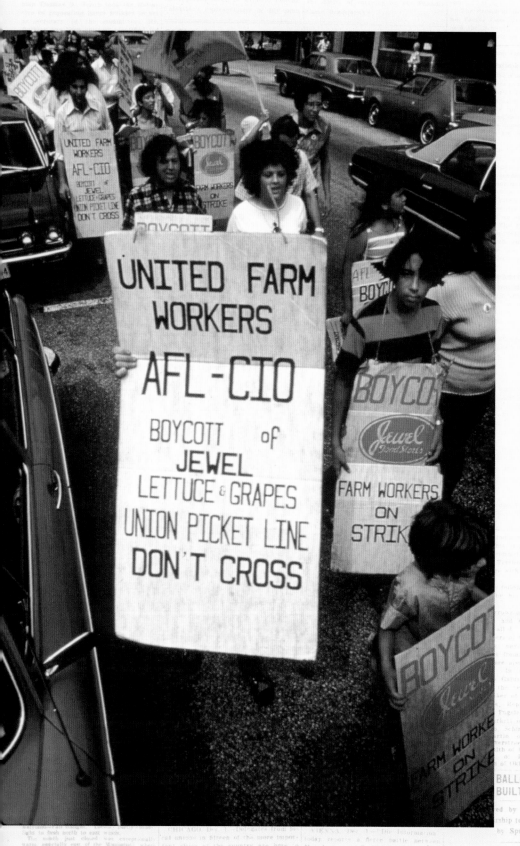

Union picketers outside a grocery store, 1973. *National Archives and Records Administration*

Carrying banners, posters, and flags, Chavez and about one hundred workers were trailed by the press, FBI agents, and various onlookers. Covering about fifteen miles per day, their ranks grew along the way. By the time they reached Stockton, California, the march had some 1,500 members.

Hurt by the increasing popularity of a national and international boycott of California table grapes, and by the growing press coverage of the march, Schenley Industries agreed to settle with the UFW. They would recognize the union and negotiate a contract for workers. But the DiGiorgio Corporation held firm. The day before Easter, the marchers arrived in Sacramento to international fanfare.

The UFW finally overcame DiGiorgio resistance with the help of secondary strikes. When Oakland stevedores refused to load the grapes, they rotted on the docks. And when the Teamsters union refused to truck them, losses became insurmountable.

On August 30, 1967, DiGiorgio allowed its workers to vote on the matter, and they soon elected to join the union. Migrant farm workers could now bargain collectively to improve their wages and working conditions.

THE UNRIVALED CHAMPION

SECRETARIAT WINS THE TRIPLE CROWN

In 1969, horse owner Penny Chenery brought two of her thoroughbred mares, Hasty Matelda and Somethingroyal, to Claiborne Farms in Kentucky. Each would be mated with Bold Ruler, one of the nation's premier studs. But instead of taking cash payment for his services, Bold Ruler's owners would take one of the offspring. Who chose first was to be determined by a coin flip.

Bold Ruler's owners won the toss, and they chose the filly that would come from Hasty Matelda. That meant Chenery got the colt born from Somethingroyal the following March. A bright-red chestnut horse with three white socks, the colt still had no name after its first birthday, as the Jockey Club had turned down Chenery's first five applications. Her secretary, Elizabeth Ham, finally submitted a sixth name, which she had come up with herself, and it gained approval: Secretariat.

After losing his two-year-old debut on July 4, 1972, Secretariat reeled off eight consecutive victories (though he was disqualified in one), including several important preps for the Kentucky Derby. He was named the two-year-old horse of the year.

Secretariat began his three-year-old season with two impressive wins before losing a third; it turned out he had an abscess in his mouth. After healing, he was ready for the premier events in American horseracing, the Triple Crown races: the Kentucky Derby, the Preakness Stakes, and the Belmont Stakes.

On the first Saturday in May 1973, Secretariat was a three-to-two co-favorite going into the mile-and-a-quarter Kentucky Derby. In an unprecedented display of power, Secretariat gained speed the entire race, running each quarter-mile segment faster than the previous one. He shattered the hundred-year-old Derby record, becoming the first horse to run the race in under two minutes.

Two weeks later, Secretariat won the Preakness in Baltimore, again setting a race record. Though his time of 1:53.4 over a mile and three-sixteenths was initially disputed, it was ultimately upheld and is now recognized as the standing Preakness record. On June 9, Secretariat set out to become only the ninth horse ever to win all three Triple Crown races and the first since Citation in 1948.

At a mile and half, the Belmont Stakes is the longest race in American thoroughbred racing, nicknamed "the Test of Champions." Secretariat arrived in New York a one-to-ten favorite (bet ten to win one). He would exceed even those lofty expectations and produce the most dominant performance in thoroughbred racing history.

Secretariat and Sham, who had finished a close second in the two prior races, opened with a blistering pace. Sham tired halfway through and eventually finished last. But instead of coasting to an easy victory, jockey Ron Turcotte put Secretariat's unmatched power on display.

Entering the back stretch, the chestnut stallion was already one-sixteenth of a mile ahead of the field. Eventually his lead grew so large that television cameras could not pan back far enough to keep his competitors in the frame. The camera showed just Secretariat, racing against history.

He crossed the finished line in 2:24, smashing the Stakes record by more than two full seconds and besting the field by an unfathomable thirty-one lengths.

Today, Secretariat is considered to be one of the two greatest race horses of all time, with the other being early twentieth-century champion Man o' War. All three of Secretariat's Triple Crown record-winning times still stand.

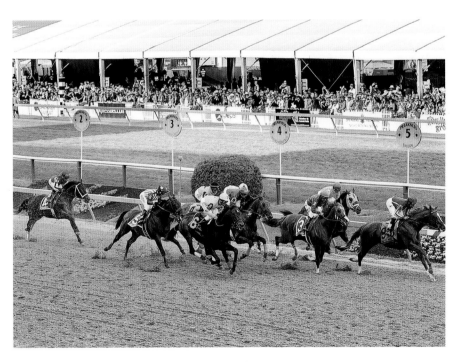

First time past the stands at the 139th Preakness Stakes. *Jay Baker/Maryland State Archives*

AMERICAN NOBEL PRIZE WINNERS

During the nineteenth century, Swedish chemist and engineer Alfred Nobel made several important contributions to the field of explosives, including his invention of dynamite in 1867. In 1895, a year before his death, Nobel signed the final version of his will. It declared that the bulk of his vast wealth should be used to create an award that would bear his name and that would grant "prizes to those who, during the preceding year, shall have conferred the greatest benefit to mankind."

Nobel's family contested the will, and the first prizes were not handed out until 1901. Awards were designated in the fields of physics, chemistry, physiology or medicine, literature, and peace. Among the first winners were German physicist Wilhelm Conrad Röntgen, who discovered x-rays, and German microbiologist Emil von Behring, who developed a treatment for the disease diphtheria. The Nobel Prizes were soon recognized as the most prestigious in the world.

Except for interruptions during World War II, the prizes have been awarded every year since their inception. In 1969, the category of economics was added. Since 1901, well over five hundred Nobel Prizes have been awarded to nearly nine hundred people, with some prizes having joint winners.

The first American to receive a Nobel was President Theodore Roosevelt, who garnered the prize in 1906 after he helped mediate an end to the Russo-Japanese War. The following year, German-born American scientist Albert Michelson claimed the physics prize; eventually, nearly one-third of all American Nobel winners would be immigrants.

The peace and literature prizes would become the most familiar to Americans, and more than twenty Americans have claimed the peace prize thus far. Frequently given to international political elites, the prize is sometimes controversial. Critics have voiced concern over the peace prizes given to Roosevelt, President Woodrow Wilson (1919),

top: Nobel Peace Prize Laureate Jane Addams. A sociologist, author, and philosopher, Addams was known for her work with immigrants and her leadership in women's suffrage. *Library of Congress*

left: Chemist, peace activist, and author Linus Carl Pauling won the 1954 Nobel Prize in Chemistry and the 1962 Nobel P...

President Al Gore (2007), and President Barack Obama (2009), as these men have also been intimately involved in warfare. Indeed, when Kissinger was awarded the peace prize, two members of the prize committee resigned in protest, and Kissinger's co-winner, Vietnamese politician Le Duc Tho, refused to accept the award. However, other peace prize winners, such as Americans Martin Luther King Jr. (1964) and Emily Balch (1946), have been widely lauded.

Among the dozen Americans to win the Literature prize are some of the most renowned writers of the twentieth century, including William Faulkner (1949), Ernest Hemingway (1954), John Steinbeck (1962), and, most recently, Toni Morrison (1993).

But most of all, the United States has dominated the sciences. Well over a hundred Americans have claimed various science prizes since Michelson in 1907.

An illustration of the American Century, the number of American winners is more than triple the next-highest number of recipients from any other country (namely the United Kingdom and Germany). In all, more than 350 Nobel Prizes have been awarded to Americans, more than half of them in the sciences.

top: An official military photo of George C. Marshall, World War II general of the army and Nobel Peace Prize winner in 1953. *US Army*

left: American pacifist and Nobel Peace Prize laureate Emily Greene Balch. *Library of Congress*

THE MIRACLE ON ICE

THE US TEAM DEFEATS THE USSR IN OLYMPIC HOCKEY

In 1980, professional athletes were still barred from participating in the Olympics. Only amateurs, who could not be paid for athletic competition, were allowed. However, during the Cold War, communist countries from Eastern Europe found creative ways around this restriction.

In the case of the Soviet Union men's hockey team, many members were officially enlisted in the Soviet Army. But hockey was their primary assignment, and the team competed in a world-class league. In 1980, the USSR men's hockey team was widely recognized as the best in the world at any level. They had won every gold medal in hockey since 1964, going 27–1–1 during that period and outscoring their opposition 175 to 44 in Olympic competition.

The 1980 Winter Olympics were held in Lake Placid, New York. In preparation, the Soviets played nine games against top National Hockey League clubs, winning five, losing three, and drawing once. The Russians then routed a team of NHL all-stars, 6 to 0.

University of Minnesota head coach Herb Brooks was tapped to helm the US men's Olympic team. Faced with a daunting task that virtually no one thought he could achieve, Brooks selected twenty college hockey players and emphasized rigorous training. He knew his young players' skill level was no match for the Soviets, but he hoped that an ultra-fit American team could at least keep up with them. During the five months leading up to the

The jersey worn by Dave Christian of the Team USA "Miracle on Ice" squad during the 1980 Winter Olympics on display in the Hockey Hall of Fame. *Robert Meeks*

Olympics, his team played an astonishing sixty-one exhibition games.

In their final tune-up for the Olympics, the US team played the Soviets at Madison Square Garden in New York City. Less than a week before the opening ceremony, the Russians humiliated the Americans, 10 to 3. The US team was widely expected to make a quick exit from the upcoming games.

During the initial stage of Olympic group play, the members of the US team showed themselves to be a cohesive unit, energetic, boasting strong defense, and showing a flair for last-minute heroics.

After a late comeback to earn a draw against Sweden, they stunned a powerful Czechoslovakian team that had been favored to win the Silver Medal, trouncing them 7 to 2. The United States finished with impressive wins against Romania, Norway, and West Germany, advancing to the medal round.

Meanwhile, the Soviets had won all five of their games by a combined score of 51 to 11. The two teams would meet in the first game of the medal round. No credible observers believed the young American squad could win. But the hometown,

A 1980s Soviet stamp commemorating the Olympics. *Public domain*

sellout crowd of 8,500-plus was raucous from start to finish.

The Russians scored first. However, the "Miracle on Ice" started to coalesce when American Mark Johnson scored with just one second left in the first period, tying the game.

The Soviet coach reacted harshly. He shocked Americans and Russians alike by pulling from the game Vladislav Tretiak, who at the time was universally acknowledged as the world's best goalie (and who was later inducted into the Hockey Hall of Fame).

The Soviets began their assault in full during the second period, outshooting the Americans 12–2 and taking a 3–2 lead. After a Soviet penalty, the Americans tied the game on a power-play goal eight minutes into the third period. Less than two minutes later, the unthinkable happened when US team captain Mike Eruzione scored to put the US ahead, 3 to 4.

For the remaining ten minutes, the US team weathered a relentless assault from the Soviets, with goalie Jim Craig rising to the occasion. By the time he turned away the last Soviet shot with half a minute remaining, Craig had racked up an astonishing thirty-six saves.

With seven seconds remaining, TV announcer Al Michaels asked the audience, "Do you believe in miracles?"— and then answered his own question with a resounding "Yes!" The United States amateur men's hockey team had just completed arguably the biggest upset in the history of competitive team sports.

Three days later, the US team came back from a 2-to-1 deficit, beating Finland 4 to 2 to win the Gold Medal.

SIOUX NATION V. UNITED STATES
RECLAIMING SACRED LAND

During the Powder River War of 1866 to 1868, also known as Red Cloud's War, the Lakota Sioux became the last indigenous nation to defeat the United States in a war. The ensuing Treaty of Fort Laramie (1868) acknowledged enormous Lakota landholdings across the northern Great Plains. Among them were the Black Hills mountain range in South Dakota and Wyoming, which is sacred to the Sioux.

However, despite the victory, the Sioux would soon succumb to US expansion. As bison herds diminished, the Sioux economy collapsed, forcing them onto the Great Sioux Reservation, which the Fort Laramie treaty had designated as their homeland.

right: Sitting Bull. *David Francis Barry*

below: View of the Sioux camp at Pine Ridge, South Dakota, 1890. *National Archives and Records Administration*

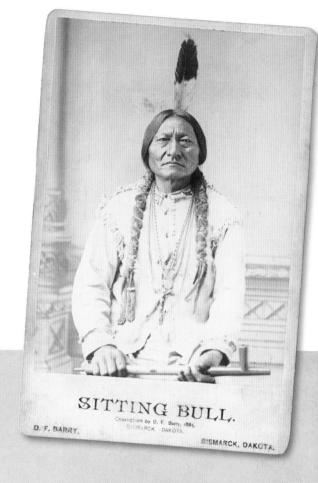

SITTING BULL.

Copyrighted by D. F. Barry, 1885.
BISMARCK, DAKOTA.

D. F. BARRY,

BISMARCK, DAKOTA.

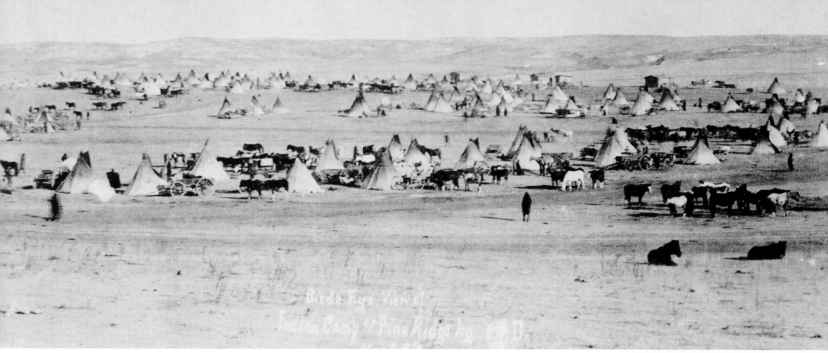

Red rock canyons in the southern Black Hills of South Dakota. *Wikimedia user Runner1928/Creative Commons*

Even as the Sioux and their Cheyenne allies obliterated Lt. Col. George Custer's Seventh Cavalry in 1876, more and more Indians were forced to settle on the reservation and live under US control.

Discovery of gold in 1874 had sent American miners flooding into the Black Hills. US officials soon disregarded their treaty obligation and stopped trying to stem the tide of miners. Instead, negotiators attempted to strong-arm the Sioux into selling the Black Hills. When they refused, the United States illegally seized the mountains, extricating them from the Great Sioux Reservation.

By 1881, Sitting Bull and the last of the Sioux holdouts had finally surrendered. The impoverished reservation now functioned as a prison camp (*see* **Cultural Genocide**, *page 160*). Indian people living under US authority needed federal approval to leave it. The United States continued seizing more land. By decade's end, the Great Sioux Reservation had been divided into six smaller parts, with tens of thousands of acres lost in the process.

As conditions on the reservations worsened, many Sioux rallied around the new Ghost Dance religion. In 1890, the US Army massacred more than two hundred Ghost Dancers at Wounded Knee Creek.

Over the next several decades, the combined Sioux reservations launched numerous legal actions to regain the Black Hills, or to at least receive financial compensation. But these efforts went nowhere. In the 1950s, the Sioux revived their legal efforts, and a team of lawyers sought financial redress for the Black Hills. The federal government was recalcitrant, initiating legal maneuvers that delayed the case for a quarter century.

In 1980, more than a century after the United States had broken the Fort Laramie treaty and illegally taken the Black Hills, the US Supreme Court heard the case of *Sioux Nation v. United States*. The justices ruled eight to one that the land seizure had been illegal, and the court recognized an "obligation on the Government's part to make just compensation to the Sioux."

"That obligation, including an award of interest," the Court said, "must now be paid." However, by 1980, many Sioux people were no longer willing to accept financial compensation. Instead, they demanded the return of their sacred Black Hills. Congress authorized payment of more than $100 million, the largest ever to an indigenous nation, but the Sioux tribes have remained united and refused to accept it.

The money has sat in escrow ever since, accruing interest. It is now approaching $1 billion.

TEAR DOWN THIS WALL!

THE COLD WAR ENDS

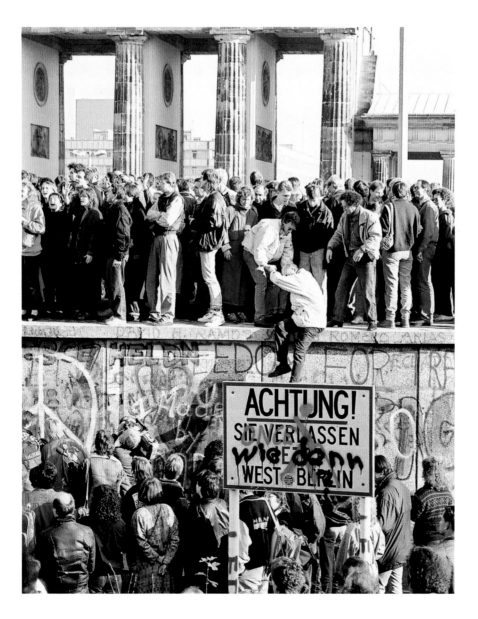

Following World War II, the United States and the Soviet Union engaged in the Cold War, a fierce competition for global supremacy. The two sides never engaged in a physical war, but across the administrations of nine US presidents and six Soviet premiers, the two superpowers competed with each other in a variety of ways.

They engaged in a decades-long arms race, building up arsenals of both nuclear and conventional weapons (see **The Atomic Specter**, *page 187*). They waged a space race that led each side to make astounding technological breakthroughs (**Beyond the Stars**, *page 95*). In an endless propaganda war, each side attempted to present itself as the superior force for good while smearing the other side as evil (**Loius Armstrong**, *page 40*). They locked horns in international athletic competitions (**The Miracle on Ice**, *page 242*). And they both eagerly meddled in the political affairs of countless smaller nations, attempting to win them over through means good and ill, ranging from foreign aid to political coups and even warfare (**Korea**, *page 184*, and **Vietnam**, *page 194*).

The entire world was affected by the Cold War. For Americans and Soviets, of course, it was more immediate; it was part of everyday life, with the rivalry's intensity ebbing and flowing for decades. Many assumed the stalemate would never end during their lifetimes.

Soon after World War II, the United States and the Soviet Union had vied for control of Germany, dividing the nation into two parts: democratic West Germany and communist East Germany, the latter of which became part of the Soviet bloc of communist nations in Eastern Europe. Located within East Germany, the city of Berlin was itself divided east and west, West Berlin existing as an island of democracy within totalitarian East Germany.

People celebrate on top of the Berlin Wall near the Brandenburg Gate, 1989.
Sue Ream/Creative Commons

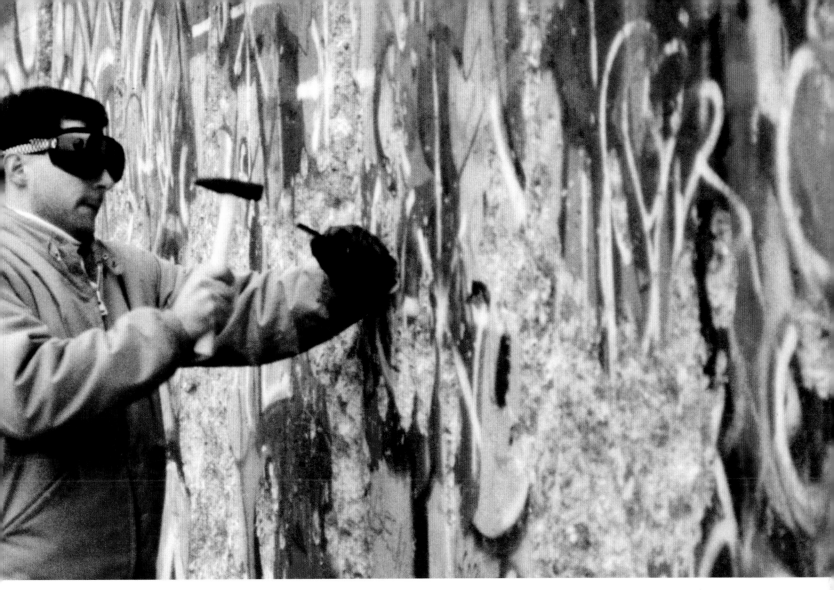

Chipping at the Berlin Wall, 1989. *Raphaël Thiémard/Creative Commons*

West Berlin prospered while East Berlin suffered under communist rule. In 1961, East Germany built a physical wall between the two sides. The Berlin Wall sealed off West Berlin from East Germany and prevented East Germans from fleeing poverty and repression by escaping to West Berlin.

Over the years, as it grew into a massive concrete structure topped with barbed wire and armed guard posts, the Berlin Wall became the preeminent symbol of Cold War tensions and of communist totalitarianism.

On June 12, 1987, President Ronald Reagan was in West Berlin to celebrate Berlin's 750th anniversary. He gave a speech in front of the magnificent Brandenburg Gate. Built in the late eighteenth century, it was now within easy sight of the Berlin Wall. Reagan gave a speech advocating freedom and liberty. He then addressed Soviet president Mikhail Gorbachev, who was not present:

> *General Secretary Gorbachev,*
> *if you seek peace, if you seek*
> *prosperity for the Soviet Union*
> *and Eastern Europe, if you seek*
> *liberalization, come here to this*
> *gate. Mr. Gorbachev, open*
> *this gate. Mr. Gorbachev, tear*
> *down this wall!*

Reagan's open challenge to Gorbachev eventually became an iconic moment of the Cold War, pointedly daring his Soviet counterpart to destroy the much-hated edifice and embrace freedom.

Two years later, the Soviet empire entered a state of terminal collapse. The USSR was no longer able to underwrite the Soviet bloc countries, and in 1989, one nation after another threw off communist rule. The Berlin Wall fell in November.

The following year, Soviet republics within the Soviet Union began breaking away, leaving only Russia. On Christmas day, 1991, the Soviet Union officially dissolved.

The United States had finally won the Cold War.

CODA

9/11

On New Year's Eve, 1999, the world was about to not only ring in the New Year, but welcome a new century.

New Zealand began the celebration, broadcasting live from Chatham Island near the International Date Line. Each hour, as the clock struck midnight on another location to the west, people reveled in the dawning of the twenty-first century and paid homage to the passage of the twentieth. In city after city, fireworks lit the sky, music filled the air, and drinks flowed freely.

The United States' six time zones each celebrated in turn, beginning on the East Coast and ending in the Aleutian Islands and Hawai'i. American Samoa became the last US possession to celebrate, almost a full day after New Zealand had begun the party.

Later that week, unbeknown to all Americans save a few high-ranking politicians and intelligence officials, an al-Qaeda summit was held in Kuala Lumpur, Malaysia. In attendance were the nineteen men who would highjack four American planes twenty months later.

In the meantime, life went on as normal in the United States.

At the end of January, the St. Louis Rams defeated the Tennessee Titans in a Super Bowl that came down to the last play of the game.

In February, the final *Peanuts* comic strip was published after the death of creator Charles Schulz earlier that month.

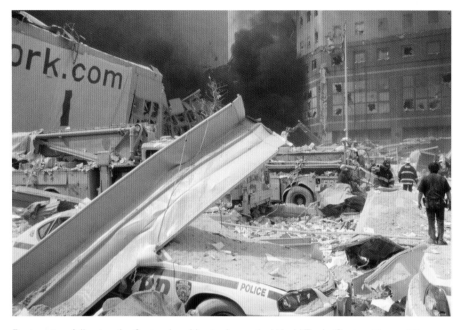

Destruction following the September 11 attacks on the World Trade Center. *Library of Congress*

In March, Pope John Paul II apologized for all the wrongs the Catholic Church had committed in the past and made the first-ever official papal visit to Israel. Vladimir Putin was elected president of Russia.

In April, the federal government released preliminary findings of the 2000 census, which counted 281,421,906 people living in the United States. And a federal court declared that Microsoft had violated antitrust laws, acting as a monopoly and restraining competition.

In May, the ILOVEYOU (a.k.a. LOVE LETTER) computer worm emerged from the Philippines and quickly became the most pervasive computer virus to date. To prevent damage, the Pentagon and CIA shut down their entire email systems. ILOVEYOU eventually infected 10 percent of the world's computers, caused somewhere between $5 billion and $8 billion in damages worldwide, and required another $15 billion to repair.

In June, the Human Genome Project announced from the White House that it had completed a preliminary draft of the human genome map.

In July, the Republican National Convention began, eventually nominating George W. Bush as the party's presidential candidate.

In August, *Dora the Explorer* debuted, as did the Nintendo GameCube. The Democrats chose Vice President Al Gore as their presidential nominee.

In September, the Summer Olympics were held in Sydney, Australia.

In October, the New York Yankees defeated the New York Mets in an all–New York City "subway" World Series. An al-Qaeda suicide bomber badly damaged the USS *Cole*, which was stationed in Yemen. And the first residential crew departed for the International Space Station, since which time there has been continuous human habitation of space.

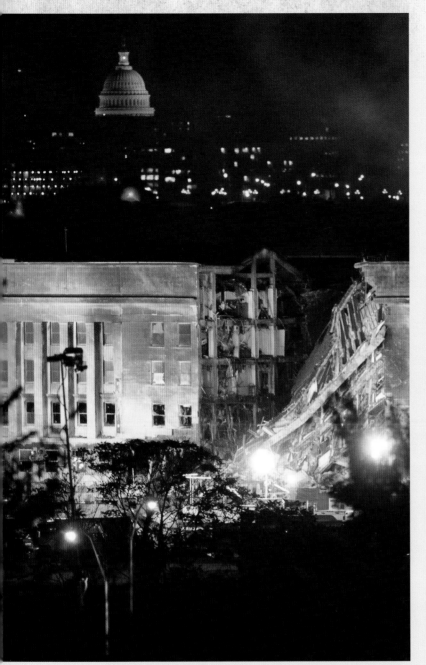

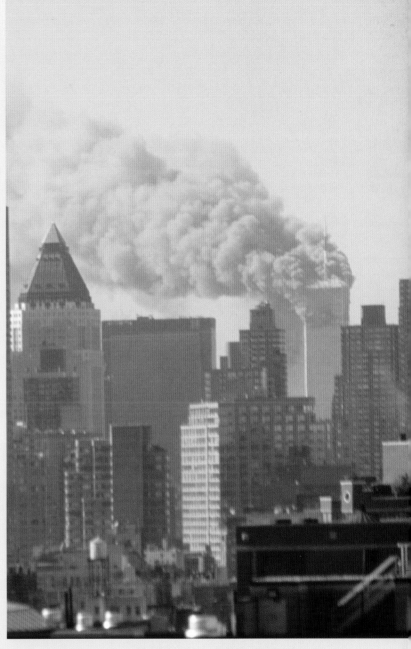

top left: The Pentagon, partially collapsed, late into the night following the attack. *Photographer's Mate 2nd Class Bob Houlihan/US Navy*

top right: A view of New York after the attack on the North Tower. *Library of Congress*

In November, George W. Bush narrowly pulled ahead of Al Gore in a tight election. The results in Florida were contested, requiring a recount. Meanwhile, Hillary Rodham Clinton became the first former first lady to be elected to the US Senate.

In December, the US Supreme Court issued a five-to-four decision in the case of *Gore v. Bush*. It ordered the Florida recount to end, allowing George W. Bush to be declared the winner.

The following year, things continued to look up for the most part. The political atmosphere stabilized after the disputed election. The economic surge of the late 1990s continued. In general, American society felt confident.

Then came September 11.

When two planes destroyed the World Trade Center towers in New York City, another exploded into the Pentagon outside Washington, D.C., and a fourth crashed in rural Pennsylvania before it could reach the nation's capital, the United States faced a new struggle. In some ways it was one familiar to those old enough to remember the 1941 attack on Pearl Harbor; like the Japanese assault, the 9/11 attacks were a complete surprise and resulted in a similar number of casualties. However, there were also important differences between the two tragedies.

The attacks happened not in a distant territory, but in the nation's capital and in its largest city. Instead of being relegated

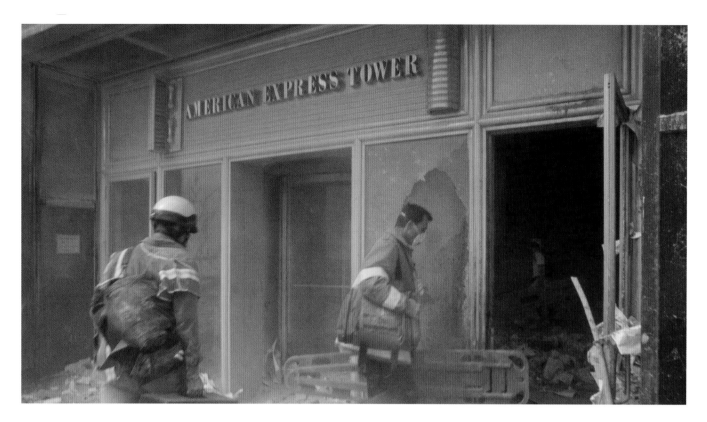

right: Rescue workers enter the Three World Financial Center on September 11. *Library of Congress*

above: A New York City firefighter at Ground Zero on September 11. *Photographer's Mate 2nd Class Jim Watson/US Navy*

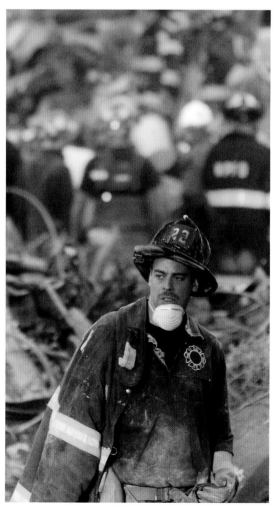

to military targets, it was specifically designed to kill and terrorize civilians. And the violence did not originate with a rival empire locking horns with the United States in a bid for global supremacy; rather, it came from a non-state actor, a terror organization that the vast majority of Americans had never heard of.

In New York City and Washington, D.C., Americans struggled to cope with the loss of life, the tremendous damage, and the immediate security lockdown. In the rest of the country, hundreds of millions of people struggled to make sense of what had just happened—struggled to find meaning in the unimaginable.

Americans disagreed on numerous issues surrounding the disaster. They questioned what the proper response should be in foreign policy and military intervention abroad. But they also quickly overcame many divisions among themselves and found ways to triumph over fear.

Despite differing opinions, nearly all Americans rallied behind the idea of America. As fellow citizens and residents, they came together and gave of themselves. Whether donating money, blood, time, or hard work, they found ways to contribute toward making the country whole again, and they fought against the instinct to be afraid.

As they began the process of healing and rebuilding, Americans discovered new ways to envision themselves in the aftermath of tragedy. They cast themselves as brave instead of frightened; as strong instead of weak; as taking the initiative instead of being surprised. Many Americans, particularly those too young to remember World War II, discovered a strength within themselves, and in the nation as a whole, that allowed them to overcome the

terrifying events of that day. Despite their differences, most Americans felt a sense of common purpose, of shared commitment and sacrifice, of wanting to pull together for a greater good.

As the twenty-first century continued to unfold, eventually the initial shock of the tragedy faded. Life returned to normal, albeit a new normal.

By 2003, Americans were forced to confront new uncertainties. There were burdensome security measures when they traveled. The economy was slumping. New fears reshaped old bigotries. And the nation was fighting not one but two controversial foreign wars.

Politicians and citizens debated the calculus of security and liberty, safety and constitutional rights. The divisions and quarrels that plague pedestrian, day-to-day life became more commonplace again, as Americans wondered about which was the right path forward.

Even memories of 9/11 became contested at times, as various politicians, community leaders, and business leaders debated what to do with Ground Zero; the spot where the World Trade Center crumbled was considered hallowed ground, but what was the best way to memorialize it?

As Americans struggled during the first decade of the new century, there was one thing they could agree on. Those who had lived through September 11, 2001, would forever carry its memory.

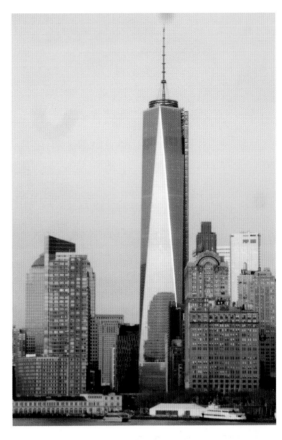

right: Freedom Tower November, 2013. *Wikimedia user Ariarmstrong/Creative Commons*

below: New York City's "Tribute in Light" memorial on the fifth anniversary of 9/11. *Denise Gould/US Air Force*

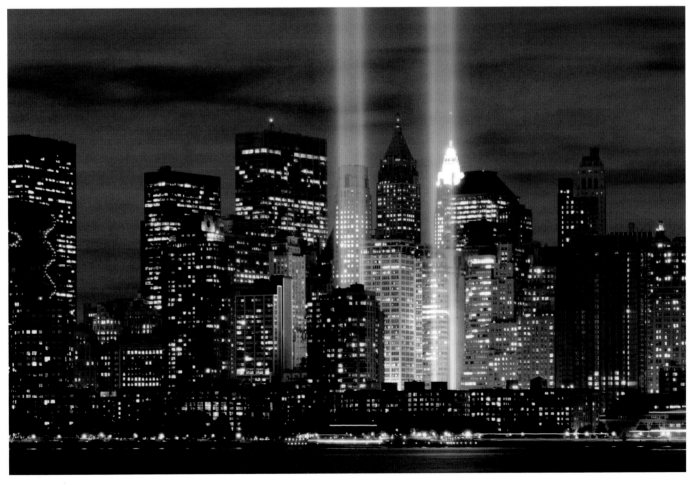

On the eve of the twentieth century, the United States had reveled in its victories. The nation had begun rounding out its continental borders and adding the last of the lower forty-eight states; it boasted the world's preeminent economy; and its easy victory over Spain in 1898 had signaled to the rest of the world that the United States was an overseas empire. Cities grew, farms issued forth their bounty, the industrial sector roared, and the nation emerged from a prolonged depression to begin three decades of prosperity.

Beneath the glitz and ballyhoo, however, lurked serious problems. Racial animus still plagued American society. Likewise, profound sexism was widespread and largely unquestioned. National growth had come at the expense of indigenous peoples, first in North America, and now around the world. And though the US economy grew with more ups than downs, a vast disparity in wealth meant that many were left behind as millions of Americans remained mired in deep poverty.

During the twentieth century, Americans would struggle to make sense of and eventually overcome many of these paradoxes. As the nation's prowess and confidence grew, so too did the opportunities for those members of society who had previously been shut out. By century's end, the United States was hardly perfect; vestiges of older problems remained. Nevertheless, no one could doubt the many strides the nation had made or the unrivaled economic and military power that marked it in many ways the envy of the world.

The twentieth century had been the American Century. But what would become of the twenty-first?

As people tried to make sense of the shock of 9/11, it became commonplace to assert that "nothing would ever be the same." It seemed to be conventional wisdom that the attacks had "changed everything." But what did that change actually mean? Aside from longer lines at airports and a supposed loss of innocence, how would things actually be different?

As the twenty-first century opened amid war and economic malaise, some began raising uncomfortable questions about the United States. Would the twenty-first century be the inverse of the twentieth? Instead of being a nation on the rise, was the United States now on the decline? Had it passed its zenith? Or would the setbacks during the early years of the twenty-first century prove to be minor blips as America maintained its position as the world's most prosperous and powerful country?

The future is unknowable. But it seems that the United States faces new challenges and opportunities, even as it continues to address older concerns and celebrate its previous victories.

Nuclear arsenals have changed the limits of conventional warfare. The end of the Cold War has reshaped world politics. Globalization, deindustrialization, modern finance, and the rise of China, India, and other developing nations have radically altered the economic equation. New waves of immigration from Latin America, Asia, and Africa are reshaping American society. And the digital revolution has led to new technologies appearing on the scene at an astonishing rate, transforming American culture and society along the way.

The twentieth century is now something to celebrate, to remember solemnly, and to wonder at. The twenty-first century is for us to live.

Pentagon Memorial dedication ceremony on September 11, 2008. *Master Sgt. Adam Stump/US Air Force*

above: The first American flag to be raised above Ground Zero following the attacks is presented to the crew of aircraft carrier USS *Theodore Roosevelt* (CVN-71), to be flown during the ship's deployment. *Chief Photographer's Mate Eric A. Clement/ US Navy*

right: Soldiers roll out the flag in preparation for a December 11, 2001, Pentagon ceremony to commemorate 9/11 victims. *R. D. Ward/US Department of Defense*

INDEX

BUSINESS MEN ENTER COAL YARDS TO LEARN CAUSE OF HIGH PRICE

Without Waiting for Formal Meeting, Committee Named Saturday Begins Active Operations.

Will Interview Local Railroad Men Regarding Situation in Addition to Visiting Dealers.

Without awaiting the formal meeting of the committee appointed Saturday by the District Commissioners to investigate the discrimination which, it is alleged, is practiced against this city in the distribution of coal from the mines, the work was aggressively taken up this morning and an important report will be ready for submission when the committee meets late this afternoon. Chairman Thomas W. Smith took the initiative by requesting Barry Bulkley to act as secretary of the committee. Mr. Bulkley has been actively identified for several weeks with the investigation of the coal situation. He is considered one of the best-informed persons in the city with reference to the situation.

Immediately following this appointment arrangements were made for an inspection of all of the coal yards and dumps in the city and the interviewing of the local railroad officials with a view to ascertaining what the condition actually is. An accurate report will be submitted this evening at the meeting in the Board of Trade rooms as to the approximate receipts of the day of all kinds of coal and the amount of the visible supply. All facts bearing upon the situation which it is possible to ascertain in the limited time at the disposal of the members will be submitted for the consideration of the committee as a whole.

All of the members of the committee were informed this morning by Secretary Bulkley of the work outlined, and all signified their intention of taking part in the investigation, with the exception of ex-Commissioner George Truesdell, who is in Chicago. Just when he will return is not known.

Charles F. Weller, secretary of the Associated Charities, and one of the most active members of the Citizens' Relief Association, has arranged to present to the committee this afternoon the needs of the poor and to ask that action be taken to care for them in case of emergency. The local dealers have been supplying limited quantities of coal to the association and to the relief committee at an advanced price, but have announced that they cannot guarantee to continue to do so.

ENGLISH TORPEDO BOAT DESTROYER IN COLLISION

Narrowly Escapes Foundering in Channel—Dense Fog Prevailing at Time of Accident.

BOULOGNE, Dec. 1.—The torpedo bat destroyer Dr Horter, bound from Baulogne to Cherbourg, was in collision with an unknown vessel in the Channel last night. A dense fog prevailed at the time.
The De Horter sustained extensive

MINISTER CONCHA OF COLOMBIA RECALLED BY HIS GOVERNMENT

Given Leave of Absence From His Post to Place Himself Under Care of Physician in New York.

The State Department was informed this afternoon, by Secretary Herran, of the Colombian legation, that Senor Concha, the representative of Colombia, has received leave of absence from his post in this city to go under the care of a doctor in New York. It is understood, in department circles, that this is equivalent to Senor Concha's recall.

The State Department has not yet received any official advices respecting the reported recall of Minister Concha, Colombia's representative in this country, although it is generally believed that he has been summoned home by his government, on account of dissatisfaction with his diplomacy in the matter of the Panama Canal negotiations.

The understanding is that Senor Herran, present secretary of the legation, will have charge of Colombia's affairs here until the appointment of a new minister, which will probably be himself, and that he will at once assume the duties of carrying on the Panama Canal negotiations.

GLENS FALLS DEALER'S COAL SUPPLY SHUT OFF

Declares Operators Discriminated Against Him.

SARATOGA, N. Y., Dec. 1.—The Citizens' Alliance, an association of business men and manufacturers of Glens Falls, are probing the matter of the cost of coal in that place.

They have learned that Delaware and Hudson Coal, for which $8 per ton is charged there, is being sold at Plattsburgh, 112 miles' haul, for $6.50; in Fort Ann for $6.50; in Ganzevort for $6.25; in Saratoga Springs and Ballston Spa, rail communication only, for $6.50.

The grievance is laid at the door of the Delaware and Hudson Canal Company, which, as alleged, has taken a hand in controlling prices.

J. H. O'Connor, a Glens Falls dealer, who has 2,000 tons of Lehigh and Lackawanna coal on land, which he is selling at $7.50 per ton, allows to be published today a communication he received from G. W. Church, agent of the Delaware and Hudson Company, in which O'Connor is charged with selling coal at a lower figure than his competitors and saying that "you are not strong enough to stand a run in prices or to undertake to sell coal at less than any other dealer can do."

It is stated that O'Connor "gave bonds to pay for his coal, but because he did not see fit to keep the price up his supply was cut off and he has received no coal of the Delaware and Hudson Company since."

ST. LOUIS ARRIVES AT PIER ONE DAY OVERDUE

Delayed by Gale and Defective Boiler.

NEW YORK, Dec. 1.—The American Line steamer St. Louis arrived in port early this morning from Southampton and Cherbourg after a very stormy passage.

The St. Louis is usually due on Sunday morning. Owing to the fact that her boilers have not been up to their usual steaming capacity, added to the violent gales encountered, her average speed was reduced to 15.22 knots per hour.

The St. Louis left the channel with moderate breezes which later increased to a gale with violent squalls and a very high dangerous sea. The gales continued in violence from the north, northwest and southwest, until Friday, when they fell to a light breeze from the south, southeast, with hazy weather.

From Thursday noon to Friday noon, the ship made 409 knots. After noon Friday, the ship had fog for 183 miles, which further delayed her. The daily runs, except that ending Friday noon, were all under 400 knots, that of Saturday being only 364 knots.

Among the passengers were J. Allison Bowen, United States deputy consul general, Paris; the Comtesse D'Ilier and Gen. Ben I. Viljoen, late of the South African republican burgher forces. General Viljoen has come for a three-months' lecture tour in this country and to make arrangements for the publication here of his new book, "My Reminiscences of the Anglo-Boer War," of which he brought advance proof sheets.

DEATH OF MAN WHO AIDED IN FALL OF CHARLESTON.

Thomas Semmes Furnished Plans Which Helped Federal Forces to Take City...Had Exciting Career.

MANY CALL ON THE PRESIDENT

Senator Warren of Wyoming Tells Chief Executive That Bears Are Plentiful and Promises Rare Sport.

OFF DAY FOR POLITICS

Those Who Visit White House Do So to Pay Their Respects, as Is Customary at Opening of Congress.

As is customary at the opening of every Congress, many of the members of the House and Senate called on the President.

Senator Warren of Wyoming and Representative-at-Large F. W. Mondell were the first to arrive at the White House. The Senator referred to the President's trip to Mississippi and declared Wyoming afforded much better sport.

"The President is looking forward to his Pacific Coast tour of next spring," said the Senator, "and will then take the 100-mile trip on horseback from one side of the State to the other, which I proposed to him last spring."

The Outlook in Kansas.

Representative Curtis of Kansas also paid his respects to the President.

"The Senatorial outlook in my State is very encouraging," he said, "and I expect to have the largest support of any of the candidates for Senator Harris' seat in the upper house. I have the lead now and am confident of keeping it."

Senator Millard of Nebraska, who was an early visitor, does not regard the alleged encroachments of Western cattlemen upon Government lands as a matter of much consequence.

This is a subject upon which the President has taken a decided stand, in view of the reports made by Col. John S. Mosby, now an agent of the Interior Department. The President's order to all squatters to vacate within a year has not been obeyed, and drastic measures to enforce the law are contemplated here, it is understood, by high Government officials.

Government Lands.

"We do not hear much about any such accusation of Government lands illegally," said the Senator on leaving the White House offices. "All we have heard is in the reports of Colonel Mosby."

Attention was called to Edward Rosewater's recent allegations of rascality in office made against certain Federal place holders in Nebraska. The Western editor did not present any specific charges of malfeasance in office, but did charge that high officials were so controlled by bad political influences as to impair their usefulness to the General Government and to the State.

"One of the officials Mr. Rosewater is fighting, according to reports," said the Senator, "is United States District Attorney Summers. His term expires December 29. He is a capable official, and I hope to see him reappointed."

Many Pay Respects.

Senators and Representatives returning for the session came in pairs to pay their respects. Callers having political matters to present had little opportunity to say much to the President along